PRINTS

PRINTS

A Collector's Guide

Ellen Kaplan

Coward-McCann, Inc.
New York

Sotheby Parke Bernet catalogue information
copyright © 1982 by Sotheby Parke Bernet, Inc.

Designed by Irwin Wolf

Library of Congress Cataloging in Publication Data

Kaplan, Ellen.
 Prints, a collector's guide.

 1. Prints—Collectors and collecting. I. Title.
NE885.K36 1983 769′.12 83-5161
ISBN 0-698-11246-6

PRINTED IN THE UNITED STATES OF AMERICA

Contents

Foreword

When I was studying law in the late 1940s, free time was no easier to find than it is today. I had to make a conscious effort to keep up with the things which interested me outside of school, especially the arts. Sometime during 1949, I managed to attend an exhibition of work by Edvard Munch, a relatively obscure Norwegian artist, at the Boston Museum of Fine Arts. Although I'd never seen anything by Munch before—in fact he was only a footnote in an art history textbook at the time—that exhibit had tremendous impact on me, and continues to influence my life and my thinking about the visual arts.

Today I am a partner in a highly regarded national law firm with offices in five cities. I'm proud to have attained this position, notwithstanding my "persistent" outside interests, but perhaps even prouder to have become a serious collector of important, original prints. What I continue to find most remarkable about my involvement with art is that I never intended to build a collection, and certainly not to purchase art as an investment. Yet today I often think that this part of my life seems somehow more real than the commercial and legal matters which occupy most of my time.

My first prints were purchased with absolutely no forethought, purely for enjoyment. I was in New York on business, several years after seeing Munch's work for the first time, when I noticed a listing for an exhibition of his prints at the Allan Frumkin Gallery on 57th Street. Visiting the show, I discovered that the collection belonged to the prominent architect Mies van der Rohe and had been sold in its entirety to the Chicago Art Institute. A few odd pieces—some duplicates, some unrelated to the collection—were however, still available. To my own surprise, and with a certain amount of trepidation, I purchased three of these for the staggering sum of 1,500 dollars.

At first, I didn't quite know what to do with my new acquisitions. Fearful that I had been misled about the price of the works, I consulted a variety of acquaintances in the art world as soon as I returned to Washington and was relieved to find that the prices were fair. But, having bought the art without serious premeditation, I still didn't feel completely comfortable about owning the prints and hid them in the basement for several months.

From that unlikely gallery space I doled the prints out as gifts to my wife—one for her birthday, one for Christmas, and one for our anniversary. And I thought that would be the end of it. But those prints had a magical effect. If in the morning I walked through the dining room, where they hung, I remembered later in the day that I had done so. Owning the art seemed to raise my level of awareness in a way that affected my entire life.

I found myself thinking about the images in the middle of the day, wishing to become more familiar with the artist who intrigued me and the process by which he created his work. I visited the galleries regularly and read extensively about the history and technique of printmaking. I met dealers, collectors, and curators in Washington and New York—in fact, everywhere I traveled on business. These "art professionals" taught me more than books ever could about the minute differences in quality and condition which determine the value of older works. And, naturally, as my confidence grew, so did the collection.

At the beginning, my purchases were somewhat whimsical, each possessing a unique appeal. But gradu-

ally a collection began to take shape. I began to foresee which pieces would have long-term appeal after I had lived with them and which would complement the overall feeling of the collection. And since budget was an important consideration at the time, I was usually prudent enough to discuss each purchase with an expert, often Robert Light of the Light Gallery in Boston. Limiting myself to works of recognized quality, I could be sure that each piece had inherent resale value should it (as was inevitable from time to time) turn out to be a mistake.

With constant exposure to a tremendous variety of artists and styles one's taste begins to define itself, at least as far as purchasing is concerned. (I don't believe a person should ever limit the kinds of art he or she experiences.) In my own case, I discovered that I was consistently attracted to prints as a medium, and to lyrical, narrative, or allegorical subjects. This didn't mean I was unable to appreciate a wide spectrum of artists or media, but that I had found a focus for my own desires to collect. For a collector, finding this "center" of one's perceptions is a pivotal accomplishment, which lends direction and rationale to what is essentially a mania for possession (albeit a thoroughly enjoyable one).

There's really no simple explanation for how my wife and I came to concentrate our efforts on Edvard Munch. After several years of experimentation and some memorable dalliances with the work of other artists, it became clear that Munch's work continued to exert the strongest force on every one of our sensibilities. Emotionally, aesthetically, and psychologically, our first encounter with his art was electrifying. And the effect was only intensified by living with it. Happily, circumstances favored our enthusiasm in two respects: Not only was Munch's work available at that time, but we could afford to buy it.

During the last three decades, my wife and I have assembled the most extensive collection of Munch's graphic oeuvre privately held in the United States. The collection, which now travels throughout the world, grew organically from those first three prints—always a product of personal enjoyment of the art and pleasure in collecting it.

I cannot say that my enthusiasm was dampened by the rapid appreciation of my first three purchases: the hand-colored woodcut, black-and-white woodcut, and lithograph are now worth 50,000 dollars, 25,000 dollars, and 20,000 dollars respectively. Nor can I say as a businessman and lawyer that the real and anticipated value of an item is irrelevant. But I can emphasize that our primary incentive was, and continues to be, love of the particular objects and images we have acquired.

I can also say, as someone who has given serious thought to the philosophy of collecting, that there are several ways in which it can be approached, and one should be careful to distinguish among them. Otherwise—and this word of caution applies at every budgetary level—you run the risk of eventual disappointment when a purchase fails to perform as expected.

If you have purchased a work of art on impulse, for example, using as your rationale the hope that it will appreciate in value, you will be sorely disappointed when the artist remains unknown and you are unable to sell the work in a gallery or through advertisement. By contrast (and here the loss is emotional rather than financial), if you purchase a piece by a recognized artist because the dealer swears it will be the best investment you'll ever make, and you do not, as the dealer promised, grow to love it, you have caused yourself a good deal of psychological discomfort merely by hanging this monstrosity in your home. In other words, know your motives.

I believe prints lend themselves especially well to the purposes of nonprofessional collectors for a variety of reasons. The first of these is aesthetic. It's a matter of personal preference, but I find the printed image the most expressive an artist can employ and, in that sense, somewhat more accessible than many types of painting. Perhaps it's the technical excellence required, perhaps it's the aspect of multiplicity—several variations on a single theme—which so intrigues me. Then again, it could be the challenge of locating a certain image in a particularly fine state. I also enjoy the way my prints interact when hung on a wall together. Images from different periods in completely different styles can be placed within inches of each other; when arranged with sensitivity Winslow Homer is perfectly at home beside Richard Lindner.

A second, undeniably important reason is economics. Prints are almost invariably less expensive than paintings, which makes them easier to buy and sell (assuming they have a recognized market value). It is also happily true that while work by a lesser known artist may not be easy to sell, it is also not so expensive at purchase that it will represent a major loss later. Thus, prints offer a somewhat safer alternative for the buyer whose enthusiasm exceeds his budget.

I speak about money here with some reluctance because I do not wish to weaken my original point, which had to do with understanding why you are purchasing art and what you expect your investment to do

for you. Unless you are collecting exclusively for the sake of investment, a purchase which does not make you personally, ecstatically happy is not a good investment. On the other hand, when you are collecting on behalf of someone else, your office, for example, it is equally inappropriate to impose your tastes on their bankroll.

In 1979 my firm's Washington office expanded into dramatically larger quarters, custom-designed for us by well-known architects. The new space was spectacular, particularly since it called for huge expenditures on art to make it come alive. When I asked those in control of the budget what they planned to do, it was immediately apparent that their primary concern was the bottom line: how to obtain what was needed at the least expense and, it was hoped, with the most profit to the firm. Their answer was to lease art, which allowed us a tax deduction and in fact resulted in a profit. My idea was different.

I sent around a memo urging the firm to allocate a budget item each year with which I could curate a collection. In answer to objections about expense, I explained that owning the art would give us long-term benefits which leasing could not: First, we would be surrounded by better art, and second, there would, I hoped, be some appreciation in value. After some hesitation, this view prevailed and I began to collect.

Buying for the firm, however, is entirely different from buying for myself. Not only are my company purchases subject to approval by a committee but they must be keyed to increase in value. At times I find myself purchasing a fairly high-priced item which does not appeal to my own sense of aesthetics simply because it is the right thing to do. But situations like this are helpful in clarifying one's own opinions and rewarding in the sense of accomplishing a goal. Most rewarding are the occasions where my personal tastes and those of the firm coincide, and I am able to introduce them to a piece I find especially wonderful.

A while ago, I bought a Jim Dine lithograph for the firm. It was a huge, empty, red bathrobe with arms defiantly akimbo, and I placed it across from my desk where I could see it all day long. I was fascinated with the image. Thinking about it occupied my subconscious during the time I spent in the office and afterwards. Although the most salient fact about the robe was its emptiness, there was no denying the presence of a personality—a very strong, aggressive personality—in the room.

I finally came to terms with my affinity for this image when I realized that for me, this enormous, virile, totally vacant robe was a metaphor for America in the later years of the twentieth century. Viet Nam, the sexual revolution, the "me generation," the growing strength of a corporate America not responsive to its citizens, all were epitomized by this silent, red form. In the strength of the impression it conveys and its ability to convey these feelings to a vast and disparate audience, this print is one of the seminal images of our present culture and, in that sense, one of the century's great works of art. (I knew that it had attracted the attention of the rest of the firm when they made me take it out of my office and give my colleagues a chance at it.)

I recount the story of the Dine lithograph to illustrate a concept which is fundamental to any discussion of collecting, and that is the art of identifying and understanding your own reactions. Whether you are looking for attractive objects to complement your decor or works which will tantalize your intellect or a combination of both, it is essential to become familiar with your personal sense of aesthetics. This is ultimately a matter of paying attention to your own emotional and psychological makeup (perhaps more closely than ever before) and reacting to your instincts with trust rather than uncertainty or even fear.

Thomas Hoving, editor of *Connoisseur* magazine and former director of the Metropolitan Museum of Art, provides the best example I can give of a man who understands and trusts his own instincts. On being shown a vaguely sculptural object in an advanced seminar on art (in which he was the only undergraduate), Hoving differed from the sophisticated and pithy assumptions of his fellow students by observing, "It doesn't look like art; it looks like something you use." And indeed, at the end of the class, the professor admitted that the *objet d'art* which had so ignited the analytical skills of most of his students was a tool used in obstetrics. Thereafter, Hoving, never one to undermine his own perception in the first place, was more convinced than ever that he knew what he was looking at. In fact, he made a career of it.

This is not to say that each of us comes equipped with impeccable judgment and flawless instincts but that there is a central core of aesthetic truth which is available to us all, following which comes personal taste. And, finally, there is old-fashioned good eyesight. While you may not always recognize the world's next Mona Lisa when you see it, you are as likely to do so as anyone else. The more you look at art, the more refined your tastes will become. The idea is to pay attention to your reaction to a piece of art. If you are

immediately smitten with it and you can afford it without tremendous complications, you should probably have it. Equipped with a certain number of facts (readily available in art books and catalogues) and a strong magnifying glass, you should have as good reason to trust yourself as any expert.

One note of caution about the instincts I continually emphasize: The negative information they convey is equally as valid as the positive. If you feel a certain hesitation about a piece you had planned to purchase, accept it. While there's no denying a common tendency among determined individuals to complete the project they had planned despite instinctual misgivings, one learns to give credence to the most unwelcome feelings of uncertainty. This is especially important in the case of older works, whose authenticity and condition are of necessity an issue. Newer works, whose origins should be immediately verifiable and which were produced by advanced technology, should be of a more uniform quality and may be assumed to demand less painstaking scrutiny.

A few months ago, I was told that a very important etching by Munch, one which I've been hoping to add to my collection, was available in New York. Arriving with an all-but-signed check in my hand, I was truly disappointed to experience a negative reaction to the work. It was definitely authentic. There was no mistaking the artist's signature. And the numbering made sense. But there was still something vaguely disturbing about the piece.

I couldn't decide if it was the color, the texture, or the condition of the paper; or maybe the condition was too good? With a magnifying glass and, in places, just by the feel of the paper, I could tell that the print had been restored. And judging by the smell, it had also been cleaned in an acid bath.

Still, there was nothing definitively wrong with it. It just didn't have the right impact. Perhaps the color didn't sit correctly on the paper, or wasn't in keeping with the print's edge, or the fibers in the paper had lost their texture in the cleaning process. It was impossible to pinpoint exactly what was amiss, but it obviously stemmed from the fact that the work had been tampered with. Although the restoration was excellent, the piece had been through too many changes since leaving the artist's hand and was no longer able to communicate his original message. I believe there must be a direct, emotional connection between the collector and the artist. Such connection should be distinctly discernible from the moment you see the work. And while one may return home empty-handed from time to time, the integrity, pride, enjoyment (and ultimate value) of your collection will benefit.

As for facts, you'll find them in this book. I suggest familiarizing yourself with the techniques of printmaking, the various categories of prints (Old Master, Modern, and Contemporary), and the state of the market today. In this way, you can plan a general direction for your collecting activities before venturing into an ever-expanding, often confusing marketplace. Take advantage, too, of the opportunity for increased eclecticism offered by the book's overview of two hundred artists.

The book will also be helpful in clarifying the risks and rewards involved in purchasing art from various sources—the individual, the gallery, and the auction house. But intellectual concerns aside, I suggest you go out and look at art. Take the book with you as a source of facts and recent prices, but above all try to connect on every level—instinctual, emotional, intellectual, and financial—with what you are seeing. And when your most recent purchase begins to haunt you on your way to work or becomes a recurrent metaphor in your conversation, you'll know you're on the right track.

Lionel C. Epstein, Esq.
Advisor to the Washington Print Club
January 1983

Introduction

Printmaking today is an energetic, audaciously creative pursuit. And never have there been so many people interested in the aesthetics, connoisseurship, and investment potential of prints. But this was not always the case. The elevation of prints to the status of a collectible art form came about only in the 1960s when, for the first time in modern history, there was a climate of understanding and appreciation. Those were the years, too, when the greatest technological advances in printmaking took place.

Before that time almost everyone believed the graphic arts were synonymous with commercial design, not a serious artist's endeavor but merely a way to make a living while establishing a reputation as a painter or sculptor. Collectors felt there was value only in owning something that was one-of-a-kind. Art critics were loathe to acknowledge prints in their writings, except for deferring occasionally to the virtuosity of a few geniuses of the past like Dürer and Rembrandt. Art historians, magazine editors, and authors of popular books relegated prints to the bottom of the list when writing about an artist's body of work. Museums and libraries that owned prints (either by purchase or bequest) kept them hidden in cabinets and brought them out only on request.

Consequently, there were few sources open to the collector who was genuinely interested. The only readily available information about prints was in textbooks that explained the various printmaking techniques and the catalogues raisonnés of artists, which gave detailed information about the size and scope of an artist's production but nothing about where and how to buy his work. The tone of the literature was geared to a select group of collectors and curators who had already had an art history background, knew which were the best prints to buy, and could judge which would continue to appreciate if they were properly conserved. This made whatever movement existed in the trading of fine prints an insular, elitist enterprise. Serious collectors hoarded their treasures, rarely offering them for resale in such a public forum as an auction. The only places the average person could buy prints were through print clubs, from department stores, and from a small group of dealers, some of whom sold inexpensive works by new artists and others of whom sold more expensive Old Master and Modern prints by artists who were long established.

In the late 1940s the major European cities, particularly Paris, were far ahead of the United States in the appreciation of printmaking as more than just a commercial vehicle and in the proliferation of workshops available for artists' experimentation. It was also a wonderful period for collectors. Many of the School of Paris artists were actively involved in printmaking and dealers were selling work at what today would be considered ridiculously low prices. In the 1950s it was possible to buy prints by Calder, Miró, and Chagall for less than fifty dollars. But in the United States few artists were motivated to make prints, either because of slim recompense for the time and effort expended, or because they were not technically proficient and were not aware of those people who were.

Then, dramatically, the scene changed. The 1960s was a decade marked by a newly prosperous middle class of enthusiastic, educated people who wanted to partake of the finer things in life. Owning art was one of

the priorities. Of course, they couldn't afford to buy paintings by the artists whose work they had studied, but they could afford prints by the same artists. Thus a demand for prints was created. Art dealers, curators, and auction houses were astounded at the enormity of interest and the buying frenzy.

Galleries specializing in graphic work opened, seemingly overnight. Art dealers staged print exhibitions, wrote literature about printmaking slanted toward the novice, hired sales forces to go on the road to sell prints, and spoke to various business and philanthropic organizations about the advantages of prints as investment or fund-raising tools. (Frequently, a special edition would be published for the benefit of a charity.) Museum curators mounted exhibitions which took a more scholarly look at the evolution of prints. These shows educated the public and, at the same time, legitimized the print as a serious art form. Auction houses held more print sales and became actively involved in searching out private collectors and estates for consignments. Catalogues were expanded to include all information known about the condition of each print for sale. Print biennials and competitions were held. A new category opened for government and privately awarded grants.

As the boom continued into the 1970s, the press began to devote more space to the phenomenon. Newspapers carried advance publicity and reviews of exhibits; they covered auction sales, and the feature pages carried interviews with popular artists. Business pages (as well as such magazines as *Business Week)* carried articles which measured prints against other kinds of investments. *ARTnews,* a leading art magazine, devoted entire issues to prints—and still does today. Print magazines and newsletters were started for the purpose of disseminating information about all aspects of the new print market.

The most amazed reaction to the demand for prints, however, came from the artists themselves, who because of lack of profit or skill had been disinclined to make prints. In the late 1950s and early 1960s they were prevailed upon to produce prints by dealers who understood that a ready market existed and who encouraged them to broaden their creative viewpoints.

At about the same time, some exceptionally visionary publishers opened their doors, providing artists with a stimulating atmosphere, with expert craftsmen for collaboration, and with the most advanced tools and machinery. In 1957, Tatyana Grosman, a pioneer, started Universal Limited Art Editions in the garage of her West Islip, New York home. She invited a small, select group of artists (Larry Rivers was the first) to investigate the possibilities of lithography. Grosman lavished warmth, respect, and sound judgment on her artists. She was generous to them in material ways and gave them the luxury of time to think their projects through carefully before executing them. Quality was the most important factor and, to Grosman, it didn't matter how long it took to achieve that goal.

In 1959, printmaker June Wayne received a grant from the Ford Foundation, making it possible to establish the Tamarind Lithography Workshop in Los Angeles, California. Tamarind was an educationally oriented facility concerned with the training of printers as well as artists. For fourteen years artist fellows went to California for two-month residencies and worked in collaboration with extraordinarily skilled printer fellows who became today's master printers and publishers. Wayne and her staff addressed themselves to all aspects of the lithographic process, from paper and ink to framing and selling. They documented hundreds of technical experiments and published manuals which clearly stated the terminology of the medium.

Kenneth Tyler, who had been technical director at Tamarind (and is now director of Tyler Graphics, Ltd., in Bedford Village, New York), founded Gemini G.E.L.—Graphics Editions Limited—in 1966, also in Los Angeles. Tyler, with partners Sidney Felsen and Stanley Grinstein, built a large, incredibly organized, streamlined, supermodern atelier where printers and other craftsmen worked with the newest equipment to translate the artist's design precisely to paper. They researched and invented procedures which would best facilitate the various print media and pioneered techniques which produced unconventional, stunning visual effects. Many artists, including Josef Albers, David Hockney, and Frank Stella, found the environment particularly suited to their styles.

In England, where the Beatles and Carnaby Street signaled an era of rejuvenation, artists and dealers were increasingly open to the idea of contemporizing the print media. Editions Alecto Limited was founded in 1962 to encourage British artists (some already well established as painters or sculptors) to experiment with the graphic arts. They established themselves in a former factory, which gave them ample space to house several workshops and living quarters for visiting artists as well. Their unyielding attention to detail and strong belief that prints were art rather than commodities earned them a reputation for excellence which spread to Europe and the United States.

The next decade saw the emergence of adventurous publishers who were particularly attuned to contemporary art movements. Many were art dealers

already involved in shaping the careers of the pop art, op art, minimalist, and superrealist stars. Their artists were eager to accept modern methods and to look for ways to expand them to meet their needs. In a mechanized, computerized, industrialized world, the graphic arts seemed like a logical extension—a perfect complement to the new life-style.

As the years passed, more painters and sculptors tried their hand at printmaking, first as a new artistic expression and then, as they had more command of the media, as an active response to the technical challenges involved. They were stimulated by the amount and variety of materials available and by the endless combinational possibilities. Serigraph, collagraph, cast-paper, and mixed-media are words which leaped into print language. New inks and papers were developed to do justice to color-field artists. Plastics and fabrics were used as printing surfaces. And new parts were invented for presses to adapt them to the different printmaking combinations. In short, there was no end to the exploration generated by the interest in graphics from all quarters.

The new printmakers felt great satisfaction in the knowledge that their work (and their ideas, emotions, and values) would reach a wider public. The fact that more collectors chose to live with their images was a source of great pride and a confirmation of their art. And the financial rewards were at least promising. More art sold obviously meant more profits.

One thing is a given—in boom times like those, opportunists join the bandwagon at an alarming rate. And that's what happened in the print market in the 1970s. Thousands of editions flooded the market every month, released by people who had easy access to a press but no real knowledge. Suddenly, car salesmen bought new suits and sold art; hundreds of "going-out-of-business" type stores opened to hawk "drastic sales," and tax shelter schemes proliferated. Ostensibly, the public was stimulated to own prints to the point of urgency. It seemed that the well would never run dry, either because of a burgeoning interest in art or because prints were touted as fast-earning investments.

Then the bubble burst. The world was in a recessionary period the likes of which had not been seen for fifty years. And in times of recession, the middle class is the hardest hit. Dollars, which might have been spent frivolously on decorative or luxury items, are needed for car payments and dental bills. Less available cash and far fewer buyers left the slick talkers with enormous inventories and large overheads. Real "going-out-of-business" signs replaced the old come-ons. And when the quick-turnover-minded buyers tried to sell back or auction their prints, they found, most of the time, that they couldn't even get back the initial amount of purchase. However, those who collected primarily because they appreciated art, who researched and bought quality graphics from reputable dealers, did not find the same to be true. To the contrary, fine original prints continued to hold their own and, in some cases, appreciated considerably even in those difficult years.

The survivors of the recession are those artists, publishers, art dealers, and auctioneers with knowledge, honesty, and taste. They are men and women who are committed to the print world for all the right reasons. This book is dedicated to those professionals whose driving force is a real love of art. We, as collectors, have a rare opportunity to learn from them.

Ellen Kaplan

All About Prints

What Is a Print?

A print is made by creating a design on a selected medium such as stone, wood, or metal, which is then inked and pressed against paper, thus leaving an image. The methods of printmaking fall into four categories: *relief* is the oldest known technique of image duplication and includes woodcuts, wood engravings, and linoleum cuts; the *intaglio* process, which includes engravings, etchings, drypoints, aquatints, and mezzotints; the *planographic* or *lithographic* process; and the *stencil* process, which includes serigraphs or silkscreens.

The following are simplified descriptions of specific techniques. Printmaking is, however, a highly innovative art which employs available materials, and since many educational centers are devoted to the study of experimental methods, not every process that is or has been used is listed below. These techniques are the most common, and this listing is intended as a basis for recognition and the foundation for discovery.

Aquatint is a tone process used to give the impression of color washes. In this process the plate is partially protected with a porous material, such as a cheesecloth bag. Resin is dusted through the bag onto the plate. The plate is then heated, and the particles adhere to the surface. The image is then etched into the plate as it is immersed in an acid bath, and the acid bites tiny rings around each resin grain. These rings hold enough ink to print a kind of wash area. The printer uses a protective varnish on the areas he wants to "stop out," or leave light. The plate then receives another acid bath. Gradations of tone are achieved by repetitive bitings and varnishings of the plate.

Cellocut involves the use of a smooth wood or metal surface which is coated and built up with liquid plastic. The plates may then be used for relief or intaglio printing.

Chiaroscuro woodcuts are woodcuts printed in color. This technique uses several blocks of varying tone which serve to highlight the image.

Cliché verre is an image drawn with a stylus on a glass plate which is coated with an opaque emulsion. The lines are left transparent and print black. The drawing can be reproduced on photographic paper exposed to light.

A drypoint is printed from a metal plate into which an image has been scratched with a sharp tool. When the tool is pulled across the surface, it displaces fragments of metal, called the burr, on either side of the furrow. These metal shavings retain ink during printing and produce a smooth velvety texture. Uniformity is difficult to achieve because the burr wears down when pressed. Collectors of early drypoint prints should look carefully at the quality of the impression.

Embossed prints are three-dimensional and are usually most successful in pristine white on white or when only a few colors are used. The convexity is achieved by pitting the plate and the concavity by fitting (or overlapping) the plate with strips of metal or leather.

An engraving is made by incising a design in a copperplate with a tool called a graver or burin. As with drypoint, metal shavings are displaced, but in engraving the burr is removed with a sharp blade before printing. The result is a somewhat cleaner image than that of the drypoint or etching.

Etching is achieved by applying an acid-resistant covering to a polished metal plate. This layer, composed of waxes, resins, and gums, is usually applied in liquid form. When this layer is set, the image is drawn through it onto the plate below with a stylus or burin. An acid bath follows, which bites the design into the plate. As with the aquatint, a varnish "stop out" may be used to leave these lines light and delicate. The burin is then used again to create thicker lines for more definition. During the next acid bath the varnished areas are protected. The duration of the acid bath helps to determine the darkness of the lines by the depth to which they are bitten.

Linoleum cuts are made in the same way as woodcuts. A piece of linoleum is, however, an easier surface to work with than a wood block.

Lithographs are made by using a greasy pencil, crayon, or lithographic ink, called tusche, to draw an image on a metal plate or a stone. The surface is then dampened with water, which only stays on the blank areas, since the grease repels water. Greasy printing ink is then rolled on the surface and, again, this adheres only to the image—not to the dampened area. Paper and plate are then run through a press together where ink is transferred to the paper. Anything may be used to draw the image on the plate as long as it is greasy. Different drawing mediums will produce lithographs with different textures.

Metal cuts are certain very early engravings printed in relief. For these, metal plates were used as design surfaces.

Mezzotint is a tone process in which the entire surface of a metal plate is pitted with tiny holes using a curved, serrated tool called a rocker. The plate prints completely black in this state. The design is then scraped into the plate, making those surface areas smooth again and resistant to ink. The image appears to emerge from a black background.

Monotype by definition means one impression. A design is created on a plate with printing ink and transferred to paper by running the plate and the paper through a press while the ink is still wet.

Serigraphy, or screen printing, is a variation of the stencil process. A screen, usually made of silk, is stretched on a wooden frame. A design is created on that screen by one of several methods. One way is to block areas in the screen by brushing them with a gluey substance. The screen is then placed on a piece of paper. Pigment is pushed through the areas left unblocked with a rubber blade, a squeegee, and the color appears in the appropriate place on the paper. Each color to be printed requires a separate screen.

Soft-ground etching has a soft, somewhat chalklike effect, which is achieved by spreading the plate with tallow or Vaseline. Paper is then placed on top and a stylus is used on the paper to draw the design. When the paper is removed the plate shows the entire image. It is then acid-bitten and inked like a regular etching, but it reproduces a softer image because the plate picks up the qualities of the paper.

A stipple print is an intaglio tone process. The design is produced by etching or engraving hundreds of tiny dots into a plate.

A woodcut is made by drawing a design on a wood block cut parallel to the grain. A knife is used to cut away all the areas but the design. These appear white on the finished print. Ink is then applied to the design with a roller and transferred to paper in a press.

A wood engraving is made by using hard wood, cut against the grain. A burin is used instead of a knife to produce finer detail and more subtle shadings than those of a woodcut. Because the design lines are incised the effect appears to be white lines on black, the reverse of a woodcut.

Linoleum Cut

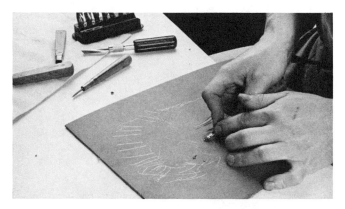

1. *Creating an image by cutting into the linoleum block. The areas that are cut away will be blank when the print is made.*

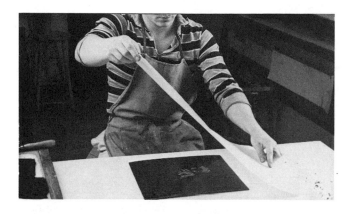

4. *The paper is positioned over the block.*

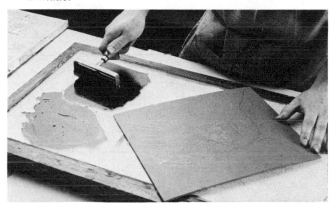

2. *Rolling the ink on the brayer.*

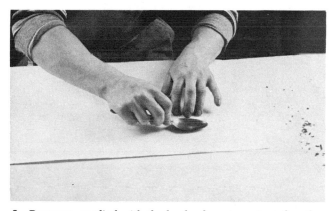

5. *Pressure, applied with the back of a spoon, transfers the ink to the paper.*

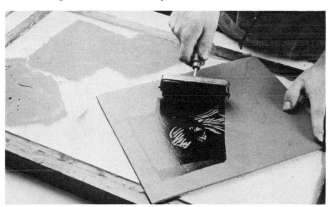

3. *Using the brayer, the ink is transferred to the linoleum block.*

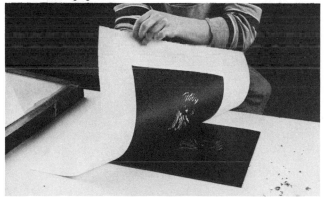

6. *The final print, which is the negative image of the carved linoleum block.*

Etching

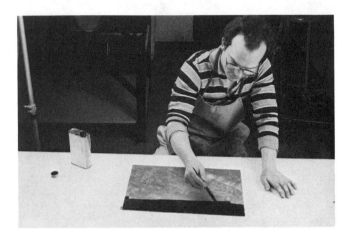

1. *Applying the acid-resistant ground. When the plate is later bathed in acid, the ground will protect those areas of the plate where there is no image to be printed.*

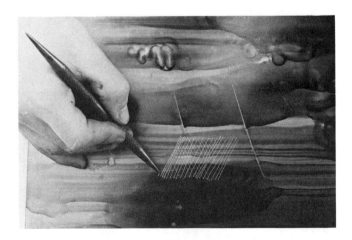

2. *Drawing the image by scraping through the ground to expose bare metal.*

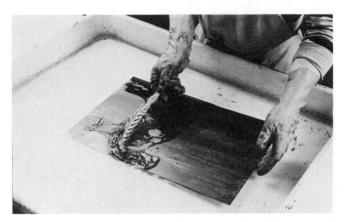

3. *Bathing the plate in the acid solution. A feather is used to brush away bubbles on the plate caused by the acid.*

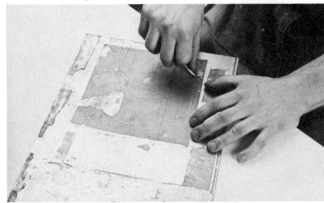

4. *Burnishing the finished plate, after the ground has been removed, to make small corrections or changes.*

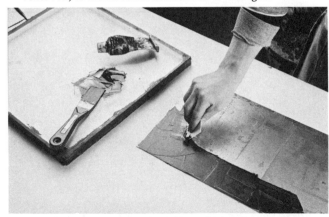

5. *Applying ink with hard cardboard strips.*

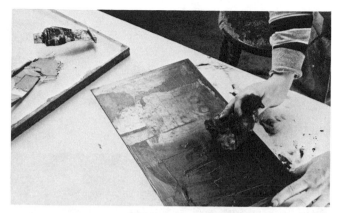

6. Wiping excess ink with a soft cloth also forces ink into the incised areas.

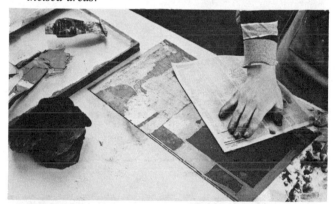

7. Cleaning the plate with newsprint before printing.

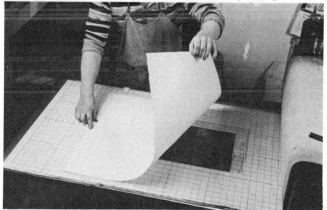

8. Positioning of the paper. The paper has been dampened so that it will be forced into the incised areas during printing.

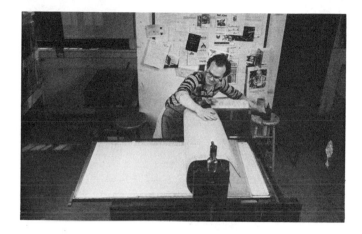

9. Passing the paper and plate through the press.

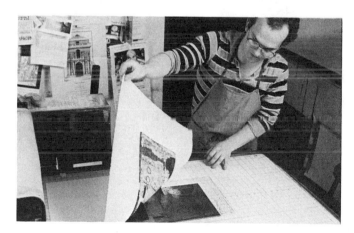

10. The final image.

Lithograph

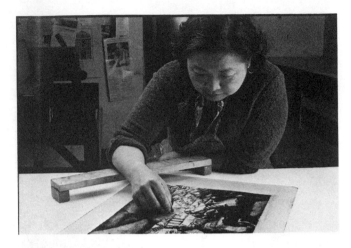

1. *The image is drawn on a plate with a greasy tusche crayon.*

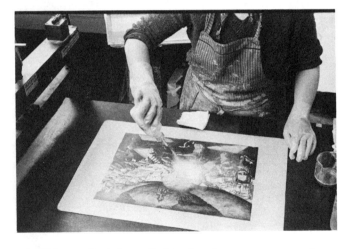

2. *A layer of talc is applied to absorb excess grease and to fix the image in place.*

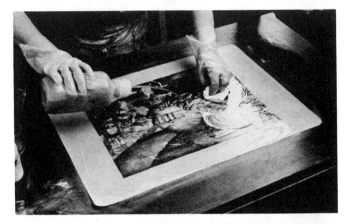

3. *A thin layer of gum arabic is then applied to protect the image during the next step.*

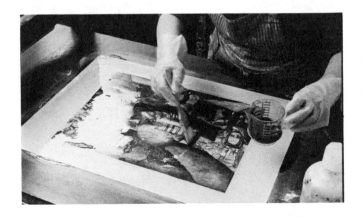

4. *The plate is now etched by applying an acid solution. The grease and gum arabic protect the plate where the image was drawn. The rest of the plate is bitten by the acid, causing it to become pitted and able to hold water.*

5. *Cleaning the plate with turpentine to remove the grease crayon. The plate is then wiped with a wet sponge. Water is absorbed only in those areas previously pitted by the acid.*

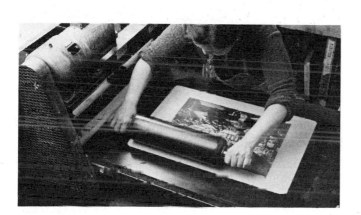

6. *Rolling the plate with a grease-based ink. The ink is attracted to the greasy image and repelled by the dampened areas.*

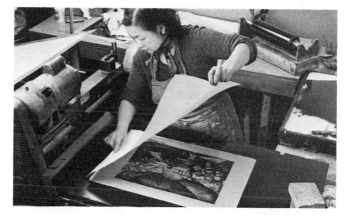

7. *Placing the paper over the plate.*

8. *The printed image after the paper and the plate have been passed through the press.*

Screen Print

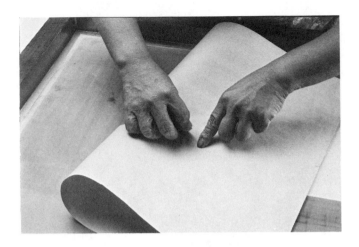

1. *Tearing the paper, to make a torn paper stencil.*

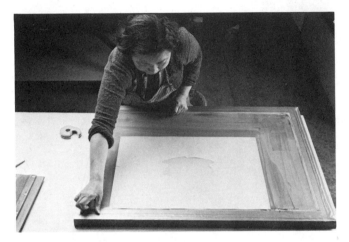

3. *Taping the stencil to the stretched silk frame.*

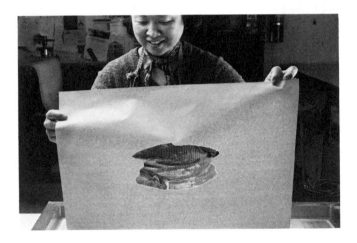

2. *The stencil.*

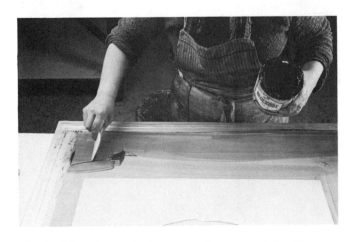

4. *Applying glue to the background screen so ink will pass only through the image opening.*

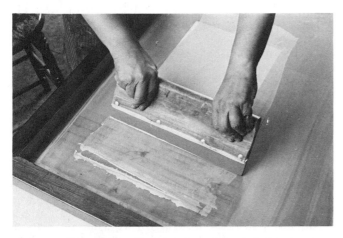

5. *Using a squeegee, the ink is forced through the open weave of the silkscreen.*

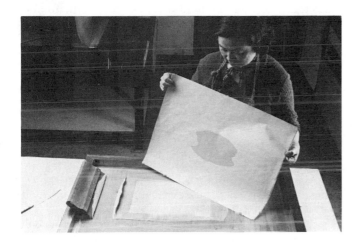

6. *The finished print.*

Photographs by David Arky.
Courtesy Original Print Collectors Group, Ltd., New York

Original Prints

An original print is made from a unique image created by an artist on a plate or other printing surface. The prints are produced in multiples by the artist or by skilled craftsmen under the artist's supervision. The sum of the multiples is called an edition.

The concept of originality in printmaking is different from conventional definitions. Original, according to the dictionary, means that from which a copy is made. In printmaking, however, the printing surface is not the original—it simply provides the elements for the creation of an original print. Each successive print is considered an original. When the matrix, or printing surface, is destroyed after the specified number of prints is made there will only be a specific number of "original" prints of that image.

Art scholars have long argued about the correct meaning of the word "original" as applied to various print media. Purists believe that an artist must complete the entire procedure himself using one of the formal "acceptable" techniques—like etching or woodcut. Since World War II, however, attitudes have begun to change. With the advent of innovative mechanical processes and the continual patenting and marketing of new art products, more and more creative possibilities are available to the artist. And though the artist may visualize his perfect creation in his mind's eye, he may not be sufficiently dexterous or knowledgeable to personally execute each step in a technical process.

Throughout history there have always been brilliant craftsmen who were instrumental in helping the artist achieve true representation of his idea. And so it is today. Master printers and artists enter into remarkable, inspired collaborations to make quality works of art which genuinely exemplify the artist's vision. In each case, the extent of the artist's participation is different. In no way, however, does that collaboration or the utilization of innumerable products and techniques detract from the originality of the print. No matter how the process is achieved, if it follows the unique design of the artist, under his supervision, it is an original print.

Afters, reproductions, and restrikes are not original prints.

An after is a print that is a handmade copy of an existing work of art. Such a print may be of excellent quality, far superior to anything the original artist could have done, but it was not created by that artist. Centuries ago, prints were made specifically as copies of paintings. In the image itself, or directly below it in the margin, a copyist made note of his participation, and of all the craftsmen who worked on the plate. It was a matter of pride. This is not so today when copying has an altogether different connotation. Afters today may be technically superb and visually stunning, but they are on very shaky ground in terms of value.

A reproduction is a print that is a copy of an existing work of art, usually created photomechanically, without the artist's permission. Your magnifying glass will be your best friend if you have a question about the authenticity of a print. The photomechanical process of copying involves a process which breaks down colors and gray areas on the original. The result is a pattern of tiny dots which will be on the copy when viewed through the magnifying glass. Any reputable art dealer or auction house will let you use a magnifying glass to examine a print. If you are planning to spend a good amount of money for a print, you should research that print, and its peculiarities, before you buy it.

Photoengraved copies of etchings, engravings, and woodcuts (all line drawings) will not have dots. These are identifiable under the glass by heavier, less defined lines than the original hand-drawn ones. A clue to photoengraved copies is the paper. A reproduction will appear flat. An etching or engraving has raised inked surfaces on the recto (or front side of the paper), where pressure forced the paper into the incised lines. A woodcut has embossed areas on the verso (back of the paper) due to the impression forced into the paper by the raised image on the block.

Restrikes or reprints are later impressions made from the original printing surface sometime after the first edition was completed. They may be printed in unlimited editions long after the artist has died. Museums and other public institutions sometimes buy the original matrix or obtain it by bequest. They reprint the image and sell the prints under their own auspices to familiarize a large public with an artist (usually one whose work is in their permanent collection), at a relatively low cost to the buyer, and to raise money for operations and acquisitions. These reprints are not signed by the artist, even though they may be approved by his family or heirs. Some museums, the Metropolitan Museum of Art in New York for example, also sell original prints. Such a distinction should be made known when you are being sold a print.

The Limited Edition

The limited edition is simply a marketing strategy created to give the impression of rarity, a strategy that became accepted practice during the latter part of the nineteenth century. Before then, many artists made only as many prints as there were commissions. Of course, the number of images that could be printed was dependent on the medium. Plates frequently wore down after only a few impressions. The highly sophisticated techniques used today make it possible to produce large quantities of prints with uniform quality. Consequently, the decision must be made of just how many prints should be published in an edition.

An artist and his publisher usually make this decision together. There are many considerations. Sometimes the medium of the print imposes a natural limitation, but this is rarely a consideration today. Supply and demand are key factors. If an artist has a large public clamoring for his work, he is sure to sell a larger number. If, however, an artist has a more select audience, it makes sense to print fewer. Frequently, even when the artist has an enormous following, it is decided to print fewer impressions in order to maintain a uniqueness and play a hard-to-get game with the collector who is thinking in investment terms. In some cases an artist may want to print an unusual number to get a particular message across or to print editions of the same image in different colors, as Andy Warhol did with his *Marilyn Monroe* series. It is important that the artist and publisher be careful not to glut the market. Today, when an artist and/or publisher accedes to a great demand, they may ultimately be lowering the resale value, not to mention the reputation of the artist in terms of his artistic integrity.

It is an unwritten law that an edition, to retain the concept of specialness, be limited to less than 300, with an added run of approximately 10 percent which are called artist's proofs. These are reserved for use by the artist or for use at the discretion of the publisher. When the total edition is completed the plate or stone must be cancelled (destroyed or defaced) so that no further editions may be run or sold. Unfortunately, many publishers have taken advantage of the print boom by printing editions on a different kind of paper and selling them in other countries, by making an inordinate number of artist's proofs, which are then put on sale, or by reprinting the edition without the artist's consent. Publishers have also offered posthumous editions with the consent of the family or heirs. Here again, it is up to the collector to study the catalogue raisonné (the listing of the artist's works which gives details of the publication of his prints) and to ask for documentation at the time of purchase.

The numbering of each print by the artist connotes originality. That print is an "original" in the series. The number given (for example, as 9/100, meaning this is the ninth print pulled in an edition of 100) is found in the lower margin. That is also where you'll find the letters A.P., artist's proof. When an edition is made for a foreign country the numbering is in roman numerals and starts again from one. Before the latter part of the nineteenth century, artists used many methods of numbering. Some noted the total number of proofs of an edition in the margin, rather than numbering each progressively. Others numbered each print as it was sold, and some had no numbering system at all. This is where the chronicles of art historians can be of help to the collector.

The questions most often asked are: "Are the lower numbers more valuable?" and "Are the artist's proofs more valuable?" The answer to both questions, when speaking about contemporary prints, is no. In previous periods, the printing medium often dictated the result. For example, when the burr wore down in the drypoint process the velvety look would fade and, therefore, the earlier proofs (or lower numbers) would be the best impressions. Before lithography was perfected, it might have taken many runs through the press to get the desired intensity of color, making the higher number the best impression. This rarely happens today, when each print is exactly the same as the one printed before and after it. Frequently, too, the order of the prints may be shifted as they are stacked and prepared for the printing of the next color. The numbering takes place only after the whole printing process is complete.

The Role of the Publisher

The publisher acts as liaison between the artist and the dealer. He is directly responsible for what the public sees. Some artists choose to self-publish their work, controlling all aspects of production and distribution. Most, however, are neither equipped nor eager to grapple with the innumerable administrative details involved in publishing prints. They lack the time, money, and specialized business knowledge needed to successfully bring a new edition to the attention of the public.

A publisher contracts with an artist to: finance an edition; provide the premises, quality materials, and expert personnel necessary for the printmaking process; supervise the production of the edition from the first mark on the plate until the last proof is pulled (making sure the specifications of the print law are followed); promote the edition through advertising and/or public relations; and handle the distribution of the finished product.

In the best of circumstances, the publisher acts as a spiritual guide, constructive critic, and shoulder to lean on. In short, a wise, caring friend. The atmosphere generated by such a friendship is one which fosters artistic experimentation, sensitivity to detail, and, therefore, the best possible product.

A great many prominent publishers preside over their own ateliers, where they house all manner of sophisticated equipment and where expert printmakers assist the artist in the translation to reality of his or her concept. The artist approves each trial proof to be sure that the printed image is consistent with the original design and has the desired coloration. When the entire edition is completed and the plate cancelled, the artist signs each proof under the supervision of the publisher. The consumer should be aware of art sellers who boast that an edition was "signed in the plate" by the artist. The law affirms that a correct print is a finished print autographed individually by the artist, regardless of whether it was signed or unsigned in the plate.

Publishers may offer a great deal of input as to the content of a print. This will, of course, depend upon the artist's popularity and upon the nature of the aesthetic dialogue between the artist and the publisher. Some artists have reached a point in their careers where they can be assured critical and financial success with every endeavor. (Collectors buy the name as well as the print.) They are often accorded the total freedom of creative license. Others work closely with a publisher to maintain a "signature-style" important in building a following. Still others pay particular attention to the financial forecasts of publishers and dealers when choosing a subject which will sell well in certain markets. At every level the artist wants to produce work which will speak well of his talents for generations to come. The extent of the publisher's contribution rests on the variables involved in each case.

Publishers do not usually sell directly to the public. Their continuing success is based, to a large degree, on their relationship with dealers. Good will, dedication to high standards, and strict pricing controls are imperative to sustaining a long, mutually beneficial association. Word travels fast in the art world, and continued business is in direct relation to a reputation. There are, however, publishers who become dealers and open galleries to sell their artists' work, and dealers who become publishers as a consequence of encouraging their painters or sculptors into another art form, then monitoring the output. Whatever the extent of his or her participation, it is the publisher who is most influential in regulating the market for prints.

The Artist's Signature

The artist's handwritten signature is usually made in pencil in the lower left or right margin just below the image. The autograph is a declaration by the artist that the print is an original, that he or she has participated in each important phase of the printing process, and that he or she approves of the finished product. In today's market the signature means that the print is a premium item, one that commands a much higher price than an unsigned, but otherwise exact, duplicate.

Print laws state clearly that a print may be referred to as signed only if the artist has manually signed it upon completion.

Be aware that there are those who will inaccurately create an aura of specialness about their product to reap big profits. Slick literature and smooth-talking salespeople may advise you to buy "signed-in-the-plate" or "signed-in-the-stone" prints. These are misleading labels put on works and have absolutely no validity in terms of market value.

The notion of preciousness of signed prints was introduced in the late nineteenth century by Sir Francis Seymour Haden, an English etcher. Up to that time, artists inscribed either their names, monograms, or identifying symbols on the printing surface. Haden, a collector himself and a man with great business acumen, had the idea that prints would sell well if buyers believed that there were limited quantities available, and even better with the added cachet of personalization by the artist. He and his brother-in-law, James McNeill Whistler, promoted this practice and found that their work was selling much faster and for more money.

This was a good sales strategy then and it still works today. There are many examples of price disparities in signed and unsigned prints from the same edition. One of the most well-known stories documents Picasso's *Vollard Suite*. In 1939, Picasso had made a series of one hundred prints (well over thirty thousand impressions on different papers), but he signed only about one hundred and fifty impressions. Ambroise Vollard, Picasso's dealer, died that year, the war ensued, and nothing further was done about the signatures. Henri Petiet, another French dealer, bought the prints from Vollard's estate and for nineteen years, from 1950 until 1969, coaxed, cajoled, and pleaded with Picasso to sign the remaining impressions. He did sign about half during that period. Today the signed prints are worth more than twice as much as the unsigned prints.

The signature is not always a guarantee of originality, however, and collectors should be careful. Artists may agree to sign posters or reproductions of their work for charity, at an opening or public appearance to encourage sales of original prints or other artwork, or as approval for the fine job someone else has done copying their work. These posters and copies often wind up in second-rate galleries as "originals."

Forged signatures on prints are legion. Dealers are sometimes fooled by an expert forger, but for the most part they have educated themselves about the artist and can tell if the signature looks right. The same resources for research are available to the collector. An artist's catalogue raisonné will give illustrations of the artist's signature and changes in the signature through the years. It will also list other identifying marks. Information about just how many signed and unsigned impressions exist will also be found there. The French multi-volume encyclopedia of artists by Benezit, found in the larger branches of the public library, provides valuable information and samples of signatures.

Facsimile, or stamped, signatures have been affixed to book illustrations and magazine pullouts and then sold as originals. The thing to watch for here is the even quality. A true signature will show inconsistencies of shading and depth, according to the amount of pressure applied while writing.

Posthumous editions have frequently been issued by an artist's family or heirs. The prints are either stamped with a facsimile signature or an estate stamp. This is supposed to mean the family or heirs endorse the work on behalf of the artist. Unless the artist communicates his feelings through a medium, however, it would be impossible to know if he approves of the product. And since the motivating force in these instances is most often money rather than aesthetics, with relatives happily (albeit sometimes unknowingly) stamping poor quality impressions or fakes, it's safe to say these editions are not considered valuable.

Fakes

The best insurance against buying a fake print is a good education. Fakes (original works unauthorized and unsigned by the artist) and forgeries (copies of existing, authorized works) have existed since the art of printmaking began. In earlier centuries, a copy in the style of a well-known artist may have been considered the sincerest form of flattery. Sometimes the images created by copyists were even more aesthetically pleasing, because they were executed by people whose specialized, technical knowledge was more extensive than the artist's.

Collecting Old Masters is somewhat less problematic than collecting Modern and Contemporary prints because the work of most of the Old Masters has been painstakingly catalogued through the years. Annotations of deceptive prints of one form or another have been added to these catalogues upon discovery.

During a period when there is great demand, however, there are those who will "cash in." Questionable prints seem to proliferate in establishments run by people who are either uneducated, disinterested, or unscrupulous. Dürer was one of the most prolifically copied artists of the Old Master period. A nineteenth-century German scholar named Heller devoted his entire lifetime to cataloguing Dürer's work and all of the copies after it; he went insane in the process. When Braque, Chagall, Léger, Matisse, Miró, and Picasso were first considered fashionable, the demand far outnumbered the supply of their prints available to collectors. Unorthodox steps were taken, some innocently, some deceitfully, to meet the demand. The results are still circulating today. This is certainly not to say that the work of these artists is any less important, less desirable, or less a prudent investment. It simply means the collector should do his homework before buying.

Homework should consist of reading everything you can about an artist's oeuvre (body of work), visiting museums and galleries which exhibit the work, studying auction catalogues and attending auctions, and talking with other collectors. Above all, don't be afraid to ask questions. An honest dealer or auctioneer will be glad to provide documentation and let you study carefully any print in which you are interested.

Before you buy a print familiarize yourself with the style of a particular artist. If he or she is known for several styles, it should be clear that the date of the work coincides with a specific stylistic period. Look for irregularities in print techniques (lithography and serigraphy were not, for example, Old Master techniques), signatures, or other identifying marks, size of image, age and type of paper used, and tonal qualities. Even after an elaborate aging process, the papers and inks available today never exactly duplicate those used for an earlier work.

It should be said here that most art sellers are educated, experienced, honest people whose love of art is certainly as important as their desire for monetary gain. If you are armed with basic information you'll be able to recognize them and also to spot the unethical dealers who come along occasionally.

Protecting Yourself

The states of California, Illinois, and New York passed laws governing the sale of fine prints in 1971, 1972, and 1982 respectively. The laws in California and Illinois pertain only to editions made after the date of enactment, while New York's ruling covers Old Master and modern prints as well as contemporary prints. Each law sets up informational requirements, which the seller is obliged to put in writing and give to the purchaser when he buys his print. These requirements include:

- The name of the artist.
- Information about the signature. Documentation that states the print was manually signed by the artist whether or not it was signed in the plate. If the print was not manually signed by the artist, it should have accompanying data as to the method of signature.
- Description of the medium.
- Whether the print is being offered as a limited edition and, if so, how many signed and numbered impressions there are, how many artists proofs there are, and the total size of the edition.
- The year the print was made.
- Assurance that the plate was "destroyed, effaced, altered, defaced, or cancelled after the current edition."
- If there were any prior states of the same impression, how many there were and to which state the purchaser's print relates.
- If there were any prior or later editions from the same plate, the total size of all other editions.

- Whether the edition is posthumous or a restrike and, if so, whether the plate has been reworked.
- The name of the workshop, if any, where the edition was printed.

Reputable dealers have always provided such information as a matter of course and have been equally responsible in presenting documentation from the publisher who sold them the work. Always use the above as a guideline when buying prints from a dealer, but particularly from someone whose business methods are even remotely questionable.

The statutes say that the seller must accept the return of a print if he misrepresented a sale by lack of information or honest mistake; but the purchaser may sue the seller for three times the amount of the purchase if he finds that the seller willfully misled him to make the sale. The statute of limitations is "within one year after discovery of the violation—and in no event more than three years [in New York it is four] after the print was sold." The only problem here is proving your case. You have to prove you were cheated and the seller has to prove it was an innocent mistake. The laws also say that a seller may disclaim knowledge of any of the relevant details required as long as he so states this in his advertising, catalogues, bill of sale, etc. This would appear to leave room for maneuvering if someone was so inclined.

The best way to protect yourself and to combat potential problems is to develop a strong combination of knowledge, common sense, and the conviction of your taste.

Where to Buy Prints

There are many places which offer opportunities for viewing and buying prints. Before buying a print from any outlets, however, be sure you are buying what you like, what you really want, and what you really can afford. Don't buy the sales technique rather than the print itself. Remember that most art sellers are honest, but they are also sophisticated salespeople. There is no educational requirement for becoming a dealer or auctioneer. Although most people enter the trade with a genuine appreciation (and sometimes substantial knowledge) of art, they have to keep moving inventory to earn a living. It is always a good idea to investigate as many sales outlets as possible to be sure you are making a wise purchase. It's fun, too!

Galleries

There are thousands of galleries which sell prints. Not all of them, however, are print specialists. If you enjoy a particular artist's work, or if you find a certain style of art more intriguing than others, it is a good idea to find out which galleries specialize in such work.

The Yellow Pages of your telephone directory has an Art Gallieries and Dealers Guide, listing all the galleries in your city and their areas of specialization. Art magazines and the art advertisement section of your local newspaper will give you some idea of the scope of the outlets available to you, where they are located, and which ones cater to your interests. Museum curators and heads of auction house print departments will recommend galleries to you if you request specific information about an artist or category of print.

You can also write to the Art Dealers Association in New York. They will refer you to their select membership—dealers noted for their honesty and high standards. Ask other collectors whose taste you admire where they bought their prints. Keep visiting all the galleries you can. It's a wonderful experience, and relatively quickly you will have an idea of what feels right for you.

When you visit a gallery, you'll be able to tell immediately if you would like to buy there. A good art dealer knows that well-informed, satisfied clients will stay with him. He will spend time talking with you, share his knowledge and his resources with you, and help you make the right decision for your pocketbook. Some dealers are willing to accept payment on an installment plan. Many will allow clients to "trade up" for other artists or more expensive prints when they can afford them.

You should be able to sense a dealer's genuine love for the art he sells and a willingness to discuss an artist's career, style, or particular technique at length. Good dealers will also have libraries of books, catalogues, and print newsletters which are important when authenticating prints or setting sales prices.

Run the other way when someone says "This is a good investment" before he says "This is a beautiful print." That is a sure sign that the dealer is not careful about what he sells and is not interested in you beyond your money.

Private Dealers

Private dealers usually work out of their homes or in small offices where they see clients by appointment only. They go to the same auctions as the public dealers (gallery owners and directors), buy from other dealers, and buy from estates of artists or clients. In other words, a buyer can find a wide variety of prints from which to start a collection, or round out a collection by visiting a dealer who specializes in certain artists.

Finding private dealers is certainly not as easy as finding galleries, but many people find it a less intimidating way to buy art. These dealers rely on the referrals of other clients, museum curators, and auction print department heads. They choose to be private dealers because of the lower overhead and because they like having the luxury of time to spend with a client, to build trust and nurture the relationship. They realize they won't have as many sales as a gallery, so each has to be a quality sale to encourage word-of-mouth referral.

Artists

If you are fortunate enough to meet the artist and visit his studio you may be able to purchase prints at lower prices than through commercial outlets. Most established artists, however, work hand-in-hand with their publishers and dealers to set price levels and are not likely to undercut their business partners. A mutual respect exists here, and usually a friendship of many years. Younger, less established, and unaffiliated artists will be more receptive to selling direct to the public.

In almost every big city with artists' enclaves (artists tend to live in areas where they can find large, well-lighted studios for reasonable rents), open-house studio tours are available to the public. Look in local newspapers and magazines for listings. And if you see a print that you like in someone's home, discuss it with the owner; the artist may live in your home town.

Auctions

Auction sales give a great boost to the careers of artists and to the price levels of prints. They keep the market fluid. It all seems baffling to the uninitiated, but if you relax and observe you'll find attending an auction can be an enjoyable, enlightening experience. Here are some pointers:

- Subscribe to the catalogues. If you don't walk by the auction house chances are you won't remember to inquire about the sales.
- Study the catalogues carefully. Each has conditions of sale explained clearly in the front section. The condition of each offering is described as well as possible in writing (i.e., tears in the margin, light stains, etc.).
- Go to the previewing period (each sale has one) and see for yourself. Condition is all-important, and it may not be accurately conveyed in the photograph and/or description in the catalogue. Remember, you can't return a work once you've bought it.
- Never hesitate to talk to the print specialist. That's why he or she is there. Never worry that your question will seem silly.
- Make up your mind in advance about how much money you can spend. It's easy to get carried away by auction fever. The catalogue lists an estimate (low and high) for each sale item, so you'll have some idea where to begin.
- If you can't personally attend an auction you may leave an order bid (written maximum amount) with the print specialist. The house will act as your agent, never bidding over your limit, and trying to buy the item for less than the limit.
- At an auction you will register and be given a number. The auctioneer will start the bidding at about one-half the low end of the estimate (the one in your catalogue). When you wish to make a bid you raise your hand. Bidding can go very fast so remember your spending limit.
- If you are successful at buying a print, your number will be recorded and you can settle with the house. The sale price (the winning bid) is called the hammer price. The buyer also pays a 10 percent premium to the house for acting as agent.

Print Membership Organizations

There are a number of organizations whose membership consists of collectors from all over the country. These groups do a brisk sale as a result of direct mail catalogues and special offerings. Most of them also have showrooms or offices so their members, and prospective members, may visit and view the prints. Collectors learn about these organizations from other collectors, from advertisements, and from direct mail literature.

Usually, a fee entitles a person to a year's membership. A free print, free or discounted art books, catalogues, and art tours may be some of the extras offered with the membership. Depending on the group, the fee may be set or may be on a sliding scale, each level carrying more membership privileges. A wide variety of prints are sold through print organizations. In some cases, the buyers for such groups will commission an established artist to create an edition just for them. The organizations may act as exclusive agents for an artist or may offer a few proofs of one well-known edition.

Generally, an effort is made to keep prices at an affordable level so collectors will want to buy again. Since much of this business is done by mail, there has to be some way to build trust. If a buyer receives a print through the mail and it is everything the seller said it would be (consistent with quality and price), he or she is likely to place another order.

Art Fairs

A fairly recent phenomenon in the United States, art fairs have been held for many years in Europe. Essentially, they are trade fairs for dealers, but they are also open to the public. For the price of admission you can go in and browse (it usually takes hours) and see art in every shape and form. You don't have to buy, but you will probably see many things you'd like to buy. These fairs are well promoted far in advance of the opening day.

You can also buy prints in department stores, museum gift shops, bookstores, and frame shops, but you probably won't find the same number of quality original prints you will find in other outlets.

Prints as Investments

Original prints have gained stature as investments since the late 1960s because of their favorable comparison with other speculative opportunities. The stock market has undergone several dramatic swings during this period, real estate taxes have soared, and commodities and foreign currencies are on a perpetual seesaw. Prints are more attractive as investments than other art forms because a fine impression in good condition does not cost an exorbitant amount of money and because of the liquidity of the market.

Since prints are published in multiples and are traded more frequently than paintings or sculpture, there are more opportunities to chart their financial progress. Dealer catalogues list prices, and auction house personnel will let you know the prices realized in their sales rooms for specific items. Such dictionaries as Martin Gordon's *Print Price Annual* report the sale price and condition of every print sold internationally at auction. Most dealers have the book, as do art bookstores.

The positive view, in terms of investment, focuses on the strength of art against international currency devaluations. In other words, if many impressions of the same print are sold in different countries at the same time, the sales will vary, but the prevailing price will be the one received in the strongest market. If the collector is aware of the financial climate and wishes to sell a print, he may consign that print to an auction house in a "strong" country, providing a market exists there for his artist and for the style and period of the print.

The cautionary view stresses the longevity of the investment. Few prints are overnight successes. And it takes specialized knowledge and day-to-day involvement with the art world to recognize trends. Many factors influence the cost of a print at any particular moment.

Recognition of the Artist

The investment potential of a print is largely due to the artist's integrity and to the historical significance of that particular work. Generally, if an artist has distinguished himself in another medium, his prints will be more seriously considered and sought after. Their value will rise in direct proportion to the artist's reputation. There have been artists, however, whose command of the print media allowed for quality which could not be equaled in other art forms. The best of Dürer's prints, for example, will continue to rise steadily.

It is important to digest all the information available about an artist. This includes where he has exhibited, who bought his works (museums, foundations, corporations, and private parties), any honors awarded him, and what critical acclaim, if any, has been accorded him. Art dealers keep reviews and biographical materials on hand for anyone who is sincere about learning.

Gallery and museum exhibitions, retrospectives, traveling shows, and acceptance by a first-line auction house for inclusion in its catalogue are all signs that an artist has gained art-world recognition for his work. Any record sales at auction will help to substantiate him as well. And the publicity garnered from such events encourages the popular appeal of the artist, consequently raising the price of his work.

The artist's death is a ponderable. Certainly fewer prints will be in circulation years after his death. One must consider, however, the output before his death in terms of numbers and quality. Too many prints can glut the market, and it would take generations for them to be considered scarce. If the artist was not remembered as a major influence on art history, the chances are his prints won't be regarded that way either. Also, if the death of an artist is anticipated for a long time, prices for his prints will have stabilized before he died. Some dealers with large inventories have been known to create a false market by skyrocketing prices immediately after their artists have died, but these prices quickly reach a saturation point and stop climbing.

Rarity and the Edition Size

The size of many Old Master editions was determined by the print media used. Considering that with the passage of centuries impressions have been lost, destroyed, or ruined beyond repair, the existence of prints in excellent or very good condition is limited. A particularly popular image by an artist, perhaps one that duplicates a famous work hanging in a museum, will be desired by thousands of people, but will be obtainable only by the number of people corresponding to impressions in the edition.

World politics may also contribute to scarcity. When Hitler closed the Bauhaus in Germany and much of the art of that period was destroyed in the ensuing war, few impressions of an image were available for exhibit and sale. The same was true in England, which was devastated by bombs during World War II.

Contemporary artists who, for a variety of reasons, decide to limit the number of prints to a minimum, are now laying the foundation for rarity in later years. (This, of course, is so only if they are established and will continue to have an impact on the art world.)

The Price
Obviously, it is desirable to buy a print at a low price. This would preclude buying at a time when speculative fever runs high. There are boom times in every business, and a collector should follow prices carefully to see evidence of abnormal activity for an artist, group of artists, or a particular period. A sure way to get burned is to buy something in an inflated market and then try to sell it for a profit (or even for what you paid for it) after the market has normalized. Remember, too, that today's vogue may not be tomorrow's.

The Image
In the United States particularly, collectors lean toward color prints that have a pleasant subject matter. In Britain sporting prints, country scenes, and landscapes are most popular.

Provenance
The line of succession of ownership, or provenance, of the print can be a significant factor in the sale of Old Master and early modern prints.

The Condition of the Print

All things being equal, a print in mint condition will command a higher price in a dealer's showroom as well as at auction. The important thing is to know what to look for when assessing the condition of a print; some deficiencies are permanent while others are easily corrected. Never commit yourself to a purchase without having a print removed from its frame. The frame and the mat can cover many problems.

First assess the paper type. Almost all prints published in the last century have been printed on 100 percent rag paper in one form or another. This paper has the desirable quality of remaining remarkably stable because it is acid-free. It will not turn the yellowish-brown often associated with old paper. Therefore, always examine the paper and look for watermarks to determine that it is a 100 percent rag paper.

Next, look carefully at the image. Obviously, it should appear as the artist intended and as it looked when it was printed. The main problem associated with image in modern and contemporary prints is fading and color change due to overexposure to ultraviolet light. These problems are potentially more serious if the print is colored; colored inks are much less light stable than black ink. A collector would be wise to compare a print offered for sale against a known standard, or a good photograph, to determine the quality of the image.

Check the margins around the print's image. They should be full and not trimmed. In addition to aesthetic considerations, many prints are catalogued according to the publisher's (or artist's) original paper size; trimming margins will cause a discrepancy between the measurements given in a catalogue and other descriptions of the print in question. Such a discrepancy could call into question the authenticity of the print and would certainly reduce its value.

Look for stains. There are several types of stains associated with prints on paper. The most common is acid burn, which is caused by contact between the print and an acid-bearing source such as a wood pulp mat board or backing, or an acid adhesive or tape. Acidity will cause the paper to turn yellowish-brown and to become brittle.

Foxing, another common problem, is the result of mold growth on the paper. Such molds literally consume the paper's fibers and can eventually eat a hole right through it. These mold colonies are easily visible to the naked eye as dark reddish-brown circular spots, usually in clusters. If the mold is active it has a musty odor, not unlike a mildewed closet. Such mold must be killed because it will destroy the paper and can spread to other prints. Once this is accomplished the stains may be removed; removal does not pose a hazard to the overall condition of the print.

Are there any tears, scuffs, or punctures? Obviously, this type of damage detracts from both the aesthetic and economic value of the print. Such damage, if it occurs in the image, is much more serious than if it is found in the margins. Often a tear, scuff, or puncture can be repaired, but it will never disappear completely and will always lessen the value of the print.

Most of the problems mentioned above can be dealt with successfully by means of expert restoration. Keep in mind, however, that there are risks. For example, special bleaches are used to remove stains. The bleach, quite capable of removing a coffee stain, might also affect the intensity of certain colors in the print or change the background tone of the paper. The acid yellow stain can be bleached out of paper, but this treatment might prove disastrous to the already weakened fibers. Restoration is a complicated and delicate business which should be entrusted only to an expert. These services are expensive and should be added to the cost of the print, since they are part of your investment.

Framing and Conservation

After a print has been purchased and, if necessary, restored to as near perfect condition as is technically or economically feasible, it is ready to be framed. Because of the enormous variety of framing materials, artistic styles, and differences in taste, there are no rules that can be applied to the design of a frame. What looks good to the print's owner is, indeed, the perfect frame.

In the long run, however, much more important than aesthetics is the frame's function of conserving the print. The future condition of the print, and hence its investment value, depends to the greatest extent on the quality of framing materials used and the manner in which they are assembled.

The Frame
Be it wood, metal, or plastic, the frame itself should be strong enough to support the weight of the artwork, glazing, and matting. Other than this basic need for structural support, the greatest latitude exists for the choice of frame material.

Glazing
The most important point about glazing is that it is absolutely necessary to prevent dirt and dust from settling on the print and to protect the paper from excess moisture. Glass has the advantage of being easy to clean and relatively scratch-resistant. Acrylic sheeting, known by the trade names of Lucite and Plexiglas, tends to attract dust and scratches rather easily. It is, however, lightweight and strong. Acrylic offers a distinct advantage for large prints in terms of framing strength, but it is also quite costly and will raise the price of the framing considerably.

Matting
The mat serves several functions. First, it provides an aesthetically pleasing border between the image and the frame. The size of this border depends upon the size of the artwork and the taste of the designer. There is, however, one important constraint; the size of the mat should never be such that it is necessary to either fold or trim the margin of the print. Trimmed margins always lessen the value of the work.

The mat should be sufficiently thick to provide a space between the glass or acrylic and the print. This prevents moisture (which condenses on the inner surface of the glass) from transferring to the paper.

The mat must be made of 100 percent acid-free material. There are currently several types to choose from. The most common is museum mounting board, which is 100 percent rag content paper. Wood pulp mat boards that have been buffered and are guaranteed to be acid-free are a somewhat less expensive alternative.

Hinging
The mat should be hinged to a sheet of acid-free board at least one-eighth of an inch thick.

Ideally, the mat and the board should be attached by a hinge along the top or left edge, and then the print attached to the board, again using a hinge. The hinges should be made of the lightest possible acid-free material (such as mulberry paper), which is nevertheless sufficiently strong to support the weight of the print. The adhesive used to attach the hinge to the print must be a nonpermanent, water soluble, acid-free paste. Never put glue anywhere on a print. Rubber cement, masking tape, and clear tape all require solvents to remove, and will cause severe staining because of their high acid content. They should be avoided at all costs.

Backing
Finally, the framed print should be backed, or sealed, with a sheet of heavy, acid-free board.

Hanging a Print
When choosing a location for hanging, it must be remembered that the artwork should never be exposed to direct sunlight. Sunlight contains a high proportion of ultraviolet light, which will fade color. If acid-free framing materials have not been used, sunlight will accelerate the acid reaction, causing the paper to turn yellow and brittle.

Never hang a print on a damp outside wall. Dampness promotes mold growth. The best possible atmosphere is one with constant temperature and humidity control.

Insects can be a problem. Silverfish, for example, enjoy eating anything made of cellulose, including paper. They thrive in damp conditions so, here again, humidity control is a must.

Air pollutants exist everywhere, but especially in cities. Since sulfur dioxide causes discoloration and potential disintegration of the paper, it is crucial that a print be properly sealed in its frame.

Artists and Their Prints

Now that you know the basics of collecting prints, it's time to decide whose prints to collect. This is not by any means an easy decision. Literally thousands of artists have experimented with the graphic media since the fifteenth century, some with better results than others in terms of skill, style, and inventiveness. But art is subjective, and the most technically perfect work may not always be the most popular. Of course, it's important to buy the best quality artwork for your money. Beyond that, there are no dictates. You should pay attention to what critics have to say about major art movements, particularly fertile creative periods of artists, and whether their work is exhibited and collected by distinguished art dealers and museums. If you like landscapes, however, and landscapes are not supposed to be "in," don't be put off. Simply study the work of artists who made landscapes (in the style you like best) and find a print which delights you and which is in excellent condition. Loving the print is always the first priority because you will be living with it for a long time.

The categories of prints are designated Old Master, Modern, and Contemporary. Old Master prints date from the beginning of the fifteenth century to about 1790. Modern prints date from 1791 to the mid-1940s. Contemporary prints are those done from then on. Each period is characterized by particular art movements and technologies. Some artists, among them Goya, completed works (in various media) during two of these periods and so are often included in discussions of both.

This section, which deals with the artists and their work, was compiled on the basis of conversations with respected print publishers, art dealers, and heads of auction house print departments. It would be impossible to include every artist who has made or is now making prints. The absence of an artist from these pages is in no way meant to detract from his or her talent or to imply that he or she is not well received. Those who do appear have been chosen for significant contribution in a historical sense, for technical superiority, and/or the benefit of a large collecting public.

To better acquaint you with the artists, a brief biography, photograph of a work, and current price information are given for each. The biographies are by no means complete. It would not be possible in a book of this size to include all the awards, commissions, or exhibitions each artist has had, nor all the collections in which his prints may be found. For additional details contact the representatives listed next to each print. They will be pleased to answer any questions or refer you to those who can provide full information on an artist and his work. The print which has been selected will give you an idea of the style of the artist. The prices listed below will give you some idea of what you can expect when you go into the market.

In the Old Master and Modern sections, the prices reflect 1982 auction sales and some dealer sales. They are listed next to descriptions of the prints, since condition is the major factor in determining what a lot (sale item) will bring. Descriptions are taken verbatim from auction and dealer catalogues, with their permissions. They present a wide sampling of prints that come on the market. If you look closely, you'll be able to see why one Homer fetches 19,800 dollars and another 3,740 dollars; why one Rembrandt reaches 66,000 dollars and another 777 dollars; or why one Gauguin realizes 56,100 dollars and another 1,925 dollars.

Contemporary prints are usually uniform in quality—in beautiful condition. There is little or no history, or provenance, attached to the print and therefore little chance for it to have been sullied by time, weather, or poor handling. The prices here were taken from the current price lists of publishers and dealers, since they are responsible for setting the value of the work they represent. Though there was only the slightest fluctuation between dealers, reputable dealers and publishers, careful to pace their artists, engage in constant dialogue about price.

It is important to understand, however, that the prices given here are not gospel. For a number of reasons they are subject to change daily. As editions sell out the individual proofs become rarer, and when impressions are available they command a higher price. If

a dealer buys a print at auction one day, you can be sure the price will change overnight to satisfy his profit margin. Price will also vary according to print size, medium (combinations of media, number of colors, etc.), edition size (a smaller number increases the notion of rarity), and year of publication.

Auction prices include the 10 percent buyer's premium. Prices for London sales have been converted into dollars using the rate of exchange on the day of sale.

Prices given in the Contemporary section all reflect sales by dealers.

The code used for the Old Master and Modern sections is as follows:

S-NY	Sotheby Parke Bernet, New York
S-LA	Sotheby Parke Bernet, Los Angeles
S-L	Sotheby Parke Bernet, London
C-NY	Christie, Manson & Woods International, New York
C-L	Christie, Manson & Woods International, London
P-NY	Phillips Fine Art Auctioneers, New York
P-L	Phillips Fine Art Auctioneers, London
D	Dealer

The Old Masters

Heinrich Aldegrever (c. 1502–1558)

Aldegrever was born in Westphalia, although there is no agreement on the exact date of his birth. One of the most talented of the Little Masters (so called because of the actual size of their work), Aldegrever produced some of the best Renaissance ornamental prints. A painter for churches and convents, he later turned his attention to etching and engraving studies of patricians and other costumed subjects. His three hundred prints show the strong influence of Dürer. Aldegrever's later works concentrated on variations of single letters. In the sixteenth century, because of the growth of the middle or trade class, there was a great demand for a "correct" script which could be used universally to conduct business. Aldegrever, like many artists of the times, devoted his energies to this need.

Ornament with a Bat, engraving, 1550, 2⅝ in. × 2 in. *Photograph courtesy Kennedy Galleries, Inc., New York*

The Power of Death. Four plates (B., Holl. 135, 139–41), engravings, from the set of eight, fine to very good impressions, unevenly trimmed just inside the platemark, with thread margins in places, slight staining, other lesser defects. S. 78 × 50 mm. and smaller (4) C-L $478

Two richly decorated Spoons (B., Holl. 268), engraving, a very good impression, trimmed just inside the platemark, a short repaired tear at the lower edge, another repair (?) to the left of the monogram, slight stains, backed, S. 66 × 99 mm.; Latin Alphabet on a richly decorated Plate between two Genii (B. 206), engraving, slightly trimmed, a loss at the upper left corner; and a slightly damaged impression of B. 72. (3) C-L $287

Albrecht Altdorfer (1480–1538)

*St. Jerome in a Cave, woodcut, c. 1513–15, 6¾ in. × 4⅝ in.
Photograph courtesy Kennedy Galleries, Inc., New York*

Albrecht Altdorfer flourished as a painter, print-maker, architect, and city councillor in Regensburg, Germany. Although he was influenced by Dürer and Cranach, Altdorfer was much taken with the more florid Italian scenes. Consequently, his graphic work included powerful, dramatic woodcuts as well as lovely, serene engravings. A leading exponent of the stylistic movement known as the Danube School, he was an important interpreter of nature. Nearly all his engravings (1505–11) and woodcuts (1511–13) are dated, but there are several undated prints which are presumed to have been completed by 1520, since after that year his interests changed to a great extent, and in 1526 resulted in his being named official city architect. In this capacity, he was responsible for the design and construction of all municipal buildings in Regensburg.

Resurrection of Christ (B. 47; Holl. 49), woodcut, 1512, a very good, strong, clear impression, trimmed to the border-line, in good condition except for a printer's crease in the upper left part of the aureole, a few reinforced thin spots in the edges, a tiny tear lower right, and a small repaired loss in the upper left corner related to previous hinging. 132 × 180 mm; 5¼ × 7⅛ in. S-NY $1,760

The Fall and Redemption of Man: Christ Before Pilate (Bartsch, Hollstein, 22; Winzinger 47), woodcut, 1515. A fine, clear impression with narrow margins. In good condition. Borderline: 2⅞ × 1⅞ in. (72 × 48 mm). P-NY $165

Madonna and Child in a Landscape (B. 17). Line engraving; trimmed to thread margins, glued down at corners, related tear top left, soiled, ink spots and other stains, a gray impression. 16.2 cm. × 11.6 cm. P-L $450

Hans Sebald Beham (1500–1550)

Hans Sebald Beham, one of the Little Masters, was born in Nuremberg and lived there until 1525, when he was exiled for heresy. His vast graphic oeuvre (more than two hundred and fifty prints) was begun at an early age. While a student of Dürer he perfected the technique of precision in intricate designs, many of which were used as patterns for silversmiths and architects. Like Dürer, he had an equal command of the woodcut and engraving media. In 1531 Beham settled in Frankfurt, his style underwent a marked change (becoming increasingly ornamental), and he altered his signature. He signed early prints with the monogram HSP, and those after 1531 with the monogram HSB. His prints come up for auction frequently and command a good price.

The Bagpipe Player and His Mistress (Bartsch 195; Pauli 197), etching, 1520. An impression taken after the foul-biting of the plate, trimmed to or just inside the platemark. A fair printing of the damaged plate, with slight paper loss at the corners recto. Sheet: 4½ × 2⅞ in. (117 × 172 mm). P-NY $44

An Allegory of Christianity (B. 128; P., Holl. 130), engraving, fourth (final) state, trimmed to just outside the borderline, a nick at the upper edge, slightly stained, backed at the left edge, S. 76 × 48 mm.; and an impression of B. 100. (2) C-L $228

Viola da Gamba Player; and *A Maid Seated* (Pauli, Holl. 1233 and 1234), two woodcuts printed on a single sheet, 1518–1525, a very good impression, trimmed to the borderline, a small repaired loss and a few nicks in the upper edge, a few slight stains, collection stamp upper right corner, recto. 78 × 111 mm: 3⅛ × 4⅜ in. S-NY $1,155

Women's Bath, woodcut, early sixteenth century, 11¼ in. × 11⅜ in.
Photograph courtesy Kennedy Galleries, Inc., New York

Jacques Bellange (c. 1575–1616)

***Kaspar,** etching, from* Der heiligen drei Konige, *c. 1610–15, 11¾ in. × 6½ in.*
Photograph courtesy Phillips Fine Art Auctioneers, London

Bellange was born in Nancy, capital of the Duchy of Lorraine, and worked as a court painter there. A portraitist with an elegant and sumptuous style, he was regarded as one of the last great mannerists. His printmaking career, divided into three phases, spanned a ten-year period and yielded about forty-eight etchings. During the first phase, Bellange learned the basics from a professional etcher. In the second, during which he did most of his work, his studies are more controlled and greatly influenced by the Old Masters. The prints are complex in composition, and many show evidence of reworking on the plate. The last phase (when his technique was streamlined) allowed for more aesthetic treatment of the subject; prints from this period show unusually strong painterly effects. Lively, witty, theatrically devised portraits mark this stage of his work, which was taken from imagination rather than models and delighted and amused the bored courtiers in Nancy.

Melchior, King of Nubia, etching, c. 1610–15, 281 × 170 mm. Plate 3 of the series of *The Three Magi.* In beautiful condition, traces of plate tone throughout the plate. D $11,000

The Three Marys at the Tomb (Walch 46). Etching, second state of two, a fine impression, with five vertical wiping scratches, trimmed to the borderline (just into the work at top and upper sides), horizontal center crease partly broken and reinforced, a mended tear in the hair of the angel, a few small scrapes and a pinhole in the lower edge of the subject, a printer's crease visible in the blades of grass alongside the tomb at right, otherwise in good condition. 540–543 × 290 mm; 21¼ × 11⅜ in.

Amy N. Worthen and Sue Welsh Reed, in their exhibition catalogue, *The Etchings of Jacques Bellange,* Des Moines Art Center, Des Moines, Iowa, 1975, state: "*The Three Women at the Tomb* is probably Bellange's best-known etching. Often discussed and reproduced, it has been the basis of most people's familiarity and knowledge of Bellange's style. . . . (It represents) the moment when Bellange's dramatic and stylistic intentions, and his technical abilities came together in a most perfect meeting." S-NY $12,500

William Blake (1757–1827)

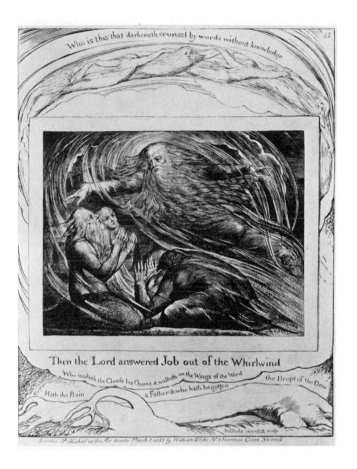

Who is this that darkeneth counsel by words without knowledge

Then the Lord answered Job out of the Whirlwind
Who maketh the Clouds his Chariot & walketh on the Wings of the Wind the Drops of the Dew
Hath the Rain a Father & who hath begotten
WBlake invent & sculp
London. Published as the Act directs March 8 1825 by William Blake N 3 Fountain Court Strand

William Blake was a mystic whose abstract philosophy is evident in his work. Blake earned a living as an engraver for publishing houses, while writing his own poetry and engraving the text. He surrounded his poems with illustrations he and his wife colored by hand, later publishing these himself. Some of these works, *Songs of Innocence* and *Songs of Experience*, are considered to be among his best, but his masterpiece is his engraved illustration for the *Book of Job*, which he produced in 1826. Blake spanned the art forms of his time as his philosophy became more expansive and insightful. His imagination led him away from the more traditionally defined arrangement of figures to a more subjective use of form, color, and light. His romantic vision was a reaction to the Age of Reason.

Then the Lord Answered . . . from The Book of Job,
engraving, 1825, 8½ in. × 6¾ in.
Photograph courtesy Kennedy Galleries, Inc., New York

The Book of Job, Plates 6 and 12 (Binyon 111 and 117), two engravings, 1825, from the set of twenty-one, good impressions, on laid India paper, with the word *proof* removed, with large margins, in generally good condition apart from mat stain and foxing (mainly in the margins). Each 218 × 170 mm (8⅝ × 6¾ in.) S-NY $715

Pieter Brueghel the Elder (1525–1569)

Pieter Brueghel the Elder was the patriarch of a family of Flemish artists whose name was carried by at least a dozen painters up through the eighteenth century. The best-known of the Brueghel line, he had the reputation of being one of the foremost Flemish landscape painters and satirists. Initially, he worked in Antwerp in an engraving workshop, and in 1551 he became a master in the Antwerp Guild. The following year he traveled to France and Italy, and his eventual return over the Alps provided him with visual memories that he later incorporated in a masterful group of drawings. Brueghel then started creating drawings specifically for the purpose of having them copied by etchers and engravers.Although he made only one print, he is regarded as one of the most influential artists of the mid-sixteenth century. At a time when styles were predominantly florid, Brueghel's work was refreshingly, imaginatively realistic.

The listings below are of prints made after (in the style of) Brueghel the Elder.

The Fall of the Magician Hermogenes (Bast., Holl. 118), engraving, 1565, by Pieter van der Heyden, a very good impression, on paper with a Gothic P and Flower watermark, trimmed to the platemark at the sides, just within at top, and nearly to the borderline below (lacking title), a diagonal printer's crease across the lower right corner, slight thin spots in the upper and right edges, lightly foxed. 210 × 290 mm; 8¼ × 11⅜ in. S-NY $1,760

The Last Judgment (Bast., Holl. 121), engraving, 1558, by Pieter van der Heyden, a very good, strong impression, on paper with a Gothic Letter watermark, trimmed to the platemark on three sides and nearly to the borderline below (lacking title), a few printer's creases, a few thin spots and light foxing, glue stains on the verso. 214 × 294 mm; 8⅜ × 1⅝ in. S-NY $1,320

The Fight of the Money-Bags and Strong-Boxes (Bast., Holl. 146), engraving, c. 1558–67, by Pieter van der Heyden, a fine, strong impression of the first state of two, trimmed to or just outside the borderline (lacking title), top right corner lost, a vertical crease and a printer's crease at right, a few other, slighter creases, glue stains on the verso and one in the lower right edge on the recto. 221 × 305 mm; 8¾ × 8⅛ in. S-NY $1,870

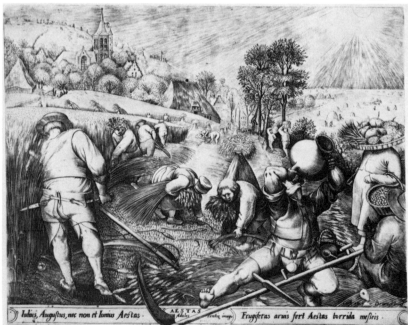

Pieter van der Heyden, after Brueghel, **Aestas,** *from the set of* The Seasons, *engraving, 1570, 9 in. × 11⅓ in.*
Photograph courtesy Lucien Goldschmidt, Inc., New York

Jacques Callot (1592–1635)

Jacques Callot, who is considered one of the greatest etchers, was born in Lorraine. In 1608, when he was sixteen, his parents finally permitted him to go to Rome to study art, but only after he had run away several times and joined a band of gypsies on the way to the Eternal City. In 1611 he went to Florence, and that city inspired his numerous etchings of fair and festival scenes. It was on his return to Nancy, in Lorraine, that Callot's work matured and became more serious. His masterpiece of this period, *Grandes Misères de la Guerre* (1633), is assumed to have been at least partially inspired by Richelieu's invasion. It is considered the most terrifying record of the atrocities of the Thirty Years' War and is unique because the brutality of the subject is juxtaposed with the delicacy of the treatment.

The Fair at Impruneta, 1st version. 1620. Etching. Meaume 624. Lieure 361 III (of V), 425 × 670 mm. A very good impression of the third state, showing the word "Firenza" instead of "Firenze" in the lower right and still with the word "In." Very rare in this state according to Lieure.

This is probably Callot's most important large subject, and the masterpiece of his Florentine period. The fair was held in a small town, Impruneta, outside of Florence, on the feast day for St. Luke, October 18. Callot made a series of magnificent little sketches on the spot and then produced this incredibly detailed etching, depicting more than a thousand characters of every possible description. Grand Duke Cosimo II de Medici was so delighted, he presented the artist with a gold medal.

Printed, as usual, on two sheets joined together in the center. Traces of having been glued down around the edges visible at the back; a mark from a piece of tape in the center, visible only from the back. D $8,000

Le Marché d'Esclaves (L. 369; M. 712), etching, 1620, a fine impression of the rare first state of six, with small margins, in good condition (faint fox mark lower center, traces of a vertical crease right of center). 114 × 217 mm; 4½ × 8½ in. S-NY $2,640

The Hanging (Lieure 1349ii), etching, 1633, plate 11 from the *Grandes Misères de la Guerre*. A good impression on laid paper with full margins. In very good condition. Framed. *Plate:* 3¼ × 7¼ in. (80 × 186 mm). P-NY $220

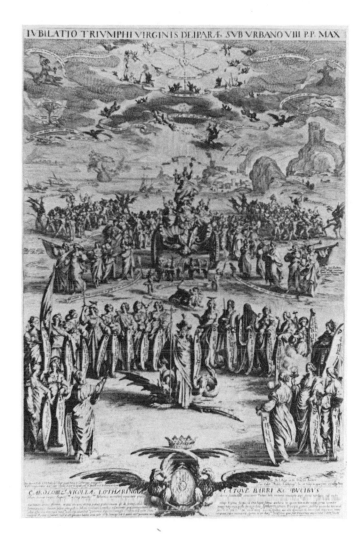

La Petite Thèse or ***Le Triomphe de la Vierge,*** engraving, 1625, 22⅜ in. × 14½ in.
Photograph courtesy Pasquale Iannetti Art Galleries, Inc., San Francisco

Antonio Canale called Il Canaletto (1697–1768)

Canaletto was born in Venice and began his career as a scene painter. Artists of the time usually painted from drawings, and Canaletto's earliest datable works—four scenes of Venice—were unusual because they were painted on the spot. He later changed his method and worked from drawings and etchings. Canaletto completed about thirty etchings of scenes in and around Venice. They were beautiful for their depiction of shimmering sunshine. In the mid-1700s he began working in England, where he met Joseph Smith, later British Consul in Venice. Smith had first choice of the artist's works and often arranged sales for him. The collected edition of Canaletto's etchings was published with a dedication to Smith.

The Portico with the Lantern, *etching, c. 1790, 12⅛ in. ×
17⅜ in.*
*Photograph courtesy Phillips Fine Art Auctioneers,
London*

The House with the Peristyle (Br. 14; DeV. 13; P. & G. 12b). Etching, c. 1741, a very good impression of the second state of two, with small margins, a small circular loss in the hull of the boat at lower center, otherwise in good condition. 299 × 216 mm; 11¾ × 8½ in. S-NY $1,500

Landscape with Ruined Monuments (De Vesme 28; Bromberg 31), etching, after 1735, on paper with a fleur-de-lys watermark (Br. 13), trimmed to the platemark, a small repaired tear in the upper left edge, hinge stains in the upper corners, slightly rubbed along chain lines. 144 × 216 mm (4⅛ × 8½ in.). S-NY $880

La Piera del Bando. V. (B. 19; DeV. 16; P. & G. 17), etching, before 1741, third (final) state, a good impression of this state, on paper with part of an R watermark (cf. Bromberg 10), trimmed along the platemark, a small stain and two small repairs in the upper edge at left, framed. 145 × 212 mm; 5¾ × 8⅜ in. S-NY $495

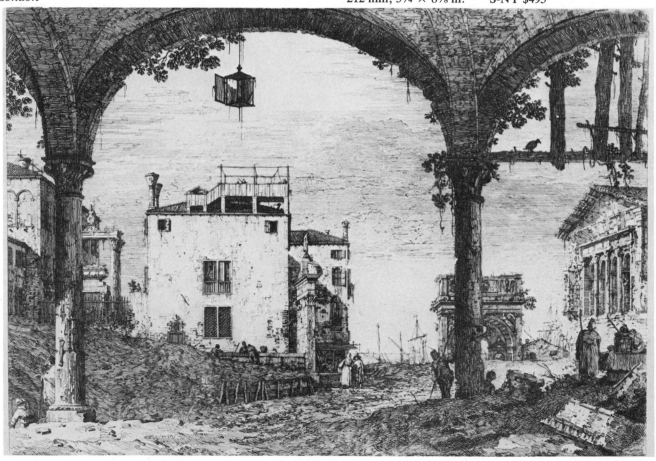

Agostino Carracci (1557–1602)

Agostino Carracci was one of three brothers who founded the eclectic school of Bologna. Agostino was the first to introduce the academy method of teaching as a response to the established master-apprentice method, which he felt did not offer enough all-round experience. In the second half of the sixteenth century Bologna was a university town and a literary and economic center. Prints were considered an important learning tool, especially for those in other cities who wanted to know about the great intellectual accomplishments of the day. Carracci was friendly with the great thinkers and achievers of his time and sought to translate their brilliance pictorially in his work. Printmaking, his primary artistic concern, won him fame from the 1580s until his death. He was the most sought-after engraver in the south, as Goltzius was in the north.

A Headpiece in the Form of a Fan, engraving, c. 1589–95, 14⅝ in. × 10 in.
Photograph courtesy Kennedy Galleries, Inc., New York

The Mystic Marriage of St. Catherine. Paulli Caliarii Veronensis opus in ecclesia D. Caterinae Venetiss. Original engraving after a painting by Veronese, 1582. 507 × 345 mm., mounted. Bartsch XVIII, 98, "one of the best works of Agostino Carracci." Bohlin, National Gallery cat. 104, I/II. Le Blanc I, 77, I/II. The painting of Veronese occupied the high altar of the monastery of St. Catherine in Venice. Carracci worked there in 1582. Fine impression. Two small ink spots. D $750

The Large Crucifixion. 1589. Engraving. Bartsch 23; Bertela and Ferrara 153; Bohlin 147. Indecipherable watermark. Overall: 514 × 1200 mm.; Left: 513 × 400 mm.; Center: 510 × 405 mm.; Right: 511 × 400 mm.

It would be difficult to argue with Bohlin's assertion that the large *Crucifixion* is "probably Agostino's most elaborate engraving, including both his reproductive and original work." (p. 254) After the Tintoretto painting of the same subject in the Scuola di San Rocco, Venice, this ambitious work was renowned in its own day. According to Bellori, Tintoretto acted as godfather to Agostino's son Antonio in appreciation of the beauty of this engraving. It was the engraved work after Tintoretto, including the *Crucifixion,* which established firmly his reputation as the leading engraver in Italy at the time.

We see here a great development of the artist's hatching technique together with a brilliant use of the "swollen line." Through his mastery of the burin, great textural and tonal variety was achieved. Colors translated into black and white produced a powerful interpretation of a painting rather than a slavish copy. Agostino thus adhered to the principles of the Carracci Academy, where improving upon the model according to the "ideal" was as important as the ability to copy accurately.

A superb impression, richly and evenly printed with brilliant contrasts. Margins all around, and in fine condition, apart from some minor staining and some creases. A skillful repair of a tear in the right (third) sheet, visible on the verso but not affecting the image. Some old glue stains at vertical edges (also on verso) indicating previous points of attachment. D $3,500

Lucas Cranach the Elder (1472–1553)

Lucas Cranach the Elder was a painter, etcher, and designer of woodcuts. His earliest works were religious subjects in landscape settings. In the early 1500s he made a number of woodcuts influenced by Dürer, but after 1520 his woodcuts were crudely executed and are often indistinguishable from those of his two sons, Hans and Lucas II. These woodcuts were religious in nature and illustrated the Bible or the writings of the Reformers. (He was passionate about Luther as a subject.) His body of work is uneven, but at its best it is charming, elegant, and sensitive. Cranach's prints were signed with a winged snake and the initials LC.

The Penance of St. John Chrysostom. 1509. Engraving. Hollstein 1. Watermark: Small Coat of Arms (Briquet 1191). 255 × 202 mm.

The story illustrated here has little to do with the actual life of St. John Chrysostom (one of the Greek fathers of the Church), other than the depiction of him as a hermit. Rather Dürer, and later Cranach, drew upon a fourteenth-century source that told the story of the saint seducing an emperor's daughter who had wandered into his cave during a storm. Stricken with guilt, John flung the young mother and child from a cliff and vowed to crawl on all fours and to live like a wild animal until he received forgiveness from the Pope. Fifteen years later, the girl and her child were found miraculously alive, after her mother's second child mysteriously expressed the wish to be baptized by the same saint.

While it is generally agreed that Cranach fashioned this image after Dürer's engraving of the same subject (1497), Cranach's interpretation of this strange tale shares little more than its subject with the Dürer that served as its model. Still, the pose of the nude young woman, a mirror-image of Dürer's *Sea Monster,* and the inclusion of an elaborately antlered stag, resembling the one in Dürer's *St. Eustace,* suggest an acknowledgment of debt to Dürer's engraved work of c. 1500.

Cranach used an extensive vocabulary of linear pattern to create an overgrown landscape of which man and beast are an integral part. The interweaving of forms, which seem to be made of a common stuff, relates this print to the work of the Vienna, or Danube, School, as well as to Dürer's art. Unlike the highly classicizing structure that separates the various components in Dürer's image, the elements in this print spill over into one another, emphasizing the unity of man and nature over spatial fidelity and narrative clarity.

An unusually rich impression, in very good condition apart from some minor staining and an old center fold. D $6,500

St. Andrew (B. 38; Holl. 54), woodcut, c. 1539, a very good, clear impression, trimmed to the borderline on three sides, along or just within the borderline at bottom, a small repaired tear running into the back of the man on horseback at left and a few touches of pen and ink in the upper left part of the subject. 161 × 126 mm; 6⅜ × 4⅝ in. S-NY $550

St. Christopher (B. 58; Holl. 79), woodcut, apparently Hollstein's state IIa, without the date, but lacking Stigel's verses, late, trimmed just inside the borderline on three sides, cut to the Coats-of-Arms at the top, a backed loss near the top, a repaired tear upper left, a few stains, partly laid at the edges, S. 269 × 193 mm.; and a copy of Luther as an Augustinian Friar with Cap (cf. B. 6), engraving. (2) C-L $2,037

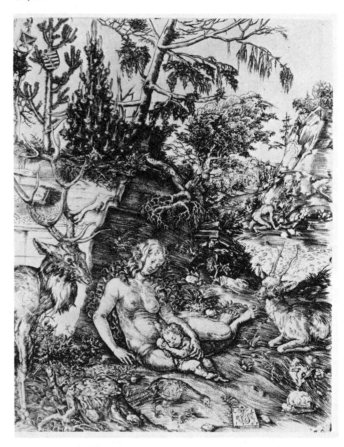

The Penance of St. John Chrysostom, *engraving, 1509, 10¼ in. × 8 in.*
Photograph courtesy Kennedy Galleries, Inc., New York

Stefano Della Bella (1610–1669)

Stefano Della Bella was born in Florence. His father was a sculptor, and when he died, it was necessary for the young Stefano to work. He chose to apprentice in various goldsmith shops. He studied painting for a while, but inspired by Callot's success, decided to become an etcher. His first print in 1627 was dedicated to Prince Gian Carlo de Medici. This brought him to the attention of the Medicis, who gave him patronage and funding for most of his artistic life. He studied in Rome and Paris with their help and continued to receive commissions from them even after he returned to Florence in 1650. Della Bella completed more than one thousand prints, almost all of them etchings. He made landscapes, genre scenes, and, from the Roman period onward, he put the experiences of his own life into his work. Other artists considered his renderings of ornaments important examples to follow.

Screen with a Robus of Fortune, etching, c. 1660,
11²/₁₆ in. × 8³/₁₆ in.
Photograph courtesy Kennedy Galleries, Inc., New York

Clovis and Clothilde (Riders in a Storm). Original etching, c. 1650. 298 × 214 mm. and margins. De Vesme 211. Massar 211, with illustration. Stanford University cat. Sopher, 1978, Seventeenth Century Prints, no. 105, with illustration.

A horseman galloping with a young woman behind him in a stormy landscape; another rider following at the left. The scene is framed by an elaborate ornamental border. At the top two putti support a blank escutcheon. There have been controversies concerning the subject and date of this print. The Stanford catalogue entry supports Massar's correction of De Vesme, which states that it represents Clovis and was probably printed in France in the 1650s, but Anthony Blunt notes that the style of ornament in this print resembles a series of ornamental engravings published by Nicolas Langlois in Paris, 1657, as an illustration for the first canto of the poem "Clovis ou la France Chrestienne" (see Blunt, The Drawings of Castiglione and Stefano Della Bella at Windsor Castle, London, 1954, Della Bella cat. 15, illus. no. 5). Watermarks: a pair of bells (?) and the initials CBA. Even impression. Some very light foxing. D $950.

Albrecht Dürer (1471–1528)

Dürer is regarded as the inventor of etching and is considered one of the greatest German artists. In addition to paintings, drawings, and watercolors, he created woodcuts and engravings that influenced the graphic arts all over Europe. Dürer was born and lived in Nuremberg where he apprenticed first to his father, a goldsmith, and later to Michael Wolgemut, a painter and engraver. From his trips to Venice in 1494 and 1505 he brought back to Germany the ideals of the Italian Renaissance, incorporating varied intellectual pursuits into his artistic life. Dürer painted numerous portraits and, as a devoted follower of Martin Luther, frequently depicted religious themes in his work. His talents were widely acclaimed in his lifetime, and in 1512 he became court painter under the Emperor Maximilian. Dürer is best known, however, for his woodcuts and copperplate engravings. He was the first artist to design, print, and publish an entire book, *The Apocalypse,* in 1498.

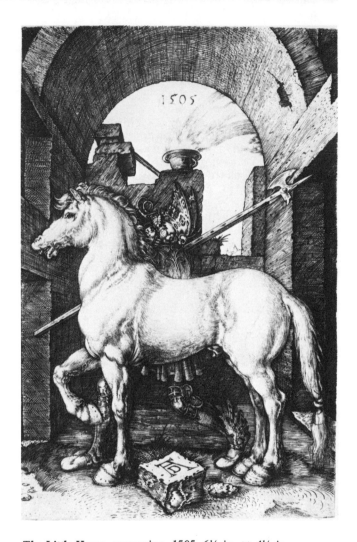

The Little Horse, engraving, 1505, 6½ in. × 4¼ in. Photograph courtesy Lucien Goldschmidt, Inc., New York

Adam and Eve (B., M., Holl. 1), engraving, 1504, the completed composition in the second state (of three; the first, with the 5 of the date reversed, is known in one impression), very early, before the scratch on Eve's left knee and the scratches across the mountain goat, this impression unusually heavily inked, on paper with a Bull's Head with Flower and Triangle watermark (M. 62), trimmed to the edge of the subject and the borderline where it exists top right and fractionally inside lower left and places in the center and lower right edge, and perhaps top left, a minute surface loss at the top of the ram's horn, a minute tear at the left edge and a minute repair at top. S. 9¹¹⁄₁₆ × 7⁹⁄₁₆ in. (246 × 192 mm.) C-NY $33,000

The Bagpiper (B. 91; M., Holl. 90), engraving, a good though damaged impression, trimmed on or just inside the borderline, made-up areas and several repaired tears, stained, backed, L. 115 × 73 mm.; and *St. Jerome in a Cave* (B. 113; M., Holl. 229), woodcut, some damages. (2) C-L $378

The Passion: The Lamentation (B., M., Holl. 14), engraving, 1507, a very good (Meder a-b) impression, with thread margins, in good condition apart from a soft diagonal crease, a pen notation on verso, faintly showing through. 115 × 70 mm.; 4½ × 2¾ in. S-NY $2,200

The Virgin with the Swaddled Child (B. 38; M., Holl. 40), engraving, 1520, a very fine, bright and clear (Meder a-b) impression, with delicate plate tone in the shadows of the drapery and in the background, with thread margins most of the way around (trimmed just to the platemark at bottom), in good condition apart from slight foxing and a few soft creases. 143 × 97 mm; 5⅝ × 3⅞ in. S-NY $9,075

Anthony van Dyck (1599–1641)

Anthony van Dyck, the Flemish student of Rubens, was considered the best portrait painter of his time. His portraits of important men and women were notable for their objectivity as well as their accuracy. Some of the new techniques he used—for example, leaving the background lightly sketched in while concentrating on the portrait with opened lines and dots for definition—were not fully appreciated until centuries later. Before settling in England in 1632 as the court painter to Charles I, Van Dyck began an ambitious project known as the Iconography—a collection of one hundred portraits of the most famous men of his day. About twenty of these were executed as etchings. He seldom undertook the entire printmaking process, but preferred to provide drawings to skilled artisans and then supervise their work.

Philippe Le Roy, first state before letters, etching only, c. 1650. 6¼ in. × 9⁹⁄₁₆ in.
Photograph courtesy Kennedy Galleries, Inc., New York

Jan Brueghel (Holl. 1), etching, before 1632, a fine impression of the second state of six, with delicate vertical wiping scratches printing with tone, on paper with a wreath watermark, trimmed to or along the platemark, in good condition except for slight thin spots (mainly in the edges), and traces of old diagonal creases in the lower corners. 245 × 157 mm; 15¾ × 6¼ in. S-NY $5,500

Christ Crowned with Thorns (Holl. 20), etching, c. 1630, a very good impression of the fifth state of seven, on paper with letters IB watermark, with margins, in good condition (slight horizontal crease). 260 × 215 mm; 10¼ × 8½ in. S-NY $605

Jan "Velvet" Brueghel (Mauquoy-Hendrickx, Wibiral, Holl. 1), etching and engraving, probably late 1620s, second state (of six), watermark Eagle in a Wreath, with a thread margin at bottom, trimmed almost to the borderline left and right (shaved within it top and bottom right) and to the engraved work at top, inscribed in brown ink in a contemporary hand "joannes Broughel, Antuerpiae Pictor florum, et ruralium prospectuum," two slightly thin patches. S. 9⁹⁄₁₆ × 5⁵⁄₁₆ in. (243 × 151 mm.). C-NY $1,650

Hendrik Goltzius (1558–1616)

Hendrik Goltzius was an engraver as well as a painter and was considered to be a prominent Mannerist. In 1582 he founded a school of engraving in Haarlem, his birthplace. The many engravings by his hand, or by others to his design, are considered technically superb. His fame grew as a result of his proficiency. He was particularly lauded for his experiments with the thickness and curve of lines, resulting in the swell of the image to its fullest limit; this gave his prints power and exuberance. Goltzius made several chiaroscuro woodcuts—prints made using separate blocks for tonal variation. These woodcuts were the first of their type, outside of Italy, to be created without drawings for reference. Goltzius was the first artist to use color woodcuts for landscape prints.

Henry IV, King of France (Holl. 193; Strauss 357), engraving, c. 1600, a very fine impression of the second state of five, on paper with a contemporary divided shield watermark, with margins, in good condition apart from a vertical crease in the left edge of the subject, trace of a horizontal center fold (mainly visible on the verso), faint hinge stains in the corners and light foxing, lower right corner touched to mount. 363 × 263 mm; 14⅜ × 10⅜ in. S-NY $7,260

Nox (Holl. 372; Strauss 420), chiaroscuro woodcut, c. 1594, printed from three blocks in black, creamy beige and green (beige block over a blue block), a fine early impression, before the loss in the borderline at lower left, on paper with a small crowned shield watermark, with octagonal margins, slight soiling, thin spots, nicks and a few small tears in the edges (running just into the subject at right), horizontal printer's crease (visible mainly on the verso). 350 × 264 mm; 13¾ × 10⅜ in. S-NY $4,125

Mars Surprised with Venus (B. 139; Holl. 137; Strauss 216), engraving, first state (of three), watermark Strasburg Lily, with small margins, the lower right corner made up, an unobtrusive central horizontal crease, some minor stains. P. 423 × 311 mm. C-L $267

Frederik de Vries (B. 190; Holl. 218; Strauss 344), engraving, second state (of three), a good impression, trimmed to the borderline. laid and remargined, a wormhole lower left, two small surface abrasions above the dog's tail, some staining, framed. 354 × 264 mm. C-L $535

Great Hercules, *engraving, 1589, 22¹/₁₆ in. × 16 in. Photograph courtesy Kennedy Galleries, Inc., New York*

Francisco José de Goya y Lucientes (1746–1828)

Goya was born near Saragossa, where he studied art at the Escuela Pia of Padre Joaquin. A court painter and satirist, Goya lived an earthy, sometimes violent existence. The pathos and misery of the life he witnessed was dramatically revealed in his work. In the latter half of the 1770s Goya produced his masterpiece, *Los Caprichos* (The Caprices), a series of eighty etchings that provided a savage, but somehow detached, commentary on the society in which he lived. The entire edition went on sale for the equivalent of twenty-five dollars. The political turmoil of the times had a marked effect on Goya's art. Napoleon invaded Spain in 1808, removing Ferdinand VII from power and replacing him with Joseph Bonaparte. Ferdinand returned to power in 1814. Goya's protests against the bloodshed are reflected in a series of etchings vividly depicting the atrocities of war. In the 1820s he also worked in the field of lithography—a new medium for a new century of art. His four studies of bullfights (c. 1825) are considered the first lithographs with artistic merit.

***Asta Su Abuelo (And So Was His Grandfather),** Plate 39 of* Los Caprichos, *aquatint/etching, 1799, 8⁷⁄₁₆ in. × 6 in. Photograph courtesy Lucien Goldschmidt, Inc., New York*

Los Caprichos (Harris 36-115; Delteil 38-117), the set of 80 plates, etchings with aquatint, very fine impressions of Harris's trial proofs before the first edition (1799), with three plates before correction of the titles (plates 1, 8, and 21), with plate 45 before the scratch across the chin of the background figure, and with many other printing characteristics throughout associated with only the earliest impressions, such as the dark printing of the freshly burnished areas on plates 6 and 12, the plate polishing scratches on plate 7, the burr on the drypoint work in plates 31, 33, and 41, the strength and lack of wear of the aquatint in plate 32, the warmth and clarity of the aquatint and etched work in plate 1, which has accents of burr on the cravat, and the exceptional clarity of the aquatint work throughout, in good condition apart from some unobtrusive foxing, a rubbed thick spot in the paper of plate 5 (above the figures), with contemporary Spanish marbled end papers end mottled calf binding, gilt tooled and with a green panel on the spine lettered CAPRICH DE GOYA. S-NY $104,500

Esto Si Que Es Leer, plate 29 from *Los Caprichos* (T.H. 64; L.D. 66), etching, burnished aquatint, and drypoint, from the first edition, 1799, on soft laid paper, with margins, a few very light foxmarks, disbound at left. P. 8⁷⁄₁₆ × 5¾ in. (215 × 147 mm.). C-NY $550

Otras Leyes Por El Pueblo (Delteil 222; Harris 268iii), etching and aquatint, the first edition as printed by Liénard and published in *L'Art,* 1877. A rich impression on cream laid paper with full margins. In excellent condition. Plate: 9¾ × 14 in. (248 x 355 mm). P-NY $715

William Hogarth (1697–1764)

Hogarth began engraving in 1720 after he had completed his apprenticeship with a silversmith. Though not proficient as a draftsman, he recognized the need for education and promoted a new academy in St. Martins, which was the forerunner of London's Royal Academy. Hogarth's best-known works were moral subjects. Originally executed as paintings, their fame spread when engravings were made from them in 1732. These engravings were so popular that they were often copied by other artists. Hogarth eventually had a Copyright Act passed. The engravings in the *Rake's Progress* series were the first to be printed under that law, and bear the inscription "Published according to Act of Parliament." Because portrait painting could not sustain his family, Hogarth sold etchings at one guinea per set of six. More than 1,200 people bought these sets. His *Portrait of Lord Lovat* was so popular he had to print 240 a day for many weeks.

The Distrest Poet (P. 145), 1736–37; *The Enraged Musician* (P. 158), 1741; *The Four Times of Day* (P. 152-55), 1739, the set of four plates; *A Midnight Modern Conversation* (P. 128), 1732–33; *Strolling Actresses Dressing in a Barn* (P. 156), 1738; *Southwark Fair* (P. 131), 1734; and *The Gate of Calais, or The Roast Beef of Old England* (P. 180), 1749, etchings with engraving, all final states except P. 154 iii/iv, 18th century impressions, on laid paper, with margins (several unevenly trimmed), creases, foxing and stains, a few with tears and losses, mainly in the margin.
(10) S-NY $770

A Rake's Progress (Paulson 132-39), etchings with engraving, 1735, the set of six plates, plate 3 an impression of the first state of three, with narrow margins, several tears, small scrapes, and losses in the edges, soiled and laid down; the others final states, 18th century impressions, on laid paper, with margins, some creases, stains and tears, soiled and foxed; together with *Industry and Idleness* (P. 168-79), etchings with engraving, 1747, the set of twelve plates, plates 6 and 9 penultimate states, the rest final states, 18th century impressions, on laid paper, with unevenly trimmed margins, several with tears and glue (mainly in margins, verso), foxed and soiled. (18) S-NY $935

An Election Entertainment, line engraving, 1755–58, 17½ in. × 22½ in. Photograph courtesy Phillips Fine Art Auctioneers, London

Wenzel Hollar (1607–1677)

Muffs and Other Articles of Dress and Toilet, etching, 1647,
4⁵/₁₆ in. × 8³/₁₆ in.
Photograph courtesy Lucien Goldschmidt, Inc., New York

Wenzel Hollar was born in Prague, the son of a nobleman who eventually lost everything in the Bohemian
Wars. Though his family wanted him to practice law,
Hollar defied them by moving to Frankfurt to study
engraving. In Germany he met the Earl of Arundel
who admired his prints and took him home to live in
England and to reproduce the treasures of his collection. Following an introduction to Charles I, Hollar
married a lady-in-waiting to the Court. Their life-style
inspired many of his costume and period prints. His
scenes of London, considered his best works, are
among 2,700 completed etchings noted for their
dainty, precise style and sober characterizations. Because of his connection to the Court, Hollar was
commissioned to record the festivities attending the
arrival in England of Maria de' Medici.

Ceres und Stellio (P. 273), etching, after Hendrik Goudt, a
good impression, on paper with a foolscap watermark, with
margins, lightly foxed. 300 × 230 mm; 11¾ × 9 in.
S-NY $275

Wenzel Hollar, after J. Meyssens (Parthey 1419), etching,
the very rare first state before the text and before the first
published edition of 1649, a fine impression, with part of a
foolscap watermark, with thread margins or trimmed on the
platemark, a small repaired and touched hole above Hollar's
head, a pinhole at right, a light stain on the thumb, two light
glue stains in the blank area, traces of an old crease, a few
faint foxmarks. P. 6¼ × 4½ in. (159 × 114 mm.)
C-NY $990

Wenzel Hollar, after J. Meyssens (P. 1419), etching with
burin and drypoint, the very rare first state before the addition of the text, a fine, sharp impression, part of a foolscap
watermark, trimmed on the platemark or with thread margins, two small repairs in the blank area below the subject,
another above Hollar's head and a small pinhole at the
right, a soft diagonal crease, very slightly stained, P. 158 ×
113 mm; and *Lady Buts,* after H. Holbein by W. Hollar (P.
1553) (2) C-L $956

Lucas van Leyden (1494–1533)

Lucas van Leyden was a precocious Dutch artist who engraved his first plate at the age of fourteen. He was influenced by many, including Dürer and Marcantonio Raimondi, but his work had two distinctive styles. In early years his work was the summation of Dutch ebullience. It changed in response to the Renaissance, which was to alter considerably the artist's outlook and life-style. His brilliance as a draftsman can be seen in his portraits, religious works, and illustrations of everyday life. Van Leyden completed a large body of work, including many woodcuts and etchings which were recognized for their skill and inventiveness. His portrait of the Emperor Maximilian (1520) was the first print known to have been made on copper and in which etching and engraving were used together.

The Woman with the Hind (B., Holl. 153), engraving, 1509, first state (of two), watermark small Eagle, trimmed outside the borderline, a tiny piece of paper adhering to the surface at left, the collector's mark showing through faintly at bottom, thin spots, old hinges. S. 4¼ × 2¹³⁄₁₆ in. (108 × 71 mm.). C-NY $462

Mars, Venus and Cupid (B., Holl. 137), engraving, 1530, first state (of four), a fine impression, watermark Shield with three Cross-Beams (Holl. 7) as found on the earliest impressions (see also the impression sold in these rooms, May 7, 1981, lot 422), with narrow or thread margins except where trimmed on the platemark upper right and fractionally within it for about 1 in. top left, an uninked hairline lower left, an old central vertical fold showing almost entirely on the reverse, a few faint foxmarks. P. 7⁷⁄₁₆ × 9⁵⁄₈ in. (189 × 245 mm.) C-NY $6,600

The Passion (B., Holl. 43-56), engravings, 1521, the set of fourteen in fine, uniform impressions, exceptionally rare thus, with parts of watermarks (three with a Flower, one with a letter [?p], one indistinct) or without watermark, with good margins (7 to 10 mm. all round), six with some weakness on the platemark on one side, a little foxing in the margins of some plates, the collector's mark showing through on the bottom margins, but generally in very fine condition, averaging P. 4⁹⁄₁₆ × 2¹⁵⁄₁₆ in. (116 × 75 mm.) the set. (14) C-NY $7,150

Adoration of the Magi, engraving, 1513, 12 in. × 17¼ in. *Photograph courtesy Kennedy Galleries, Inc., New York*

Claude Lorrain (1600–1682)

Berger et Bergère Conversant, etching, 1651, 7⅝ in. × 10 in. Photograph courtesy Lucien Goldschmidt, Inc., New York

Claude Lorrain was born in France but moved to Rome where he earned a reputation as one of the finest landscape painters of his time. He made a drawing of each of his paintings, as a record and as insurance against forgers. He had a poetic, rather ethereal style focused on the mood of a particular setting rather than its realistic properties. He was able to capture, for example, a shimmering atmosphere created by the play of light on trees or water. The first major impressionist in etching, Lorrain did not have great technical skill, but his best works are considered masterpieces, and their unique, dreamy quality reserves for him an important place in art history.

The Flight into Egypt (Blum 2), etching, 1630–33?, trimmed just within the platemark, a small skinned spot just left of center on the verso and a small tear in the left edge. 106 × 173 mm; 4⅛ × 6⅞ in. S-NY $412

L'Enlèvement d'Europe; La Danse au Bord de l'Eau; and *Le Pont de Bois* (Blum 9, 19 iv/iv, 33 iii/iv), etchings, the state for Blum 9 uncertain as trimmed to the subject, the other two plates trimmed on or just inside the platemark, a few slight stains and minor defects, Blum 19 backed, partly laid. S. 195 × 256 mm and smaller (3) C-L $419

Adriaen van Ostade (1610–1684)

Adriaen van Ostade was born in the village of Ostade in Holland. A painter and etcher, he concentrated on everyday interior and outdoor scenes, with a special interest in the ways of peasant life. Most of his one thousand paintings and fifty etchings are caricature-like depictions of "peasant rudeness," particularly earthy, often drunken outlooks on life. Van Ostade lived in Haarlem for most of his life, and it was there that he entered the Painters Guild in 1634. In 1646 he became commissar of the Guild and in 1662 its president. Skillfully etched images continued to be printed long after his death. There are many impressions of each of many states of his prints, which come up for sale often. Consequently, it is the very early impressions that fetch the highest prices.

Le Violon et Le Petit Veilleur, etching, 6 in. × 5¼ in. *Photograph courtesy Phillips Fine Art Auctioneers, London*

The Anglers (G., Holl. 26), etching, c. 1653, a very good impression of Godefroy's fifth state of seven (Holl.'s fourth of six), as published by Picart, trimmed to the borderline (to the edge of the work at bottom), in good condition except foxed on the verso. 110 × 160 mm (4⅜ × 6⅜ in). S-NY $605

The Organ Grinder (G., Holl. 8), etching, 1647, a very good impression of the rare third state of five, on paper with a phoenix in laurel wreath watermark, trimmed to the border-line, in good condition apart from a slight filled hole at the top of the hat, and slight soiling. 108 × 91 mm (4¼ × 3½ in). S-NY $1,100

The Family (G. 46), etching, 1647, fifth state (of seven), trimmed on the platemark, pinholes in two corners, a little old backing paper on the reverse corners. P. 6¹⁵⁄₁₆ × 6³⁄₁₆ in. (176 × 157 mm). C-NY $418

The Anglers (Bartsch, Hollstein, Godefroy 26v), etching, c. 1653. A good impression on laid paper with narrow margins. With the collector's mark of J.W. Nahl (Lugt 1954) on the verso. In good condition. Plate: 4½ × 6½ in. (113 × 164 mm). P-NY $990

Giovanni Battista Piranesi (1720–1778)

Piranesi was a Venetian-born architect who went to Rome and was acclaimed for creating a vision of that city which endured for centuries. A skilled draftsman, his etchings of ancient and modern Roman architecture are considered the best ever made. They reflect the romantic aspects of the mid-eighteenth century and served as inspiration for the development of the Empire style of interior design which emerged in France. Piranesi's skill and vision far surpassed others of the day, and his work was desired by thousands who wanted to know about Rome but could not travel there. In demand, the etchings continued to be published long after his death. Piranesi also made hundreds of etchings of antiquities, but his architectural prints are the most prized.

Veduta dell'Arco di Tito (Hind 55iii), etching, 1760. A handsome impression, from the first Paris edition. With the normal vertical centerfold; hinged to the mat on the verso. With margins in generally good condition. Plate: 16⅛ × 25⅝ in. (410 × 625 mm). P-NY $300

Veduta dell'Arco di Costantino (Hind 97i), etching, 1771. A fair printing with margins; laid down and light stained. Framed. Plate: 18⅝ × 27⅞ in. (472 × 709 mm). P-NY $70

The Ponte Lucano, with the Tomb of the Plautii, from *Vedute di Roma* (H. 68), etching, 1763, first state (of four), watermark encircled Fleur-de-Lys, with margins on three sides, trimmed on the platemark at left, the central vertical fold unobtrusive, another slight crease, the top left corner torn and repaired, the right margin formerly folded back, framed. P. 18 × 26⅝ in. (458 × 668 mm.) C-NY $528

A Vast Interior, with Trophies at the Foot of a Broad Staircase and Two Large Flags on the Left (H. 8), etching, c. 1745, plate VIII of the *Carceri,* a fine impression of the first state of three, before signature and number, as published by Bouchard, before the Piranesi editions, with large margins (glued in margins between mat and backboard), trace of horizontal center fold, framed. 553 × 405 mm; 21¾ × 16 in. S-NY $6,380

Veduta di Piazza di Spagna, *etching, 1749,*
15½ in. × 21½ in.
Photograph courtesy Kennedy Galleries, Inc., New York

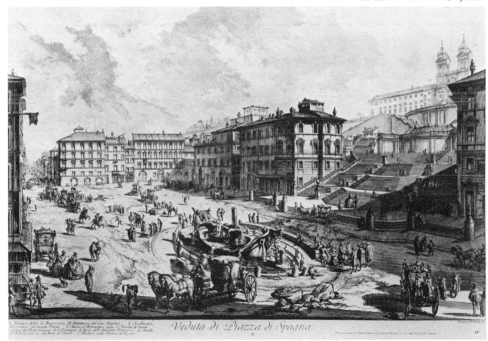

Marcantonio Raimondi (1480–1530)

Marcantonio, who was born in Bologna, established a method of reproductive engraving which was used until photographic techniques were perfected. A facile engraver, he copied the earlier engravings of Dürer and Lucas van Leyden. Dürer sued him for copying his monogram (AD) along with the image, and for selling the prints as Dürer's. The verdict allowed Marcantonio to continue copying the images, but forbade him to use Dürer's monogram. After Marcantonio copied some of Raphael's drawings, to the delight of Raphael, the two men formed a collaborative relationship that lasted for many years. Marcantonio is credited with combining a German linear representation of texture with an Italian feeling for volume, resulting in a fuller, more pictorial image.

Virgin and Child with Tobias and St. Jerome, engraving, late fifteenth–early sixteenth century.
Photograph courtesy Kennedy Galleries, Inc., New York

Parnassus. c. 1508. Engraving. Bartsch 247. Only state. 359 × 470 mm. Taken from one of Raphael's preparatory drawings for the great fresco in the Stanza della Signatura in the Vatican Palace (commissioned by the della Rovere Pope, Julius II), this is nonetheless one of Marcantonio's most beautiful and important prints. Beauty, one of the great Neo-Platonic concepts, is symbolically illustrated in this image of poets and gods assembled on the most sacred of ancient mounts. Apollo sits in the center, playing his lyre in the presence of the nine Muses. Present also are the great poets, both ancient and contemporary. Dante and Virgil stand to either side of the blind Homer, to the left of the central group. Identification of the figures to the right, among whom are Ovid, Boccaccio, and Ariosto, is more difficult, since the finished painting differs in several aspects from Marcantonio's model.

A very fine, deep impression whose even printing enhances the sculptural quality of Marcantonio's style. Some staining on the verso, as well as repaired tears in the upper left and center. Some restoration work in the lower left corner, and an old center fold which does not affect the image. Otherwise in good condition.

Ex coll: Peter Lely (Lugt 2092); G. W. Reid (Lugt 1210). D $4,500

Rembrandt Harmensz. van Rijn (1606–1669)

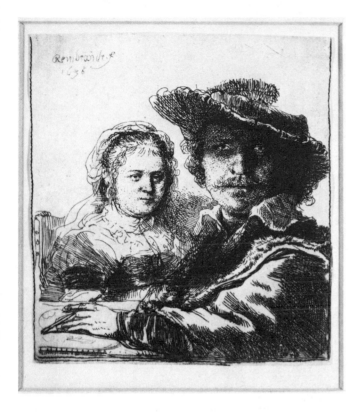

*Self-Portrait with Saskia, etching, 1636, 4⅛ in. × 3¾ in.
Photograph courtesy Lucien Goldschmidt, Inc., New York*

Rembrandt, painter of portraits and biblical subjects, was born in Leyden, the son of a well-to-do miller. He attended university, and then undertook a three-year apprenticeship to a local painter, which gave him his technical background. When he was twenty-five, he moved to Amsterdam where he achieved success as a painter and married the wealthy Saskia van Uylenburgh who brought him position and money. Rembrandt's printmaking spanned nearly his entire career as an artist. He made about three hundred etchings and drypoints between 1626 and 1665. No other Dutch painter of that period produced as large a body of work in printmaking or one so varied in subject, style, and scale. His revisions on the copper plate and his bold use of varied printing surfaces, along with painterly inking in later prints were the greatest influences on the course of nineteenth-century printmaking.

The Woman with the Arrow (Venus and Cupid?) (B., Holl. 202; H. 303; BB. 61-A), etching, drypoint and burin, 1661, second state (of three), a very fine and beautifully wiped impression of this exceptionally rare plate, the right side of the woman's body except for her right knee and the lower part of the leg, the part of the sheet above her thigh and the chemise behind her back all wiped fairly clean, the rest of the plate suffused with tone, watermarked with the WR pendant of a Coat-of-Arms (the Morgan library impression of the second state has the WR and the lower point of the shield), apparently with some thread margin, otherwise trimmed on the platemark, a tiny dot of surplus printer's ink, a tiny spot and a small patch of very pale staining, a tiny paper inclusion, slight staining on the reverse, an ink borderline added to the edges of the sheet, otherwise in excellent condition. P. 8 × 4⅞ in. (204 × 123 mm.)

Apart from the rather wooden and lifeless posthumous portrait of van der Linden (B. 264), which was actually copied from a painting by Abraham van den Tempel, this is Rembrandt's last print, and is probably his most successful and sympathetic printed rendering of the female nude. C-NY $66,000

Self-Portrait with Saskia (B., Holl. 19; H. 144; BB 36-A), etching, 1636, a very good impression of Holl.'s second state of three, with thread margins or trimmed to the platemark, a small loss in the right margin, thin spots in the top corners, faint glue stains in the left corners. 105 × 96 mm; 4⅛ × 3¾ in. S-NY $5,500

Head of a Man in a Fur Cap, Crying Out (B., Holl. 327; H. 37; BB 30-14), etching, c. 1630, third (final) state, a fine impression of this state, before the modern reprinting, with thread margins (trimmed to the platemark at right), in good condition. 36 × 28 mm (1⅜ × 1⅛ in). S-NY $1,650

The Baptism of the Eunuch (Bartsch, Hollstein 98ii, Hind 182ii), etching 1641. A good impression of the second state on laid paper with an illegible fragment of a watermark, with narrow margins. A faint stain in the area of the horseman, otherwise in good condition. Framed. Plate: 7 × 8⅞ in. (178 × 211 mm). P-NY $770

Salvator Rosa (1615–1673)

Salvator Rosa was an archetypal Renaissance man whose accomplishments as painter, poet, musician, and actor came to bear on his etchings. His early works, mostly landscapes and battle scenes, were inspired by his native Naples. He later lived and worked in Rome; first in 1639 when he continued to paint landscapes and battles, and again in 1649 when he chose historical and religious subjects. A reputation for scandalous behavior (he composed and publicly recited a satire on the highly respected Bernini) earned him banishment from Rome for a time and hampered his success as an artist. Rosa began his etching career in the 1650s and completed fifty-six plates. As a result of his diverse interests he left more than fifty unfinished plates as well.

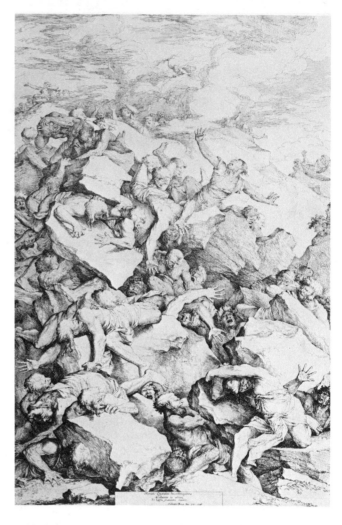

Death of Atilius Regulus (B. 9; Rotili 105; Wallace 110), etching and drypoint, c. 1662, second (final) state, a good eighteenth-century impression, with margins, a printer's crease at bottom, the central vertical fold showing on the reverse only, creases and some soiling in the margins, framed. P. 18⅜ × 28⅞ in. (467 × 734 mm.) C-NY $275

Fall of the Giants, *etching with drypoint, 28¾ in. × 18¾ in. Photograph courtesy Kennedy Galleries, Inc., New York*

Martin Schongauer (1445–1491)

Martin Schongauer was born in Colmar, Germany, the son of a wealthy goldsmith. He was educated at the University of Leipzig but eventually gave up his scholarly pursuits for an artist's life. He lived as a "dandy," and this was evident in the style of his work, which was elegant and refined. Famous in his day, Schongauer was known for his engravings and was reputed to be the greatest engraver of the fifteenth century. His best works deal with religious themes— saints, madonnas, devils, Virgin and Child. All of his 115 recorded engravings have his signed monogram (MS) and are important because they are the most developed prints of the early German school.

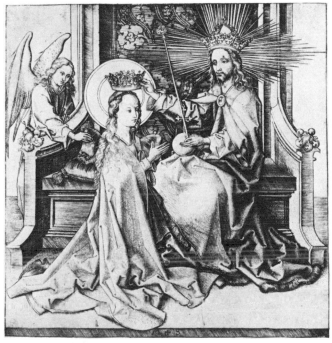

The Coronation of the Virgin, engraving, late fifteenth century, 6³/₈ in. × 6¹/₄ in.
Photograph courtesy Kennedy Galleries, Inc., New York

The Virgin Receiving the Annunciation. Engraving. Bartsch 2; Lehrs 3. Watermark: Blossoming Fleur-de-lis (similar to Briquet 7279). 6¹¹/₁₆ × 4⁵/₈ in. (170 × 118 mm). Ex coll: G. J. Morant (Lugt 1823); Alfred Morrison (Lugt 151). An extraordinary impression, printed with great clarity and warmth on creamy paper. This example retains many of the very fine modeling lines (such as in the Virgin's face, and in the ewer) which are lost in even only slightly later impressions. In fine condition save for some thin spots and three minute stains in the Virgin's robe. With ¹/₈ inch margins. D $75,000

Christ Blessing the Virgin. c. 1480–90. Engraving. Bartsch 71; Lehrs 18; Shestack 102. 160 × 155 mm., with margins. A very good impression, printed clearly and with good contrast. Lehrs knew some forty impressions of this mature subject of Schongauer's *oeuvre,* probably done in the 1480s. This subject is an excellent example of Schongauer's late engraving style in which he achieved a classical monumentality absent from his more anecdotal, youthful works. The print is one of a group of five subjects in square format. Iconographically it forms a pair with *The Coronation of the Virgin* (Lehrs 17) which, however, is somewhat more formally complex with its elaborate throne and detail. Here, Schongauer has sought a hieratic effect, achieved through the overall simplification of the composition and elimination of ornamental detail as well as an absolutely symmetrical arrangement of the figures. The subject arose around the twelfth century and is closely linked with the development of the cult of the Virgin. In the *Coronation* and the *Blessing of the Virgin,* she is seen as the Bride of Christ and the personification of the Church; she thus takes her place alongside Christ as his equal. D $28,000.

Christ Carrying the Cross, the large plate (B. VI.21; Lehrs 9), engraving, c. 1475, a fine, strong impression, trimmed 1 7 mm into the work at left and a few mms at other sides (made-up), a restored loss in the cross to the right of the head of Christ, tears and small repairs mainly in the upper left and upper right parts of the subject, old horizontal and vertical center creases, pale foxing and slight discoloration. Sheet 287 × 432 mm; 11¹/₈ × 17 in. Lehrs indicates about seventy known impressions. S-NY $11,000

Giovanni Battista Tiepolo (1696–1770)

Giovanni Battista Tiepolo, who was born in Venice, became well-known when, in 1720, his early dark manner of painting changed to a lively, uncomplicated decorative style. He was then commissioned to paint frescoes in palaces and churches in Italy, Spain, and Germany. Assisted by his two sons, he worked from small painted models. In 1775 he was elected the first president of the Venetian Academy. His techniques and the style in which he commented on society influenced many artists including Goya. Tiepolo etched about thirty-eight plates, but the two series considered to be his best are entitled *Scherzi* and *Capricci,* the Italian words for jokes and whimseys. His prints, varied, adventurous, and fanciful, show spirit but little depth.

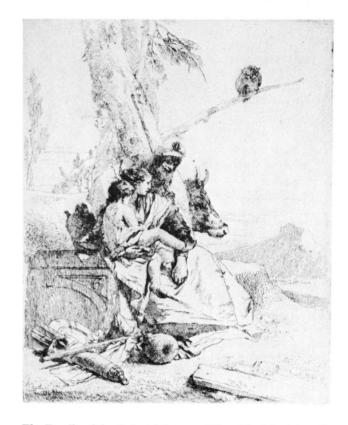

The Family of the Oriental Peasant (Plate 18 of the Scherzi*),
etching, c. 1735, 9 in. × 7 in.
Photograph courtesy Lucien Goldschmidt, Inc., New York*

Nymph with a Small Satyr and Two Goats (Rizzi 33; De Vesme 7), etching, 1740–43, from the *Capricci,* with margins, a few creases and light soiling. 141 × 174 mm; 5½ × 6⅞ in. S-NY $770

The Astrologer and the Young Man (De V. 11; Rizzi 37), from *Vari Capricci,* etching, a good impression, trimmed just within the platemark, a stain on stone wall at left, other very light stains. 132 mm × 169 mm. S-L $245

The Modern Artists

John Taylor Arms (1887–1953)

John Taylor Arms was born in Washington and studied architecture at the Massachusetts Institute of Technology. He started etching professionally in 1919. His early prints, that depicted Gothic cathedrals of Europe, earned him an enthusiastic following in European cities that continues today. His disciplined technique became increasingly exacting as he reported accurately the most minute patterns in the architectural lacework of those cathedrals. A later series, *Gargoyles,* added bizarre elements to those studies, which were devoid of sentiment because Arms was concerned more with precision than character. Arms was very popular, especially in the 1930s and 1940s, and generated the same kind of respect Joseph Pennell did among serious students of printmaking. He made 448 prints during his career.

Aspiration (Church of the Madeleine, Verneuil-sur-Avre) (A. 334), etching, 1939, signed in pencil, dated and inscribed "V," from the edition of 152 impressions; with *Louviers Lace;* and *Chartres the Magnificent* (A. 307 and 422), etchings, 1936 and 1948, each signed and dated in pencil, from the respective editions of 100 and 150, all with margins, framed. S-NY $1,210

Arch of the Conca, Perugia (Arms-NYPL 177), etching from the Italian Series, 1926. Signed and inscribed in pencil "Trial Proof XI." From an edition of 104, in good condition, on Japan, with wide margins. Plate: 10¼ × 14⅝ in. (260 × 374 mm). P-NY $632

Gerona (Arms-NYPL 166), etching, 1925, in brownish-black ink, from the edition of 148. Signed and dated in pencil, a clean impression with wide margins, framed. Plate: 12¼ × 7¾ in. (312 × 196 mm). P-NY $247

Watching the People Below, Amiens Cathedral (Arms-NYPL 103), etching, 1921, from an edition of 75. Signed in pencil in the lower margin. A beautiful impression on laid paper with wide margins. In excellent condition; hinged to mat. Framed. Plate: 4¾ × 8 in. (120 × 124 mm). P-NY $495

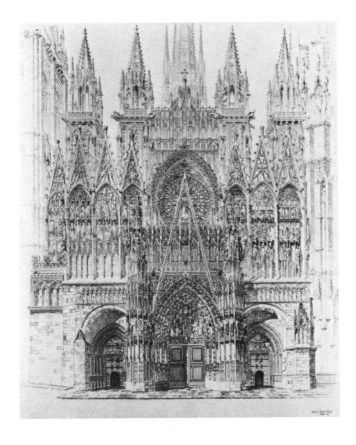

Lace in Stone, etching, 1927, edition of 100, 14¹/₁₆ in. × 11¼ in. Photograph courtesy Kennedy Galleries, Inc., New York

John James Audubon (1785–1857)

Audubon was born in Haiti and spent his childhood in France. He came to the United States in 1803 and eventually settled in Louisiana. He was an ornithologist with a talent for painting, and his life's work was the artistic recreation of the known birds in North America. He traveled extensively throughout the United States and Canada to research his project and to sell subscriptions to the engraved prints that would be made from his paintings. These hand-colored aquatint engravings were published over a period of eleven years by the firm of Robert Havell in London. Havell's son finished the printing after his father died in 1832. About two hundred bound sets of *The Birds of America* went on sale in the 1830s for $1,000 dollars each. There were 435 plates in each set.

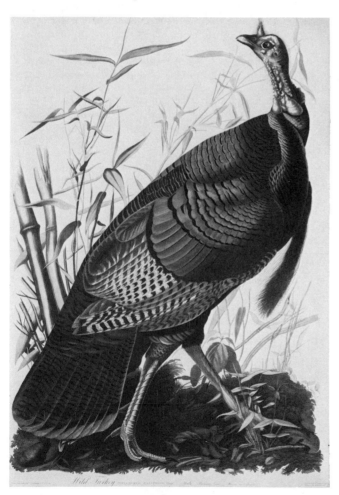

The prices below were realized at a spectacular sale held by Christie's in 1982 in Houston, Texas.

Wild Turkey . . . Male (Plate I). *Meleagris gallopavo.* Sheet 38¼ × 25½ in. (970 × 647 mm.) Very good. $35,200

Wild Turkey . . . Female and Young (Plate VI). *Meleagris gallopavo* Sheet 26½ × 39⁵⁄₁₆ in. (673 × 999 mm.) Very good. $15,400

Baltimore Oriole (Plate XII). Northern Oriole, *Icterus galbula.* 26 × 20⅝ in. (661 × 524 mm.) Superb. $8,250

Carolina Turtle Dove (Plate XVII). Mourning Dove, *Zenaida macroura.* 26¹³⁄₁₆ × 20⁹⁄₁₆ in. (682 × 523 mm.) Very good. $6,050

Carolina Parrot (Plate XXVI). Carolina Parakeet, *Conuropsis carolinensis.* 33¼ × 23⅞ in. (846 × 607 mm.) Very good. $12,100

White-Crowned Pigeon (Plate CLXXVII). *Columba leucocephala.* 25¼ × 20⅝ in. (642 × 523 mm.) Fine. $5,500

Great Blue Heron (Plate CCXI). *Ardea herodias.* 38½ × 25¾ in. (978 × 654 mm.) Fine. $28,600

Wood Ibis (Plate CCXVI). Wood Stork, *Mycteria americana.* 38⅜ × 25⅞ in. (975 × 657 mm.) Fine. $12,100

Great White Heron . . . View Key-West (Plate CCLXXXI). Great Blue Heron, *Ardea herodias.* Sheet 26⅛ × 39⅛ in. (663 × 993 mm.) Fine. $18,700

Trumpeter Swan (Plate CCCCVI). *Olor buccinator.* 25½ × 38⅝ in. (648 × 981 mm.) Very good. $33,000

Rough-Legged Falcon (Plate CCCCXXII). Rough-legged Hawk, *Buteo lagopus.* 28⅜ × 25¼ in. (720 × 641 mm.) Very good. $2,420

Wild Turkey . . . Male (Plate I), 38¼ in. × 25½ in. Photograph courtesy Christie, Manson & Woods International, Inc., New York

Milton Avery (1893–1965)

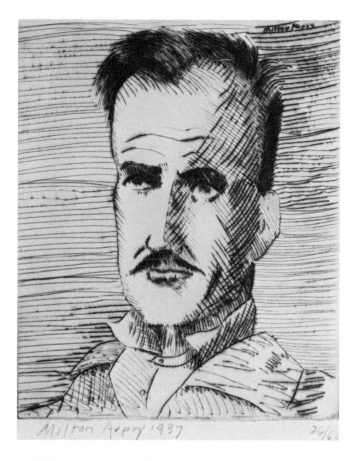

Self-Portrait, drypoint, 1937, edition of 60,
7¹⁵/₁₆ in. × 6½ in.
Photograph courtesy Christie, Manson &
Woods, International, Inc., New York

Milton Avery was born in New York State. He studied at the Connecticut League of Artists and held his first exhibit, a watercolor show, in Chicago in 1928. His work has been described as figurative but open to new forms of plastic language. The human figure and landscapes and seascapes are the most prominent themes in Avery's graphic work. The simplicity of his lines speaks volumes about his own poetic vision. Avery made his first prints, drypoints, in the late 1930s, but they were not published until ten years later at Stanley William Hayter's Atelier 17 in New York. In successive years he made several woodcuts but found the idea and technique of monotype best suited to his style and printed more than two hundred during the 1950s and 1960s. Major retrospectives of his work have been held in Baltimore and in New York at the Whitney Museum of American Art.

Flight (L. 51), woodcut, 1953, printed in brown and black on Japan, a heavily inked impression, signed in pencil and inscribed "1955," from the edition of 100 in these colors published by the Collectors of American Art (there were a further 20 in black and 25 in blue and black published prior to this edition), with margins (slightly uneven at top), some printer's ink and old glue stains in the top margin, two pieces of yellowed cellophane tape in the top margin. L. 7⅛ × 9⅛ in. (182 × 232 mm.) C-NY $330

Self-Portrait (Lunn 13), drypoint, 1937, printed in brownish black on sturdy wove paper, a good impression with burr, signed and dated in pencil, numbered 26/60, with margins, unobtrusive surface rubbing just outside the platemark at bottom, light staining, framed. P. 7¹⁵/₁₆ in. × 6½ in. (201 × 165 mm.) C-NY $935

Hooded Owl (L. 39), linocut, 1953, on thin soft wove paper, signed and dated in pencil, inscribed "artist's proof" (the edition was 20), with (slightly uneven) margins, an unobtrusive printing defect at center, some rubbing around the inscription at bottom, two pinholes, printer's ink and surface soiling in the margins, light staining. L. 9 × 7 in. (229 × 178 mm.) C-NY $440

Beach Birds (L. 55), woodcut, 1954, printed in black on soft wove paper, signed and dated 1953 in pencil, numbered 17/25 (there were a further 25 in blue), with (irregular) margins, slight creasing at the top margin corners, faint light staining. L. 7⅝ × 12⅛ in. (193 × 357 mm.) C-NY $352

Peggy Bacon (1895–)

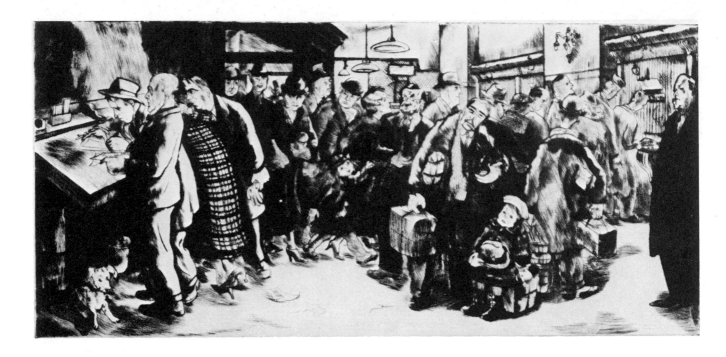

Post-Haste, *drypoint, 1936, 5½ in. × 11⅞ in. Photograph courtesy Christie, Manson & Woods International, Inc., New York*

Peggy Bacon was born in Connecticut to artist parents. From 1915 to 1920 she studied at the Art Students League in New York under John Sloan and Kenneth Hayes Miller. In 1917 she began experimenting with drypoint, the medium which best translated her ideas and for which she became well-known. Most of her subjects were created out of her amusing observations of life and were keen perceptions tempered with gentle wit. Bacon was popular with American collectors in the 1920s and 1930s. She made about two hundred prints, but was also active, and recognized, as a book illustrator, often illustrating children's books she wrote herself.

The Rival Ragman, drypoint. Signed and titled in pencil. A rich impression on Rives with full margins. In excellent condition. Plate: 5⅞ × 8⅞ in. (150 × 225 mm). P-NY $440

Peanuts. Lithograph. 1930. (Flint 94) Edition: 50. Printed in 1976. 10¼ × 13⅛. Signed in pencil. An excellent impression on heavy wove paper. D $475

Max Beckmann (1884–1950)

Max Beckmann was one of Germany's leading expressionist painters before World War II. He exhibited, with Otto Dix and George Grosz, paintings that depicted the seamy side of life in Germany in the 1930s. Beckmann taught art in Frankfurt and was considered a major influence until Hitler came to power. It was part of Hitler's strategy to unify the country by denouncing all minorities, and especially those involved in pursuits which were potentially harmful to his credo. This included writers, artists, and other intellectuals. In 1937 Beckmann was labeled degenerate, and he left his homeland for Holland, where he lived for ten years until he emigrated to the United States. Beckmann's prints, like his paintings, continued to be social commentaries throughout his career. His style changed in later years to simpler composition, but still retained the sharp, angular shapes he used to denote his subjects.

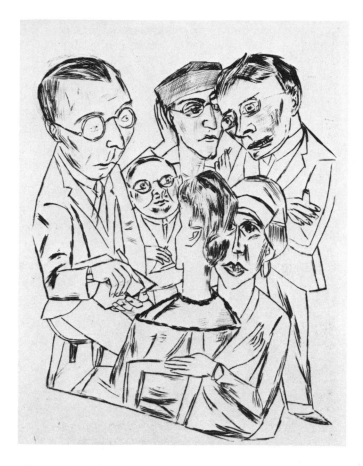

Der Zeichner in Gesellschaft (Rudolf Grosmann), etching, 1922, 12⅞ in. × 9⅜ in.
Photograph courtesy Kennedy Galleries, Inc., New York

Der Neger, plate 6 for *Jahrmarkt: 10 Original-Radierungen von Max Beckmann,* Verlag der Marées-Gesellschaft, R. Piper & Co., München, MDCCCCXXII (Gallwitz 168), drypoint, 1921, on thick yellowish wove paper, first state (of three), signed, titled and dated in pencil, inscribed "Handprobedruck 1. Zustand," with margins, some rubbing, soiling and old creases in the margins. P. 11⅝ × 10¼ in. (296 × 261 mm). C-NY $990

Schlangendame, plate 10 from *Jahrmarkt: 10 Original-Radierungen von Max Beckmann,* Verlag der Marées Gesellschaft, R. Piper & Co., München, MDCCCCXXII (Gall. 172), drypoint, 1921, on wove paper, fourth (final) state, signed in pencil, from the edition of 125 (plus 75 on Japan), with the blindstamp of the Marées-Gesellschaft, with margins, somewhat light-stained. P. 11⅜ × 10¼ in. (289 × 266 mm). C-NY $572

Selbstbildnis (G. 195; G. 200), woodcut, 1922, signed in pencil, on laid paper, with full margins, in good condition aside from faint mat stain, framed. 223 × 154 mm; 8¾ × 6 in. S-NY $2,310

The Dancers, drypoint, on wove, signed in pencil, numbered 41/50, with wide margins, a faint overall light stain, some overall foxing mainly in the margins, framed. S-L $1,944

George Bellows (1882–1925)

George Bellows moved to New York in 1904 from his birthplace, Columbus, Ohio. He studied under Robert Henri who introduced him to the earthy, gritty world of the so-called Ashcan School. Bellows empathized with the subject matter of that school and soon became one of the most dramatic chroniclers of those times. He enjoyed tremendous success as a painter before he made his first lithograph in 1916. *A Stag at Sharkey's,* printed in 1917, after a painting, earned Bellows wide public recognition. It is one of the most famous American prints of the century. He published all his own prints (more than 190) in his home studio with the help of expert printmakers. Many prints relate to similar, earlier paintings, but show more strength because of his confident technique in lithography.

A Stag at Sharkey's (M. 46; B. 71), lithograph, 1917, a fine impression, signed in pencil, titled and numbered 63, from the edition of 98, on laid Japan paper, with large margins, in good condition except for a small loss from the tip of the upper left margin corner, faint light stain, discolored on the edges of the margins, framed. 18⅝ × 23⅞ in. (474 × 608 mm). S-NY $27,500

River-front (M. 168; B. 24), lithograph, 1923–24, on Basingwerk Parchment, a fine impression, signed and titled in pencil, from the edition of 51, inscribed by the printer "Bolton Brown, imp," with margins, several repaired tears, some rubbing and discoloration at the top margin edge, framed. 14⅞ × 21 in. (378 × 534 mm). C-NY $3,190

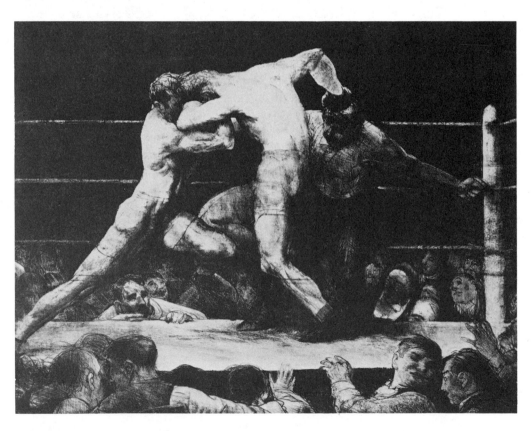

A Stag at Sharkey's, lithograph, 1917, 18¾ in. × 23⅞ in. Photograph courtesy Sotheby Parke Bernet, Inc., New York, copyright by Sotheby Parke Bernet, Inc., 1981

Thomas Hart Benton (1889–1975)

Thomas Hart Benton was born in Neosho, Missouri, into a prominent family. In 1908 he went to Paris where he studied art. When he returned to the United States four years later he disavowed his early avant-garde leanings and concentrated on realistic, regional studies, which were a kind of folk art. He traveled extensively through rural America during the Depression and this was partly responsible for the depth of character evident in his subjects. He empathized with them, but was able to unveil their foibles in his work. A stint in the U.S. Navy (1918–19) as a draftsman equipped Benton with the technical knowledge that later led to his recognition as a highly skilled print-maker. He used this expertise in the creation of eighty lithographs, most of which depict the American heartland.

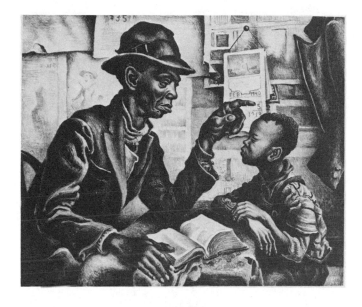

Instruction, lithograph, 1940, edition of 250, 10¾ in. × 12¼ in.
Photograph courtesy Phillips Fine Art Auctioneers, New York/Associated American Artists, New York/ V.A.G.A., New York

Jesse James (Fath 13), lithograph, 1936, second (published) state, signed in pencil, from the edition of 250, circulated by Associated American Artists, with margins, in good condition apart from remains of cloth tape in the upper corners, recto, framed. 16¼ × 21⅞ in. (413 × 557 mm). S-NY $4,180

The Music Lesson (F. 60), lithograph, 1943, signed in pencil, from the edition of 250, distributed by Associated American Artists, with full margins and in good condition (in original mat, as issued). 10⅛ × 12¾ in. (257 × 325 mm). S-NY $1,595

Instruction (Fath 41), lithograph, 1940, from the edition of 250 as published by Associated American Artists. Signed in pencil. A rich printing on white wove with full margins. In excellent condition. 10⅜ × 12¼ in. (264 × 310 mm). P-NY $1,650

Frankie and Johnnie (F. 11), lithograph, 1936, on Rives, signed in pencil, from the edition of 100, with margins, a few faint foxmarks bottom right showing through from the reverse, some glue staining in the top margin. 16⅜ × 22⅛ in. (416 × 561 mm). C-NY $4,620

Muirhead Bone (1876–1953)

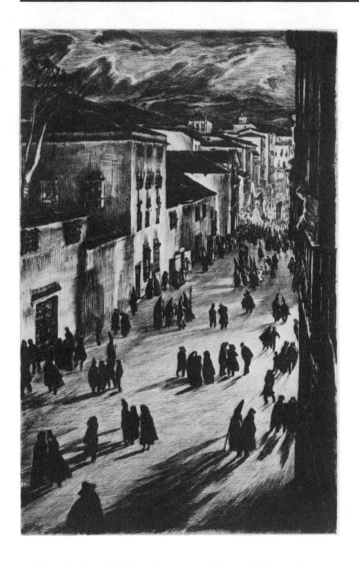

A Spanish Good Friday, drypoint, edition of 160,
12¾ in. × 8¹/₁₆ in.
*Photograph courtesy Madeleine Fortunoff Fine Prints,
Long Island, New York*

Bone was born in Scotland and studied at the Glasgow
School of Art. He was particularly interested in fol-
lowing the etching careers of Meryon and Whistler
and etched in their styles until his own very definite
technique emerged. In 1901 he moved to London
where he studied at the Royal Academy as well as
other art schools. A member of the International
Society of Painters and Gravers, Bone was a major
contributor to the Franco-British Exhibition in 1908.
He was known as a consummate technician, especially
with the drypoint process, and was highly acclaimed
for his complex renderings of a variety of subjects.
The Tate Gallery in London houses most of Bone's
work, which recently has been receiving renewed in-
terest in auctions of prints of the modern period.

Demolition of St. James Hall, Exterior. Drypoint. 1907.
(Campbell Dodgson 207). Edition: 64; iv/IV. 11⅝ ×
10¹⁵/₁₆ in. Signed in pencil. A fine impression printed on
beautiful thin laid paper. D $600

A Windy Night, Stockholm. Drypoint. c. 1936. (Campbell
Dodgson 457). Edition: 93. 11⅞ × 7¾ in. Signed in pencil.
A very rich impression. D $600

A Spanish Good Friday. Drypoint. (Campbell Dodgson
412). Edition: 160; 83 in this state (xxix/XXIX). 12¾ ×
8¹/₁₆ in. Signed in pencil. Slight time staining in the margins,
not affecting the image. A brilliant impression printed with
tone on laid paper, with fleur-de-lis watermark and collec-
tion stamp of *City Art Museum,* St. Louis, on the verso.
D $2,900

Manhattan Excavation. Drypoint. 1923–28. (Campbell
Dodgson 390). 12¼ × 10 in. Signed in pencil. Excellent im-
pression. Fine condition aside from slight light stain.
D $1,200

Pierre Bonnard (1867–1947)

Pierre Bonnard was born in Paris. He attended the École des Beaux-Arts and the Académie Julian, where he met Vuillard. Bonnard was an early advocate of lithography. His experimentation with color in that medium helped him to express varying moods in his paintings. His first lithograph was a poster, published in 1891, commissioned by a wine merchant. It is said that this poster brought the artist, and the medium, to the attention of Toulouse-Lautrec. Bonnard's first one-man show in 1896 included lithographs. He also won recognition as a book illustrator, and eventually preferred to continue to illustrate books rather than to create individual color lithographs.

Rue Le Soir sous la Pluie, from *Quelques aspects de la vie de Paris* (R.-M. 66; J. 10.10), lithograph in colors, 1895–99, on fine wove paper, the colors fresh, signed in pencil, inscribed "No. 56," from the edition of 100, with margins, very slight soft rippling, a little mat stained, a small loss and crease at the extreme margin edges, framed. L. 10⅛ × 13⅞ in. (256 × 353 mm). C-NY $4,950

Le Bain (R.-M. 79), lithograph, 1925, probably an intermediary state between Roger-Marx's first and second, with the shadow at right cut back, and with the lithographic initials of the artist removed, but with scraped highlights in the hair of the woman and in the background, signed in pencil, on wove paper, with large margins, in good condition aside from a printer's crease in the right margin, running 55 mm into the image, very faint light and mat stain, a thin spot in the lower left margin, and a small crease in the lower margin, framed. 290 × 205 mm; 11⅜ × 8 in. S-NY $1,760

Femme Debout Dans Sa Baignoire (Roger-Marx 81iv), lithograph, c. 1925. Signed in pencil and numbered 18/25, as published by Galerie des Peintres-Gravures, with blind-stamp (Lugt 1057b). A good printing on cream wove with full margins. In good condition aside from scattered spots of foxing recto and verso. Image: 11⅝ × 7⅜ in. (295 × 190 mm). P-NY $715

Rue Le Soir sous la Pluie, *lithograph, 1895–99, edition of 100, 10⅛ in. × 13⅞ in. Photograph courtesy Christie, Manson & Woods International, Inc., New York*

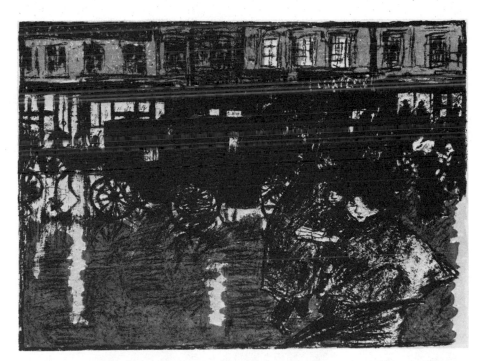

Georges Braque (1882–1963)

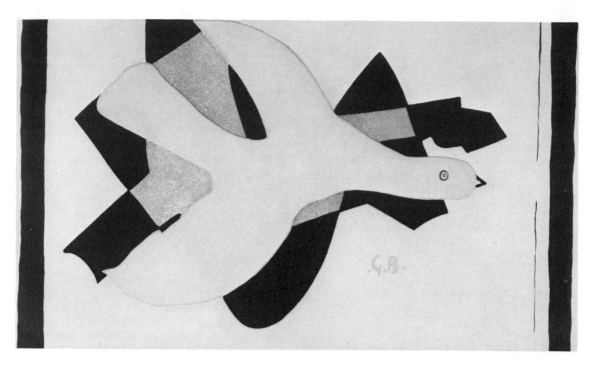

L'Oiseau et Son Ombre, lithograph printed in colors, 1959,
20 in. × 33½ in. ·
*Photograph courtesy Sotheby Parke Bernet, Inc., New York,
copyright by Sotheby Parke Bernet, Inc., 1983*

French painter Georges Braque studied art in Paris at
the École Nationale des Beaux-Arts and then at the
Académie Humbert. With Pablo Picasso, he devel-
oped the cubist art movement in the early years of the
twentieth century. After 1907 he and Picasso worked
together, continually experimenting with this new art
form. Their brilliant collaboration was brought to an
end with the onslaught of war in 1914. Braque went to
fight and did not resume painting until 1917. He con-
tinued to grow as an artist (best known for his still-life
studies), gaining the stature of a major figure in twen-
tieth-century art. In addition to his paintings, Braque
made woodcuts, etchings, and lithographs; the etch-
ings and woodcuts were earlier works, the lithographs
were published in Paris after World War II.

Feuilles Couleur Lumière (W. 24; M. 29), lithograph printed
in colors, 1954, signed in light brown ink and numbered
48/75, the full sheet, printed to the edges, in good condition
(a slight scuff in the right sheet edge, slight mat stain, soil-
ing, foxing and slight skinned spots on the verso), framed.
Sheet 974 × 604 mm; 38¼ × 23¾ in. S-NY $8,250

Thalassa I (H. 86), etching printed in colors, 1959, signed in
pencil and numbered 9/60, published by Maeght, printed by
Crommelynck and Dutrou, on cream-toned wove paper,
with full margins, in generally good condition aside from a
small thin spot, light stain, and soft creases in the margins,
framed. 106 × 264 mm; 4⅛ × 10⅜ in. S-NY $1,540

Le Tir à l'Arc: Taureaux ailés (Wünsche 90), lithograph
printed in colors, signed in pencil and numbered 26/70
(aside from the edition of 165 on Auvergne), on Chine ap-
pliqué, published by Louis Broder, Paris, 1960, with full
margins, in good condition aside from very faint mat stain in
the margins, framed. 180 × 135 mm (7 × 5¼ in).
S-NY $385

L'Ordre des Oiseaux, Paris, 1962, number 70 of the edition
of 100, signed by Braque and the author of the text, St. John
Perse. Containing 12 color aquatints and lithographs by
Braque. The complete portfolio with original slipcase. The
case slightly worn and stained, the volume in good con-
dition. P-NY $2,200

Gerald Leslie Brockhurst (1890–1978)

Gerald Leslie Brockhurst was born in Birmingham, England. He did not do well scholastically so his headmaster suggested he matriculate at the Birmingham School of Art. He blossomed during his five years there, and his work matured to the extent that he won the King's Prize, the Messenger Prize, and a scholarship to continue his studies. In 1907 he joined the Royal Academy School in London and won their Gold Medal four years later. He then traveled to Paris and Milan, married, and settled in Chelsea in London. In 1921 Brockhurst was elected Fellow of the Royal Society of Painter-Etchers and Engravers and in 1923 became Fellow of the Royal Society of Portrait Painters. The Duchess of Windsor and Marlene Dietrich were two of his most famous subjects. He met Kathleen Dorette Woodward in 1927. He divorced his wife to marry her and the two moved to New Jersey in 1939. She was the major subject for his etched portraits.

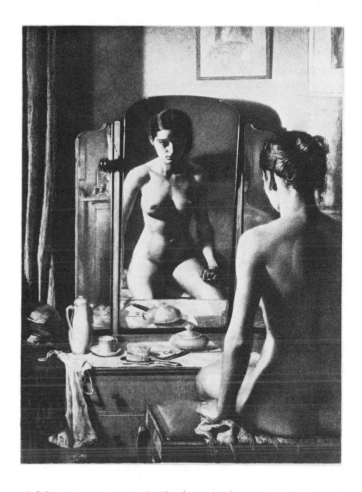

Adolescence, etching, 5th (final state) edition of 91, 1932, 14¾ in. × 10½ in.
Photograph courtesy Phillips Fine Art Auctioneers, London

Adolescence (Wright 85), etching, 1932, fifth (final) state, signed in pencil, from the edition of 91, with margins, in good condition apart from two small tape stains in the side and lower margins. 370 × 264 mm; 14½ × 10⅜ in.
S-NY $5,060

Viba (Wright 63), etching, 1929. Signed in pencil at lower right. A handsome impression in good condition; taped to mat at upper corners. Framed. Plate: 8⅜ × 6¼ in. (214 × 171 mm). P-NY $165

Jeunesse Dorée. Etching. 1942. Edition: 100. 10⅞ × 8⅞ in. Signed and dated in pencil. A portrait of Brockhurst's wife, Dorette Woodward. The painting of the same title was exhibited at the Royal Academy in 1934. A superb impression on laid watermarked paper. In excellent condition aside from a few tiny fox marks in the margins and on the verso, and remains of old tape at the margin edges. Probably the artist's last etching. D $1,100

Bernard Buffet (1928–)

French painter Bernard Buffet attained recognition as an artist when he was very young. By 1948 he had had his first one-man show and received the Prix de la Critique. In the 1950s he was considered the principal figurative artist in Paris. In this phase he was influenced by the *misérabilisme* movement: his compositions, all grays and dull whites, had a somber mood. Buffet's subjects have tremendous range, especially in later works, and include still lifes, interior scenes, and views of such cities as New York, Paris, and London. He has also worked as an illustrator and in 1954 created a series of drypoints on the theme of the Passion. The lithographs he created resemble his paintings. They were promoted widely and prices rose extraordinarily fast at first, but then leveled off. His work appears in many museums, including the Tate Gallery in London and the Musée d'Art Moderne in Paris.

Paris, la Place des Vosges (Mourlot 34), lithograph printed in colors, 1962, signed in pencil and numbered 16/150, on Rives paper, with full margins, in good condition aside from mat stain in the margins and on the verso, taped to mat along upper edge, verso, framed. 530 × 670 mm; 20⅞ × 26⅜ in. S-NY $715

Toreador, lithograph printed in colors, signed in pencil, numbered 56/150, on Arches, with margins, in generally good condition aside from an indentation in the background of the subject, minor handling creases, slightly skinned along the top edge of the margin, verso. 693 × 485 mm; 27¼ × 19 in. S-LA $578

Tête de Clown, lithograph printed in colors, signed in pencil, numbered 28/125, with wide margins, a faint light and backboard stain, otherwise in good condition, framed. 370 × 290 mm. S-L $310

L'Arc de Triomphe, lithograph printed in colors, signed in pencil, numbered 6/150, with full margins, in good condition apart from old hingeing glue at three places along upper sheet edge verso. 535 × 685 mm. S-L $503

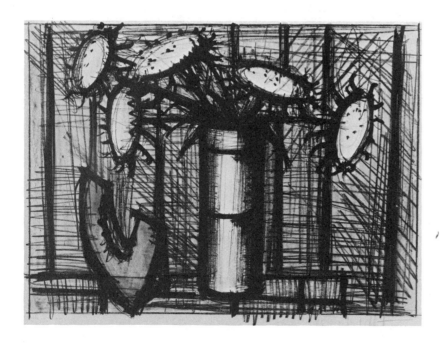

Sunflowers and Melons, *lithograph, 1955, 18⁵/₁₆ in. × 24⁷/₁₆ in.*

Félix Buhot (1847–1898)

Félix Buhot was born in Valognes, France. He studied painting for one year at a time with several French painters whose styles he particularly admired. His studies were, however, brought to an abrupt halt by the war of 1870. After his tour of duty, Buhot was offered a job teaching at the esteemed Rollin School. He stayed there for many years and during that time won recognition for his watercolors and etchings. He gradually stopped painting to concentrate on etching because he felt he could achieve stronger expression with his printmaking while still maintaining painterly effects. Buhot is best known for his delicate etchings and book illustrations. Light and shadow figure prominently in these works. Although lines in the prints are usually lightly sketched, they show great strength and purpose. Buhot received numerous awards, and his work was acquired by many prestigious European institutions.

Le Château des Hiboux (Bourcard/Goodfriend 51iv), etching, aquatint, and drypoint. A handsome impression on cream wove with wide margins. With Buhot's stamp (Lugt 978). Slightly light struck, otherwise in very good condition. Plate: 4½ × 7⅛ in. (113 × 180 mm). P-NY $770

Environs de Gravesend (Bourcard/Goodfriend 157), etching, drypoint, and aquatint. Since the plate is inscribed "Cat. No. 157" the present impression would seem to correspond with Bourcard's "intermediate state." With Buhot's stamped monogram (LUGT 977). A handsome impression on rice paper, with wide margins. Glued to the mat at the edges of the sheet. Slight surface dirt, some foxing largely confined to the upper margin, framed. Plate: 10¼ × 13¾ in. (258 × 350 mm). P-NY $633

Convoi Funèbre au Boulevard de Clichy (B., G. 159), etching, drypoint, aquatint, and roulette, 1887, printed in brownish black and soft teal blue on thickish wove paper, a proof of the second state (of three), with false margins in black aquatint on a second sheet, with the artist's large red stamp (L. 977), with margins, some staining and discoloration showing mostly in the margins, small foxmarks visible on the top sheet, traces of old glue along the extreme edge of the top margin of the bottom sheet. P. 13 × 17⅝ in. (330 × 448 mm). C-NY $3,300

La Falaise—Baie de Saint-Malo (B., G. 165), etching, drypoint, aquatint, and roulette, 1889–90, printed in brownish black and black on thickish wove paper, fifth state (of six), with the artist's large red stamp (L. 977), with margins, faintly light stained, traces of discoloration in the margins and on the reverse. The last monumental work by the artist. P. 11¾ × 15¾ in. (299 × 400 mm). C-NY $990

Le Château des Hiboux, etching, aquatint, and drypoint, c. 1890, 4½ in. × 7⅛ in.
Photograph courtesy Phillips Fine Art Auctioneers, New York

Alexander Calder (1898–1977)

Calder began his working career as an engineer, but went on to become a sculptor, painter, illustrator, and printmaker. Born in Philadelphia, Calder moved to New York in the early 1920s and studied painting at the Art Students League. In 1926 he went to Paris where he began creating his small circus figures and animals, first from metal and wood, then in wire sculptures. Calder exhibited at the Salon des Humoristes in 1927 and had his first one-man show in New York the following year. His playful, curvaceous, and seemingly weightless sculptures—Calder called them "mobiles"—draw motion from the movement of air. These plastic forms in motion contrast with his "stabiles," static abstract sculptures. This exuberance was beautifully translated to print. After enjoying the atmosphere of creative freedom at Atelier 17, Calder went on to produce many large-scale lithographs and screen prints which reflect his energetic imagination and his unusually heightened sense of color.

Alphabet et Serpent, lithograph printed in colors, 1966, signed in pencil and numbered 60/90, with full margins and in good condition, framed. c. 500 × 700 mm (19⅝ × 27½ in). S-NY $495

Spiral, color lithograph. Signed and numbered in pencil 34/125. A good printing of the full sheet, in good condition. Framed. Sheet: 25½ × 19½ in. (648 × 495 mm). P-NY $99

Le chevalier, lithograph signed in pencil and numbered 84/90, with full margins, in good condition. 530 × 485 mm; 20⅞ × 19⅛ in. S-LA $275

La grenouille et la scie, lithograph printed in black, orange, and red, 1969, signed in pencil and numbered 37/75, published by Maeght, the full sheet, printed to the edges, in good condition. Sheet: 555 × 750 mm; 21⅞ × 27⅛ in. S-LA $440

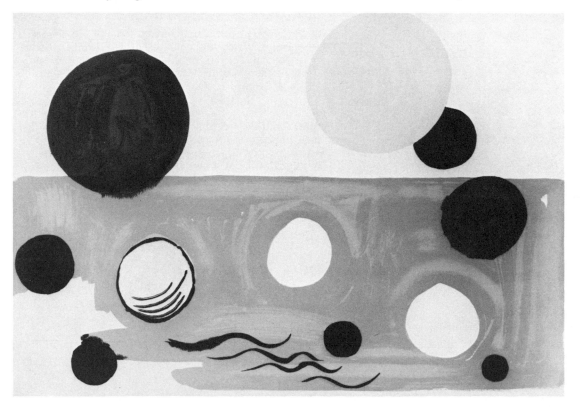

Landscape, *lithograph, 1975, edition of 150, 30 in. × 44 in.*
Photograph courtesy Transworld Art, Inc., New York

Mary Cassatt (1845–1926)

Mary Cassatt was born in Allegheny City, Pennsylvania, into a family whose ancestors had come to America from France in the eighteenth century. Despite her father's disapproval of her desire to become a painter, Cassatt went to Europe to study art and then, in 1874, moved permanently to Paris. Cassatt was intrigued by the impressionists and became involved with the group after meeting Degas, who had seen an exhibition of her work in the Paris Salon in 1872. She exhibited with the impressionists in 1879, 1880, 1881, and 1886, and actively supported the movement. Her prints, mostly drypoints, were made between 1879 and 1911, with one particularly notable color series executed in 1891. Very few of her prints were published during her lifetime. In 1980, Sotheby Parke Bernet, in New York, held a spectacular sale in which new important price levels for prints in excellent condition were established. The print illustrated on this page fetched 72,000 dollars.

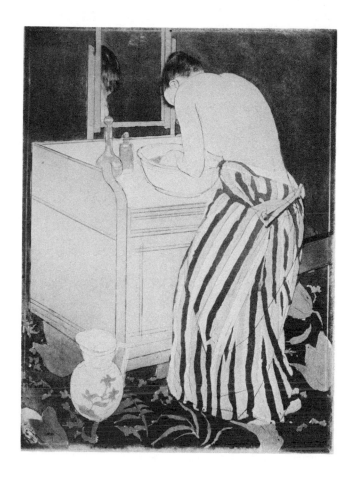

Woman Bathing, or La Toilette, *drypoint and aquatint, 1891, 14³⁄₈ in. × 10¹⁄₂ in.*
Photograph courtesy Sotheby Parke Bernet, Inc., New York, copyright by Sotheby Parke Bernet, Inc., 1980

The Parrot (Breeskin 138), drypoint, 1891, printed in black on van Gelder, first state (of seven), a fine impression, with (wide) margins, slight foxing, a brown stain in the bottom margin (well away from the subject), slight light and time staining, framed. P. 6³⁄₈ × 4¹¹⁄₁₆ in. (162 × 119 mm). C-NY $1,100

Margot Resting Arms on Back of Armchair (B. 189), drypoint, c. 1903, on antique laid paper, watermark Unicorn, first state (of two), a fine impression with burr, signed in pencil, with margins, two tiny brownish paper imperfections at bottom, barely perceptible light staining, framed. P. 8⁷⁄₈ × 5⁷⁄₈ in. (225 × 150 mm). C-NY $6,050

En Déshabillé (Italian Girl) (D. 95), drypoint, c. 1889, a fine impression, printed with delicate plate tone in the lower part of the image, signed in pencil and inscribed "No. 3," one of only a small number of impressions, on fine Van Gelder laid paper, with margins, in good condition apart from slight discoloration and handling creases, framed. 182 × 140 mm; 7¹⁄₈ × 5¹⁄₂ in. S-NY $3,300

Woman Seated in a Loge (Au Théâtre) (Breeskin 23), lithograph, c. 1880, a very fine luminous impression, one of only five impressions, on Chine appliqué, with large margins, in good condition (a few pale fox marks, faint mat stain), framed. 282 × 219 mm; 11¹⁄₈ × 8⁵⁄₈ in. This is the only known privately owned impression. (Other impressions are in the Avery Collection of the New York Public Library and the Museum of Fine Arts, Boston. S-NY $26,400

Marc Chagall (1887–)

Chagall was born in Vitebsk, Russia. He apprenticed under the portrait painter Pen before traveling to St. Petersburg in 1907 to study first at the Imperial School of Fine Arts and then with theatrical designer Léon Bakst. From 1910 until 1914 Chagall worked in Paris, combining a respect for cubism with his travels into the realms of fantasy and memory. His subjects floated on the canvas, unbound by the laws of gravity. Chagall became Commissar of Fine Arts in Vitebsk in 1917 and founded an academy. He later resigned and became involved in theatrical art in Moscow (including creating murals for the Yiddish theater). Returning to Paris in the 1920s, he made almost two hundred etchings as illustrations for two books. These were not published until 1949 and 1952. At the invitation of the Museum of Modern Art in New York, Chagall came to America in 1941. Up to that time his work contained many images of village life in Russia, but it began to reflect the suffering of his people during World War II. In the ensuing years he continued to paint religious subjects. Chagall returned to France in 1948.

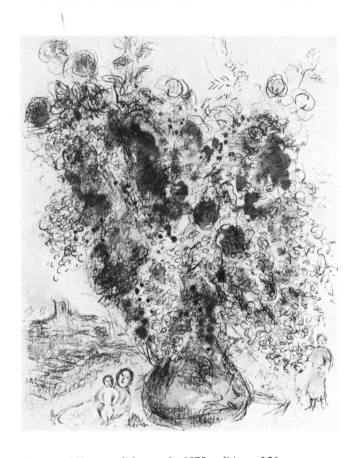

Roses et Mimosas, lithograph, 1975, edition of 50, 32½ in. × 25¾ in.
Photograph courtesy Transworld Art, Inc., New York

Story of the Exodus (M. 444-467), the complete portfolio of 24 lithographs printed in colors, with text, published by Léon Amiel, 1966, in a total edition of 285, this copy numbered 62, signed on the justification page, in original wrappers and linen box, in good condition. (24) Each sheet 505 × 370 mm; 19⅞ × 14½ in. S-NY $12,100

The Poet (M. 442), lithograph printed in colors, 1966, signed in pencil and numbered 34/50, with full margins at sides, top and bottom margins slightly trimmed, several skinned areas in the margins, two small surface cuts in the upper left margin corner, colors a little faded. 458 × 357 mm (18 × 14⅛ in). S-NY $2,750

Der Spaziergang. 1, supplementary plate to *Mein Leben* (K. 26 IIa), etching and drypoint, 1922, on laid paper, the trial proof of the second (final) state, signed in pencil, inscribed by the printer "Π/2" and "Probedruck 2. Zustand," with margins, a little old light staining, a few faint foxmarks. P. 9¾ × 7⁷⁄₁₆ in. (248 × 188 mm). There are five impressions of the first state, one in the Art Institute of Chicago and four in the St.-Paul-de-Vence archive. The published edition was 110, of which 26 were on Japan. C-NY $4,180

Then He Spent the Night with Her Embracing and Clipping . . ., plate 3 from *Four Tales From the Arabian Nights* (M. 38), lithograph in colors, 1948 on laid paper, signed in pencil, inscribed "Pl. 3" and numbered 22/90 (the total edition was 111), with margins, masking tape along the reverse edge of the top margin, light and mat staining, framed. L. 14½ × 11⅛ in. (368 × 282 mm). C-NY $8,250

Edgar Chahine (1874–1947)

Edgar Chahine was born in Vienna. He studied first in Venice and then at the Académie Julian in Paris. He entered his first painting in the 1899 Salon des Artistes, but it was put in the print section by mistake and was very popular under that heading. This error inspired Chahine to make prints. He was prolific and created more than six hundred etchings and aquatints, many of which were printed in color. People bought his works because they were pleasant to look at. Street scenes, festivals, and familiar seascapes were his favorite subjects. Chahine illustrated many books and eventually published his own album of etchings, consisting of his impressions of Italy.

La Promenade, etching, drypoint, and aquatint, 1902, 14¼ in. × 22 in.
Photograph courtesy Christie, Manson & Woods International, Inc., New York

Un Couple de Soupeuses (Tabanelli 68), drypoint and aquatint in colors, 1901, on Arches, fifth (final) state, signed in pencil, from the edition of 60 in colors (of which 25 were on Japan) though this impression not numbered with margins, slight rubbing and soiling in the margins, printer's creases in the margins. P. 15¼ × 7¹¹⁄₁₆ in. (388 × 195 mm). C-NY $605

La Promenade (T. 92), etching, drypoint, and aquatint, 1902, on Japan, a fine impression, signed in pencil, numbered 27/50 (there were a further 50 impressions in colors), with the blindstamp of the publisher Sagot (L. 2254), with margins, faintly mat stained, framed. P. 14¼ × 22 in. (362 × 560 mm). C-NY $2,640

Ada (Tabanelli 65ii), drypoint, 1902, from the edition of 50. Signed in pencil. A very handsome impression with rich burr and plate tone. On laid paper with margins; in very good condition. Framed. 7¼ × 13⅜ in. (184 × 340 mm). P-NY $550

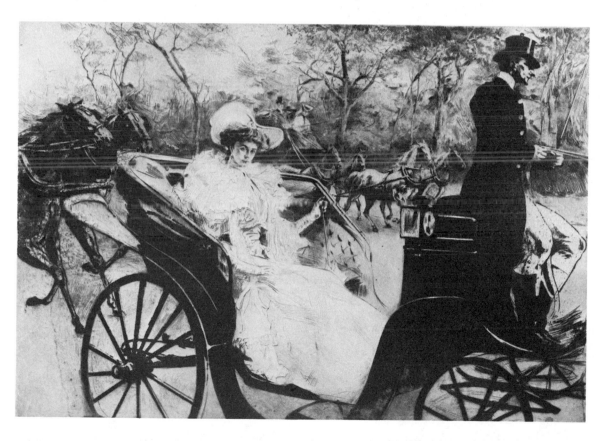

Nathaniel Currier (1813–1888)
James Merritt Ives (1824–1895)

Currier and Ives were American lithographers who formed the company Currier & Ives and printed thousands of lithographs of American life that sold all over the world. Currier studied under William and John Pendleton in Boston and M.E.D. Brown in Philadelphia, before opening his own lithography establishment with Adam Stodart in New York. The pair separated in 1835 and Currier started his own printing firm. James Ives joined him in 1852, and they became partners in 1857. Over the next half century the firm of Currier & Ives published approximately seven thousand prints. These lithographs were hand-colored, using a mass-production approach of one worker handling one color. The subjects covered a wide range of American scenes, including the Wild West and the American Indian, battle scenes, disasters, sporting events, and portraits. Currier and Ives both retired in the 1880s and their sons continued their business.

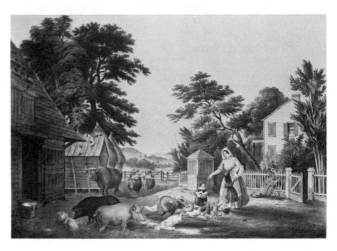

American Farm Scenes No. 2 (Summer): Woman Feeding Chickens, Turkeys, Etc., lithograph, 1853, 17 in. × 24 in. Photograph courtesy Christie, Manson & Woods International, Inc., New York

American Homestead: Autumn; Spring; Summer; and Winter (Conningham 168, 170-172; Peters 2313-6), lithographs, extensively hand colored, 1868–69, on wove paper, with margins, a few repaired nicks and short tears at the sheet edges (well outside the subject), remains of old stains. Each L. 8¾ × 8⅝ in. (223 × 329 mm.) The set (4) C-NY $990

Winter in the Country. A Cold Morning, after G. H. Durrie (C. 6736; P. 2545), lithograph, extensively hand colored and with touches of gum arabic, 1864, on thick wove paper, with (shaved) margins, a puncture and surface scratch in the right margin, the scratch extending 8.7 cm. into the subject, a repaired diagonal tear through the lower right corner, some staining showing through from the reverse, a few tiny surface scrapes top right, mat stained in the margins and on the reverse, framed. L. 18½ × 27 in. (470 × 686 mm.) C-NY $2,420

View on the Harlem River, N.Y., the High Bridge in the Distance. Lithograph by F. F. Palmer, hand-colored, published 1852; small patch of discoloration in top margin. 44.5 cm. × 55 cm. (SH) P-L $836

Salvador Dali (1904–)

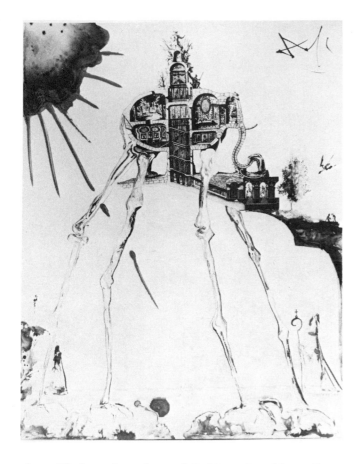

Space Elephant, from the portfolio Memories of Surrealism, *etching on lithograph, 1971, edition of 175, 30 in. × 21½ in. Photograph courtesy Transworld Art, Inc., New York*

Dali, who was born in Figueras, Catalonia, is one of the best-known of the surrealist artists. He became affiliated with the group in the late 1920s, but in the 1930s, as the result of his curiosity about Nazism, fell into disfavor with them. He moved to the United States and did not return to Spain until after the war. Dali's work was well-received in America. He addressed himself to religious themes around this time and painted some of his most famous pictures, such as *The Crucifixion* and *The Last Supper.* Dali's visual language, based on his unique perception of popular images and subjects, carried through to his vast graphic oeuvre. His flamboyance and his unusual business practices (he has been known to give his publisher signed blank sheets of paper) have caused him to be the center of much industry speculation. His work is in the permanent collections of most of the world's prestigious museums.

St. George and the Dragon, etching, 1947, from the total edition of 260, published by the Print Club of Cleveland, with full margins, in good condition aside from a few pin holes in the upper left margin, slight creasing and faint discoloration in the margins, 450 × 287 mm; 17¾ × 11¼ in. S-NY $1,155

Le Bureaucrate, drypoint, 1969, signed in pencil and numbered 57/120, published by Galerie André François Petit, Paris, on wove paper, with full margins, in good condition aside from a few minor soft handling creases in the margins, slight soiling on the verso. 341 × 269 mm (13⅜ × 10½ in). S-NY $550

Les Dîners de Gala, the complete portfolio, comprising twelve photo-offsets, printed in colors, after paintings, each with a drypoint vignette in the lower margin, each signed in pencil and numbered 187/395, on Rives B.F.K. paper, published 1971, with full margins, in good condition, in original portfolio (slightly scuffed). Each sheet 560 × 755 mm; 22 × 29¾ in. S-NY $1,870

Honoré Daumier (1808–1879)

Daumier, the French painter and lithographer, was highly regarded in his lifetime for his caricatures and political cartoons. Daumier's cartoons appeared in many French newspapers. For almost five decades he contributed to *Le Charivari,* a publication of Charles Philipon, and this was his chief source of income. His caricature of Emperor Louis-Philippe, which appeared in Philipon's liberal *La Caricature* in 1832, earned Daumier six months in prison, where he began working in watercolors. Daumier's paintings did not have the satiric bite of his illustrations; some of them reflected a deep intensity of feeling for the trials of the human condition (the noble dreams of Don Quixote were a favorite subject). Daumier produced approximately four thousand lithographs in the course of his life. In 1878, the year before his death, the Durand-Ruel Gallery had an exhibition of his work that included two hundred lithographs and one hundred paintings.

A Group of 51 Lithographs from various series, as published in *Le Charivari,* with text on the verso: most in fair condition. (51) P-NY $550

Les Gens de Justice: Quel dommage que cette charmante . . . femme . . . (Delteil 1360), lithograph, 1846, a good impression of the second state, on white wove paper, with full margins, in good condition (a slight smudge in the left margin just into the black area of the subject's coat at far left, a slight rubbed spot in the upper margin, very faint discoloration in the margins). 242 × 192 mm; 9½ × 7½ in. S-NY $990

Quel dommage que cette charmante petite femme ne m'ait pas chargé de défendre sa cause . . . Comme je plaiderais que son mari est un gredin! Plate 24 from *Les Gens de Justice* (L.D. 1360), lithograph, 1846, second (final) state *sur blanc,* with margins, a small tear at the right edge, very slightly soiled at the edges. S. 14⅛ × 10¾ in. (358 × 272 mm). C-NY $1,320

Le Fantôme, plate 488 for *Caricature* (L.D. 115), lithograph, 1835, on white wove paper, a good impression of the rare first state (of three), with margins, slight and unobtrusive soiling and a tiny nick in the margins, generally in excellent condition. L. 10⅝ × 8¾ in. (270 × 223 mm). C-NY $880

Les Gens de Justice, lithograph, 1846, 14⅛ in. × 10¾ in. Photograph courtesy Phillips Fine Art Auctioneers, New York

Stuart Davis (1894–1964)

Stuart Davis, born in Philadelphia, went to New York in 1910 to study with Robert Henri. His work, semi-abstract in style, came from a love and fundamental understanding of the cubist and constructivist movements which were gaining momentum in Europe. Davis introduced his work at a time when the United States was smitten with the realists and he was considered one of the most important avant-garde artists in the country. He was an outspoken advocate of artists' rights and became a force in the American Artists' Congress, which was formed to promote and protect the interests of the artist. Most of his twenty-two lithographs were made in Paris between 1928 and 1931 and deal with the energetic rhythm of the urban scene. These prints met with little acceptance at the time they were issued, but today Davis is considered a major force in the change of direction of American art.

Anchor (A.A.A. 19), lithograph, 1935, signed in pencil and inscribed "100 Ed," published in the First Annual Print Series, issued by the American Artists School, 1936 (stamp on verso), on BFK wove paper, with full margins, slight soiling, mat stain and discoloration. 216 × 327 mm; 8½ × 12⅞ in. S-NY $1,540

Bass Rocks (A.A.A. checklist 24), silkscreen printed in colors, 1939, signed in pencil, from the edition of 100, with margins, light stained, lightly foxed, tape hinged and with a skinned spot in the upper edge, recto, from removal of old hinging, a few slight creases. c. 215 × 295 mm (8½ × 11⅝ in). S-NY $1,760

ARCH No. 2 (Associated American Artists checklist 11), lithograph, 1929, signed in pencil and numbered 10/20, printed on cream wove paper mounted on white wove paper, with margins, traces of hinge stains in the upper margin corners, two small spots of foxing in the subject. 243 × 339 mm; 9½ × 13⅜ in. S-NY $2,200

Theater on the Beach (A.A.A. 15), lithograph, 1931, signed in pencil and numbered 15/25, on cream wove paper, with full margins, in good condition apart from minor soiling and a few nicks in the sheet edges, handling creases. 280 × 382 mm; 11 × 15 in. S-NY $3,850

Theater on the Beach, lithograph, 1931,
11 in. × 15 in
Photograph courtesy
Sotheby Parke Bernet, Inc., New York/
Associated American Artists, New York/
V.A.G.A., New York,
copyright by Sotheby Parke Bernet, Inc., 1983

Edgar Degas (1834–1917)

Degas was one of the leaders of the French impressionists. A wealthy aristocrat, he studied at the École des Beaux-Arts in 1855 and later in Italy. Initially, he created historical paintings and portraits in a style strongly influenced by Ingres. He participated in the first impressionist exhibition of 1874, as well as the following six. In 1872 Degas visited the United States and began in his work to express a developing interest in modern and everyday themes. He turned away from earlier subject choices and eventually devoted most of his time to the themes of dance, the theatre, and horseracing. The paintings of dancers, for which Degas is so famous, first appeared in the early 1870s. His approach to printmaking was experimental. He believed effects could be achieved by etching that were impossible to achieve in any other medium. Degas completed forty-five etchings and twenty lithographs, often reworking the plates, thereby producing many states of a print.

Le Client Sérieux, monotype in black ink, c. 1879, 8¼ in. × 6¼ in.
Photograph courtesy Sotheby Parke Bernet, Inc., New York, copyright by Sotheby Parke Bernet, Inc., 1977

Deux Filles dans un Café (Janis 60; Adhémar 31). Monotype, c. 1876–77, on China paper, mounted on white wove, in good condition (pin holes at corners). 113 × 164 mm; 4⅜ × 6½ in. S-NY $22,000

[Chanteuse] (not in Janis), monotype printed in black ink on off-white wove paper, c. 1877–78, a small tear in the right margin, slight soiling and discoloration, a few very faint fox marks, laid down. Image 85 × 74 mm; 3⅜ × 2⅞ in. Sheet 206 × 154 mm; 8 × 6 in. With the red Atelier stamp showing through in the lower right margin corner. S-NY $6,050

Alphonse Hirsch (L.D. 19; Adhémar and Cachin 24), drypoint and aquatint, 1875, printed in blackish brown on thick wove paper, second (final) state, rare according to Delteil, with margins. P. 4⁷⁄₁₆ × 2⁵⁄₁₆ in. (112 × 59 mm). S-NY $2,090

Eugène Delacroix (1798-1863)

Eugène Delacroix was one of the leading artists of France's romantic movement. His mind was open to every kind of experience, and he sought to combat bourgeois culture in his art. His early work was influenced by Rubens and by Constable, who he felt captured the lush quality of the English countryside. Delacroix's style changed dramatically after a visit in 1832 to North Africa where entirely new subject matter presented itself. He began to depict the lives of the people he met there, as well as references to wars or other conflicts that were a part of their history. After years of criticism about his use of color, which differed from the usual French palette of the day, he was finally held in high esteem in the 1830s. He was especially respected by the younger French artists. Delacroix made 126 etchings and lithographs.

Un Homme d'Armes (Delteil 17), etching, with plate tone, 1933, second state of four; and *Étude de Femme Vue de Dos* (D. 21), etching with plate tone, 1833, third state of four, printed together on one sheet of laid paper, with full margins, in good condition aside from a few small tears and nicks in the sheet edges, a tiny thin spot in the left margin, slight discoloration and soiling in the margins and sheet edges, a small glue stain on verso. 109 × 169 mm; 4¼ × 6⅝ in. S-NY $880

Mephistopheles (Delteil 69vi), lithograph, 1828, from the portfolio as printed by Vayron. A good printing on heavy white wove with full margins. In good condition save for light spots of foxing. Image: 10½ × 8¾ in. (266 × 222 mm). P-NY $220

Juive d'Alger et Une Rue à Alger (Delteil 101-102), lithograph printed in black, (with borders by Desmadryl printed in brown), 1838, an impression in the third state of four, as published in *Le Livre d'Or des Contemporains,* on wove, with margins, in generally good condition aside from some remnants of soiling, creasing and foxing primarily in the margins, multiple small repaired tears at the sheet edges. 398 × 305 mm; 15⅝ × 12 in. S-LA $605

Tigre Royal, *lithograph, 1829, 13 in. × 18½ in.*
Photograph courtesy Sotheby Parke Bernet, Inc., New York, copyright by Sotheby Parke Bernet, Inc., 1983

Paul Delvaux (1897–)

Paul Delvaux was born in Belgium. He studied art in Brussels and was influenced by expressionism early in his artistic career. In the 1930s his inspiration began to come from the works of Magritte, and he finally developed his own unique surrealist style in the latter part of the decade. He visited Italy and was impressed by the architecture he saw there. References to Roman architecture can be found in many of his works from that point on. A dominating theme was the appearance of half-clothed or nude women with delighted faces gazing at classic Roman architecture. His prints, the best of which are lithographs, follow the theme of his paintings. In 1950 Delvaux was made Professor of Monumental Painting at the École Nationale d'Art et Architecture in Brussels, where he taught until 1962.

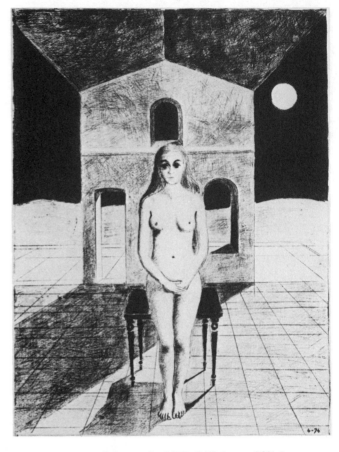

The Clairvoyant, lithograph, 1974, 34½ in. × 23½ in. *Photograph courtesy Sotheby Parke Bernet, Inc., New York, copyright by Sotheby Parke Bernet, Inc., 1983*

Woman's Faces (Jacob 16), lithograph, 1967, on Arches, signed in pencil, numbered 44/65, with margins, framed. L. 16 × 11⅞ in. (406 × 302 mm). C-NY $880

The Station (J. 51), lithograph, 1971, on Arches, signed in pencil, numbered 65/75, with margins, glued to the overmat along the top margin edge, framed. L. 22⅝ × 30⅞ in. (574 × 784 mm). C-NY $3,080

The Window (J. 53), lithograph in colors, 1971, on white wove paper, signed in pencil, numbered 4/75, with margins, a tiny tear in the bottom margin edge, framed. L. 22⅞ × 30⅝ in. (581 × 777 mm). C-NY $3,300

Phryne (Jacob 40), lithograph printed in colors, 1969, signed in pencil and numbered 13/75, with full margins, in good condition aside from faint mat stain, skinned spots in the upper margin and remains of old tape, verso, framed. 310 × 242 mm; 12¼ × 9½ in. S-NY $1,320

Raoul Dufy (1877–1953)

French artist Raoul Dufy began his career as a painter, inspired by the impressionists. He studied at the École des Beaux-Arts in Paris just after the turn of the century and painted in the style of the impressionists until he discovered the work of Henri Matisse. Responding to Matisse's influence, he immediately began working in the fauvist style and completed many of his most important works in this period. His next transition, to cubism, was ill-received, and, finally, in the 1920s his own decorative and airy style of painting evolved. Dufy also worked with textiles, ceramics, tapestry, watercolor, woodcuts, lithography, and book illustration. The first edition of Guillaume Apollinaire's *Bestiary,* illustrated by Dufy, is now a valuable rare book.

Le Havre, lithograph printed in colors, after a maquette by the artist, c. 1945, signed in pencil and numbered 84/150 (aside from the poster edition), on thin, wove paper, the full sheet, printed to the edges at top and sides, in good condition aside from slight discoloration, a few minor creases in the lower margin (one just within the image). Sheet 505 × 660 mm; 19⅞ × 26 in. S-NY $1,870

Sirens; also titled *Mer,* lithograph, signed in pencil and numbered 32/33, on B.F.K. Rives; together with *Nude with Shell,* etching, signed in pencil and numbered 85/100, both with margins and in generally good condition. (2). 350 × 507 mm; 13¾ × 20 in. 187 × 140 mm; 7⅜ × 5½ in. S-LA $1,210

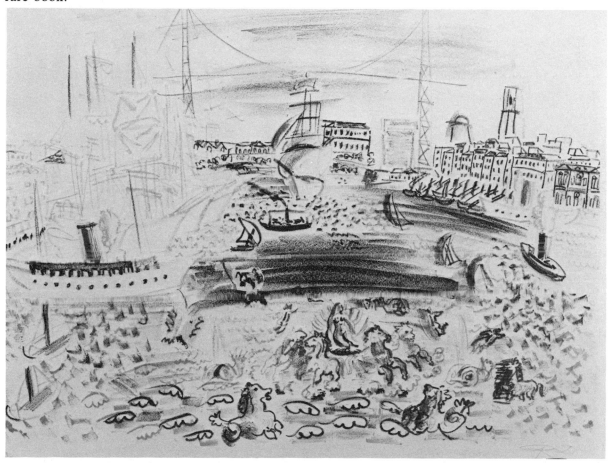

Port de Marseille, lithograph printed in colors, c. 1920, 12 in. × 17 in.
Photograph courtesy Sotheby Parke Bernet, Inc., New York,
copyright by Sotheby Parke Bernet, Inc., 1980

James Ensor (1860–1949)

James Ensor was born in Ostend, Belgium. He stayed in that city, in his parents' home, all his life, except for three years when he studied at the School of Fine Arts in Brussels. Ensor's father was a dealer in tourist souvenirs and he kept his vast stock in the house. Even after his parents died, Ensor kept the stock around him. These objects greatly influenced his work, and he often used carnival masks to denote phoniness or stupidity. An artistic descendant of Brueghel and Bosch, Ensor created macabre, often satanic images of carnival-oriented life. In 1886 he began to make etchings and drypoints. Half of his total print production was made between 1886 and 1888.

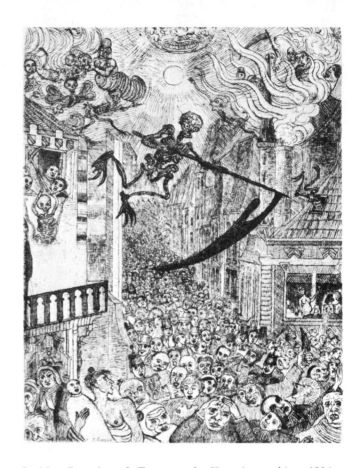

La Mort Poursivant le Troupeau des Humains, etching, 1896, 9⅜ in. × 7 in.
Photograph courtesy Sotheby Parke Bernet, Inc.,
New York, copyright by Sotheby Parke Bernet, Inc., 1974

La Cathédrale—2me planche (T., D. 105), etching, 1896, on stiff, cream-toned simile Japan, with full margins, paper tone darkened from exposure to light, light foxing on the verso (slightly visible on the recto), otherwise in good condition. 240 × 180 mm; 9½ × 7⅛ in. S-NY $2,860

Le Christ Insulté (Taevernier 1), etching, 1836, second (final) state, signed, dated, and titled in pencil, countersigned in pencil on the verso, on cream simile Japan, with full margins, in good condition aside from faint traces of mat stain, slight rubbing and traces of old hinging around edges, verso. 240 × 162 mm; 9½ × 6¼ in. S-NY $770

Les Bons Juges (T. 88), etching, 1894, second (final) state, signed, dated, and titled in pencil, also countersigned and titled in pencil on the verso, on simile Japan paper, with full margins, in good condition apart from faint soiling, a few creases and slight skinned spots in the margins, mat stain on the verso. 180 × 239 mm; 7 × 9⅜ in. S-NY $1,540

Jardin D'Amour (L.D., T., C. 61), etching with hand coloring, 1888, on Japan, Taevernier's third (final) state, signed in brown ink, titled in pencil, countersigned in pencil on the reverse, with margins (the bottom margin shaved unevenly), the colors oxidized in places, slight surface rubbing in the margins. P. 4⅝ × 3⅛ in. (118 × 80 cm). C-NY $1,650

Max Ernst (1881–1976)

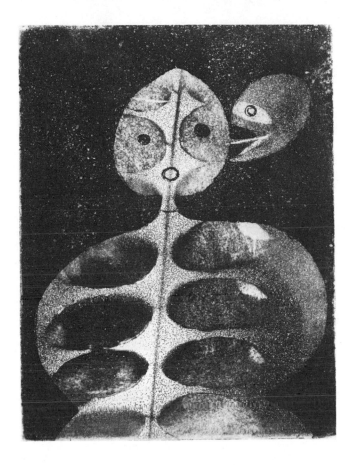

Figure (Le Secret), aquatint, 1950, 9¼ in. × 7 in.
Photograph courtesy Sotheby Parke Bernet, Inc.,
New York, copyright by Sotheby Parke Bernet, Inc., 1975

Ernst was born in Brühl near Cologne, Germany. He studied philosophy and psychology in Bonn and in 1919, after four years of military service, founded the Cologne dada group with Jean Arp. His prints at this time were skillfully drafted studies of varying perspectives. In 1922 Ernst moved to Paris and aligned himself with the surrealists. In the same year he had his first exhibition of collages which were hailed as a revelation. They were based on the relationship between real but completely dissimilar entities coming together in unassociative settings. Ernst's unique collage prints were collotypes of frottages (compositions made by rubbing a pencil over an object underneath a sheet of paper, thereby transferring it to the paper). Ernst emigrated to the United States in 1941 but returned to France in 1958 and became a citizen of that country. His works are in the collections of prominent museums throughout the world, including the Museum of Modern Art in New York, the Tate Gallery in London, and the Musée d'Art Moderne in Paris.

Lewis Carroll, *Die Jagd nach dem Schnark,* Manus Presse, Stuttgart 1968 (Leppien 124), lithographs printed in colors, 1968, on Arches, title, text, justification and set of 22 plates, signed in pen and ink on the justification, numbered 31/33, lacking the extra suite (the full edition was 165), the full sheet, in excellent condition, loose in original linen cover with vignette on the front, gilt tile on spine, linen covered slipcase, slightly scuffed. L. 325 × 250 mm. (album) C-L $419

Les Chiens ont Soif (Spies/Leppien 98 II., III), the book with two etchings printed in colors, both signed in pencil, and 20 lithographic reproductions of drawings, text by Jacques Prévert, published by Au Pont des Arts, Paris, 1964, in a total edition of 320, this copy numbered 272, with full margins, in good condition, in original wrappers and cloth-covered box, except the two prints taped to mats with masking tape on three sides, verso, framed. Sheet size 430 × 310 mm; 17 × 12½ in. S-NY $990

La Ballade du Soldat: Pls. VII, X, XIII, XIV, XVIII, XXII, XXIII, XXV, XXVI, XXXV, XXXVI, XXXVIII (Leppien A. 25), lithographs printed in colors, 1972, from the set of thirty-four, on Japon nacré, each signed in pencil and numbered V/XIX, Hors Commerce (the full edition was 79 on Japan, 19 Hors Commerce, 749 on velin d'Arches including 18 Hors Commerce), printed by P. Chave for G. Ribemont-Desaignes, 1972, with margins, framed. S. 385 × 285 mm. (12) C-L $765

Maurits Cornelis Escher (1898–1972)

Escher was a Dutch artist whose structured but bizarre view of life earned him a following of scientists, mathematicians, and LSD trippers. Escher's style falls into two distinct periods, before and after 1937. In the early years he attended the School of Architecture and Decorative Arts in Haarlem. After he completed his studies, he moved to Italy where he depicted mainly landscapes of an intense realism. The animal forms in these are exaggerated to the point of being grotesque. After Escher returned to Holland in 1937, his work showed a unique mastery of perspective. In this later work, architectural forms are stretched to their limits, creating a strange, hallucinatory vision of the world. Escher showed great technical virtuosity in his etchings and drypoints, many of which were issued in small editions and are quite rare.

Belvedere, lithograph, 1958, 18⅛ in. × 11⅝ in.
© *Beeldrecht, Amsterdam/V.A.G.A., New York, 1983*
Photograph courtesy Sotheby Parke Bernet, Inc.,
New York, copyright by Sotheby Parke Bernet, Inc. 1980

Order and Chaos (Locher 157), lithograph, February 1950, signed in pencil, on slick wove paper, with full margins, in good condition aside from a small crease in the image, diagonal creasing in the lower left margin. S-NY $1,980

Waterfall (L. 258), lithograph, October 1961, signed in pencil and inscribed "Proefdruk III," aside from the numbered edition of 103 in the III. Edition, on Holland paper, with full margins, in good condition, apart from faint mat stain and soft handling creases in the margins, framed. 378 × 300 mm; 14⅞ × 11¾ in. S-NY $4,400

Encounter (L. 127), lithograph, May 1944, signed in pencil and numbered 37/200, on stiff Holland paper, with large margins, in good condition apart from traces of discoloration in the margins, thin spots in the corners and at center points of edges. 343 × 469 mm; 13½ × 18⅜ in. S-NY $3,300

Convex and Concave (L. 198), lithograph, March 1955, signed in pencil and numbered 64/80 V, on Holland paper, with full margins, in good condition, two small glue stains from tape hinges at lower margin edge, verso, framed. 11 × 13 in; 281 × 330 mm. S-NY $3,300

Lyonel Feininger (1871–1956)

Lyonel Feininger was born in America but lived most of his creative life in Germany, where he became allied with the Bauhaus movement. He worked first as a cartoonist, creating a series for the *Chicago Tribune* in 1906. The childlike but literal style in which the strip was drawn is reflected in his early graphic work. He went to Europe when the fauvist, cubist, and Bauhaus movements were beginning to take shape and they greatly influenced his later, more mature style. The confidence of his lines formed unique, forthright compositions which told of intricate spatial relationships. Feininger's graphic work began with lithographs, changed to etching and drypoint, and then, after World War I, to woodcuts. The discipline of the woodcut best complemented his subject matter and style.

Marine (Prasse W77), woodcut, 1918, as published by *Der Dichtung,* 1921 in an edition of 125. Signed and titled in pencil and inscribed "very rare print!" Also signed by the printer, Fritz Voigt. Prasse mentions "one on Chinese laid grey paper the artist penciled "very rare," which may or may not refer to the present impression. A rich impression on greyish Japan with full margins, and the blindstamp of *Der Dichtung* at lower right. Some surface dirt; soft creases in the wide margins; minor nicks and tears at the sheet edges; both right corners of the sheet lost. Image: 11 × 15 in. (280 × 376 mm). P-NY $1,870

Ships (With Man on a Pier) (Prasse W216), woodcut, circa 1921, on wafer-thin Japan, signed in pencil, with margins, faint foxing, some creasing, several small tears and losses at the margin edges, laid down at the extreme margin corners. L. 3⅛ × 4⅜ in. (79 × 111 mm). C-NY $418

Estuary (P. W238), woodcut, 1921, on wafer-thin Japan vergé, signed in pencil, inscribed with the work number "2i0i," inscribed by Julia Feininger on the reverse "Block destroyed," from the edition of unrecorded size, with the estate stamp lower right, with margins, a small loss at the tip of the top left margin, some slight creasing in the right margin, taped to a sheet of thin tissue with two small pieces of yellow tape. L. 6⅜ × 9⅛ in. (163 × 231 mm). C-NY $990

Vor der Küste, Stein 3 (Off the Coast) (P. L14), lithograph, 1951, second (final) state, signed in pencil, from the edition of 250, printed by George C. Miller, New York, with the stamp of the publisher, The Print Club of Cleveland (Lugt 2049b) on the verso, on white wove paper, with full margins, in good condition aside from a small fox mark in the lower margin, and a faint red pencil mark in the left margin, framed. 230 × 375 mm; 9 × 14¾ in. S-NY $2,090

Marine, woodcut, 1918 (published in 1921), edition of 125, 11 in. × 15 in.
Photograph courtesy Phillips Fine Art Auctioneers, New York

Tsuguharo Foujita (1886–1968)

Foujita was born in Tokyo. He attended the Imperial School of Fine Arts in that city and was a success immediately after he began painting. Despite his following, Foujita moved to Paris in 1913 because he felt he could learn more in that fertile artistic community. It was there that he pioneered the technique of using stamped impressions of color along with brush strokes on his canvases. He traveled extensively and took inspiration from each trip, blending elements in a seductive style that meshed Japanese tradition with Occidental modernism. Foujita was a success in France and lived there for most of his life, returning to Japan only for three years during World War II. He made lithographs, soft-ground etchings, and aquatints, which were usually portraits.

Woman Resting Her Chin on Her Right Hand, soft-ground etching and roulette, 1929, signed in pencil and numbered 70/100, on Japan paper, with full margins, in good condition apart from a few minor creases in the sheet edges, a slight skinned spot and a small tape stain on the verso. Image 345 × 310 mm; 13⅝ × 12⅛ in. Plate 388 × 347 mm; 15¼ × 13½ in. S-NY $3,300

Les Enfants [Little Girl with Braid and Top Notch, Holding a Pansy in Her Hand], etching and roulette printed in colors, a fine impression, signed in pencil and numbered 21/100, on Chine appliqué, from the portfolio published by Apollo Editions Artistiques, 1929, with full margins, in good condition aside from a band of light stain in the margins of the support sheet, tape hinged along the right edge, framed. Image 335 × 258 mm; 13¼ × 10⅛ in. Plate 370 × 290 mm; 14⅝ × 11½ in. S-NY $4,125

Femmes [Two Seated Nudes], etching and roulette printed in colors, signed in pencil and numbered 64/100, on Chine appliqué, published by Apollo Editions Artistiques, 1930, with margins, in good condition aside from traces of foxing, faint discoloration in the margins. Plate 591 × 405 mm; 23¼ × 16 in. Sheet 640 × 446 mm; 25¼ × 17½ in. S-NY $7,425

Girl with a Cat, from the suite of ten entitled Les Enfants, *drypoint with roulette, c. 1930, 14¾ in. × 11½ in. Photograph courtesy Phillips Fine Art Auctioneers, London*

Paul Gauguin (1848–1903)

Gauguin was born in Paris, but spent part of his childhood in Peru. He was a stockbroker and a Sunday painter, one of the principal founders of the symbolist school of Pont-Avon, and participated in impressionist exhibitions until 1883 when he began to dedicate himself entirely to his art. Gauguin had a great wanderlust and traveled extensively in search of cultural differences. His keen interest in primitive sculpture and Far and Near Eastern art led him to reject Western styles. In 1890 he set up a studio in Tahiti. Gauguin made woodcuts and lithographs. His technique with woodcuts was unique. He took flat pieces of wood and cut, scratched, and sandpapered them in unconventional ways. He then added his design; usually figures in distorted forms, to complement the textural quality of the background. Although his woodcuts did not sell during his lifetime, he was convinced they would be popular one day.

Maruru, woodcut printed in colors, 1894, 8½ in. × 14 in. Photograph courtesy Sotheby Parke Bernet, Inc., New York, copyright by Sotheby Parke Bernet, Inc., 1982

Maruru (Guérin 24), woodcut printed in colors, 1894, one of only a few trial proofs printed by the artist (before the small and rather unsatisfactory edition of about 25 or 30 impressions printed by Louis Roy), a very fine impression, printed in three stages from the same block: yellow, with gray on the standing figure, the flutist and in the smoke in front of the statue of the goddess Hina; orange-ochre, with touches of green in the smoke at right; and black, on Japan paper, with full margins, in good condition (inconsequential soiling in the margins and a few fox marks). 206 × 356 mm; 8⅛ × 14 in. Sheet 235 × 395 mm; 9¼ × 15½ in.

The very few extraordinary impressions which Gauguin printed of his own woodcuts are the only examples of these important works which capture the full range of his personal technique, from delicate surface scratches to bold gouge work. (The impressions printed subsequently by his friend, the painter Louis Roy, were so heavily inked that the clogged block surface yielded only a coarse, opaque image, far from the mysterious effect of Gauguin's own.) Ex coll. M. E. Sadler, University College, Oxford (Lugt 1915c, inscription on the reverse). S-NY $56,100

Manao Tupapau (G. 50; Stein and Karshan 28), lithograph, 1894, signed in ink and numbered 50, from the edition of 100 included in *L'Estampe Originale,* April-June, 1894 (with the blindstamp in the lower right margin), on wove paper, with full margins, in good condition aside from a few tape hinge stains on verso, and a crease in the lower margin, framed. 181 × 272 mm; 7⅛ × 10⅝ in. S-NY $26,400

Pastorales Martinique (Guérin 9), lithograph, 1889, one of the second, unnumbered edition, published by Vollard in 1894, on *simili* Japan paper, with wide margins (slightly trimmed), in good condition, aside from slight yellowing of the paper in the margins, faint stains in three spots at the sheet edges, and one small area of skinning at lower sheet edge, framed. 185 × 223 mm; 7¼ × 8¾ in. S-LA $1,925

Alberto Giacometti (1901–1966)

Swiss-born Alberto Giacometti is best known as a sculptor. The son of the painter Giovanni Giacometti, Alberto began sculpting busts in his early teens. In 1919 he studied at the School of Arts and Crafts in Geneva and spent the following year studying the Masters in Italy. In 1922 he moved to Paris where he eventually joined the surrealist movement and where he solidified the artistic foundation of his international fame. The elongated figures and heads which are his sculptural trademark were also the focus for his prints. Giacometti learned to engrave and to etch at Atelier 17 in 1933, but his print output was not significant until after World War II when his lithographs took on a more energetic feeling, reflective of his busy creative life.

Nu Assis, lithograph, 1961, 22⅛ in. × 29⅞ in.
Photograph courtesy Sotheby Parke Bernet, Inc., New York,
copyright by Sotheby Parke Bernet, Inc., 1981

Head of Man (Tête d'Homme) (Lust 102), lithograph, 1957, signed in pencil and numbered 43/100, from Jean Genet's *L'Atelier d'Alberto Giacometti,* published by Maeght, 1957, on Arches wove paper, with full margins, in good condition aside from traces of glue and mat stain on the verso, framed. 100 × 130 mm; 3⅞ × 5⅛ in. S-NY $605

Rimbaud vu par les Peintres (L. 175), etching, 1962, signed in pencil and numbered 7/97, published by Matarasso, Paris, on Rives paper, with large (full) margins, paper tone slightly mottled, faintly light stained, otherwise in good condition, framed. Image 220 × 226 mm; 8⅝ × 8⅞ in. S-NY $605

Têtes et Tabouret (Lust 22), lithograph, 1954, signed in pencil and numbered 9/30, with full margins (slightly shaved at bottom right), in good condition apart from two skinned spots and tape hinge stains in the upper margin, verso, framed. 535 × 332 mm; 21 × 13⅛ in. S-NY $1,430

L'Atelier 1955 (L. 25), lithograph, 1956, signed in pencil and inscribed "épreuve d'artiste" (aside from the numbered edition of 125), in good condition aside from two skinned spots and traces of tape stains in the upper margin, verso, framed. 480 × 375 mm; 18⅞ × 14¾ in. S-NY $2,090

Eric Gill (1882–1940)

Eric Gill, the son of a clergyman, was born in Brighton, England. His religious background had a profound effect on his art. From 1899 to 1903, Gill studied at the Chichester School of Art where he was most interested in religious architecture. In 1913 he converted to Catholicism as a reaction to what he considered an increasingly commercial, jaded world. He was scandalized by the superficiality of life and sought to simplify it through his work, adhering strictly to Bible studies and drawing his inspiration from those stories. He started printmaking in 1907, creating images directly on wood and metal, rather than working from a model. Gill had his first exhibition in 1911. Recognition for his work, however, only came years after his death, and he is today considered one of the most important English modern artists.

Engravings—A selection . . . representative of his work to the end of the year 1927. Wood and metal engravings on tissue-thin Japan, complete but for D. 44 and the colophon, 318, from the extra set of engravings which accompanied the signed catalogue raisonné numbered 15 from the edition of 80 published 1929 by Douglas Cleverdon; comprising Ditchling nos. D. 14, 17, 29, 35, 38-40, 43, 49, 53, 58-60, 68-74, 76, 77, 79, 81-103, 108, 109, 113, 117, 120, 121, 122, 124, 127, 133, 137, 143, 144, 148, 155, 156, 164-167, 174, 175, 179, 186-192, 195-198, 200, 202-206, 208, 210-213, 215, 217-219, 225, 240; Capel-yffin nos. 5-9, 13, 15, 25, 31-34, 39, 40, 50, 54, 57, 60, 63, 64, 71, 74, 82, 90-95, 100, 102, 106, 115, 118, 126, 132 (photogravure reproduction), 161, 162, 166, 181, 192, 197, 200, 206, 207, 209, 213, 214; unframed, in good condition. (coll.) P-L $1,782

Angel and Shepherds (P. 269), handcolored wood engravings, 1923, two impressions, on Whatman wove paper, the colors extremely fresh, with small margins, L. 92 × 103 mm; *Ave Jesu Parvule* (P. 48), handcolored woodcut, L. 99 × 58 mm; *Adeste Fideles,* a Christmas Hymn, text with five woodcuts by Gill, 1919; and *St. Dominic's Press Calendar,* 1926, calendar with twelve woodcuts. (20) C-L $382

Woman with Snake, *engraving, c. 1920.*
Photograph courtesy Phillips Fine Art Auctioneers, London

George Grosz (1893–1959)

George Grosz was born in Berlin and studied at the Royal Saxon Academy of Fine Arts in Dresden and then at the Royal Arts and Crafts School in Berlin. He was one of the founders of the dada movement. In 1914 he served in the German army, but was court-martialed for insubordination. He was fined in 1920 and 1923 for insulting the army in his drawings, and in 1928 for blasphemy. His disillusionment and, at times, his outrage, is the fiber running through all his work. Through his searing caricatures, Grosz became a major social commentator of pre-war decadence and post-war decay. He came to the United States in 1932, taught at the Art Students League in New York in 1933, and five years later became a United States citizen. After the war his prints took on even more alarming qualities as his figures appeared more ravaged and spectre-like.

Seekt als Weinachtsengel, lithograph, 1923,
12¼ in. × 9¾ in.
Photograph courtesy Phillips Fine Art Auctioneers, New York

Seekt als Weinachtsengel (Dückers, Einzelblätter 96), lithograph, 1923. Signed in pencil. A good printing of a very rare image: Dückers lists only two other examples. On cream laid paper with full margins and the watermark "Johann Wilhelm." In very fine condition. Image: 12¼ × 9¾ in. (310 × 248 mm). P-NY $1,100

S. M. (Reichspraesident Friedrich Ebert) (D. E. 87), photolithograph, 1922–23, on yellowish wove paper, signed in pencil, from the edition of unrecorded size (Dückers records one known example only), with margins, very slight and unobtrusive soiling in the margins. L. 13¼ × 9¹¹⁄₁₆ in. (337 × 247 mm). C-NY $880

Lotte (D. E. 74), lithograph, 1921, signed in pencil, an impression aside from the edition of 40, on cream-toned smooth laid paper, with full margins, in good condition aside from a small paper loss in the upper edge, a few creases and slight discoloration in the edges, faint mat stain on the verso. c. 492 × 305 mm; 19⅜ × 12 in. S-NY $330

Fischer aus Pommern (Dückers E. 102), transfer lithograph, 1926, signed in pencil, published in an edition of 125 in *Die Schaffenden,* on laid paper, with full margins, in good condition aside from mat stain in the margin edges and several specks of foxing. 287 × 350 mm; 11¼ × 12¾ in. S-NY $137

Francis Seymour Haden (1818–1910)

Sir Francis Seymour Haden was an English surgeon and one of the most prolific etchers of his day. A dictatorial Victorian, Haden had a distaste for anything copied (such as engravings) and wrote and spoke out about etching being the only true print form. He collected etchings, loved them, and made more than two hundred himself. He always carried a copper plate around with him in case he got an inspiration. Haden showed a real feeling for the lushness of landscapes and credited Rembrandt with being his major influence. He was the brother-in-law of James McNeill Whistler, and together they introduced the concept of the limited edition in England. They sold their etchings as good investments and started a vogue which still exists today.

Breaking Up of the "Agamemnon" (Harrington 145), etching, 1870, a fine impression of the first published state, printed in dark sepia with light plate tone, signed in pencil, also inscribed by the printer, "This is a good proof I think, on a choice leaf of old paper. F. Goulding Imp," on old laid paper, with margins (full on three sides), in good condition apart from light foxing. 194 × 411 mm; 7⅝ × 16¼ in. S-NY $1,320

Kensington Gardens (small plate) (Harrington 12), etching and drypoint, 1859, second state of three, signed in pencil, published in *Études à l'eau-forte* (No. III), on fine laid Japan paper, with margins, lightly foxed and discolored, glued to the backing in the margin corners. 162 × 118 mm; 6⅜ × 4⅝ in. S-NY $110

The Holly Field (Harrington 33), etching, 1860. Signed in pencil at lower right, a good impression, hinged to mat on verso, in good condition apart from slight staining in margins. Plate: 2⅛ × 5 in. (52 × 127 mm). P-NY $60

Thames Fisherman, *etching and drypoint, 1859, 5¾ in. × 8⁹⁄₁₆ in.*
Photograph courtesy Madeleine Fortunoff Fine Prints,
Long Island, New York

Childe Hassam (1859–1935)

Childe Hassam was born in Boston. He traveled extensively in Europe where he became enamored of the impressionists. They influenced his work to such an extent that he was eventually recognized as the American counterpart of the French impressionists and one of the leading painters of the time. It was not until 1915, when he was fifty-six, that he began his work in etching. He was, however, quite prolific, producing more than 370 etchings and some 45 lithographs before his death. Many of the etchings depict tree-lined streets, harbors, and other familiar American country scenes. Hassam is remembered for the beauty and grace of his compositions, and for the way he used light and shadow to define his subjects.

Avenue of the Allies (Griffith 42), lithograph, 1918, signed with monogram and dedicated in pencil in lower margin. A good impression on wove paper, laid down, otherwise in good condition. 13¾ × 7⅛ in. (352 × 180 mm). P-NY $825

Cos Cob Dock (C. 58), etching, 1915, signed in pencil with the cypher and inscribed "imp," a fine impression on wove paper, tape stains and losses in the margin edges, several creases (with two slight breaks in the image), framed. 8½ × 6½ in. (215 × 165 mm). S-NY $385

Easthampton (C. 134), etching, 1917, signed in pencil with the cypher and inscribed "imp," with full margins, in good condition apart from slight, light stain, tack holes from drying in the margin edges, framed. 7½ × 11¼ in. (191 × 288 mm). S-NY $2,090

Lion Gardiner House, Easthampton, *etching, 1920,*
9⅞ in. × 14 in.
Photograph courtesy Kennedy Galleries, Inc., New York

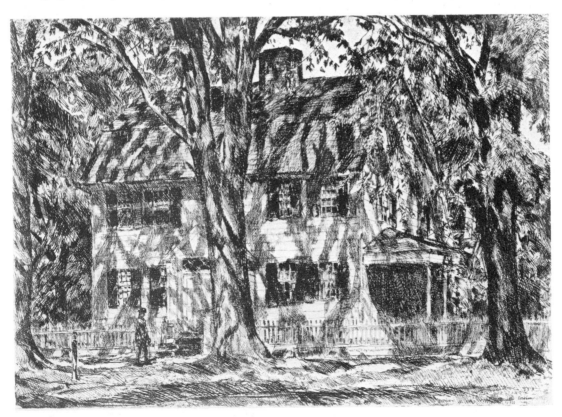

Stanley William Hayter (1901–)

London-born Stanley William Hayter was responsible for the most profound changes in the direction of the graphic arts in the twentieth century. After earning his degree in organic chemistry and geology in 1921, he worked in the oil industry for five years but then decided to dedicate his life to the artistic studies which had been his hobby. Influenced by the graphic work of Jacques Villon and Joseph Hecht, Hayter organized in 1927 the workshop that became known as Atelier 17, where many artists, Picasso and Miró among them, found unusual experimental freedom and devotion to the highest standards of craftsmanship. Atelier 17 is still in existence in Paris. Hayter had his first one-man show in Paris in 1928 and after that had major exhibitions in museums and galleries throughout Europe and America. He taught at the California School of Fine Arts, the New School for Social Research in New York, and the Art Institute of Chicago. This pioneer printmaker received many honors, including the Legion of Honor in 1951, the Order of the British Empire in 1959, and Commander of the British Empire in 1967.

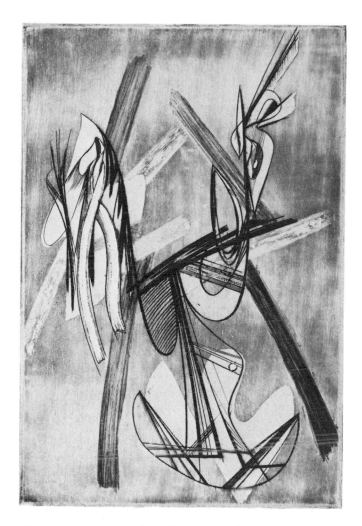

Pavane, engraving and intaglio, 1935, 11⅝ in. × 7¾ in. *Photograph courtesy Sotheby Parke Bernet, Inc., New York, copyright by Sotheby Parke Bernet, Inc., 1979*

Pegasus, engraving and soft ground etching printed in colors, 1951, signed in pencil, dated and numbered 48/50, with the blindstamp of the publisher, Jeune Gravure Contemporaine, on wove paper, with full margins, in good condition, a few faint fox marks in the margins and on the verso; with *Gulf Stream,* engraving and soft ground etching printed in colors, 1959, signed in pencil, titled, dated, and inscribed "E 4/5," also inscribed "for George + Jean a good Life, happiness + . . . Bill H. 18-11-60," on white wove paper, with full margins, in good condition aside from a diagonal crease in the lower margin, running just into the lower corner of the subject, slight soiling and discoloration in the margins, traces of old glue on the verso. (2) 199 × 303 mm (7¾ × 11⅞ in) and 512 × 496 mm (20⅛ × 19½ in). S-NY $275

Personnages voilés, etching and aquatint printed in colors, 1952, signed in pencil and inscribed *"Ep d'artiste 9'15,"* on handmade paper with the Hayter watermark; together with *Paysage Lunaire,* etching and aquatint printed in colors, 1955, signed in pencil, dated, titled and numbered 21/50, on Rives, both with full margins and in generally good condition. (2) 400 × 330 mm (15¾ × 13 in.) and 365 × 288 mm (14⅜ × 11⅜ in). S-LA $385

Paul César Helleu (1859–1927)

Paul César Helleu was born in France. He was a student at the École des Beaux-Arts in Paris and was there inspired to work in numerous artistic media. He started by painting scenes in churches and designing stained glass windows. He then developed the styles which made him famous: elegant studies of women in silhouette, sporting scenes, and, in general, the lifestyle of privileged society. Helleu was also a printmaker, popular for his subject matter and widely acclaimed for technical virtuosity in his engravings. His drypoints are recognized as some of his most beautiful works.

Mme. Clement, drypoint, a fine, delicately printed impression, signed in pencil, on laid paper, with large margins, in good condition aside from faint light stain and a small nick in the upper edge. 402 × 301 mm; 15⅞ × 11⅞ in.
S-NY $605

Ellen 13 ans, drypoint, a fine impression, printed in sanguine, with plate tone, signed in brown crayon, on wove paper, with large (full) margins (the lower margin creased back), some rippling in the plate area due to printing pressure, and light soiling in the margins and on the verso, otherwise in good condition. 397 × 275 mm; 15⅝ × 10⅞ in.
S-NY $440

The Artist's Son Drawing Madame Helleu Nursing Her Baby, drypoint, a fine impression, signed in crayon, with full margins, in good condition aside from traces of discoloration, mat stain, and foxing. 280 × 505 mm; 11 × 19⅞ in.
S-NY $1,760

Ed Sagot. Estampes et Affiches Illustrées (Das frühe Plakat 466), lithograph in reds and beige with the white scraped highlighting on the beige stone, circa 1900–1901, on glazed paper, with margins, some creasing (mostly in the margins), small tears and nicks at the margin edges, laid down on linen, framed. S. 41⅞ × 29½ in. (1064 × 758 mm).
C-NY $440

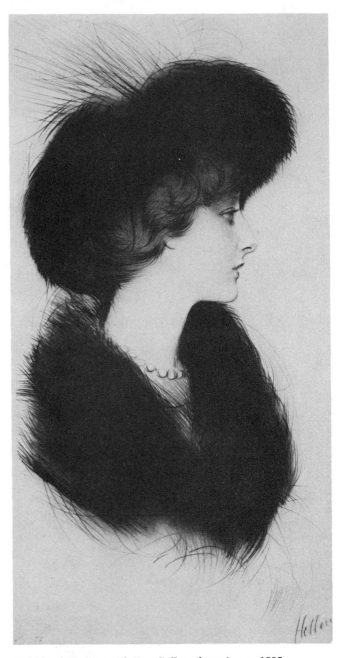

Profile of Woman with Fur Collar, drypoint, c. 1895, 21⅝ in. × 11¼ in.
Photograph courtesy of Sotheby Parke Bernet, Inc., New York, copyright by Sotheby Parke Bernet, Inc., 1983

Winslow Homer (1836–1910)

Winslow Homer, one of America's great realist paint- ers, was born in Boston. At the age of nineteen he was apprenticed to a lithographer in that city. Two years later he opened his own studio in Boston and sent some of his prints to *Harper's Weekly* in New York. In 1859 he moved to New York and joined the staff of *Harper's* as an illustrator. He was a correspon- dent in the Civil War, making illustrated reports of life in the camps. These scenes were handled in a light- hearted manner to make the subjects more palatable for readers. When the war ended, Homer turned to children as his models. In 1881 he moved to a small fishing village in England where he lived and painted for two years. He then moved to Maine, where he continued to paint fishing scenes and landscapes. His beautifully executed etchings followed the themes of his paintings.

Eight Bells (Goodrich 95), etching, 1887, a fine, rich impres- sion, printed with plate tone in the foreground, signed in pencil, one of about 100 impressions, published by C. Klackner, on vellum, with large margins, slight discoloration and a few printer's creases, a few small repaired splits and spotting in the margins (not affecting the subject), framed. 481 × 625 mm; 19 × 24⅝ in. S-NY $19,800

Eight Bells (Goodrich 96; plate 94), etching, 1887, a very good, strong impression, printed by Charles White, c. 1941, on stiff cream wove Japan paper, with margins, skinned in the edge of the upper margin, recto, from removal of old hinging, slightly creased and soiled in the margin edges, oth- erwise in good condition. 490 × 630 mm; 19¼ × 24¾ in. S-NY $3,740

Fly Fishing, Saranac Lake (Goodrich 104, and page 17), etching, with burnished aquatint, 1889, signed in pencil and numbered 31 (the size of the edition is not known, but was probably about 100), on cream-toned simile Japan, with margins, in good condition apart from a glue stain in the edge of the upper margin, recto, two inconspicuous printer's creases in the sky at right, two skinned spots in the margins, verso, slight rubbed spots and minor creases in the margins and faint light stain. 440 × 557 mm; 17⅜ × 22 in.

In his introductory essay to the catalogue, *The Graphic Art of Winslow Homer,* Lloyd Goodrich observes that in this work, possibly his last etching, Homer was particularly am- bitious in his experimentation with burnished aquatint. S-NY $12,650

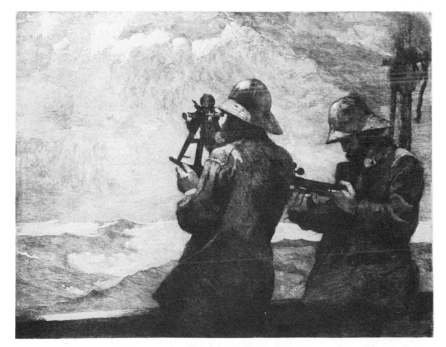

Eight Bells, *etching, 1887, 19⅜ in. × 25 in. Photograph courtesy Sotheby Parke Bernet, Inc., New York, copyright by Sotheby Parke Bernet, Inc., 1979*

Edward Hopper (1882–1967)

Edward Hopper was born in Nyack, New York. He studied with Robert Henri and was greatly influenced by him. He traveled in Europe several times between 1906 and 1910 and was struck by the difference in lifestyles: America exposing her nerve endings, as compared to a more genteel existence in Europe. The idea that the United States was a bleak, lonely place populated by detached souls was a continuing, potent theme in his work. During his most fertile graphic period, the years 1915 to 1923, he produced some seventy drypoints and etchings. He then turned away from these media to concentrate on painting. Hopper was a highly acclaimed popular artist whose particular vision was substantiated by a 1933 retrospective at the Museum of Modern Art in New York and a recent major show at the Whitney Museum of American Art. He continues to be regarded as a leading American painter and etcher.

Night in the Park (Zigrosser 20), etching, 1921, on white wove paper, a fine, heavily inked impression, signed in pencil, with the date stamp of The Downtown Gallery on the reverse, with margins, traces of printer's ink at the bottom margin edge and on the reverse, framed. 6⅞ × 8¼ in. (175 × 210 mm). C-NY $8,800

Evening Wind (Zigrosser 9, Levin pl. 77), etching, 1921, a fine impression, printed with platetone on the bed and curtains, signed in pencil, also inscribed by the artist in the lower margin: "The Evening Wind $25. Edward Hopper, 3 Wash. Sq., No. New York," one of probably under 100 impressions, on wove paper, with full margins, in good condition (traces of glue in the edge of the lower margin) 7 × 8¼ in. (176 × 210 mm). S-NY $11,550

Night Shadows (Zigrosser 22, Levin pl. 82), etching, 1921, signed in pencil, from the edition of between 500 and 600, published by the New Republic in the *Six American Etchings I* portfolio, 1924, with margins, in good condition. 7 × 8¼ in. (178 × 211 mm). S-NY $5,775

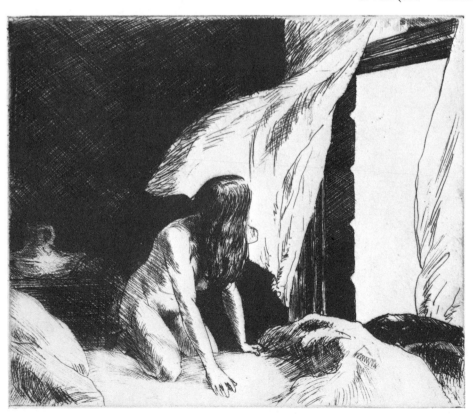

Evening Wind, etching, 1921, 6⅞ in. × 8⅜ in. Photograph courtesy Christie, Manson & Woods International, Inc., New York

Friedensreich Hundertwasser (1928–)

Hundertwasser was born Friedrich Stowasser in Vienna. He was drafted into the Hitler Youth Corps when he was thirteen and only after the war, in 1948, did he begin his studies at the Akademie der Bildenden Künste in Vienna. Hundertwasser has created a vast number of paintings and prints, and published the prints in as many as ten thousand impressions (the image in different color combinations or on different papers) to reach as many people as possible with his art. He has spoken out verbally, and visually in his work, against the confinement of modern architecture, urging people to take creative steps to combat its sterility. That is one of the inspirations for the varying colors on a single theme. In 1958, while teaching in Hamburg, Hundertwasser delivered the "Moldiness Manifesto: Against Rationalism in Architecture." This solution suggested that a mold growth on the buildings would change their monotony. Hundertwasser's work has been exhibited in galleries and museums internationally. In 1968 a major retrospective of his work was held in the University of California Art Museum at Berkeley.

Regentag, the complete portfolio of 10 silkscreens printed in colors, 1971, each stamp signed, stamp numbered 183/3000; *It Hurts to Wait with Love if Love is Somewhere Else* (Work No. 630a), signed in ink and numbered 19/300, the portfolio cover signed and numbered in colored crayon, published by Ars Viva, Zurich, all full sheets, in good condition, contained in original silkscreened box. Each sheet 699 × 490 mm; 26¼ × 19¼ in. S-NY $6,050

The Journey I (Work No. 639), etching printed in colors, 1966, signed in ink and inscribed "HC 1/14," also numbered in pencil "(51/107)" (from the total edition of about 280, 150 of which were published in *Paroles Peintes III),* printed by Lacourière, Capelle, and Jacques David, Paris, published by Lazar-Vernet, Paris, 1967, with full margins and in apparently good condition, framed. 320 × 240 mm; 12⅝ × 9½ in. S-NY $825

Good Morning City (Work No. 686), silkscreen printed in colors, with metal embossing, printed in colors, 1970, signed in pen and with the artist's stamps, dated and numbered 1513/10,000, from the series MM, with full margins, in good condition, framed, 842 × 556 mm; 33⅛ × 21⅞ in. S-NY $495

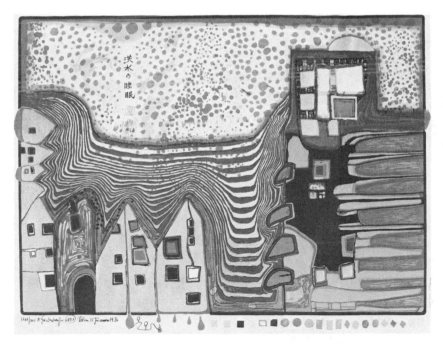

Flooded Sleep, woodcut printed in colors, 1976, 14⅛ in. × 20½ in.
Photograph courtesy Sotheby Parke Bernet, Inc., New York, copyright by Sotheby Parke Bernet, Inc., 1977

Louis Icart (1880–1950)

Louis Icart was born in Toulouse, France. He began drawing at an early age. He was particularly interested in fashion, and became famous for his sketches almost immediately. He worked for major design studios at a time when fashion was undergoing a radical change—from the fussiness of the late nineteenth century to the simple, clingy lines of the early twentieth century. Icart fought in World War I. He relied on his art to stem his anguish, sketching on every available surface. When he returned from the front he made prints from those drawings. The prints, most of which were aquatints and drypoints, showed great skill. Because they were much in demand, Icart frequently made two editions (one European, the other American) to satisfy his public. These prints are considered rare today, and when they are in mint condition they fetch high prices at auction.

Prelude, *drypoint printed in colors, 14¾ in. × 21 in. Photograph courtesy Phillips Fine Art Auctioneers, London*

Énigme, etching, drypoint, and aquatint, printed in colors, hand varnished, copyright 1935, signed in black crayon and with the blindstamp of the artist, laid down, framed. 523 × 408 mm; 20⅝ × 16⅛ in. S-NY $550

Vénus, drypoint and aquatint, printed in colors, 1929, signed in black crayon, with the blindstamp of the artist, with full margins, glued to the mat, the paper discolored, with glue stains on the verso, framed. 340 × 478 mm; 13⅜ × 18¾ in. S-NY $715

Joie de Vivre, etching, drypoint, and aquatint, printed in colors, copyright 1929, signed in black crayon, with the blindstamp of the artist, with large margins, light stained and remains of old glue in the margins, laid down, framed. Image 600 × 385 mm; 23⅝ × 15⅛ in. S-NY $1,265

Can-Can Français, etching, drypoint, and aquatint printed in colors, copyright 1933, signed in black crayon, with the blindstamp of the artist, with full margins, several small stains in the subject, slightly light and backboard stained (visible on the recto), a small tear in the right margin edge, otherwise in good condition. Image 402 × 630 mm; 15⅞ × 24¾ in. S-NY $2,310

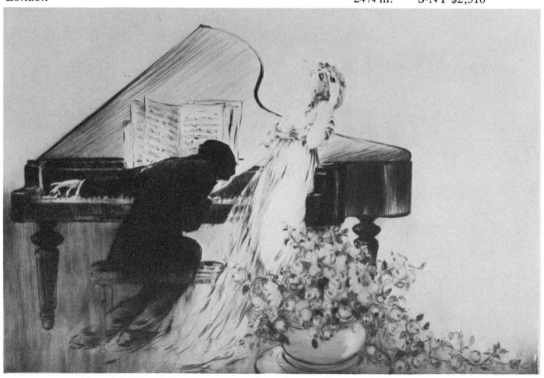

Johan Barthold Jongkind (1819–1891)

Jongkind was born near Rotterdam in Holland. He was never recognized in his native country but enjoyed great success in France. A specialist in landscapes and marine scenes, Jongkind had his first show in Paris in 1852, exhibiting his now famous painting *Clair de Lune*, which depicted the entire city of Paris. He was a favorite among other artists, and whenever he was close to being penniless, they would organize auctions to help support his further study and work. He left France at one point because he was in financial straits, but other artists persuaded him to return and participate in the 1863 Salon des Refusés. He attracted attention during that show because his work was exhibited alongside that of Manet and Fantin-Latour. He also attracted a lady who became first his student, then his patron. Her help afforded him the luxury of time to create. Jongkind was moved by nature and remained true to its glorification in all his work.

Entrée du Port de Honfleur (Delteil 10), etching, 1863, third (final) state, on thick laid paper with the *Aquafortistes* watermark, published by Cadart and Luquet and with their blindstamp, with large margins, in good condition except for some foxing. 238 × 318 mm; 9⅜ × 12½ in.
S-NY $495

Soleil couchant—Port d'Anvers (D. 15), etching printed with platetone, 1868, the final state with the publication line suppressed on laid paper, with full margins, in good condition (a few minor specks of foxing, a slight rubbed spot in the lower margin, verso). 160 × 241 mm; 6¼ × 9½ in.
S-NY $550

Sortie de Port de Honfleur Etching with drypoint, 1864, signed in the plate, with the blindstamp of Cadart and Luquet; a good impression but foxed and time-stained. 23.7 cm × 31.5 cm. P-L $1,330

Sortie de Port de Honfleur, *etching with drypoint, 1864, 9¼ in. × 12½ in.*
Photograph courtesy Phillips Fine Art Auctioneers, London

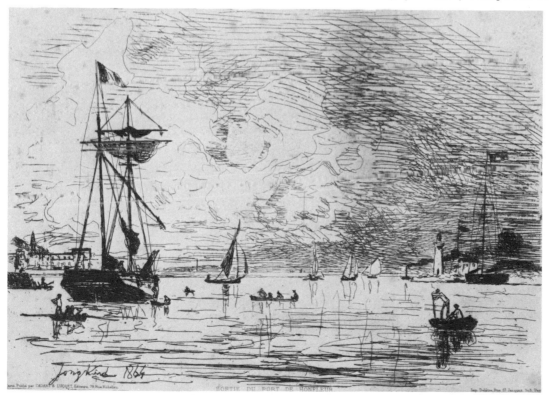

Wassily Kandinsky (1866–1944)

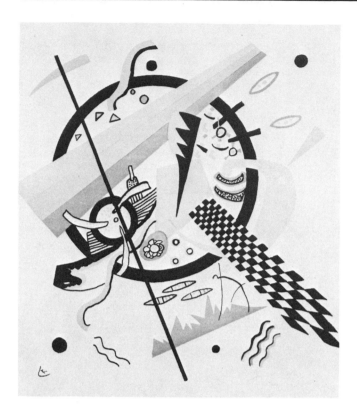

Kleine Welten IV, *lithograph in colors, 1922,*
13½ in. × 11⅜ in.
Photograph courtesy Christie, Manson & Woods
International, Inc., New York

One of the founders of abstract art, Kandinsky was almost thirty before he devoted himself to painting. Born in Moscow, he studied law but in the 1890s gave up his career and went to Munich to study art. In 1911, with Paul Klee, he founded the Blaue Reiter group, the new abstract school in Munich. Kandinsky was forced to return to Russia during World War I; prior to leaving Russia for Germany again in 1921, he founded the Academy of Artistic Sciences. In 1922 he joined the Bauhaus group at Weimar where he was to develop his distinct geometric style. Although he was closely aligned with such Russian constructivists as El Lissitzky, Kandinsky showed a more romantic, less rigid approach to composition. In 1933, when Hitler closed the Bauhaus, Kandinsky fled Germany and went to Paris. His graphic oeuvre consists of etchings, woodcuts, and lithographs, but it is the lithographs which most successfully complete the translation of his concepts.

Fünfte Jahresgabe für die Kandinsky-Gesellschaft (R. 195), drypoint, 1931, on Japan, signed and inscribed in pencil "Dem verehrten lieben Herrn Heinrich Kirchoff zu 1.I.32 herzlichst Kandinsky," from the edition of 10, all inscribed to the members of the Kandinsky-Gesellschaft, signed and inscribed by the printer "O. Felsing Berlin gdr," with margins, slight creasing, the margins a little discolored, a tiny tear in the bottom edge. P. 7¹⁄₁₆ × 5⅞ in. (180 × 149 mm). C-NY $2,640

Kleine Welten IV (R. 167), lithograph in colors, 1922, on wove paper, an extraordinarily fresh impression (the violet and green inks were particularly light sensitive and are rarely found in the unfaded state of this example), signed in pencil, from the edition of 230 (of which the first 30 were on Japan), with margins (the sheet called for by Roethel is 340 × 290 mm), a little very unobtrusive soft creasing at the edges (caused, at the top edge, by old hinges) but generally in fine condition. S. 13½ × 11⅜ in. (342 × 289 mm). C-NY $6,050

Holzschnitt für die Ganymed-Mappe (Roethel 181), woodcut, 1924, signed in pencil, from the edition of 100 included in *Ganymed-Mappe,* published by Marées-Gesellschaft, 1924, on laid paper, with full margins, in good condition aside from slight mat stain in the sheet edges, framed. 151 × 200 mm; 5⅞ × 7⅞ in. S-NY $1,430

Rockwell Kent (1882–1971)

Rockwell Kent was born in Tarrytown Heights, New York. He studied art with Robert Henri and Kenneth Hayes Miller in New York. A rugged individualist, Kent spent a great deal of his life traveling. His most famous work was created during extended stays in Greenland where the grandeur and foreboding of the landscape, extremes of climate, and Eskimo culture were tremendous influences. His strong, singular style is evidenced in wood engravings and lithographs. Kent also painted, and worked as a commercial artist in advertising and with textiles. He was a political activist who refused to testify before the House Un-American Committee in the 1950s. Blacklisted, and against the growing trend to abstract art, Kent was virtually unrecognized in those years. Today he is the focus of renewed interest, and many prominent American museums feature his work in their collections.

Mala, lithograph, 1933, edition of 150, 11⁵/₁₆ in. × 9⁷/₈ in. Photograph courtesy Kennedy Galleries, Inc., New York

Lithographs

Pasture Gate. 1928. 10⅝ × 7¼ in. B-J 26. Ed: 110. Signed in pencil. D $550

Eskimo Mother and Child. 1937. 9⅝ × 13¼ in. B-J 114. Ed: unknown. Signed in pencil. Kent's Greenland housekeeper Salamina, and her baby daughter, are shown playing on the beach at Idglorssuit, Greenland. D $650

Wood Engravings

To Frances! 1930. 4⁹/₁₆ × 2⅛ in. Burne-Jones 54. Edition: 30. Signed in pencil. This print, made in honor of Kent's second wife, Frances Lee Kent, was used as a dinner party souvenir. D $475

Night Flight. 1941. 8½ × 6⅜ in. B-J 132. Ed: 150. Signed and titled in pencil. A chiaroscuro wood engraving, printed in black and bluish-gray on white paper. D $1,100

Starry Night (B.-J. 103), wood engraving, 1933, signed in pencil, from the edition of 1750, on laid Japan paper, with margins, in generally good condition apart from foxing, faint light stain, two spots of discoloration and a small stain in the upper margin corners (recto) from glue stains on the verso. 179 × 127 mm; 7 × 5 in. S-NY $192

Paul Klee (1879–1940)

Klee was born near Bern, where he produced his first engravings in 1903 after studying art for four years in Munich. Klee's personal style came to reflect his interests in cubism, in primitive art, in impressionism, and in the art of children. After returning to Munich in 1911, he participated in the Blaue Reiter group's third exhibition. He visited Tunisia in 1914 and Egypt in 1928. His travels in these countries had a significant impact on his art. Klee developed his own often whimsical world of line and color, rich in symbolism and the expression of his vision of society. He taught from 1920 to 1931 at the Weimar Bauhaus and then at Dessau's Bauhaus. It was during this time that he met Kandinsky. While Klee's work showed the influence of constructivist tenets, it never lost the humane element which made it seem much freer.

Rechnender Greis, etching, 1929, 11⅝ in. × 9⅜ in.
Photograph courtesy Sotheby Parke Bernet, Inc.,
New York copyright by Sotheby Parke Bernet, Inc., 1974

Rechnender Greis (K. 104), etching, 1929, signed in pencil, dated, titled, with the artist's work number "s.9" and inscribed "2. Probedr.," one of a few proof impressions, before the edition of 130 published by Schweizerische Gesellschaft, on sturdy yellowish Japan paper, with full margins, in good condition aside from a slight, inconspicuous crease in the background of the image at left, a few minor creases, tiny indentations in the margins, faint light stain and a few slight skinned spots, and a tape hinge stain on the verso, framed. 298 × 239 mm; 11⅝ × 9⅜ in.
S-NY $7,700

Kopf Bartiger Mann (Kornfeld 98 Bb), lithograph, 1925, signed in pencil, from the edition of 232 on wove paper (there was a further edition of 30 on Japan), published by O. W. Gauss, Munich, c. 1930, with full margins, in good condition aside from slight discoloration in the margins and faint light stain. 222 × 183 mm; 8⅝ × 7⅛ in.
S-NY $1,760

Seiltänzer (K. 95, IVb), lithograph printed in colors, 1923, signed in pencil, dated and with the work number 138, from the portfolio *Kunst der Gegenwart,* one of 80 impressions on Japan paper (220 more were printed on laid paper), with the blindstamp of the publisher, Marées-Gesellschaft, with full margins, in good condition aside from slight light stain, a few pencil notations in the lower and right margins, framed. 435 × 270 mm; 17⅛ × 10⅝ in. S-NY $13,750

Vogelkomödie (Kornfeld 69), lithograph, 1918, signed in ink (faded), from the edition of 50 published in the portfolio *25 Originallithographien der Münchener Neuen Secession,* 1919, on Van Gelder laid paper, with full margins, in good condition apart from slight soiling and a few soft handling creases in the margins. 425 × 315 mm; 16¾ × 12⅜ in.
S-NY $2,475

Oskar Kokoschka (1886–)

Kokoschka's vividly imagined paintings and lithographs have made him a major figure among the expressionists. He was born in Austria and studied at the School of Arts and Crafts in Vienna. In the years immediately following, Kokoschka began making his deeply felt, sensitive portraits which stand as significant contributions to his body of work. These portraits reflect the intensity of his feelings about the state of man. His self-portrait, executed as a lithograph in 1923, is the very picture of a tortured soul. During Kokoschka's career, he also painted landscapes, town scenes, and allegorical studies. In 1915 he was seriously wounded in the war and went to live in Dresden where he taught at the Academy until 1924, when he started to travel for a decade through Europe, the Near East, and North Africa. He settled in England (to avoid political problems in his homeland) and acquired British nationality in 1947. Then, in 1955, he moved to Switzerland. His work can be seen in prominent museums throughout the world.

King Lear (Wingler/Welz 223–238), the complete book comprising sixteen lithographs in text, 1963, signed in pencil on the justification page, numbered 222, from the total edition of 275, published by Ganymed Original Editions Ltd., London, all with full margins and in good condition, contained in original box. Each sheet c. 455 × 360 mm; 17⅞ × 14⅛ in. S-NY $1,650

Tower Bridge, lithograph from the set *London from the Thames,* signed in pencil and numbered 27/75. 63 cm. × 90 cm. (SH) P-L $310

Beached Boats on a Thames Reach, lithograph from the set *London from the Thames,* signed in pencil and numbered 27/75. 63 cm. × 90 cm. (SH) P-L$310

Tower Bridge, lithograph from the set London from the Thames, *25¼ in. × 36 in.*
Photograph courtesy Phillips Fine Art Auctioneers, London

Käthe Kollwitz (1867–1945)

Käthe Kollwitz, German sculptor and graphic artist, married a doctor in 1891 and settled with him in a Berlin slum, where they remained until it was bombed in 1943. The pain and suffering Kollwitz experienced firsthand every day strongly influenced her art. She was recognized for her etchings in 1894 when her first *Mother and Child* studies appeared. This recurring theme was to gain a more tormented feeling after her own son was killed in 1914. A pacifist, Kollwitz made a trip to Russia in 1927 but was disillusioned by what she found there. She used the graphic arts to gain followers for her emotional social commentary and wanted to make her prints available to as many people as possible. She was known to have signed reproductions for this purpose and large posthumous editions were also issued.

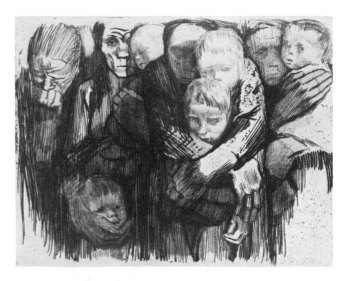

The Mothers, *etching, 1919, 9¾ in. × 12½ in. Photograph courtesy Kennedy Galleries, Inc., New York, and Galerie St. Etienne, New York*

Das Volk, plate 7 from *Sieben Holzschnitte zum Krieg* (Klipstein 183 Vc), woodcut, 1922–23, on wove paper, signed in pencil, inscribed "B" and numbered 1/100, with margins, light staining showing mostly at the mat opening, framed. L. 14⅛ × 11¾ in. (360 × 299 mm.) C-NY $880

Besuch im Kinderkrankenhaus (K.218b), lithograph, 1926, on thick grayish wove paper, signed in pencil, from the edition of unrecorded size for members of Vereinigung Freunde graphischer Kunst, Leipzig (Klipstein records 30 impressions in the edition-de-tête), with (trimmed) margins, a diagonal crease and a surface abrasion at the bottom margin corners, faint light staining. L. 10¾ × 13¼ in. (273 × 337 mm.) C-NY $4,180

Selbstbildnis (K.122/VII/a), etching and soft-ground printed in brown, 1912, signed in pencil, also signed by the printer, Felsing, on Japan paper, with full margins, in good condition aside from faint light stain, very slight soiling in the edges (slight indentation from the mat in upper margin), framed. 140 × 100 mm; 5½ × 3⅞ in. S-NY $1,650

Die Eltern der Künstlerin (K.136/a), lithograph, 1919, a fine impression, signed in pencil, an early trial proof, before the edition of 25 on Japan and 275 on wove, on wove paper, with full margins, in good condition aside from slight mat stain and a few pale fox marks in the margins, an ink inscription in the lower left corner, slight glue stains on the verso. 315 × 479 mm; 12⅜ × 18⅞ in. S-NY $935

Fernand Léger (1881–1955)

French painter Fernand Léger was aligned with the cubist movement and was an innovator in abstract art. He studied briefly at the École des Beaux-Arts in 1903. By 1911 he had become friendly with Georges Braque and Pablo Picasso and had exhibited at the Salon des Indépendants. Léger continually experimented with color, shape, movement, and space. The relations of geometric forms and mechanical elements—cranks, pistons, cogs, and robots—were an important part of his artistic vision. Léger came to the United States in 1940 to escape the German forces in Paris. He traveled extensively, and his work during this period was inspired by the American industrial landscape. It was at this point that he began to minimize the connection between color and outline. Léger experimented with lithography (a highly successful medium for him) at the Paris Atelier 17. Today his paintings and prints can be seen in prominent museums throughout the world.

Mourlot Centennial, lithograph
printed in colors, 1952, 16 in. × 23 in.
© S.P.A.D.E.M., Paris/V.A.G.A., New York, 1983.
Photograph courtesy Sotheby Parke Bernet, Inc., New York, copyright by Sotheby Parke Bernet, Inc., 1978

Lunes en Papier (Saphire 3-9), the book comprising seven woodcuts, 1921, plus the printed cover, with text by André Malraux, signed in blue ink by Léger, also signed in black ink by Malraux, numbered 88, from the edition of 112, printed by Biraut, Paris, published by Éditions de la Galerie Simon, Paris, on laid Van Gelder paper, with full margins, in good condition, with original Japan cover with woodcut (S.3) (with slight minor creases in the right edge).
S-NY $2,200

Composition au Profil (S.19), lithograph printed in colors, 1948, signed in pencil and numbered 22/75, published by Galerie Louise Leiris, on Arches wove paper, with full margins, slightly light stained, a few slight skinned spots from removal of old hinges in the upper margin edge, verso, otherwise in good condition, framed. 364 × 501 mm; 14⅜ × 19¾ in. S-NY $1,650

Composition aux deux Oiseaux (S.134), lithograph printed in colors, 1954, signed in ink (faded) and numbered 40/75, with full margins, some light stain, upper right corner detached, masking tape and mat stain on the verso, otherwise in good condition, framed. 400 × 530 mm; 15¾ × 20⅞ in.
S-NY $880

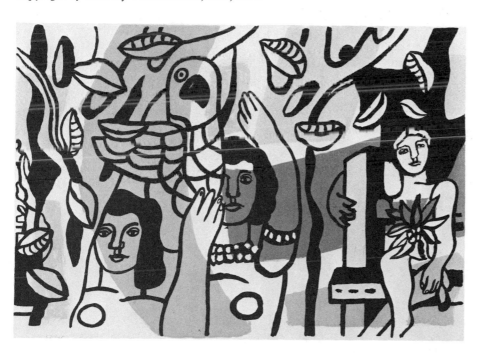

Martin Lewis (1882–1962)

Martin Lewis was born in Australia. He came to the United States in 1900, an unschooled painter whose frame of reference was the ranches and mining camps which were so much a part of his early years. He began his printmaking career in 1915 and won many prizes for his work in the 1920s and 1930s. He was influenced by Edward Hopper and helped Hopper when he began etching. A skilled etcher who worked primarily in drypoint, Lewis was particularly noted for his realistic prints of New York scenes, which show a mastery of light and weather conditions and a great sensitivity and warmth for his subjects. Lewis's popularity waned considerably after World War II, but recently there has been a tremendous surge of interest in his work.

Shadows on the Ramp, drypoint and sandpaper ground. 1927 (McCarron 59). Edition: 100. 8⅞ × 10⁷⁄₁₆ in. Signed and annotated "imp" in pencil. D $1,500

The Tree, Manhattan, drypoint with sandpaper ground. 1930 (McCarron 92). Edition: 100. 12⅞ × 10 in. Signed in pencil. Bears the collection stamp of Patricia Lewis. This is a brilliant impression of one of Lewis' finest prints. D $4,300

Haunted (McCarron 104), drypoint, 1932, from the edition of 100. Signed in pencil. A rich impression on cream laid paper with full margins. Very faintly lightly struck, otherwise in excellent condition, framed. 13⅛ × 9 in. (355 × 230 mm). P-NY $1,430

Bay Windows (M. 86), drypoint and sandpaper ground, 1929, on laid paper, a very good impression, signed in pencil and inscribed "imp," from the edition of 100, with margins, glued to the overmat at several spots along the top margin edge, very faint mat staining, framed. 11⅞ × 7¾ in. (302 × 197 mm). C-NY $2,750

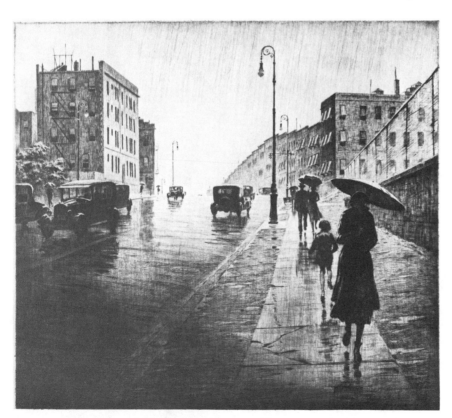

Rainy Day, Queens, drypoint, 1931, probable edition of 100, 10⅝ in. × 11³⁄₁₆ in. Photograph courtesy Phillips Fine Art Auctioneers, New York

Louis Lozowick (1892–1973)

In 1906 Louis Lozowick emigrated to the United States from Kiev, Russia. His style was greatly influenced by constructivist artists whom he met while traveling in Germany and Russia in the early 1920s. He began his printmaking activities during those years, concentrating thereafter on lithography. He made almost three hundred lithographs during his lifetime. When he returned to the United States, Lozowick was increasingly motivated by the industrial urban landscape. His black-and-white lithographs captured the austere nature of big cities like New York. His work was well received until the 1930s when he became politically active. As an editor of *The New Masses,* he fought for social reforms. These themes began to appear in his graphic work, which became less popular.

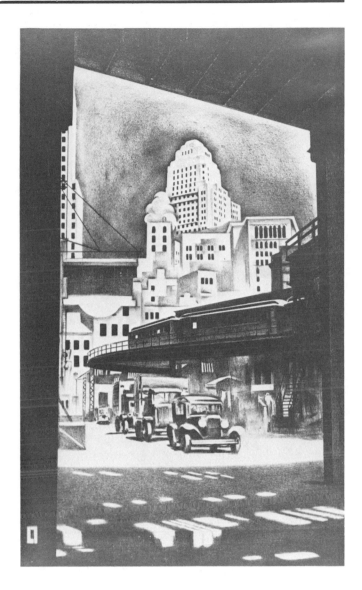

Hanover Square, lithograph, 1929, edition of 25, 14¾ in. × 8⅞ in.
Photograph courtesy Madeleine Fortunoff Fine Prints, Long Island, New York

Minneapolis (Whitney Museum Checklist 3), lithograph, 1925, signed and dated in pencil, from the edition of 20, with full margins, in good condition apart from slight discoloration and hinge stains in the upper margin edge. 296 × 228 mm; 11⅝ × 9 in. S-NY $3,630

Elevated Railway, lithograph, c. 1930, signed in pencil, from the edition of probably 20 impressions, in good condition apart from slight discoloration, with two short mended tears in the right edge. 320 × 218 mm; 12½ × 8½ in. S-NY $1,870

Spanning the Hudson (A.A.A. checklist 59), lithograph, 1936, signed in pencil, dated, titled and numbered "iv/x", from the edition printed at the request of the artist in 1972 (an edition of 15 had been printed in 1936), on white wove, with full margins and in good condition. 233 × 337 mm; 9⅛ × 13¼ in. S-NY $880

Aristide Maillol (1861–1944)

Aristide Maillol, primarily known as a sculptor in his native France, was associated with the Nabis group, which included Bonnard and Vuillard. Maillol was a master of the nude figure and concentrated on the female form, almost always making her well-built, well-proportioned, and sensuous. His graphic work, undertaken in the second half of his life, consists mainly of book illustrations. His woodcuts, simple renditions, were perfect complements to the classical texts they illustrated. In about 1912, Maillol and his nephew, while working on illustrations for a book, experimented with different papers and finally began making their own to best suit their work. Maillol's work is included in the collections of many prominent international museums.

Femme de Dos, Drapée (G. 272), lithograph, third (final) state, initialed in pencil and numbered 84/100 from *l'Album Maitres et Petits d'aujourdhui, 1re série,* with the blindstamp of the publisher, Galerie des Peintres-Graveurs, Paris, on laid paper, with full margins, in good condition aside from inconspicuous light and mat stain, framed. 275 × 130 mm; 10¾ × 5⅛ in. S-NY $605

Épanouissement (G. 280), lithograph printed in black, with the Frapier state stamp indicating an impression of the first state (L. 2921c), initialed in pencil and numbered 46/50, on soft cream-toned Japan paper, with the blindstamp of the Galerie des Peintres-Graveurs, Paris, with full margins, slightly light stained, a few faint fox marks and several handling creases, otherwise in good condition. 206 × 300 mm; 8⅛ × 11¾ in. S-NY $495

Femme en Berceau, Bras Gauche Relevé, Bras Droit Abaissé, 3eme planche (Guérin 269), lithograph, c. 1935, on Arches, initialed in pencil, numbered 1/25 (there were a further 25 impressions in sanguine and a few trial proofs on Chine), with Frapier's stamp lower left indicating a first state (L. 2921c) and the blindstamp of the Galerie des Peintres-Graveurs (L. 1057b), with margins, foxing, unobtrusive rubbing on the reverse. L.6⅛ × 7¼ in. (156 × 185 mm.) C-NY $330

Pomone (Guérin 275), lithograph printed in sanguine, 1927. Initialed and numbered in pencil 31/35. A good printing on laid Chine with full margins; with the Frapier state stamp (Lugt 2921c), indicating a first state; also with the blindstamp of the publisher, Galerie des Peintres-Graveurs (Lugt 2921 b). In good condition. Image: 8¼ × 2¾ in. (210 × 70 mm). P-NY $165

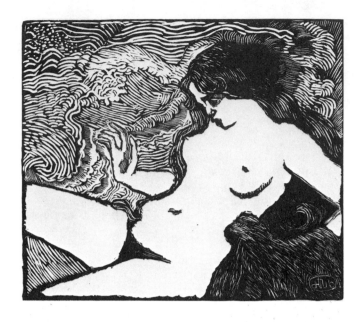

La Vague, second state, woodcut, 1895–98, 7⅝ in. × 6¾ in. Photograph courtesy Sotheby Parke Bernet, Inc., New York, copyright by Sotheby Parke Bernet, Inc., 1983

Édouard Manet (1832–1883)

Manet was born in Paris, the son of a wealthy government official who reluctantly allowed him to study art. Manet soon rebelled against his teacher's formal methods and began painting studies of the seamier side of Parisian life. Influenced by Goya, his early works are commentaries on the times. The controversial nature of his paintings caused them to be rejected repeatedly by the jury of the Salon. In 1870, Manet's style changed, and he began to use impressionist techniques and colors, and his paintings became lighter and more sensitive. The recognition he longed for came late in his life, when he received the Legion of Honor. Manet started making prints in 1860. He completed seventy-five etchings and twenty-five lithographs, but not all the lithographs were published during his lifetime.

Le Philosophe (Guérin 43; J. Wilson; Ingelheim 42; Berès 50), etching and drypoint printed in brown, 1865–66, from the edition of 30 published by Strölin, 1905, on cream laid paper, with full margin at top, three margins slightly shaved, in good condition aside from faint mat stain, a few fox marks, and slight soiling in the margins and on verso, framed. 274 × 165 mm; 10¾ × 6½ in. S-NY $495

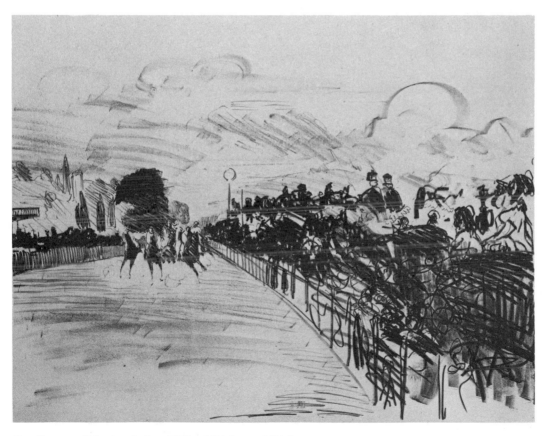

Les Courses, lithograph, late 1860s, 14½ in. × 20½ in.
Photograph courtesy Christie, Manson & Woods International, Inc., New York

Reginald Marsh (1898–1954)

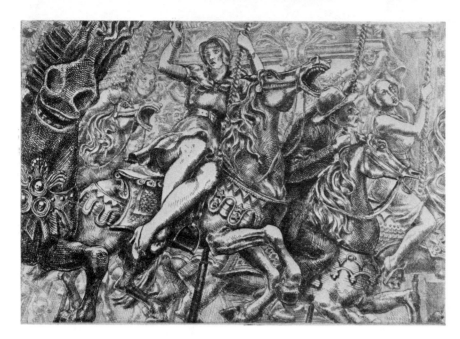

Merry-Go-Round, etching and engraving, 1930, 7 in. × 9⅞ in.
Photograph courtesy Christie, Manson & Woods, International, Inc., New York

Reginald Marsh was born in Paris to American parents who were artists. Marsh was brought up just outside New York City and went to Yale University. He began his career as an illustrator for *Vanity Fair, Harper's Bazaar,* and *The New York Daily News.* In 1923 he turned his attention to paintings. Three years later he made his first etchings. Most of these early works were patterned after paintings. They reflect Marsh's fascination with some of the sordidness of New York life and with the effects of the Depression. He was a master at conveying the rapid pulse of New York crowds which bespoke a constant, quick growth of population—people coming to the city to look for work. He also produced thirty prints of locomotives, a favorite subject. Marsh worked in the media of lithography, woodcut, and engraving, but it is his etchings which are counted among his finest work.

Girl Walking (Sasowsky 28), lithograph, 1945, from the edition of 250 published by Associated American Artists. Signed in pencil. A good printing on cream wove with all the margins. In excellent condition. 10⅝ × 8 in. (270 × 203 mm). P-NY $935

Switch Engines, Erie Yards, Jersey City, Stone No. 3 (Sasowsky 30), lithograph, 1948, a fine impression, signed in pencil, from the total edition of 263, printed for The Print Club of Cleveland (stamp on verso), on wove paper, with full margins and in good condition. 9 × 13⅜ in. (228 × 340 mm). S-NY $1,210

Merry-Go-Round (S. 99), etching and engraving, 1930, on laid paper, watermark J. WHATMAN, sixth (final) state, signed in pencil, from the edition of which Sasowsky records the highest numbered impression located at 58 (Jones pulled an edition of 8 in 1956; 100 impressions were printed by the Whitney Museum in 1969), with (uneven) margins, slight surface soiling and old hinges in the margins, unobtrusive traces of glue on the reverse. 7 × 9⅞ in. (178 × 251 mm). C-NY $2,420

Old Paris, Night Street and Two Girls (Sasowsky 6), lithograph, 1928, edition: 31, only state. Signed and annotated "30 proofs" in pencil. Dated in the plate. Some skinning in the outer margins not affecting the impression. Printed on heavy Chine Appliqué. 12⅞ × 9 in. D $1,900

Henri Matisse (1869–1954)

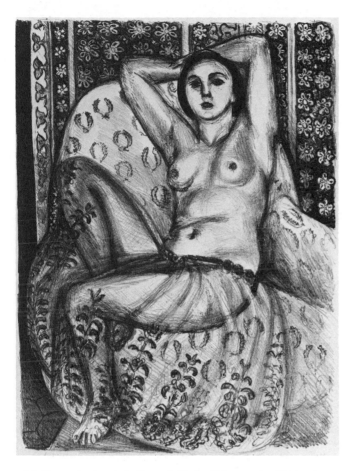

Odalisque Assise, à la Jupe de Tulle, lithograph, 1924, edition of 50, 14⅛ in. × 10½ in. © S.P.A.D.E.M., Paris/V.A.G.A., New York, 1983
Photograph courtesy Christie, Manson & Woods International, Inc., New York

French painter and sculptor Henri Matisse was the primary figure in the group of artists known as the fauves and a major influence on twentieth-century painting. In the 1890s Matisse studied in Paris as a pupil of Gustave Moreau at the École des Beaux-Arts. His style, deceptively simple, employs perfection of line to suggest the subject and, usually, the happy application of bright colors to enhance the image. He is best known for his still lifes and nudes. Matisse produced a large body of graphic work which included etchings, drypoints, woodcuts, lithographs, monotypes, and aquatints, as well as many book illustrations. In his later years, when he was an invalid, he began his highly acclaimed series of cut-out collages which he called "drawings with scissors." He was honored with the Grand Prize at the Venice Biennale in 1950, and has consistently been exhibited in the world's finest galleries and museums.

Nu au Fauteuil, les Bras Levés (Lieberman 109), lithograph, 1925, plate 63, signed in pencil and numbered 46/50, on Arches wove, with full margins, in good condition aside from traces of foxing, faint mat stain in the margins, framed. 635 × 480 mm; 25 × 18⅞ in. S-NY $41,250

Ulysses (James Joyce), the portfolio comprising six soft-ground etchings, each signed in pencil and numbered 140/150, published by The Limited Editions Club, New York, 1935, in good condition aside from minor soiling in the margins, in original wrapper and burlap-covered portfolio (slightly torn). Each sheet c. 415 × 318 mm; 16¼ × 12½ in. [6] S-NY $3,850

Odalisque Assise, à la Jupe de Tulle (F. 398; Pl. 52), lithograph, 1924, on Chine volant, a very good impression, signed in pencil, numbered 24/50, with margins, some glue staining in the margins particularly at two areas at top where removed from an old backing, slight mat staining, framed. L. 14⅛ × 10½ in. (359 × 266 mm.) C-NY $9,350

Femme au Collier (F. 420; Pl. 74), lithograph, 1925, on Japan, signed in pencil, numbered 24/50 (plus 14 artist's proofs), with margins, a minute rust spot on the figure's nose, slight rubbing bottom center, some unobtrusive creasing above the left margin edge, framed. 22 × 18 in. (559 × 458 mm.) C-NY $7,700

Charles Meryon (1821–1868)

Charles Meryon was born in Paris, the son of an English doctor. He studied painting in Toulon but was essentially unschooled in the etching medium which brought him critical success. A man given to melancholia, he sailed around the world in 1842 hoping to find a new lease on life. He returned to Paris convinced that it was the only place where he could create, and there he began a series of etchings that were to be among the most vivid ever made of that city. Meryon considered himself a visionary, living in his own world yet fascinated with history. His etchings, while not considered technically superior, were superb renderings of buildings and other Parisian landmarks. Each had a special personality, drawn in part from its place in history. Meryon exhibited these etchings to great acclaim in the Salons of 1852, 1863, 1865, 1866, and 1867.

LE STRYGE.

Le Petit Pont, Paris (Delteil/Wright 24), etching printed in brown-black ink, 1850, a very good impression of the third state of seven, on laid paper, with large margins, in good condition aside from traces of foxing, framed. 254 × 193 mm; 10 × 7⅝ in. S-NY $1,650

Le Pont-au-Change, Paris (D./W. 34), etching printed in brown-black ink, 1854, fifth state of twelve, on laid paper, trimmed to the platemark on three sides, narrow margin at right, in good condition aside from traces of foxing. 152 × 327 mm; 6 × 12⅞ in. S-NY $935

La Morgue, Paris (D./W. 36), etching and drypoint, 1854, a very good impression of the sixth state of seven, on Chine appliqué, with margins, slightly discolored in the margins from removal of previous mat, slightly skinned in the upper margin corners, verso. 234 × 208 mm; 9¼ × 8⅛ in. S-NY $2,200

La Rue des Toiles, à Bourges (L.D., W. 55), etching, 1853, on laid paper, eighth state (of nine), watermark Hudelist, with margins, some light fox marks. P. 216 × 120 mm. C-L $573

Le Stryge, etching with drypoint, 1861, edition of 30, 6¾ in. × 5 in.
Photograph courtesy Phillips Fine Art Auctioneers, London

Jean François Millet (1814–1875)

Millet was born near Cherbourg, France, the son of peasants. He received his training in Cherbourg and then went on, in 1837, to study under Delaroche in Paris. Ten years later he made his first impressive showing at the Salon in that city. His earliest works were peasant subjects. A period of portraits and nudes followed, and then he returned to the peasant subjects he understood best. In 1849 he moved to the village of Barbizon where he remained in poverty for the rest of his life, painting landscapes and vibrant peasant scenes. Millet made etchings and lithographs. He was not considered artistically effective in the lithographic medium, but his etchings showed great depth and nobility of feeling. His many prints recreated the subjects of his paintings. The most successful dealt with his humanitarian interests.

Le Paysan Rentrant du Fumier (D. 11), etching, 1855, third state of four, a fine, early impression, on laid paper with the watermark HALLINES, with full (large) margins (left margin folded back 13 mm), in generally good condition apart from a few tears, thin spots, holes and glue stains in the outer margins, and two tape hinge stains on the verso. 165 × 134 mm; 6½ × 5¼ in. S-NY $1,705

La Grande Bergère (D. 18), etching printed in sepia, 1862, on laid paper, with large margins (lower margin folded back 24 mm), a few pale fox marks in the background, faint light stain, slight soiling in the margins, a slight thin spot in the right sheet edge, otherwise in good condition, framed. 321 × 235 mm; 12⅝ × 9¼ in. S-NY $3,300

Les Bêcheurs (L.D. 13), etching, 1855, printed in brownish black on cream wove paper, fourth (final) state, with margins, time staining. P. 9⅜ × 13¼ in. (238 × 336 mm). C-NY $2,640

Gleaners, etching, c. 1890, 7½ in. × 10 in. Photograph courtesy Kennedy Galleries, Inc., New York

Joan Miró (1893–)

Joan Miró is one of Spain's foremost artists. He studied at Barcelona's Gali Art Academy while keeping abreast of the Parisian art movements. His early work was influenced by fauvism and cubism. In the 1920s the inspiration of surrealism began to be seen in his paintings. The Spanish Civil War, during which he was exiled to France, was the catalyst for the intense work he exhibited at the 1937 World's Fair in Paris. He returned to Spain in 1940 when France was invaded. One year later the first retrospective of his work was held at the Museum of Modern Art in New York. In 1947 Miró visited New York and worked at Stanley William Hayter's transplanted Atelier 17, learning etching techniques. He continued to experiment in this medium for many years, using the newest materials and equipment to get the richest textural and tonal results. Miró's calligraphy shows strong Oriental affinities, and stars and birds are magical symbols which appear throughout his work. In 1975 the Miró Museum was opened in Barcelona.

Les Philosophes II (B. 32), aquatint printed in colors, 1958, signed in pencil and numbered 36/75, printed by Crommelynck and Dutrou, published by Maeght, with full margins and in good condition, framed. 326 × 495 mm; 12¾ × 19½ in. S-NY $4,440

Le Chasseur de Pieuvres (B. 133), etching, aquatint, and carborundum printed in colors, 1969, signed in pencil and numbered 50/75, the full sheet, printed to the edges, in good condition aside from a few slight skinned spots on the verso from removal of old hinges. Sheet 1050 × 667 mm; 41¼ × 26¼ in. S-NY $3,410

Le Matador (B. 156), etching, aquatint, drypoint, and carborundum printed in colors, 1969, signed in pencil and numbered 50/75, on Arches wove paper, with full margins, in apparently good condition, framed. 1070 × 738 mm; 42⅛ × 29 in. S-NY $6,325

Équinoxe (B. 91), etching, aquatint, and carborundum, 1967, on Chiffon de Mandeure, signed in pencil, numbered 62/75, printed to the edges of the sheet, very faint discoloration along the right edge, framed. S. 41⅛ × 29¼ in. (1044 × 743 mm). C-NY $15,400

Henry Moore (1898–)

Henry Moore, Britain's greatest modern sculptor, studied at the Leeds School for Art and then at the Royal College of Art in London, where he also taught from 1925 until 1932. His first one-man show was held in 1928 at London's Warren Gallery. In addition to his sculpture, Moore produced many drawings. As an official war artist during World War II he created his very popular bomb shelter drawings. In 1948 he gained international recognition when he received the Prize for Sculpture at the Venice Biennale. He is known for his large-scale figurative works in stone, wood, and bronze. Perhaps it is his relationship with the size and complexity of these pieces that made the print media less challenging to him for much of his creative life. Moore did illustrate André Gide's translation of Goethe's *Prometheus,* but it was not until the late 1960s that he began experimenting continually with etchings and lithographs. These prints remain true to his vision and the purity of his forms. Moore's work can be seen in major museums and galleries throughout the world.

Two Women Bathing Child, lithograph, 1975, edition of 175, 19½ in. × 26 in.
Photograph courtesy Transworld Art, Inc., New York

Standing Figures and Reclining Figures (Cramer 15), lithograph printed in colors, 1950, signed in pencil, dated "50," and numbered 4/50, published by School Prints Ltd., London, printed by W. S. Crowell Ltd., Ipswich, on English, handmade paper, with full margins, in good condition (remains of tape and traces of old glue in the upper sheet edges, verso), framed. 298 × 245 mm; 11⅝ × 9⅝ in. S-NY $2,750

Four Draped Reclining Figures (C. 90), etching, 1967, signed in pencil and numbered 45/50, published by Gérald Cramer, Geneva, with full margins, in good condition, framed. 138 × 216 mm, 5⅞ × 8½ in. S-NY $880

Seven Sculptural Ideas, from *Europäische Graphik IX,* Munich/London, Galerie Wolfgang Ketterer/Felix H. Mann, 1974 (C., G., M. 296), lithograph, 1973, on Arches, signed and dated in pencil, numbered 36/65 (plus 35 on Japon Ancien and 10 artist's proofs), with margins, framed. L. 13¼ × 10¼ in. (336 × 260 mm.) C-NY $660

Reclining Figure Architectural Background IV (C., G., M. 457), lithograph in colors, 1977, on white wove paper, signed in pencil, numbered 46/100, with margins, slight surface soiling in the bottom margin, the bottom left margin corner creased. L. 12½ × 15 in. (318 × 381 mm.) C-NY $495

Alphonse Mucha (1860–1939)

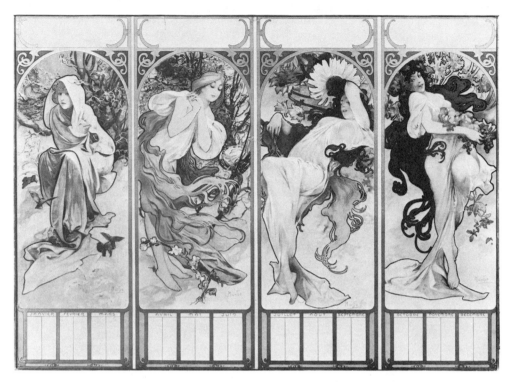

*Calendar for
Chocolat Masson, lithograph,
1895–1900,
16¼ in. × 22¾ in.
Photograph courtesy
Kennedy Galleries, Inc.,
New York*

Mucha was born in Czechoslovakia and emigrated to Paris when he was twenty-nine years old. It was there that he achieved great fame as one of the most important exponents of the art nouveau movement. He created prints, posters (many featuring the legendary actress Sarah Bernhardt), illustrations for books and magazines, and jewelry. Almost all of his designs were centered on romanticized female figures, highlighted by great flourishes. It has been said that his popularity came too quickly and he saturated his market with too many products, thereby causing a decline in quality and, eventually, demand. His early prints, in mint condition, are considered valuable today because they are some of the best representational art of his era and because Mucha earned an important place in European art history.

Imprimerie Cassan Fils. 1897. Lithograph printed in color. Mucha-Henderson ill. 74 (small version). 16¾ × 6¾ in. A fine impression in good condition apart from a small tear in the lower left area of the image. With a horizontal tear in the left margin. Mounted on canvas for support. Jiri Mucha claims that only one or two impressions of this version are known to exist. With rich colors. Framed. D $1,800

Calendar for Chocolat Masson. 1895–1900. Lithograph printed in color. Mucha-Henderson ill. 125, color plate XIX. State before the lettering in the panels above, and the dates in the calendar below. 16¼ × 22¾ in. A fine impression with two horizontal tears at right edge, two vertical tears above, and a small repair at center. Subtle autumnal colors. Mounted on canvas for support. Framed. D $4,200

Champenois Calendar (Rêverie). 1896. Lithograph printed in color. Mucha-Henderson ill. 128, color plate I with lettering above, "F. Champenois Imprimeur-Éditeur 66, Bould. St. Michel, Paris." 24¾ × 18¼ in. An excellent impression with vivid colors. In fine condition, apart from a small tear at left and one at the top edge extending slightly into the image. Mounted on canvas for support. Framed.
D $5,800

Edvard Munch (1863–1944)

Edvard Munch was born in Norway and studied art in Oslo. In 1889 the government of Norway financed his further study in France. He later produced most of his prints in Paris and Berlin. One of the forerunners of expressionism, Munch had an intensely personal style. In some of the most powerful prints of the late nineteenth century, he exorcised phobias of fear, sin, and death. The artist experienced mental problems, and the end of a love affair contributed to a severe breakdown in 1908. His work falls into two categories: before and after these troubles. In the latter period, Munch created more serene, colorful pictures that lacked the potency and significance of his earlier works. He is regarded as one of the greatest printmakers who ever lived.

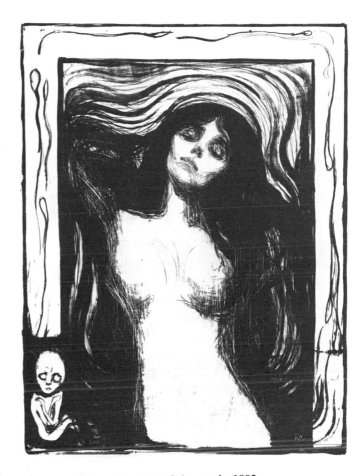

Madonna (Liebendes Weib), lithograph, 1895, 23½ in × 17⅛ in.
Photograph courtesy Christie, Manson & Woods International, Inc., New York

Der Tag Danach (Schiefler 15), drypoint, 1895, on stiff buff wove paper, signed in pencil, state IVd, printed in brownish black by Felsing and signed and inscribed by him "O. Felsing Berlin gdr," with margins, the margin corners a little creased (pinholes at top). P. 8¼₆ × 11⁷⁄₁₆ in. (205 × 290 mm.) C-NY $11,000

Das Kranke Mädchen (Sch. 59), lithograph in rose red, a lighter pinkish red, yellow, and gray green, 1896, on Japan, a fine, fresh impression, the drawing stone in the second state (of three; the first has no signature in the stone; the second has the signature E. Munch, as here; in the third this signature is removed and a new signature and date, E. Munch 1896, is substituted), signed in orange pencil (faded), inscribed "No. 1 II 2" in blue pencil, with margins, three pinholes, slight rubbing and surface soiling in the margins, a water stain at the bottom right margin edge, framed. I. 16⅝ × 22⅜ in. (422 × 570 mm.) C-NY $61,600

Eifersucht (large) (Schiefler 58), lithograph, 1896, printed by Clot, on wove paper, with narrow margins, some thin spots and damp stains (from removal of old backing), backed with thin Japan, framed. 325 × 452 mm; 12¾ × 17¾ in. S-NY $8,800

Mädchenbildnis (S. 369), lithograph printed in dark brown, 1912, an early impression, signed in pencil and inscribed "Früh Druck," on stiff cream-toned wove paper, with full margins in good condition aside from traces of mat stain and foxing, framed. c. 420 425 mm; 16½ × 16¾ in. S-NY $2,310

Emil Nolde (1867–1956)

Emil Nolde was a German expressionist painter known for his distorted figures and violent use of color. His subjects were based on the ideas underlying his private philosophy, which evolved by observing life in Germany, in the Far East, and in the South Seas. The raw, primitive qualities of these societies interested Nolde. He found demons there, nurtured them, and released them again in his work. In 1905 he was invited to join a movement called Die Brücke (The Bridge) which was based on a call to the youth of Germany to defy established values. Nolde joined them briefly, but found himself too individualistically motivated for such a movement. It was during this period that he experimented with woodcuts and lithography. He showed great skill and strength in his woodcuts, but he preferred the results he got with color in the lithographic process.

Mann im Zylinder—Portrait of Dr. Gustav Schiefler (Schiefler, Mosel 39), lithograph, 1911, on thin absorbent wove paper, second (final) state, signed in pencil, with margins, a small tear in the top margin, an old crease across the tip of the bottom right margin corner, soft creasing. L. 23⅜ × 19 in. (593 × 483 mm.) C-NY $13,200

Hamburg, Landungsbrücke (Schiefler-Mosel 139), etching, 1910, third (final) state, signed in pencil (the Schiefler-Mosel catalogue indicates 5 impressions each in the first and second states, and impressions of the third state on paper with watermark date 1929), on white wove paper, with large margins, in good condition aside from slight soiling on the margins and verso. 305 × 405 mm; 12 × 15⅞ in. S-NY $4,675

Der Tod als Tänzerin (Sch.-M. 200), etching, 1918, second (final) state, signed in pencil, printed by Kleinsorg (the Schiefler-Mosel catalogue indicates 10 impressions of the first state and over 18 of the second), on white wove paper, with full margins, in good condition (slight foxing in the outer margins). 210 × 265 mm; 8¼ × 10⅜ in. S-NY $3,300

Köpfchen (Schiefler 10a), lithograph printed in greenish black, 1907, signed in pencil, one from an edition of 50 (the first 20 impressions, according to Schiefler, were numbered), on cream wove paper, with large margins, faint traces of light stain, several creases (a few running into the subject), two small tears in the upper edge and skinned spots along the upper and left edges, verso, framed. c. 275 × 245 mm; 10⅞ × 9⅝ in. S-NY $1,760

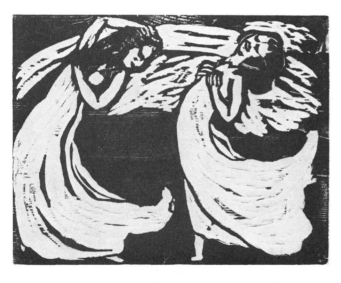

*Dancers, woodcut, 1917, edition of 12, 9½ in. × 12 in.
Photograph courtesy Kennedy Galleries, Inc., New York*

Joseph Pennell (1860–1926)

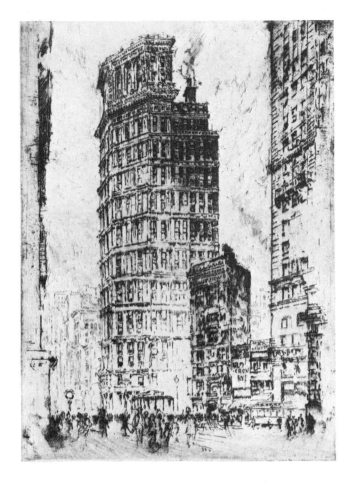

*St. Paul Building, etching, 1904, 11¾ in × 8⅜ in.
Photograph courtesy Kennedy Galleries, Inc., New York*

Joseph Pennell was born in Philadelphia. His first drawings, of a marsh in South Philadelphia, appeared in *Scribner's Monthly* in 1881 and won him a commission to illustrate articles by George W. Cable, which were later published as a book, *The Creoles of Louisiana*. In 1883 a publisher sent him to Italy to illustrate articles on Tuscan cities. He stopped in London on the way home, liked the city, and stayed there until 1917, when he returned to the United States. He met Whistler in London and became his good friend and, eventually, his biographer. An ardent admirer of Whistler's style, Pennell used elements of it in his own graphic work. He chose to turn away from traditional pictorial scenes, however, to concentrate on depictions of the work ethic. An enthusiastic, prolific printmaker, he completed more than 1,500 etchings and lithographs, a great many of which he willed to the Library of Congress in Washington, D.C. His artistic energy and his involvement with most of the printmaking societies of the times made him well-known and much admired.

Goldsmith's Tomb, The Temple; Exeter Hall; and *Clifford's Inn Hall* (W. 261, 355, 446), etchings, 1903, 1905, 1907, printed in brown, all signed in pencil and the first two inscribed "imp.," the last inscribed "del/a imp," and annotated "to F. Newlolot" (?), with margins, some slight surface soiling showing in the margins, W. 261 and 355 with some foxing and time staining, W. 355 and 446 with traces of printer's ink showing in the margins and on the reverse. (3) C-NY $264

West Door, St. Paul's (W. 272), etching, 1903, on laid paper, signed in pencil and inscribed "imp.," from the edition of probably 50, with margins, losses at the right margin edge, time staining, traces of printer's ink in the margins, surface soiling on the reverse; and *St. Augustine's and St. Faith's* (W. 433), etching, 1906, on laid paper, dated 1825, signed and titled in pencil and inscribed "imp.," from the edition of probably 50, with margins, light staining at an old mat opening, traces of old tape at the horizontal margin edges, time staining, slight surface soiling. (2) C-NY $187

Thames at Richmond (W. 277), etching and drypoint, 1903, on Japan, signed in pencil and inscribed "imp.," from the edition of probably 50, with margins, traces of printer's ink in the margins; and *Greenwich Park* (W. 407), etching and drypoint, 1906, on wove paper, signed in pencil and inscribed "imp.," from the edition of probably 50, with margins, traces of printer's ink in the margins, time staining at the top margin edge. (2) C-NY $308

Pablo Ruiz y Picasso (1881–1973)

Picasso is recognized as one of art's great geniuses. Few artists in history have matched his stature and impact. The son of an art teacher, he gave evidence of his talents early in his life. He was born in Malaga, lived for some years in Barcelona, and in 1901 moved to Paris where an exhibition of his work was held by Ambroise Vollard, an art dealer. Vollard's appreciation of Picasso's talents and his business acumen were key elements in Picasso's rise to dizzying heights. The years 1901 to 1904 marked the artist's blue period, in which he depicted grim social conditions. His rose period followed briefly, and in 1908 Picasso and Georges Braque began to develop cubism. Picasso experimented with collages and portraiture before entering, in the 1920s, what is known as his metamorphic phase, extending classical forms through his own visions. Expressionistic art was reflected in his major work *Guernica,* which was exhibited in 1937 at the Spanish Pavilion of the Paris World's Fair. Persuaded by printmaker Fernand Mourlot, Picasso turned to lithography in the 1940s. His inventiveness and verve conquered the medium, making it an exciting art form again and forever setting a standard of excellence. Picasso's graphic oeuvre is tremendous, containing drypoints, etchings, woodcuts, linocuts, lithographs, and aquatints. In 1982 a sale of ninety-eight rare prints sold for almost $1.4 million dollars at Sotheby Parke Bernet in New York.

The Vollard Suite (B. 134-233), the suite of 100 etchings and aquatints, 1930-37, each signed in pencil (except the last three signed in red crayon), one of 250 suites on Montval paper measuring 450×345 mm ($17\frac{5}{8} \times 13\frac{1}{2}$ in), form the total edition of 303, with full margins, in good condition apart from occasional foxing. (100) S-NY $275,000

Portrait of Fernande Olivier (not in Bloch or Geiser), drypoint, printed with burr and warm plate tone, 1906, on Arches laid paper, with full margins, in good condition apart from some discoloration and soiling. 162×188 mm; $6\frac{3}{8} \times 4\frac{5}{8}$ in. S-NY $71,500

This extremely rare drypoint belongs stylistically with the *Saltimbanque* subjects of 1904-5. The *Saltimbanque* plates, however, display a certain quality of detachment and abstraction, while this arresting portrait is a very personal work in which Picasso succeeds in conveying the enigmatic aspect of Fernande Olivier, whose liaison with him began in 1904 and lasted until 1911. Given the extreme delicacy of execution, it is unlikely that an edition of any size could have been successful, but it is most probably that no edition was ever contemplated. Only three other impressions are known: one in the Baltimore Museum of Art (Cone Collection), another in the Chicago Art Institute, and one in the Musée Picasso, Paris.

La Femme à la Résille (Femme Aux Cheveux Verts) (B. 612; M. 178 ter), lithograph printed in colors, 1949, signed in red crayon, an exceptionally fine, bright impression, one of a few proofs reserved for the artist, before the edition of 50, on Arches wove paper, the full sheet, printed to the edges (narrow margin at top), in good condition. Sheet 658×502 mm; $25\frac{7}{8} \times 19\frac{3}{4}$ in. S-NY $29,700

The artist's color lithographs have almost never been seen in such brilliant examples. The strong purple of this subject, for example, is usually reduced to a barely purplish gray.

Femme au Chapeau à Fleurs (B. 1076), linoleum cut printed in brown and black, 1962, signed in pencil and numbered 5/50, with full margins (lower margin folded back for framing), in good condition aside from traces of light and mat stain. 350×271 mm; $13\frac{1}{4} \times 10\frac{5}{8}$ in. S-NY $6,050

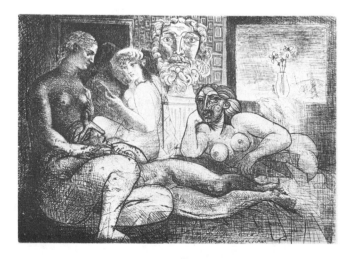

Camille Pissarro (1830–1903)

Pissarro was born in the West Indies and educated in
Paris. In 1874 he participated in the first Impressionist
exhibition and thereafter remained one of the most
important artists of the movement. He was the only
painter to take part in all eight exhibitions and it was
he who introduced Cézanne, Seurat, and Signac to the
group. Pissarro began his printmaking career in 1863
with a series of etchings. These are considered his best
prints, because he grew progressively blind in later
years. He also made lithographs in 1874, and then
again between 1894 and 1898. Only eight prints were
published in editions during his lifetime. His other
prints were made, one by one, as collectors commis-
sioned them. In the 1920s the artist's family published
posthumous editions.

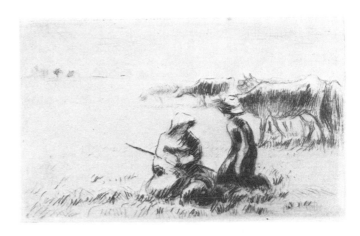

Femmes Gardant des Vaches, drypoint, 1889,
2⅜ in. × 3⅞ in.
*Photograph courtesy Phillips Fine Art Auctioneers,
New York*

Paysage sous Bois, à l'Hermitage (Pontoise) (L.D. 16),
aquatint, 1879, on Japon vergé, fifth (final) state, a fine im-
pression, signed in pencil and inscribed "Paysage sous bois à
l'hermitage près Pontoise," inscribed "no. 6/ Épreuve d'ar-
tiste, tirer á 50," from the edition of 50 (plus several trial
proofs and 4 or 5 proofs de passe), with margins, very slight
rubbing in the inscription, faint mat staining in the margins,
framed. P. 8⅝ × 10⅝ in. (221 × 271 mm.)
C-NY $17,600

Pont Corneille, à Rouen (Delteil 170), lithograph, 1896, with
the artist's stamp (Lugt 613e), and numbered 12/12, from
the 1923 (posthumous) edition (there was an earlier num-
bered and signed edition of 7), on buff, laid paper applied to
a sheet of white wove, with full margins on two sides (top
and right margins slightly shaved), in good condition apart
from slight tape stains in the upper right margin corner, in-
conspicuous soiling in the margins. 232 × 310 mm; 9⅛ ×
12⅛ in. S-NY $660

Femmes Gardant des Vaches (Delteil 88), drypoint, 1889.
With the stamped initials (Lugt 613 e: The estate stamp
added by the artist's son to unsigned works left by his fa-
ther,) and numbered in pencil 1/12. A good impression with
rich burr on thin laid paper with wide margins and a frag-
ment of Posthorn watermark. A few minor specks of foxing
in the sheet, otherwise in good condition. Plate: 2⅜ ×
3⅞ in. (61 × 99 mm.) P-NY $500

Odilon Redon (1840–1916)

Odilon Redon was born in the south of France to wealthy parents. He had no formal art training, but he was influenced by several artists whom he admired. Armand Clavaud, a botanist, may have inspired Redon's early style of semi-impressionist flowers in vases and landscapes. After Redon served in the Franco-Prussian War (1870) he began to make symbolist-like dark drawings in charcoal. He started lithography in 1879 for the purpose of reproducing the drawings. The lithographs became popular, and he continued working in this medium until 1899 when he became intrigued with color and found that oil painting best suited his visual experiments. Most of his 164 lithographs have unusual compositions (plants with heads; an egg with eyes in an eggcup) and Redon wrote explanations to accompany them.

Béatrice (Mellerio 168), lithograph printed in colors, 1897, an extremely rare trial proof, before the edition published by Vollard, a very fine impression, with exceptionally fresh color, printed in rose, yellow, pearl gray, blue and green, on Chine volant, with margins, in good condition except for light foxing in the margins and very slight soiling in the edges of the upper margin, framed. Image 336 × 310 mm; 13¼ × 12¼ in. Sheet 448-458 × 360-365 mm; 18 × 14 in. S-NY $46,200

 One of only a few full-color proof impressions known, before the edition printed for the *Album des Peintres-Graveurs*, in which two of the color stones are lacking.

Songes: Lueur Précaire, une Tête à l'Infini Suspendue (M. 112), lithograph, 1891, from the edition of 80, printed by Becquet, Paris, published by L. Dumont, Paris, on Chine appliqué, with full margins, in good condition aside from faint foxing in the margins and on the verso. 275 × 210 mm; 10¾ × 8¼ in. S-NY $1,650

La Mort: Mon Ironie Dépasse Toutes les Autres, plate III for Gustave Flaubert, *Six dessins pour la Tentation de Saint-Antoine, deuxième série* (Mellario 97), lithograph, 1889, on Chine appliqué, a fine proof before letters, scarce thus (the edition was 60), with margins, a little very faint rubbing and discoloration in the margins and creasing at the corners. L. 10¼ × 7⅝ in. (260 × 194 mm.) S-NY $4,620

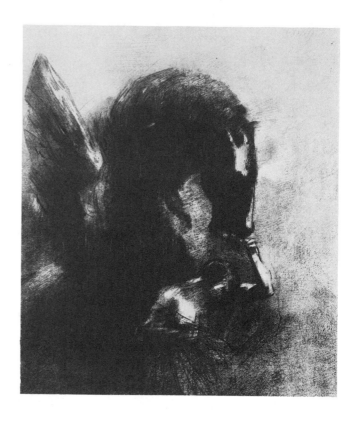

Pégase Captif, lithograph, 1889, 13⅛ in. × 11⅝ in. Photograph courtesy Sotheby Parke Bernet, Inc., New York, copyright by Sotheby Parke Bernet, Inc., 1981

Pierre August Renoir (1841–1919)

Renoir, the prolific French painter, began painting porcelain in a china factory when he was thirteen years old. In 1862 he studied at the École des Beaux-Arts where he met Claude Monet and Alfred Sisley. In 1868 he frequently painted outdoors with Monet, experimenting with light and color. His work was shown in four impressionist exhibitions, as well as at the Paris Salon after the late 1870s. His subject matter ranged from portraits and Paris scenes to landscapes, although most of his later work focused on nudes and semi-nudes. He left approximately six thousand paintings, many of which are in American museums. Renior began his graphic work in the 1890s and completed some twenty-five etchings and twenty-five lithographs before he became completely crippled by arthritis.

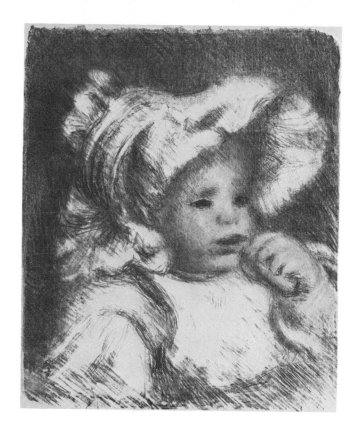

L'Enfant au Biscuit (Jean Renoir), *lithograph, 1899, edition of 100, 12½ in. × 10¼ in.*
Photograph courtesy Christie, Manson & Woods International, Inc., New York

L'Enfant au Biscuit (Jean Renoir) (L.D., S. 31; J. 110), lithograph in black, dark olive-green, terra-cotta, brown and yellow, 1899, on Ingres d'Arches, watermark MBM (France), a fine fresh impression, from the edition of 100, with margins, a few pale fox marks and a faint light staining, traces of discoloration and old glue along the left margin edge, a soft diagonal crease across the tip of the bottom left margin, generally in good condition. L. 12½ × 10¼ in. (317 × 261 mm.) C-NY $4,950

La Danse à la Campagne, 2e planche (Delteil, Stella 2), soft-ground etching, c. 1890, only state, with the signature stamp, on heavy wove paper, with margins (slightly trimmed), in good condition (inconspicuous discoloration in the margins). 221 × 137 mm; 8¾ × 5⅜ in. S-NY $3,575

Odalisque (D.; S. 35), lithograph, c. 1904, from the edition of 75 (of which some were printed in bistre) on Chine volant, with full margins, in good condition, framed. C. 82 × 125 mm; c. 3¼ × 7⅝ in. S-NY $1,430

Le Chapeau Épinglé, 2e Planche (D.; S. 30; R.-M.5/bis), lithograph printed in eight colors, c. 1898, from the edition of 200 (which was partially printed in eight colors and partially in eleven), with the lithographic signature, on laid paper, with full margins, in good condition (aside from slight stains, discoloration and a few faint fox marks in the margins), framed. 620 × 495 mm; 24⅜ × 10½ in.
S-NY $27,500

Robert Riggs (1896–1972)

Robert Riggs was born in Illinois. After serving in the U.S. Army Medical Corps during World War I he studied art in Paris and New York. He settled in Philadelphia where he began first to paint in oils and watercolors, and then to create the lithographs for which he is best known. A skilled lithographer, Riggs made prints during the 1930s and 1940s, which told of his fascination with the circus, boxing, and hospital accident wards. His portrayals were true-to-life, but had an unsettling edge, as if his subjects were a bit off-center—slightly manic. Riggs himself was considered an unusual character. He had a penchant for reptiles and kept many in his home.

Afternoon at Max's (Library of Congress 2), lithograph, c. 1933, signed in pencil, with full margins, in good condition apart from faint mat stain, a small nick in the right edge and a few slight handling creases. 385 × 527 mm; 15⅛ × 20¾ in. S-NY $715

Children's Ward; and *Tumblers* (L. of C. 11 and 73), lithographs, c. 1941 and c. 1936, each signed in pencil, titled and numbered 24 and 30 respectively, with full margins, in good condition except the second slightly mat stained. Each c. 361 × 481 mm; c 14¼ × 19 in. (2) S-NY $880

Third Round, lithograph, 1932, signed, in pencil and titled, with full margins, in good condition aside from minor creases primarily in the upper margin. 362 and 492 mm; 14¼ × 19⅜ in. S-LA $990

Center Ring, lithograph, 1934, 14¾ in. × 19¾ in. Photograph courtesy Kennedy Galleries, Inc., New York

Georges Rouault (1871–1958)

Georges Rouault was born to a poor Parisian family. Like his father, Rouault worked in a factory, but his life took on meaning when his grandfather painted with him at night. In 1891 he studied under Delauney and Moreau at the École des Beaux-Arts, but he remained apart from the mainstream and developed an expressionistic style. His early works were dark paintings of biblical scenes. He eventually abandoned these themes to paint prostitutes, judges, and the clowns which are among his best-known works. Rouault, a devout Catholic, drew heavily from his childhood experiences to depict social injustice and life's hypocrisies. He used especially strong colors to augment his statements. In 1913 he met French art dealer Ambroise Vollard, who convinced him to make prints. The large body of resulting works (etchings, aquatints, lithographs) followed the subjects of his paintings. Rouault's most famous etchings were published in 1948 as *Miserere,* a series that took ten years to complete.

Qui ne se Grime Pas?, plate VIII of the Miserere, *aquatint and drypoint, 1922, 22¼ in × 17 in.*
Photograph courtesy Christie, Manson & Woods International, Inc., New York

Le Vieux Clown, from André Suares, *Cirque* (R. 202; Johnson 202.4), aquatint in colors, 1930, on Montval, a fresh impression, one of 110 impressions on this paper (there were a further 160 on Rives), with margins, old hinges, framed. P. 12¹⁵⁄₁₆ in. × 9 in. (329 × 228 mm.) C-NY $1,320

Automne (R. 228c; Johnson 123), aquatint in colors, 1933, on Montval, a good impression with fresh colors, signed in the plate, numbered 33/175, with margins, faint discoloration in the margins and on the reverse, framed. P. 20⅛ × 25⅞ in. (511 × 657 mm.) C-NY $7,480

Frontispice-Parade (C./R. 240b), aquatint printed in colors, 1935, a fine bright impression, from the *Cirque de l'Étoile Filante,* published by Vollard in a total edition of 280, 1938, with full margins, in good condition apart from a minor crease and very slight discoloration in the edges, framed. 302 × 198 mm; 11⅞ × 7¾ in. S-NY $2,090

Saltimbanques: Petite Famille (Chapon-Rouault 330), lithograph, 1926. Signed in pencil. With the Frapier state stamps (Lugt 2921 b and d), indicating a trial proof of the second state, one of the few signed proof impressions aside from the edition of 10. A good printing on heavy Arches with full margins; with the blindstamp of the publisher, Galerie des Peintres-Graveurs (Lugt 1057 b). In generally good condition save for some surface dirt and specks of foxing in the margins. 12⅝ × 9¼ in. (322 × 235 mm.) P-NY $550

Thomas Rowlandson (1756–1827)

Thomas Rowlandson was born in London, the son of a prosperous merchant. In 1771 he went to Paris to live with a wealthy aunt and was quickly plunged into a social, festive life-style. After completing his art studies at the École de l'Academie Royale, he moved back to London and entered the Royal Academy there. He had his first exhibition at the Royal Academy in 1775. A prankish, lively man who reveled in social commentary, he launched his career in prints with studies of recognizable leaders of English society. They offer a wealth of information about the manners of the time. Their style was a combination of French elegance and English spirit. Rowlandson also made a few prints of sporting events to meet the demand of country squires and young City men who were collecting art and favored such subject matter.

The Comforts of Matrimony—A Good Toast. Miseries of Wedlock–The Tables Turned. A pair of etchings with aquatint, published 1809 by Reeve & Jones, hand-colored, unframed, laid down, time-stained, foxed, light-stained through backboards, other defects. 33 cm. × 39.5 cm. (PL) P-L $134

Abroad and At Home and *At Home and Abroad.* A pair, hand-colored etchings, published 1807 by Rowlandson; unframed, trimmed in margins. 14.8 cm. × 22.2 cm. (SH) P-L $114

From **Views of Cornwall,** *etching, c. 1812, 6¾ in. × 10 in. Photograph courtesy Phillips Fine Art Auctioneers, London*

VIEW of the CHURCH and VILLAGE of S.^t CUE, CORNWALL.
Pub. April 1.^st 1812 by J. Rowlandson N.^o 1 James S.^t Adelphi.

Ben Shahn (1898–1969)

Lithuanian-born Ben Shahn came to the United States with his family in 1906, when he was eight years old. He was an apprentice to a lithographer before studying at schools which included the National Academy of Design and the Art Students League in New York. In the 1930s his art began to reflect his humanistic approach to life, along with social commentary on the times. During that period he created his famous series of gouaches based on the Sacco and Venzetti trial. He made more than sixty lithographs and screenprints, mostly poignant studies of injustice, moral failing, or simply the difficulties and frustrations of everyday life. Shahn was a strong, purposeful artist whose curiosity and personal exuberance gave these works an unusual liveliness.

For the Sake of a Single Verse (Prescott 113-136), the complete portfolio, with text by Rainer Maria Rilke, comprising 24 lithographs, many printed in colors, each signed in red brush point (with the exception of the headpiece, which was not intended to be signed), signed in red brush point on the justification page and with the artist's red chop, numbered 7 from the edition of 200 plus 10 copies *hors commerce* (and 750 copies with the lithographs unsigned), printed by Atelier Mourlot, Ltd., 1968, the frontispiece with slight offprint of text, a few other plates slightly light stained, otherwise in good condition, contained in original half vellum and linen portfolio. Each sheet 572 × 453 mm; 22½ × 17⅞ in.
S-NY $7,150

Birds Over the City (P. fig. 78), lithograph printed in colors, 1968, signed in red brush and numbered in pencil 121/135, the full sheet, in good condition except for a few minor creases in the edges. Sheet 740 × 550 mm; 29⅛ × 21⅝ in.
S-NY $1,100

Cat's Cradle (P. fig. 38), silkscreen printed in blue and black, 1959, signed in red brush, from an edition of at least 50, on thick Japan paper, the full sheet, printed to the edges on three sides, a few tiny bits of tape in the sheet edges, glue stains in the upper margin corners, slightly discolored and faintly waterstained (mainly at upper left), framed. Sheet 520 × 668 mm; 20½ × 26¼ in. S-NY $440

Silent Night (Prescott 10), silkscreen, 1949. Signed and numbered in pencil 70/200. With full margins, in good condition. Framed. Sheet: 25¼ × 19¾ in. (654 × 505 mm.)
P-NY $385

Four and One Half Out of Every Five, silkscreen, 1941, 25¼ in. × 19⅛ in.
Photograph courtesy Kennedy Galleries, Inc., New York

John Sloan (1871–1951)

John Sloan was born in Philadelphia and studied at the Philadelphia Academy of Fine Art. He contributed numerous illustrations to newspapers, starting with a job at the Philadelphia *Inquirer.* In 1891 he met Robert Henri, who exerted a strong influence on his work. Sloan's illustrations focused primarily on city life and popular scenes. As it became more difficult to find newspaper work in Philadelphia, he sought opportunities in New York with artist friends. They formed an independent alliance called The Eight, dedicated to the principle of freedom in art, and staged their own exhibition in 1908. The earthy work, poorly received, was dubbed the Ashcan School of art. A socialist, Sloan became an editor for *The Masses* where he continued his straightforward social commentary. Later, nudes and landscapes were the focus of his work. One of the most prolific modern American artists, he made more than three hundred etchings between 1891 and 1940.

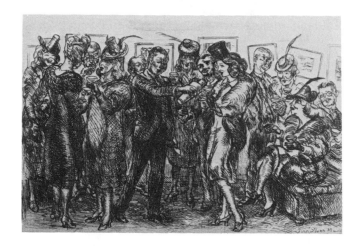

A Thirst for Art, etching, 1939, editions of 200, 3⅞ in. × 6¼ in.
Photograph courtesy Madeleine Fortunoff Fine Prints, Long Island, New York

Connoisseurs of Prints, from *New York City Life* (Morse 127), etching, 1905, on laid paper, a fine, heavily inked impression signed in pencil, from the edition of 105, with (slightly uneven) margins, very faint light and time staining, framed. P. 4⅞ × 6⅞ in. (124 × 175 mm.) C-NY $2,200

Love on the Roof (M. 167), etching, 1914, final state, signed in pencil, titled and inscribed "100 proofs" (only 50 were printed), annotated "Ernest Roth imp.," with margins, in good condition. 153 × 112 mm; 6 × 4⅜ in. S-NY $1,265

The Women's Page (Morse 132), etching, 1905, final state, signed and titled in pencil, inscribed "100 proofs," and annotated "Ernest Roth imp.," on laid paper, with margins and in good condition (minor surface soiling in the margin edges). 125 × 175 mm; 5 × 6⅞ in. S-NY $880

Graham Sutherland (1903–)

Graham Sutherland, one of England's finest artists, began painting in the early 1930s after he had achieved status as an etcher and engraver. He was appointed an official war artist in 1941 and in that capacity depicted, in semi-abstract scenes, the totality of desolation after the bombings in his country. After the war Sutherland turned to portraiture and studies of natural objects. He is best known for his landscapes which in the 1950s began to incorporate menacing forms. In the 1960s he completed a series of twenty-five lithographs, a bestiary of animals, birds, insects, and reptiles. There is a Sutherland Gallery at Picton Castle in England, and his work is found in museums worldwide, including the Tate Gallery and the Imperial War Museum in London, the Musée d'Art Moderne in Paris, and the Museum of Modern Art in New York.

Articulated Forms (T. 54), 1950, lithograph printed in colors, published by the Redfern Gallery, signed in pencil, numbered 11/60, with apparently full margins, in apparently good condition, framed. 300 × 520 mm. S-L $244

Wood Interior (M. 32; T. 29), etching, 1929-30, on laid paper, second (final) state, signed in pencil, from the edition of 60 (the full edition was 66), published by the Twenty-One Gallery, London, with margins, slightly weak along part of the upper platemark. P. 117 × 162 mm. C-L $611

Number Forty Nine (M. 22; T. 14), etching, 1924, on oatmeal wove paper, presumably third (final) state, signed in pencil, from the edition of 60 (the full edition was 80), published by the Twenty-One Gallery, London, with margins, a diagonal crease and pinhole in the upper margin, old tape at the reverse upper margin corners. P. 176 × 252 mm. C-L $669

Hanger Mill (M. 31; T. 27), etching, 1929, on antique laid paper, watermark Fleur-de-Lys on a Staff (?), sixth (final) state, signed in pencil, numbered 75/77 (the full edition was 94), published by the Twenty-One Gallery, London, with margins, small fox marks at the sheet edges. P. 138 × 129 mm. C-L $478

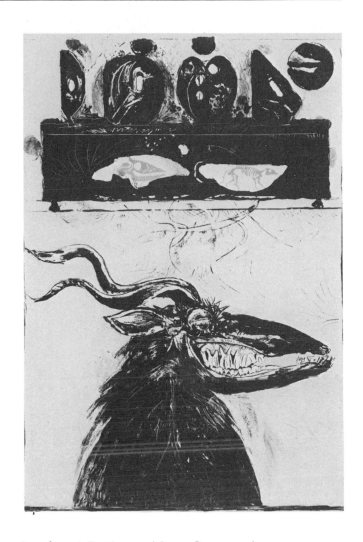

Ram from A Bestiary and Some Correspondences, *lithograph printed in black, lavender and pink, c. 1960, 26¼ in. × 20 in.*
Photograph courtesy Phillips Fine Art Auctioneers, London, and Marlborough Gallery, New York

James-Jacques Tissot (1836–1902)

James-Jacques Tissot was born in the Dubes region of France. He designed stained glass windows for churches early in his career, but switched to portraiture when he found it to be lucrative. Influenced by the Japanese style introduced in Paris in 1860, Tissot painted the beautiful people of society in an engaging manner. So many people commissioned him that he became famous and wealthy while he was still quite young. In 1870 he moved to England and made prints with the advice and encouragement of Sir Francis Seymour Haden. The drypoints, also portraits of society people, became immediately, resoundingly popular, and Tissot enjoyed great success in England for twenty years. In 1887 he suffered some personal tragedies and moved to Palestine where he stayed for ten years, only painting watercolors of the New Testament.

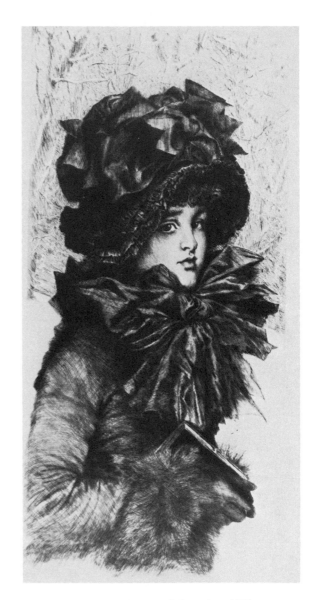

Le Dimanche Matin, etching and drypoint, 1883, 15¾ in. × 7⅝ in.
Photograph courtesy Madeleine Fortunoff Fine Prints, Long Island, New York

Printemps (W. 34), etching and drypoint, 1878, a fine impression, signed in pencil and with the artist's stamp (Lugt 1545), on soft laid Japan paper, with full margins, in good condition aside from light specks of foxing in the margins. 382 × 139 mm; 15 × 5½ in. S-NY $1,540

Le Banc de Jardin (W. 75), mezzotint, 1883, first state of three, signed in pencil, according to Wentworth, at least 500 were printed in the three states, on heavy wove paper, with margins, in good condition aside from foxing and a small nick in the upper margin edge. 420 × 570 mm; 16½ × 22½ in. S-NY $1,430

Soirée d'Eté (W. 56), etching and drypoint, 1882, second (final) state, from the edition of about 100, on cream laid paper, with full margins on three sides, in good condition aside from discoloration in the sheet edges. 231 × 398 mm; 9⅛ × 15⅝ in. S-NY $990

L'Enfant Prodigue (Wentworth 57-61ii), the complete set of four etchings with drypoint, plus the etched cover, 1882. Rich impressions printed in dark brown, the four plates on Van Gelder, the cover on Turkey Mill, all with full margins. All in generally good condition save for some very minor foxing. Each plate c. 12⅛ × 14⅝ in. (310 × 372 mm.) P-NY $495

Henri de Toulouse-Lautrec (1864–1901)

Toulouse-Lautrec depicted the world of Paris nightlife in a style that transcended categorization. Influenced by the impressionists (particularly Degas), he exhibited with them at the 1889 Salon des Indépendants. His technical skills, evident early in his career, enabled him to create a sense of motion and atmosphere with a minimum of brushstrokes. Lautrec studied art in Paris and in 1885 opened his own studio in Montmartre, where the brothels and dance halls greatly inspired his work. He began producing posters in 1891 with immediate success; the first one was commissioned by the Moulin Rouge cabaret. Between 1891 and his death in 1901, Lautrec made 357 lithographs and was a popular artist for collectors of the day. His mastery of the medium won him international acclaim and in 1895 he was given two one-man shows in London. In 1900 he was appointed to the Committee of the Exposition Universelle, commemorating the 100th anniversary of lithography.

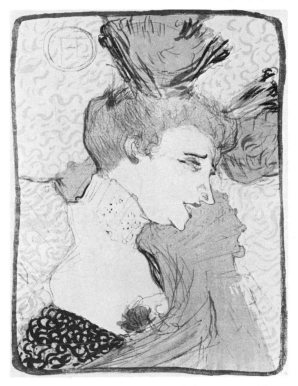

Mademoiselle Lender, En Buste, lithograph, 1895,
12¹⁵⁄₁₆ in. × 9⅝ in.
Photograph courtesy Christie, Manson & Woods
International, Inc., New York

Elles, Paris, Gustave Pellet, 1896 (L.D. 179-189; A. 200-210; A., W. 177-187), the cover printed in black and gray, the frontispiece in colors and the set of ten lithographs in colors, 1896, the cover on Japan, the remainder on wove paper, watermark G. PELLET/T. LAUTREC, superb impressions retaining the full range of colors from the brilliant to the most delicate, the cover signed in pencil by the artist, signed by the publisher Gustave Pellet with his pencil paraph (L. 1194), stamped once with Pellet's red stamp (L. 1193) and twice with his blindstamp (L. 1191), numbered 87 from the edition of 100, the frontispiece and set of ten lithographs all with the red stamp and all numbered, the full sheets with the deckle, in an exceptional state of preservation barring slight foxing on the cover and a little skinning on the reverse of the top edges where hinges have been removed (a few bits of glassine hinge remain, and a little hold hinge glue shows through at the edge of L.D. 185). Cover S. 21⅝ × 16¹³⁄₁₆ in. (550 × 428 mm.), folded; S. 26⁹⁄₁₆ × 42¾ in. (675 × 1086 mm.), unfolded. Sheets S.20⅞ × 16⅛ in. (530 × 410 mm.) C-NY $220,000

Mademoiselle Lender, En Buste (L.D. 102; Adhémar 131; Adriani, Wittrock 118 IVb), lithograph in colors, 1895, on wove paper, a fresh impression as published in *Pan*, Volume I, p. 197, the margins trimmed, removing the *Pan* letterpress below, very slightly marked at the mat opening. L. 12¹⁵⁄₁₆ × 9⅝ in. (329 × 245 mm.) C-NY $6,380

Jane Avril (D. 345; A. 12; A./W. 11), lithograph printed in colors, 1893, first state of two, before the addition of the printed letters "Jardin de Paris," with margins, tears in the dress at left, repairs in the lettering, one tear in the upper margin and two just into the work at bottom (repaired with tape, showing through), mounted on cloth backed paper, framed. Sheet 1290 × 932 mm; 50¾ × 36¾ in. S-NY $9,350

Yvette Guilbert-Soularde (Adriani-Wittrock 262), lithograph, 1898, from the album entitled *Yvette Guilbert drawn by H. de Toulouse-Lautrec (série anglaise),* from an edition of 350, published by Bliss & Sands, London. A good impression printed on textured laid paper with beige tone plate, full margins. In good condition aside from slight foxing in margins and minor tape stains along upper edge of sheet. Plate: 13½ × 11 in. (343 × 280 mm.) P-NY $1,320

Jacques Villon (1875–1963)

Jacques Villon, the brother of Marcel Duchamp, went to Paris in 1895 and found work as a cartoonist on several publications popular with Parisian society. He was friendly with Toulouse-Lautrec and was inspired by him. An accomplished engraver, Villon was regarded as one of the most distinguished burinists who ever lived. He depicted the bourgeoisie with humor. Villon became a cubist in 1911 and in the following year, with Léger and Metzinger among others, organized the Section d'Or exhibition. He fled to the South of France during World War II and was there inspired to paint the surrounding landscapes. In 1951 he had his first big show in Paris—the one that finally established him as a major talent.

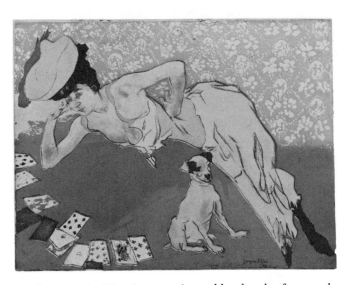

Les Cartes ou La Réussite, aquatint and hard and soft-ground etching, 1903, 13¾ in. × 17⅝ in.
Photograph courtesy Christie, Manson & Woods International, Inc., New York

Les Cartes ou La Réussite (Ginestet and Pouillon E76; Auberty and Perussaux 44), aquatint and hard and soft-ground etching in colors, 1903, on stiff cream wove paper, a fine, fresh, and bright impression, signed in brown crayon, numbered 18/25, with large margins (the right and bottom edges shaved), a loss from the bottom left margin corner, a nick and two small tears at the top margin edge, a small tear at the right edge, slight creasing in the margins, lightly mat stained and with some light foxing in the margins, otherwise in good condition, framed. P. 13¾ × 17⅝ in. (349 × 448 mm.) C-NY $44,000

L'Épingle à Chapeau (G. and P. E242; A. and P. 160), drypoint, 1909, on laid paper, signed in pencil, numbered 12/20, with margins, slight light and time staining. P. 15¾ × 12½ in. (401 × 319 mm.) C-NY $825

La Ferme de la Bendelière (G. & P. 138), etching and aquatint printed in colors, 1905, second (final) state, signed in pencil and numbered "No 34/50," with the blindstamp of the publisher, Louis Sagot, Paris, on cream wove paper, with full margins, in good condition aside from two small tears in the lower edge, slight soiling, a few faint fox marks and slight discoloration in the margins and on the verso. 466 × 469 mm; 18¼ × 18⅜ in. S-NY $4,400

Devant un Guignol (G. & P. 241), drypoint, 1909, fifth (final) state, signed in pencil, from the edition of fewer than fifty impressions, with the blindstamp of the publisher, Sagot, Paris, on laid paper, with full margins, traces of foxing, slight discoloration and soiling in the margins and on the verso, otherwise in good condition. 400 × 303 mm; 15¾ × 11⅞ in. S-NY $1,430

Maurice de Vlaminck (1876–1958)

Maurice de Vlaminck was an important member of the fauve group, but his work reflected a variety of artistic influences during the course of his long career. At the turn of the century, Vlaminck shared a studio with André Derain for fifteen months. These months with Derain, and the style of Van Gogh, influenced his early paintings. Vlaminck and Derain then joined the fauve group. Vlaminck produced some of his finest work during this period, when the group was exhibiting at the Salon des Indépendants. His admiration for the work of Cézanne became obvious in paintings he did from 1907 to 1914. Vlaminck's graphic oeuvre consists of woodcuts, which he made early in his career, and lithographs (mostly landscapes) created in the 1920s after he had achieved fame.

Paysage (W. 253), lithograph printed in colors, signed in pencil and numbered 45/75, printed and published by Mourlot, 1958, for the Mourlot Centennaire, on Arches wove paper, with full margins, in good condition (very faint light stain), framed. 370 × 475 mm; 14½ × 18⅝ in. S-NY $2,750

Montigny-sur-Avre (W. 266), lithograph printed in colors, 1956, signed in pencil and numbered 111/200, with margins (slightly trimmed), in good condition apart from faint light and mat stain, traces of old tape hinge on verso, framed. 350 × 470 mm; 13¾ × 18½ in.　S-NY $1,155

Verville, les Peupliers (Walterskirchen 176, IId), lithograph, second (final) state, signed in pencil, aside from the edition of 50, with the blindstamp of the publisher, Galerie des Peintres-Graveurs, Paris, on sturdy wove paper, with full margins, in good condition aside from some scattered specks of foxing and discoloration in the sheet edges. 245 × 349 mm; 9⅝ × 13¾ in.　S-NY $660

Nelle-la Vallée, Chemin aux Bords du Sausseron (Walterskirchen 185i), lithograph, c. 1925. Signed in pencil. A good printing on *chine* with full margins; with the Frapier state stamps (Lugt 2921b and c), indicating a proof impression of the first state; also with the blindstamp of the publisher, Galerie des Peintres Graveurs (Lugt 1057b). In excellent condition; an old hinge along the upper sheet edge verso. Image: 7½ × 9½ in. (190 × 240 mm.)　P-NY $330

Saint-Ouen-L'Aumône Près de Pontoise— Le Tournant de la Route, lithograph, 16 in. × 21½ in. Photograph courtesy Phillips Fine Art Auctioneers, London

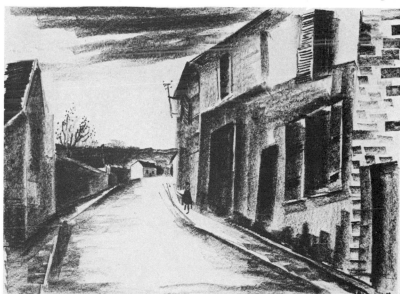

Max Weber (1881–1961)

Max Weber was born in Belostok, Russia, and came to the United States when he was ten years old. He studied at Pratt Institute in New York where he later taught. In 1905 he went to Paris where he met and was greatly influenced by Matisse. Color and clarity became the two watchwords of his work—the aspects of most concern to him. When he returned to the United States he tried to introduce new French movements, but he was misunderstood and unappreciated. His print output was modest (about ninety in all), but he did create woodcuts and linocuts, which revealed his respect for cubism, as well as lithographs, which were somewhat more figurative and freer in feeling.

Still Life with Apples (R. 90), lithograph, 1928, signed in pencil, and with the estate stamp on the verso, from the edition of 50, with full margins, in good condition apart from a few creases in the lower left margin corner and minor discoloration along the margin edges. 314 × 410 mm (12 × 16⅛ in.) S-NY $302

Mother and Child (Mother Love), lithograph, 1928, 9 in. × 7½ in.
Photograph courtesy Sotheby Parke Bernet, Inc., New York, copyright by Sotheby Parke Bernet, Inc., 1983

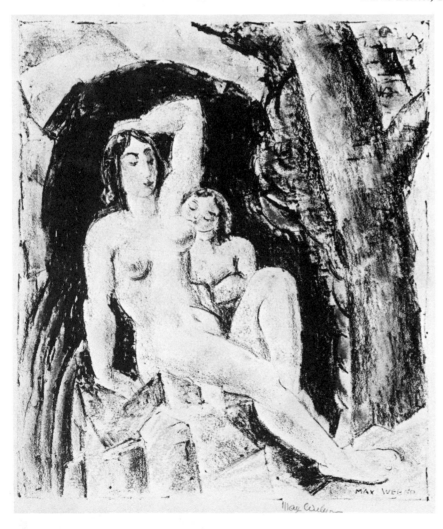

James McNeill Whistler (1834–1903)

Whistler was an American painter and graphic artist who spent most of his adult life in London. Born in Lowell, Massachusetts, Whistler attended West Point Military Academy from 1851 until 1854 but abandoned the army for art. He went to Paris in 1855 to study painting and etching. In 1959 he moved to London. Influenced by Courbet and Manet, Whistler returned to Paris frequently, following the impressionist movement. His paintings stirred controversy (Whistler sued a critic for libel because of a written comment about one of his paintings), but his skill in etching was always widely recognized. He was particularly adept, in his four hundred etchings and one hundred and sixty lithographs, at capturing the poetry in an atmosphere. His signature developed from his name to a stylized butterfly.

The Music Room, *etching, 2nd (final) state, c. 1858, 5¾ in. × 8½ in.*
Photograph courtesy Phillips Fine Art Auctioneers, London

The Traghetto, No. 2 (K. 191; M. 188), etching c. 1880, Kennedy's fifth state of six, printed in sepia, signed on the tab with the butterfly and inscribed "imp," on old laid paper with a fleur-de-lys in crowned shield watermark, in good condition except slightly mat stained, hinge stains in the upper edge (faintly showing through upper left) and a few spots of foxing, framed. 236 × 304 mm; 9¼ × 12 in. S-NY $6,325

Thames Police (K. 44; M. 43), etching, 1859, a very good impression of the first state of three, printed in brown ink with light plate tone, on old laid paper, with large margins, mat stained and with several fox marks (a few visible in the subject). 152 × 228 mm; 6 × 9 in. S-NY $1,540

Little Nurse (Kennedy 302), etching. Signed with monogram in pencil on the tab. A good impression in sepia on thin laid paper with a fragment of a watermark, with thread margins. In good condition, hinged to mat on verso. P-NY $2,640

"The Adam & Eve," Old Chelsea (K. 175), etching with drypoint, 2nd (final) state, signed with the butterfly monogram in the plate, on thin Japan; unframed, two creases at left side, 17.4 cm. × 30 cm. (PL) P-L $796

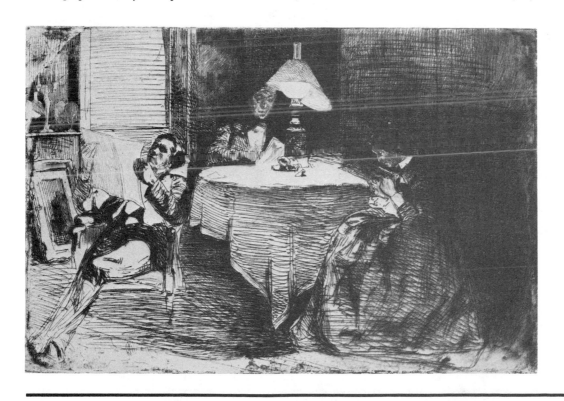

Grant Wood (1892–1942)

Grant Wood was born in Anamosa, Iowa, where he lived and worked for most of his life. He made several trips to Europe in the 1920s to study art, past and present, but felt the greatest affinity with the home-spun, simple American rural style. He enjoyed, and believed others would, art that was easily identifiable. Others did identify with his work and regarded him as a major talent. Consequently, he was highly successful during his lifetime. Wood is best known for his paint-ing *American Gothic* which won praise and an exhibition prize in 1930. His other paintings of that period show rural people and are somewhat satirical. Landscapes were the basis for his later works. Most of his lithographs, about twenty in all, are concerned with these landscape studies.

Seed Time and Harvest, lithograph, 1937, on Rives, signed and dated in pencil, from the edition of 250, with margins, old glue and paper at the top margin edge where previously hinged, some soft creasing in the bottom margin. 7½ × 12⅛ in. (190 × 307 mm.) C-NY $990

Approaching Storm, lithograph, 1940, on white wove paper, signed in pencil, from the edition of 250, with margins, a small loss at the top margin edge, a small tear in the bottom margin, very faintly mat stained, some surface soiling in the margins, traces of glue on the reverse, framed. 11⅞ × 8⅞ in. (301 × 256 mm.) C-NY $1,980

Vegetables (C. W-10), hand-colored lithograph, 1938, a fine, fresh impression, signed in pencil, from the edition of 250, distributed by Associated American Artists, with margins, in good condition apart from faint discoloration in the margins, framed. 7⅛ × 9⅝ in. (180 × 246 mm.) S-NY $1,760

Sultry Night (Cole 5), lithograph, 1940, from the edition of 250 as published by Associated American Artists, signed in pencil, a good printing on wove paper with full margins; an old tape stain and ink inventory number on the verso do not show on the recto. 9 × 11¾ in. (230 × 298 mm.) P-NY $4,400

Honorary Degree, lithograph, 1937, edition of 250, 12 in. × 7 in.
Photograph courtesy Christie, Manson & Woods International, Inc., New York/Associated American Artists, New York/ V.A.G.A., New York

Paul Wunderlich (1927–)

Paul Wunderlich was born in Berlin and then moved to Hamburg where he studied at the School of Fine Arts from 1947 until 1951. He then taught graphics there for the next nine years. Wunderlich's early style contained elements of the surreal. He studied biological charts and drew parts of the human body in a fantastic manner. His later work took inspiration from the sensuality of the art nouveau movement, with models posed alluringly on opulent rugs or furniture. Although Wunderlich is recognized for his sculpture and jewelry design, he is best known and critically appreciated for his lithographs and etchings. A major printmaker of the twentieth century, he began his career as a lithographer and published at least one hundred of his own editions. He has had numerous one-man shows internationally and his work appears in prominent museums worldwide.

Egyptian Queen, 1972, lithograph printed in colors, signed in pencil, numbered 16/100, with full margins, in good condition. 732 × 556 mm. S-L $232

Skull-Shoe, lithograph printed in colors, signed in pencil, numbered 18/100, with full margins, in good condition. 635 × 485 mm. S-L $271

Joanna Posing for the Redfern, *offset lithograph printed in colors, 1968, 19¾ in. × 25½ in.*
Photograph courtesy Phillips Fine Art Auctioneers, London

Anders Zorn (1860–1920)

Zorn, who was born in Sweden, was given a scholarship to study at the Stockholm Academy. He never finished school, however, because the portraits he painted made him a tremendous success, and the money seduced him away from his studies. In 1881 he went to Spain and a year later to England where he studied at the Royal Academy in London. Then, in 1884, Zorn moved to Portugal where the Lisbon aristocracy commissioned him to paint their portraits. His reputation spread, first to Spain where society lined up to give him commissions, and then to the United States where he had a triumphant exhibit in 1892. He then won two honor medals in the Exposition Universelle in Paris in 1900. As his fame grew, although he continued to do portraits, Zorn turned to etching, which also met with success. Enthusiastic critics called him the greatest etcher who ever lived.

Dagmar, etching, 1912, 10 in. × 7¼ in.
Photograph courtesy Phillips Fine Art Auctioneers, London

Dagmar; and *The Letter* (Asplund 250, 254), etchings, 1912, 1913, A. 250 on van Gelder, A. 254 on van der Ley, signed in pencil, with margins, foxing, light and time stained (A. 250 quite heavily so and with a glue stain at the edge of the top margin). (2) C-NY $242

The Crown Princess Margaret of Sweden (A. 264; H. 163), etching, 1914, on van Gelder, third (final) state, signed in pencil, with margins, faintly light stained, remains of old glue stains at the reverse margin edges, framed. P. 249 × 178 mm. C-L $382

The Waltz (Asplund 54), etching, 1891, third (final) state, signed in pencil, on stiff white wove paper, with large margins, in good condition apart from several reinforced areas, tape stains and slight skinned spots in the left, right and lower sheet edges, slight traces of mat stain, framed. Plate 338 × 227 mm; 13¼ × 8⅞ in. S-NY $1,870

Frightened (A. 248), drypoint, printed in dark brown ink, 1912, second (final) state, signed in pencil, on Van Gelder Zonen laid paper, with full margins and in good condition. 201 × 151 mm; 7⅞ × 6 in. S-NY $440

The Contemporary Artists

Elie Abrahami (1941–)

Elie Abrahami's unusual personal background is reflected in his art. Born in Persia, he lived there until 1955, when his family immigrated to Israel. In 1970 he moved to Paris. His artistic vision combines elements of all three cultures. Incorporating both the old and the new, Abrahami's work cannot be put into any one category. He equates all aspects of life with poetic expressions, and each work, he believes, "is a miniature soul in itself." Delicate layering of colors produce complex imagery that offers something different with each viewing. In 1970 Abrahami participated in the Second International Engraving Biennial. The following year he received the Honors Award at the International Engraving Biennial in Monaco. Abrahami's works have been exhibited in galleries in the United States, Europe, and Israel and are included in the permanent collections of many museums, including the Guggenheim Museum and the Museum of Modern Art in New York and the National Fine Arts Museum in Paris.

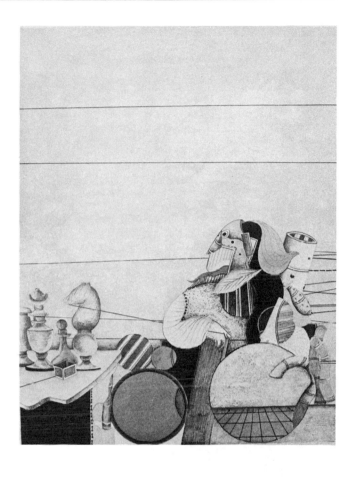

Chess, lithograph, 1980, edition of 100, 30 in. × 20 in. *Photograph courtesy Editions Press/Walter Maibaum, San Francisco*

The Pharmacy, etching and aquatint, 1972, edition of 95, 13⅜ × 9¾ inches. $300 (sold out)

The Musicians, lithograph, 1973, edition of 100, 22¾ × 16½ inches. $150

The Benediction of Jacob, etching and aquatint, edition of 100, 12⅞ × 7⅞ inches. $300 (sold out)

The Women, etching and aquatint, 1974, edition of 95, 17⅛ × 11⅝ inches. $300 (sold out)

Lace, etching and aquatint, 1975, edition of 95, 17⅛ × 15½ inches. $300 (sold out)

The Three, etching and aquatint, 1979, edition of 30, 11¼ × 8¾ inches. $225 (sold out)

The Poet II, etching and aquatint, 1980, edition of 40, 5⅞ × 4¼ inches. $110

Yaacov Agam (1928–)

Israeli-born Yaacov Agam was educated at the Bezalel School of Art in Jerusalem and the Atelier d'Art Abstrait in Paris. He has dedicated his creative life to the exploration of diverse relationships between art and technology. Using complex, seemingly scientific combinations of shapes and colors, Agam is able to create a multitude of illusions, each meeting the viewer at his particular vantage point. Among the awards he has received are a special prize for art research at the São Paulo Bienal in 1963 and first prize at the International Festival of Painting at Cagnes-sur-Mer in 1970. Agam has had exhibitions at the Tel Aviv Museum, the Musée National d'Art Moderne in Paris, and the Stedelijk Museum in Amsterdam. His work is in the collections of many museums, including the Museum of Modern Art in New York and the Joseph Hirshhorn Collection in Washington, D.C.

Star of Peace, lithograph, 1979, edition of 99, 30 × 22 inches. $500

Magic Rainbow I, serigraph, 1980, edition of 180, 41 × 48 inches. $3,250

Split Space #2 (silver), serigraph and collage, 1982, edition of 99, 41 × 48 inches. $1,250

Night Rainbow (gold), serigraph, 1982, edition of 27, 41 × 48 inches. $3,900

Bird's Eye View, serigraph, 1982, edition of 180, 27 × 38 inches. $1,550

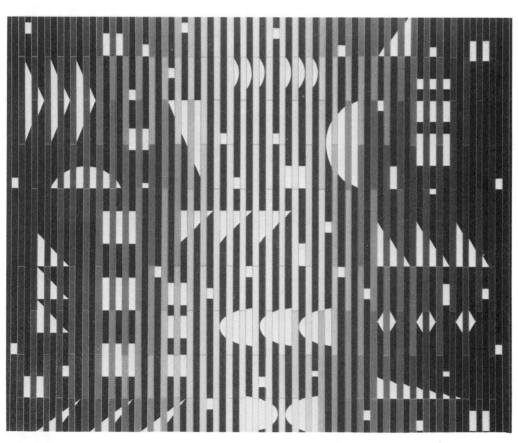

Night Rainbow (gold), serigraph, 1982, edition of 27, 41 in. × 48 in. © 1982 Agam Photograph courtesy Circle Fine Art Corporation, Chicago

Josef Albers (1888–1976)

German-born Josef Albers studied at three conventional art schools before entering the Bauhaus in 1920. Five years later he became a Bauhaus master. He was a designer of stained glass, of furniture, and of various containers, as well as a teacher. In 1933, when Hitler closed the Bauhaus, Albers emigrated to the United States where he was invited to teach at Black Mountain College in North Carolina. He later became chairman of the art department at Yale University. With a healthy respect for technology and the belief that mechanical processes were critical to artistic aims, Albers was preoccupied with the square, calling it "one of the greatest achievements of human thought." Perhaps his best-known work, the series *Homage to the Square* deals with the effect of color on the properties of the square. Murals based on these theories may be found in the Time-Life and Pan Am buildings in New York City and in the Rochester Institute of Technology. Albers' work is in the permanent collections of the world's major museums.

Embossed Linear Constructions, series of eight embossings, 1969, editions of 100, 20¹⁄₁₆ × 26³⁄₃₂ inches. Series of eight $2,800 or $400 each

White Embossings on Gray, series of ten 1-color linecuts, embossed, 1971, editions of 125, 26⅛ × 20⅛ inches. Series of ten $4,000 or $450 each

Gray Instrumentation I, boxed porfolio of twelve 3- and 4-color screen prints with writings by the artist, 1974, edition of 36, 19 × 19 inches.
Complete set of twelve $15,000 (not available)

Mitered Squares, boxed portfolio of twelve 3-color screen prints with writings by the artist, 1976, edition of 36, 19 × 19 inches. Complete set of twelve $8,000

Never Before, boxed portfolio of twelve 5-color screen prints with writings by the artist, 1976, edition of 46, 19 × 20 inches. Complete set of twelve $6,000

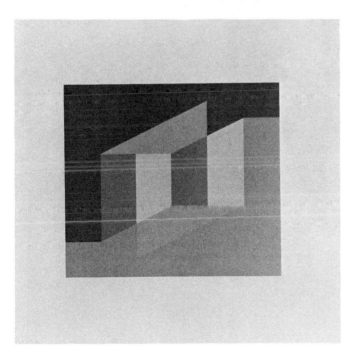

Never Before F *(from a series of twelve prints), screen print, 1976, edition of 46, 19 in. × 20 in. Printed and published by Tyler Graphics Ltd.*
© copyright Josef Albers/Tyler Graphics Ltd. 1976.
Photograph by Barbara Crutchfield, courtesy Tyler Graphics, Ltd., Bedford Village, New York

Pierre Alechinsky (1927–)

Pierre Alechinsky, who was born in Brussels, was one of the founders of the CoBrA group (Copenhagen, Brussels, Amsterdam) whose dedication to primitive form and often violent strokes of color paralleled the American abstract expressionist movement. The group was formed as a reaction to the formal, refined art popular in other European cities immediately after World War II. The artist's style, anguished during the CoBrA period, softened perceptibly as acceptance for his art grew, but it remains strongly expressionistic. He is particularly adept at achieving subtleties and intensities of color in the lithographic process. The recipient of the Andrew Mellon Prize in 1977, Alechinsky is represented in the collections of sixty-five of the world's leading museums. He has been honored with a permanent room in the Louisiana Museum in Denmark.

Windows, portfolio of seven lithographs in color with etching, 1977, edition of 99, 44 × 28½ inches.
Portfolio of seven $6,000

Paris Flying Objects, color lithograph, 1978, edition of 100, 25¾ × 19 inches. $500

Spatial Objects, color lithograph, 1979, edition of 100, 25¾ × 19 inches. $500

Invisible Flying Objects, color lithograph, 1979, edition of 100, 25¾ × 19 inches. $500

Unidentified Flying Objects, color lithograph, 1979, edition of 100, 25¾ × 19 inches. $500

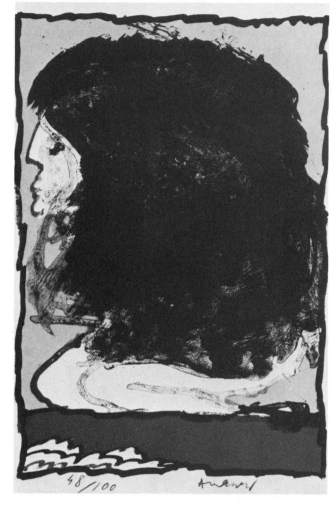

Rue Serpentine, lithograph, 1978, edition of 100,
11 in. × 7½ in. © Pierre Alechinsky 1978
Photograph courtesy Abrams Original Editions, New York

Alvar (1935–)

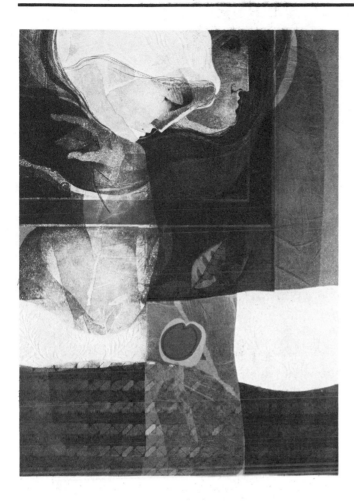

Alvar was born Sund Alvar in the coastal town of Montgat, near Barcelona. He was painting seriously by the age of twelve and at seventeen was accepted at the Escuela Superior de Bellas Artes in Barcelona. During this time he won the Young Painters Prize, sponsored by the city of Barcelona, for a painting that now hangs in its Museum of Modern Art. Alvar had his first one-man show in Barcelona in 1957. Soon after, he won first prize in another painting competition. The prize was a trip to Paris, which became the catalyst for his further studies, one-man shows, and museum exhibitions in France. Since 1963, Alvar has devoted much of his time to lithography and is directly involved in every step of the printing process. He is a skilled draftsman who achieves a wealth of textures and color gradations in his prints. His work is widely exhibited throughout the United States, Canada, and Europe.

Meditation, lithograph with embossing, 1979, edition of 250, 32¾ in. × 23¼ in.
Photograph courtesy Edmund Newman Incorporated, Swampscott, Massachusetts

Meditation, lithograph, 1979, edition of 250, 32¾ × 23¼ inches. $700 (sold out)

Personnage et Table, lithograph, 1979, edition of 250, 32¾ × 23¼ inches. $675 (sold out)

Maternité, lithograph, 1980, edition of 285, 24¾ × 35½ inches. $700 (sold out)

L'Esprit du Village, lithograph, 1981, edition of 285, 28⅝ × 20 inches. $500

Réflexions de l'Artiste, lithograph, 1981, edition of 285, 19⅝ × 30¼ inches. $500

Rêve du Village, lithograph, 1981, edition of 285, 28¾ × 20⅛ inches. $500

Le Tiroir Ouvert, lithograph, 1981, edition of 285, 29 × 20⅞ inches. $500

Carmen, a suite of five lithographs, 1982, edition of 275, 27½ × 20½ inches. $2,900 (sold out)

Richard Anuszkiewicz (1930–)

Richard Anuszkiewicz, born in Erie, Pennsylvania, was educated at the Cleveland Institute of Art, Yale University, and Kent State University in Ohio. A student of Josef Albers, he shares Albers' fascination with shapes and their relationships to color. Considered a major force in the op art movement, Anuszkiewicz is concerned with the optical changes that occur when different high-intensity colors are applied to the same geometric configurations. Each of his prints has its own rhythm and, therefore, its own energy as part of a lyrical composition. He has won many awards and has been a frequent exhibitor in museums thoughout the world. His work is included in the collections of the Corcoran Gallery of Art in Washington, D.C., the Fogg Museum of Harvard University in Cambridge, and the Whitney Museum of American Art and the Museum of Modern Art in New York.

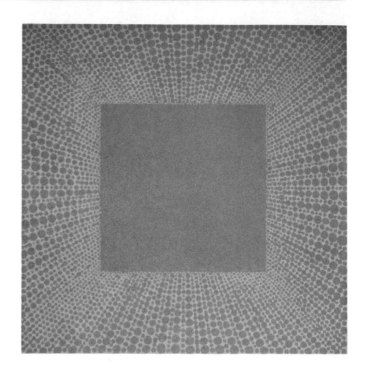

Summer V, etching, 1979, edition of 95, 32 in. × 32 in.
© 1979 International Art Partners
Photograph courtesy Circle Fine Art Corporation, Chicago

Splendor of Orange, screen print, edition of 100, 33 × 33 inches. $400

Spring V, etching, 1979, edition of 95, 32 × 32 inches
$700

Summer V, etching, 1979, edition of 95, 32 × 32 inches.
$700

Autumn, etching, 1979, edition of 95, 32 × 32 inches.
$700

Winter V, etching, 1979, edition of 95, 32 × 32 inches.
$700

Midnight V, etching, 1979, edition of 95, 32 × 32 inches.
$700

Karel Appel　(1921–　)

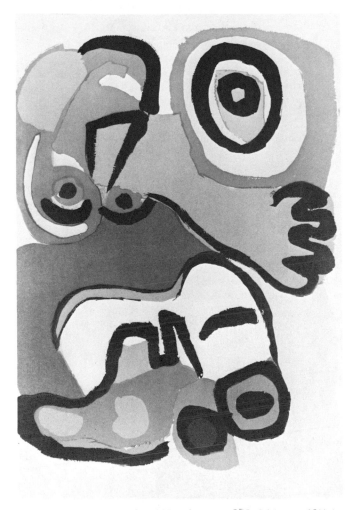

Seeing Eyes, lithograph, 1975, edition of 175, 26 in. × 19½ in. Photograph courtesy Transworld Art, Inc., New York

Dutch-born Karel Appel was part of the original CoBrA group (Copenhagen, Brussels, Amsterdam) whose works were characterized by bold expressionist forms and raw, intense colors. From 1940 to 1943 Appel studied at the Royal Academy of Fine Arts in Amsterdam. By 1951, when he painted a mural for the Stedelijk Museum in Amsterdam, he had earned an important place in the art world. His sculpture, paintings, and prints, thickly layered with color, have a childlike quality about them, but new possibilities present themselves at each viewing. He was awarded the UNESCO Prize at the 27th International Biennale in Venice, and the first prize at the Guggenheim International Exhibition in New York in 1960. He has exhibited in galleries worldwide and is represented in the collections of major museums in the United States, Canada, England, France, and Holland.

Seeing Eyes, lithograph, 1975, edition of 175, 26 × 19½ inches.　$700

Kool Luke Singing Hands, screen print, 1978, edition of 175, 26 × 37¾ inches.　$800

Philosophical Cut, lithograph, 1978, edition of 175, 20 × 26 inches.　$800

Mother and Little Boy, lithograph, 1979, edition of 160, 30 × 22 inches.　$800

Three Faces Like Clouds, lithograph, 1979, edition of 160, 30 × 22 inches.　$700

Happy Battle, lithograph, 1979, edition of 160, 30 × 22 inches.　$750

Faces Together, lithograph, 1980, edition of 160, 30 × 21½ inches.　$600

Landscape Head, lithograph, 1980, edition of 160, 30 × 21½ inches.　$600

Arakawa (1936–)

Shusaku Arakawa was born in Japan and studied medicine and mathematics at the University of Tokyo. The discipline of mathematics, along with philosophical and linguistic studies, has continued to influence his work. His prints, visually and intellectually challenging, are orchestrations of abstract words, grids, and color fields. They offer a unique perspective into the complexities of time and space. Arakawa is an exceptionally skilled printmaker who is involved in every step of the printmaking process. His deep commitment to methodology is a natural extension of the thought that goes into each work. Since 1958 he has participated in more than one hundred and fifty one-man shows and group exhibitions in important galleries and museums throughout the United States, Sweden, Switzerland, Holland, Belgium, England, Ireland, Canada, and Argentina. His work is found in major private and public collections including those of the Museum of Modern Art in New York, the Dayton Art Institute in Ohio, and the Walker Art Center in Minneapolis.

Test Mirror, color lithograph and silkscreen, 1975, edition of 100, 29¼ × 41½ inches. $2,250

The Signified or If . . . , a set of seven color etching and aquatint prints, 1975–76, edition of 60, 30 × 42 inches. $8,000 for the set, individual prints $1,200

Flash Gravity, lithograph with silkscreening and embossing, 1977, 42 × 61 inches. $3,100

Color Samples, color lithographs, set of three prints, 1979, editions of 30, 30, 35; 30 × 24 inches. $1,350 each

Blankless Tone, lithograph with silkscreen, 1979, edition of 35, 29 × 48 inches. $2,250

In Voice/In and Around, lithograph with silkscreen, 1979, edition of 40, 30 × 44½ inches. $2,250

And/Or in Profile, *lithograph/silkscreen with embossing and debossing, 1975, edition of 60, 31 in. × 42⅜ in.*
Photograph courtesy Multiples, Inc., New York

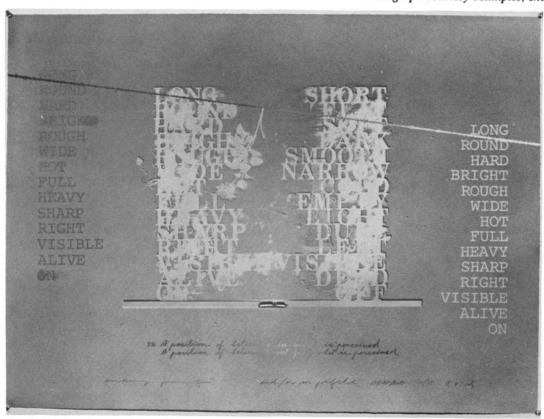

Will Barnet (1911–)

Will Barnet was born in Beverly, Massachusetts, and studied at the Boston Museum of Fine Arts School and then at the Art Students League in New York. He later taught art at such leading American schools as Yale University, Cornell University, and the Art Students League. A prolific graphic artist, Barnet changed his style significantly at different points in his career. His earliest works were influenced by expressionism; they were followed by abstract works in the 1950s and 1960s, and finally evolved into more figurative works of silhouetted forms set against geometrically designed backgrounds. Barnet has worked in most print media and is recognized for his command of all techniques. His work has been exhibited in prominent museums and galleries in the United States and Canada and is included in many prestigious collections, including the Metropolitan Museum of Art and the Guggenheim Museum in New York and the Boston Museum of Fine Arts.

Summer (Silent Season), lithograph, 1976, edition of 200, 32 × 24 inches. $900

The Caller, lithograph-serigraph, 1978, edition of 300, 46 × 21 inches. $300

The Blue Bicycle, serigraph, 1979, edition of 300, 32 × 30 inches. $300

Madama Butterfly, lithograph, 1980, edition of 300, 24 × 37 inches. $300

The Bannister, lithograph, 1981, edition of 300, 36 × 25 inches. $300

Reclining Woman, lithograph, 1982, edition of 300, 33 × 41 inches. $300

Reclining Woman, lithograph, 1982, edition of 300, 33 in. × 41 in. Photograph courtesy Circle Fine Art Corporation, Chicago

Leonard Baskin (1922–)

Leonard Baskin was born in New Brunswick, New Jersey. He studied at New York University, the Yale School of Fine Arts, the New School for Social Research in New York, and academies of art in France and Italy. Imbued with a humanistic outlook, Baskin portrays subjects who speak volumes about the injustices in the world. Taking his inspiration from great literary and historical figures, he adds his elegant signature to their treatises on war, religious or racial persecution, and the moral degeneration of man. Among the many awards he has received are a prize from the Print Club of Philadelphia, the Brooklyn Museum's Annual Print Prize, a medal from the American Institute of Graphic Artists, and the National Institute of Arts and Letters Award. His prints and sculpture are housed in the collections of sixteen American museums.

Woman with Downcast Eyes, engraving/aquatint, 1979, edition of 125, 20 in. × 15 in. Published by Horn Gallery in association with Kennedy Galleries, New York.
Photograph courtesy Horn Gallery, New York

Cheyenne Woman, lithograph, 1974, edition of 100, 29 × 41 inches. $1,000

Crow Stout, lithograph, 1974, edition of 100, 41 × 29 inches. $1,000

Rachel, lithograph, 1976, edition of 100, 41½ × 29½ inches. $600

Cave Bird, etching/engraving, 1978, edition of 125, 29½ × 20 inches. $600

Crow, etching, 1978, edition of 150, 19¾ × 16¾ inches. $400

Embattled Youth, etching/engraving, 1978, edition of 125, 28½ × 20 inches. $550

Oracular Sybil, etching, 1978, edition of 125, 19¾ × 15 inches. $425

Yom Kippur Angel, etching/aquatint, 1978, edition of 150, 41½ × 29¾ inches. $800

Lessons in the Future, etching, 1978, edition of 125, 6 × 6 inches. $165

Romare Bearden (1914–)

Romare Bearden was born in Charlotte, North Carolina. He studied at New York University, the Art Students League (with George Grosz), Columbia University, and the Sorbonne. Bearden has always been concerned with the black experience in America and has used this as his theme throughout his artistic life. The cubist and expressionist elements evident in his work have never been able to mask an innate warmth and appreciation for his subjects. In 1960 Bearden began in earnest to make lithographs and screen prints, and they have successfully brought the lyrical quality of his paintings to paper. In 1971 the Museum of Modern Art in New York honored Bearden with a retrospective. His works appear in the permanent collection of that museum, as well as in many others including the Whitney Museum of American Art and the Metropolitan Museum of Art in New York, the Philadelphia Museum of Art, and the Boston Museum of Fine Arts.

Three Women, lithograph, 1979, edition of 300, 28¼ in. × 21 in.
Photograph courtesy Transworld Art, Inc., New York

The Family, etching, 1975, edition of 175, deluxe edition of 50 on handmade board, 19½ × 26 inches. $700; deluxe edition $800

The Train, etching, 1975, edition of 125, deluxe edition of 25 hand-colored, 22⅛ × 29⅞ inches. $700; deluxe edition $1,000

Pilate, lithograph, 1979, edition of 300, 28¼ × 21 inches. $500

Conjunction, lithograph, 1979, edition of 300, 28¼ × 21 inches. $500

Firebirds, lithograph, 1979, edition of 300, 28¼ × 21 inches. $500

Three Women, lithograph, 1979, edition of 300, 28¼ × 21 inches. $500

Richard Bosman (1944–)

Richard Bosman was born in Madras, India. He studied at the Byam Shaw School of Painting and Drawing in London, the New York Studio School, and the Skowhegan School of Painting and Sculpture in Maine, where he also taught in 1982. The subjects of his work range from the mundane to the mythic, from everyday images of shaving and card-playing to scenes of panic, struggle, escape, and survival. They are united by their psychological content and concentration on formal elements. His woodcuts have been acclaimed by many leading art critics and were featured at a recent exhibition at the Whitney Museum of American Art in New York. The Museum of Modern Art and the Brooklyn Museum in New York, as well as the Fogg Art Museum at Harvard University, the Philadelphia Museum of Art, and the Toledo Museum of Fine Art in Ohio are among the many institutions which have acquired Bosman's works for their collections.

Drowning Man, color woodcut, 1981, edition of 47, 47½ ×
30 inches. $1,200

Mutiny, color woodcut, 1980–81, edition of 36,
18¾ × 24¾ inches. $750

South Seas Kiss, woodcut printed in black, 1981, edition of
17, 19½ × 23½ inches. $250

South Seas Kiss, color woodcut, 1981, edition of 31, 16½ ×
24½ inches. $750

Suicide, color woodcut, 1981, edition of 42,
13½ × 27½ inches. $500

Car Crash (Gray State), color woodcut, 1981–82, edition of
60, 34¾ × 47¾ inches. $750

Attacker, color woodcut, 1982, edition of 48,
32¾ × 29¾ inches. $650

Fight, woodcut in black, 1982, edition of 35,
27¼ × 51 inches. $600

Adversaries, color woodcut, 1982, edition of 42,
30½ × 20½ inches. $750

*Drowning Man, color woodcut, 1981, edition of 47,
47½ in. × 30 in.
Photograph courtesy Brooke Alexander, Inc., New York*

Graciela Rodo Boulanger (1935–)

The Babysitter, lithograph, 1983, edition of 320, 20 in. × 26 in. Photograph courtesy Lublin Graphics Incorporated, Greenwich, Connecticut

Graciela Rodo Boulanger was born in La Paz, Bolivia. She prepared for two careers, musician and painter, and has been successful in both. She studied at the School of Fine Arts in La Paz and in Santiago, Chile. The duality of her talent led her to Vienna, where she pursued studies at the Conservatory and at the Kunstakademie. Boulanger's love of music significantly underscores her lyrical visual compositions. Her carefree subjects often bound into flights of fancy, resulting in the kind of uplifting feelings one might experience after listening to a successful pianist's solo. Boulanger has exhibited in more than one hundred one-woman shows and group exhibitions in the United States, Bolivia, Argentina, Canada, France, Germany, Austria, Italy, Denmark, Switzerland, Belgium, Lebanon, and South Africa. Her work appears in many museums, and in 1979 the United Nations designated hers the official UNICEF Year of the Child image.

Femme avec un Chat, etching, 1972, edition of 150. $1,500 (not available)

Oiseau Indifférent, etching, 1975, edition of 170. $1,000 (not available)

Hopscotch, lithograph, 1979, edition of 320, 19 × 26 inches. $800 (not available)

Jump Rope, lithograph, 1979, edition of 320, 19 × 26 inches. $900 (not available)

Promenade en Bicyclette, lithograph, 1980, edition of 320, 22 × 30 inches. $1,500

Trois Giraffes, lithograph, 1980, edition of 320, 19½ × 27¼ inches. $1,200.(not available)

Trois Chevaux, lithograph, 1980, edition of 320, 19½ × 27¼ inches. $950

Le Petit Rat, lithograph, 1981, edition of 320, 18 × 22¾ inches. $850

The Babysitter, lithograph, 1983, edition of 320, 20 × 26 inches. $800

Charles Bragg (1931–)

Charles Bragg was born in St. Louis, studied at the Art Students League in New York, and now lives in Los Angeles. The turning point in Bragg's career came in the early 1960s when he decided to exhibit some of his work that was far from the mainstream of the art trends of the day. Biting caricatures, reminiscent of Daumier, called attention to a cast of characters who had "lost their souls while acting out depravities through tragicomic burlesques of morality and ethics." He poked fun at the military, the clergy, and the professions—and his shows sold out. During the 1970s Bragg "mellowed," turning from occupational diatribes to universal weaknesses and temptations of the flesh. He continued to poke fun at the mentality of his subjects in his paintings, drawings, etchings, and lithographs. His work is found in the collections of at least twenty international museums, including the Joseph Hirshhorn Collection in Washington, D.C., the Stedelijk Museum in Amsterdam, and the Pushkin Museum in Moscow.

Perfect Couple 340, etching, 1977, edition of 300, 16 × 13 inches. $225 (sold out)

Sanity Hearing, lithograph, 1979, edition of 300, 17 × 26 inches. $800 (sold out)

Self-Portrait with Models, lithograph, 1979, edition of 300, 20 × 26 inches. $400

Garden of Eros, lithograph, 1979, edition of 300, 26 × 20 inches. $1,600 (sold out)

Supreme Court, lithograph, 1980, edition of 300, 23 × 14 inches. $1,400 (sold out)

Lord of Earthly Delights, lithograph, 1980, edition of 300, 22 × 24 inches. $700 (sold out)

Postcards from Paris, lithograph, 1981, edition of 300, 20 × 15 inches. $825

Bad Girls, lithograph, 1981, edition of 300, 15 × 19 inches. $1,400 (sold out)

Jury Deliberation, *etching, 1983, edition of 300, 12 in. × 15 in.*
Photograph courtesy Charles Bragg, Los Angeles

Bruno Bruni (1935–)

Born in the village of Gradara in Italy, Bruno Bruni studied at the Pesaro Institute of Art, and then moved to Hamburg where he studied at the State University for the Visual Arts. It was there that he met and came to be influenced by Paul Wunderlich, who eventually introduced him to lithography. Bruni made his first print in 1963 and continued to devote himself to the medium, completing more than two hundred color lithographs since then. His unique achievements in this field have earned him the Lichtwark Prize from the city of Hamburg in 1967 and the Senefelder Prize in 1977. His works are deeply rooted in the world of Italian classical painting and are noted for their delicacy, sensuality, and "surrealistic humor." Bruni's works have been exhibited in galleries around the world with major shows in New York, Dallas, St. Louis, London, Hamburg, Berlin, Rome, Milan, Padua, Turin, Palermo, Monaco, and Brussels.

Arrivederci, lithograph, 1982, edition of 250, 40 in. × 28¾ in. Photograph courtesy John Szoke Graphics, New York.

Mafioso, lithograph, 1977, edition of 150, 8 × 28 inches. $800

Dacio Fatale, lithograph, 1978, edition of 150, 32 × 24 inches. $750

Fleur du Mal, lithograph, 1979, edition of 150, 30¾ × 22¾ inches. $650

Detail, lithograph, 1981, edition of 150, 30 × 30 inches. $600

Arrivederci, lithograph, 1982, edition of 250, 40 × 28¾ inches. $825

René Carcan (1925–)

René Carcan was born in Brussels and still lives in the region of his birth, the area that has stood as inspiration for the landscapes of the early Netherlandish painters. Heir to a tradition of family painters and printmakers, he carries forward the love of the land in his own uniquely sensitive, haunting style. The recipient of a UNESCO fellowship to visit Rome and Florence and a scholarship given by the Belgian National Ministry of Fine Arts, Carcan studied painting and the graphic arts from 1958 to 1963. He then worked for several years at the Friedlaender atelier in Paris. Exhibitions of his graphic art have been held in galleries and at biennials all over the world. Museums in Brussels, Liège, Paris, New York, Madrid, and Luxembourg have acquired his work for their collections.

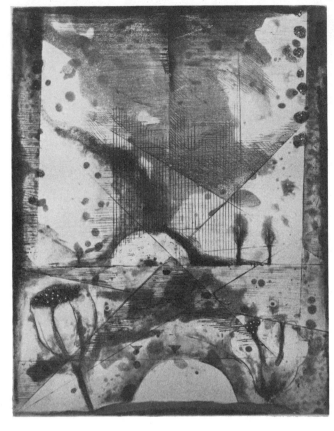

Brouillards, etching, 1983 edition of 135, 14 in. × 10¾ in. Photograph courtesy Cavaliero Fine Arts, New York, © 1983.

Snow Quarry, etching/aquatint, 1976, edition of 180, 12 × 19 inches. $250

The Passion, etching/aquatint, 1977–78, edition of 180, 24 × 20 inches. $400

The Tree of Life, etching/aquatint, 1978, edition of 180, 24 × 20 inches. $500

The Seasons of Brabant (Spring, Summer, Winter, Fall), etching/aquatint, 1981, edition of 180, 20 × 24 inches. $400 each; set for $1,600

Homage to the Sun, (Seven Images), etching/aquatint, 1982, edition of 180, 7 × 9 inches. $180

Roy Carruthers (1938–)

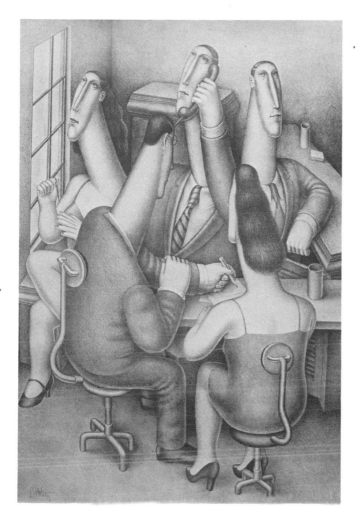

The Left-Handed Bureaucrat, State I, lithograph, 1981, edition of 30, 42 in. × 29 in.
Photograph courtesy Editions Press/Walter Maibaum, San Francisco.

Roy Carruthers was born in Port Elizabeth, South Africa, moved to London in 1961, and to New York in 1968. He had a successful career as an illustrator, winning six major awards for his work, before he decided to concentrate solely on painting and printmaking in 1974. Carruthers feels it is the responsibility of the artist to show others extraordinary views of the visible world. He is so powerfully motivated by his perception of Truth that "he is forced to reshape the world before giving it over to the viewer." His concerns are the quandaries of urban life, which he presents with elements of wit, suspense, eroticism, metaphysics, and social comment. His boldly colored lithographs are executed with meticulous draftsmanship. Since 1975, Carruthers has been given many one-man shows and has participated in group exhibitions in the United States and England. His work is in the collections of a number of museums, including the Metropolitan Museum of Art in New York and the Art Center in Miami, Florida.

Still Life, lithograph, 1981, edition of 75, 30 × 22 inches. $750 (sold out)

Standing Man, Seated Woman, Both Smoking, lithograph, 1981, edition of 75, 30 × 22 inches. $750 (sold out)

Seated Figure, lithograph, 1981, edition of 75, 30 × 22 inches. $750

The Left-Handed Bureaucrat, State I, lithograph, 1981, edition of 30, 42 × 29 inches. $775 (sold out)

The Left-Handed Bureaucrat, State II, lithograph, 1981, edition of 30, 42 × 29 inches. $775 (sold out)

Study 1, lithograph, 1981, edition of 30, 8⅝ × 6 inches. $275

Study 2, lithograph, 1981, edition of 30, 8⅝ × 6 inches. $275

Study 3, lithograph, 1981, edition of 30, 8⅝ × 6⅜ inches. $275

Study 4, lithograph, 1981, edition of 30, 8⅝ × 6 inches. $275

Woman with Remarque, lithograph, 1982, edition of 30, 8⅝ × 6 inches. $725

Christo (1935–)

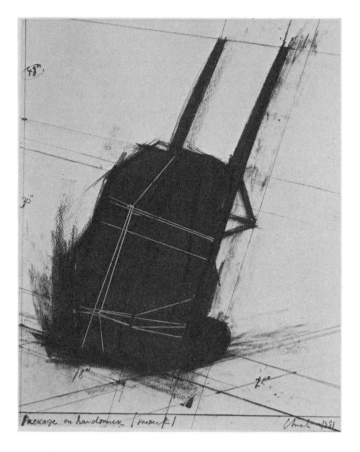

*Born in Sabrovo, Bulgaria, Javacheff Christo attended the Fine Arts Academy of Sofia and the Vienna Fine Arts Academy. He is considered a conceptual artist because the impact of his work lies in the compelling nature of its idea. In his printed and three-dimensional art, Christo wraps an object, challenging the viewer to accurately remember the concealed object and giving it the notion of rarity because it is inaccessible. A movie was made about one of Christo's most famous projects, *Running Fence,* which he constructed in Marin County, California. His work has been included in museum exhibitions in the United States, Australia, West Germany, Holland, Israel, and Denmark and is in the permanent collections of the Museum of Modern Art and the Whitney Museum of American Art in New York, the Tate Gallery in London, the Stedelijk Museum in Amsterdam, and the Albright-Knox Art Gallery in Buffalo.*

Package on Handtruck, Project, *lithograph and collage, 1981, edition of 100, 28 in. × 22¼ in., © Christo 1981. Photograph courtesy Abrams Original Editions, New York*

Wrapped Arm Chair, lithograph, 1977, edition of 100, 22 × 28 inches. $600 (sold out)

Wrapped Modern Art Book, mixed media, 1978. $1,500

Yellow Storefront, lithograph and collage, 1980, edition of 100, 32 × 23⅜ inches. $1,500 (sold out)

Package on Handtruck, Project, lithograph and collage, 1981, edition of 100, 28 × 22¼ inches. $1,500

Chuck Close (1940–)

Chuck Close, who was born in Monroe, Washington, attended the University of Washington in Seattle, Yale University School of Art and Architecture, and the Academy of Fine Arts in Vienna. The recipient of a Fulbright Fellowship Grant (1964–65) and a National Endowment for the Arts Grant (1973), Close is recognized for his pioneering techniques in the creation of photorealist portraits. His first print, *Keith*, was unusually large—45 by 35 inches. He worked from a scale-sized photograph (a collage of photo-enlargements of the original model) and set up a grid system whereby he transferred/etched the image, inch by inch, on the plate. In his recent handmade-paper prints, translations of his grid system, the images are made by using twenty-four shades of pulp, from white to black, and a plastic light grill as a template. He manipulates the pulp with his fingers while it is still wet. Close has had frequent exhibits in major American and European galleries. The Museum of Modern Art and the Whitney Museum of American Art in New York and the Walker Art Center in Minneapolis are just a few of the public institutions that collect his work.

Phil I, handmade paper (white), edition of 15, 69 in. × 53½ in.
Photograph courtesy Pace Editions, Inc., New York

Self-Portrait, etching/aquatint, 1977, edition of 35, 54 × 41 inches. $6,500 (not available)

Self-Portrait—White Ink, etching/aquatint, 1978, edition of 35, 54 × 40½ inches. $4,500

Phil/Fingerprint, lithograph, 1981, edition of 36, 50 × 38 inches. $7,500

Keith I, Handmade paper (gray paper with white ground), ½-inch grid, 1981, edition of 20, 35 × 26¾ inches. $2,500

Keith V, handmade paper (gray paper with white ground, manipulated image, air dried), ½-inch grid, 1982, edition of 20, 35 × 26¾ inches. $4,500 (not available)

Phil I, Handmade paper (gray), cold pressed, ½-inch grid, 1982, edition of 15, 69 × 53½ inches. $6,500

Self-Portrait/Manipulated, handmade paper (gray), ½-inch grid, (manipulated and air dried), 1982, edition of 25, 38½ × 28½ inches. $4,000

James Coignard (1925–)

James Coignard was born in Tours, France, and received his education at the Ecole des Arts Décoratifs in Nice. In the belief that "life and art are inextricable," Coignard has expressed his concerns for life through his work. His early work reflects the concept of man, contained in his universe, coexisting with the many aggressive elements inherent in that world. The symbols, broken lines and numbers, represent the paths man takes and how he balances himself along the way. In Coignard's newer work, it is easier to plot the points of a lifetime through definite vertical and horizontal movement. The aggressive elements still appear, but less pervasively. Coignard is involved at every level of the printmaking process, from making the paper to adding elements of collage unique to each print. Since 1956 he has had more than one hundred and twenty five one-man shows throughout the world. His work is included in the collections of twenty-five international museums.

Élaboration Partielle, etching, 1982, edition of 95, *30 in. × 22 in.*
Photograph courtesy Transworld Art, Inc., New York

Profil Blanc en Blocage S, hand-colored etching, 1980, edition of 75, 22¼ × 30¼ inches. $425

Verticalité, hand-colored etching, 1980, edition of 75, 30¼ × 22¼ inches. $425

Personnage et Agression Verticale, etching, 1982, edition of 75, 30 × 23 inches. $425

Aménagements d' Équilibre Naturel, etching, 1982, edition of 95, 25 × 39 inches. $575

Géométries Autour d'un Préalable, etching, 1982, edition of 95, 18 × 22 inches. $250

Espaces Corrigés, etching, 1982, edition of 95, 22 × 18 inches. $250

Allan D'Arcangelo (1930–)

Allan D'Arcangelo was born in Buffalo, New York. He earned a degree in history from the University of Buffalo and then moved to Mexico City where he studied art and, in 1958, had his first one-man show. His style, loosely termed "hard edge" or constructivist art, is based on spatial relationships. A keen sense of perception, complemented by expert use of color tones and shadows, points up these relationships in forceful compositions. It has been said that D'Arcangelo "has the ability to defy, yet document, spatial relationships at the same time." The recipient of fifteen awards and commissions, D'Arcangelo has had frequent one-man shows, many of which traveled to prominent museums throughout America. His work appears in more than thirty public collections, including those of the Museum of Modern Art, the Guggenheim Museum, and the Brooklyn Museum in New York, the Detroit Institute of Art, and the Walker Art Center in Minneapolis.

Mr. and Mrs. Moby Dick (Floating Bars), screen print, 1978 edition of 150, 27 × 24 inches. $300

Resonance, screen print, 1978, edition of 150, 27 × 23½ inches. $300

Left Turn, screen print, 1978, edition of 175, 31 × 24 inches. $300

U.S. Highway #1, screen print, 1978, edition of 150, 24 × 30 inches. $300

Resonance, screen print, 1978, edition of 150, 27 in. × 23½ in.
Photograph courtesy London Arts, Inc., Detroit.

Gene Davis (1920–)

Born in Washington, D.C., Gene Davis attended the University of Maryland and Wilson Teacher's College in the nation's capital. A self-taught artist, he painted in his spare time while he worked as a newspaper reporter and White House correspondent during the Truman Administration. Davis's experiments with color and form led to recognition in the mid-1960s for his "edge-to-edge" equal-width stripe paintings, which were concerned with color dynamics. Beyond merely painting stripes, Davis considers the role of numerical order, or cardinal and ordinal color, in his compositions. The stripe does not serve as subject matter, but as a unit to define intervals. The differing arrangements of vertical banks of colors create interlocking, overlapping, repeated visual intervals. Davis received many honors, including a 1974 Guggenheim Fellowship. His work has been exhibited in galleries and museums throughout the world, and can be seen in the collections of the Whitney Museum of American Art in New York, the San Francisco Museum of Modern Art, and the Tate Gallery in London, among many others.

Green Giant, color lithograph, 1979 edition of 250, 26 × 28 inches. $500

Lilac, screen print, 1979, edition of 250, 21½ × 30 inches. $500

Sonata, color lithograph, 1979, edition of 250, 21 × 29 inches. $500

Royal Curtain, color lithograph, 1980, edition of 250, 29½ × 21 inches. $500

Lilac, screenprint, 1979, edition of 250, 21½ × 30 in.
Photograph courtesy London Arts, Inc., Detroit

Michel Delacroix (1933–)

Michel Delacroix was born in Paris. He started painting when he was ten and his parents encouraged him to study art. He enrolled in the École des Beaux-Arts in Paris but, after two years, found more inspiration by taking long walks in his beloved city. The charming street scenes and the habits of his fellow countrymen became the focus of his work and continue to be so today. Paris, as Delacroix represents it, is a happy place—an ageless place. In a style described as primitive and with a strong color palette, he disregards "modern" characteristics to capture the personality of the city. The recipient of many awards, he has shown his work in major galleries and important salon exhibitions throughout the United States and Europe. He is a favorite of people who have visited American art fairs in New York, Washington, D.C., and San Francisco from 1978 to the present, because he travels from his home in Paris especially to meet the public.

Place des Vosges, lithograph, 1978, edition of 275, 19½ × 23¾ inches. $900

Place Furstenberg, lithograph, 1979, edition of 295, 19½ × 23¾ inches. $900

Nuit de Décembre, lithograph, 1980, edition of 320, 17⅝ × 23¾ inches. $1,000

Flèche de Notre-Dame, lithograph, 1980, edition of 265, 19½ × 23¾ inches. $900

Moulin Rouge la Nuit, lithograph, 1981, edition of 300, 19½ × 23¾ inches. $1,200

Chaud les Marrons, lithograph, 1982, edition of 325, 12½ × 17¼ inches. $500

Le Bal du 14 Juillet, lithograph, 1983, edition of 325, 12½ × 17¼ inches. $500

Le Bal du 14 Juillet, lithograph, 1983, edition of 325, 12½ in. × 17¼ in.
Photograph courtesy Lublin Graphics Incorporated, Greenwich, Connecticut

Jim Dine (1935–)

Jim Dine was born in Cincinnati, Ohio, and first studied painting in evening courses at the Cincinnati Art Academy while he was still in high school. He then attended the University of Cincinnati, the school of the Boston Museum of Fine Arts, and Ohio University. He moved to New York in 1959 and in that year staged his first happening. At the same time, he was painting, working in collage, and creating his first prints, the *Car Crash* series which commemorated the death of a friend. In the ensuing years, his work took on a more figurative, yet still highly personal style. He has created an autobiography through objects which are privately symbolic. His bathrobe studies, for instance, are progressive self-portraits. Dine's prints reflect his skill as a draftsman and his virtuosity as a painter. Frequently, these skills are combined, but more often he has chosen to separate them so that some prints dramatically display his linear techniques and others his power as a painter. The Whitney Museum of American Art, New York, the Museum of Fine Arts, Dallas, and the Brandeis Museum in Waltham, Massachusetts are only a few public institutions permanently exhibiting his work.

The Red Bandanna, lithograph, 1974, edition of 50, 48 × 35½ inches. $1,500

Hand-Colored Flowers (State I), etching, 1977, edition of 50, 42 × 30 inches. $2,500

Rachel Cohen's Flags, hand-painted etching and aquatint, 1979, edition of 25, 18 × 11 feet. $12,500

A Magenta Robe, A Rose Robe, sugarlift aquatint, hand-painted with oil, diptych, 1979, edition of 16, 42 × 30½ inches, each sheet. $6,000

Winter (Robe), etching, 1980, edition of 40, 42¼ × 30 inches. $2,000

Yellow Robe, three-stone lithograph, 1980, edition of 40, 49¼ × 35 inches. $7,500

Two Hearts in a Forest (State I), woodcut over three-color lithograph, 1981, edition of 24, 36 × 60 inches. $4,500

The Heart Called "Paris Spring", color etching, 1982, edition of 90, 36¼ × 25 inches. $3,000

Fourteen-Color Woodcut Bathrobe, woodcut, 1982, edition of 75, 77½ × 42 inches. $7,500

Rancho Woodcut Heart, woodcut, 1982, edition of 75, 62½ × 42 inches. $2,500

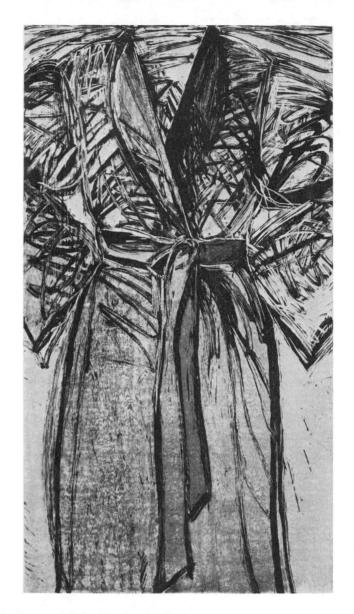

Fourteen-Color Woodcut Bathrobe, woodcut, 1982, edition of 75, 77½ in. × 42 in.
Photograph courtesy Pace Editions, Inc., New York

Jean Dubuffet (1901–)

French-born Jean Dubuffet was in his forties before he dedicated himself to painting. He had his first show in 1944 and in that year also created his first lithographs. His paintings were inspired by graffiti and featured figures composed of such materials as sand, glass, and gravel. They made unique impressions when transferred to drawings and lithographs. Dubuffet held the first *art brut* ("raw art") exhibition in 1949, which included works by amateur artists, as well as psychotics, who Dubuffet believed expressed pure creativity. He continued to explore the sense of texture in his work, adding such materials as plastic and papier-mâché. The 1950s proved to be a tremendously fertile period in the area of lithography. He kept challenging the medium, adding materials of every kind to create texture, experimenting with color combinations on the same image, and sometimes adding various liquids to the printing surface.

Le Surintendant, serigraph, 1972, edition of 120, 20 × 12¼ inches. $1,800

Solitude Illuminée, serigraph, 1975, edition of 50, 38¾ × 28¼ inches. $2,500

Le Fugitif, multiple, enameled steel and aluminum, magnetic, 1977, edition of 50, 29 × 21 inches. $5,000

Faits Mémorables, portfolio of 3 serigraphs, 1978, edition of 70, 29½ × 38 inches. Set $10,000, individually $4,000

Site de Mémoire I (Annale II), silkscreen on canvas, 1979, edition of 10, 99 × 67⅝ inches. $15,000

Site de Mémoire II, silkscreen on canvas, 1979, 84 × 58 inches. $10,000

Les Passants, lithograph, 1982, edition of 50, 32 × 44 inches. $2,000

Les Passants, lithograph, 1982, edition of 50, 32 in. × 44 in. Photography courtesy Pace Editions, Inc., New York

Peter Ellenshaw (1912–)

Peter Ellenshaw was born in England and apprenticed under the renowned painter W. Percy Day at the Royal Academy of Art in London. Early in his career Ellenwood was engaged by Sir Alexander Korda as a production design artist. His paintings were adapted as background scenery for more than forty films, including *The Thief of Bagdad, Spartacus, Treasure Island,* and *20,000 Leagues Under the Sea.* He won an Oscar for *Mary Poppins* and was nominated a second time for *The Black Hole.* Retrospectives of Ellenshaw's work have been held in public institutions across the United States, including one at the Museum of Modern Art in New York. He has enjoyed great success for his marine scenes and landscapes. To capture the essence of his art, his first etching, *Rivulet,* took more than two years to complete. His serigraphs often require seventy different screens to attain fidelity, and Ellenshaw works closely with some of the best master printers in the United States to achieve the results.

Clipper Ships, black and white etching, 1977, edition of 100, 24 × 36 inches. $400

Rivulet, color etching, 1977, edition of 300, 24 × 36 inches. $750 (sold out)

Road to Coomcallee, silkscreen, 1978, edition of 300, 24 × 36 inches. $600

Tide Turning, silkscreen, 1978, edition of 300, 24 × 36 inches. $750 (sold out)

Hyde Park, silkscreen, 1979, edition of 200, 24 × 20 inches. $550

Bookhill Kerry, silkscreen, 1981, edition of 260, 20 × 30 inches. $600 (sold out)

California Sands, silkscreen, 1981, edition of 200, 20 × 30 inches. $550

Crystal Stream, silkscreen, 1981, edition of 240, 20 × 30 inches. $600 (sold out)

Tide Turning, *silkscreen, 1978, edition of 300, 24 in. × 36 in.*
Photograph courtesy Hammer Publishing, New York

Erté (1892–)

Rendezvous, serigraph, 1983, edition of 300, 30 in. × 23 in.
© *1983 Circle Fine Art Corporation*
Photograph courtesy Circle Fine Arts Corporation, Chicago

Erté was born Romain de Tirtoff in St. Petersburg, Russia. The only son of an admiral in the Imperial Fleet, he was raised amidst Russia's social elite. As a young boy, he was fascinated by the Persian miniatures he found in his father's library. These exotic, brightly patterned designs continued to be important to him and influenced the development of his style. He moved to Paris at the age of eighteen and took the name Erté, from the French pronunciation of his initials, R and T. In 1915 he began his long relationship with *Harper's Bazaar,* during which time he created over 240 covers for the magazine. His fashion designs also appeared in many other publications, making him one of the most widely recognized artists of the 1920s. He also designed costumes and sets for the theater. In 1976 the French government awarded Erté the title of Officer of Arts and Letters, and in 1982 the Médaille de Vermeil de la Ville de Paris was bestowed upon him. His work is in many prominent museums, including the Metropolitan Museum of Art in New York, the Los Angeles County Museum, the Smithsonian Institution in Washington, D.C., and the Victoria and Albert Museum in London.

Mystique, serigraph, 1974, edition of 260, 40 × 26 inches. $2,400

Top Hats, serigraph, 1975, edition of 260, 24 × 19 inches. $3,200

Zsa Zsa, lithograph, 1975, edition of 250, 35 × 21 inches. $1,350

Wings of Victory, serigraph, 1978, edition of 325, 32 × 24 inches. $3,400

Spring Fashions, serigraph, 1979, edition of 300, 31 × 23 inches. $1,150

Heat, serigraph, 1980, edition of 300, 25 × 19 inches. $2,000

Fireflies, serigraph, 1980, edition of 300, 32 × 24 inches. $1,900

The Duel, serigraph, 1982, edition of 300, 31 × 23 inches. $1,750

Ready for the Ball, (diptych), serigraph, 1982, edition of 300, 25 × 19 inches. $1,700

Richard Estes (1936–)

Richard Estes was born in Evanston, Illinois. He studied at the Art Institute of Chicago and was greatly influenced by Edward Hopper. By the early 1970s, however, he eliminated people from his urban landscapes. Considered to be one of the most important photorealists, Estes paints from a series of photographs which freeze the exact image he wants of his subject. When transferring the image to print, he uses the medium of silkscreen because the clean, sharp lines and opaque inks allow him to work in layers—the same way he paints. Some of his prints are of such complexity that they require more than fifty screens to achieve the desired effect. Estes has exhibited in galleries and museums all over the world. His work is included in the collections of the Whitney Museum of American Art in New York, the William Rockhill Nelson Museum in Kansas City, the Toledo Museum of Art, the Des Moines Art Center, and the Art Institute of Chicago.

Urban Landscapes, portfolio of 8 screen prints, 1972, edition of 75, 18 × 24 inches. $20,000 ($2,500 each)

Untitled (referred to as *Qualicraft Shoe*), screen print, 1974, edition of 100, 32 × 48 inches. $10,000

Urban Landscapes II, portfolio of 8 screen prints, 1979, edition of 100, 18 × 24 inches. $20,000 ($2,500 each)

Urban Landscapes III, portfolio of 8 screen prints, 1981, edition of 250, 18 × 24 inches. $20,000 ($2,500 each)

Untitled, *(referred to as* Qualicraft Shoe), *screen print, 1974, edition of 100, 32 in. × 48 in.*
Photograph courtesy Parasol Press, Ltd., New York

Leonor Fini (1918–)

Leonor Fini was born in Buenos Aires and grew up in Trieste, where her work was exhibited for the first time when she was seventeen years old. She moved to Paris in 1937, where she met and exhibited with the leaders of the surrealist movement. Her work was the subject of writings by Jean Cocteau, Max Ernst, and Giorgio de Chirico. Fini's work transcends the various currents of modern art, combining elements from her own "imagery museum" with a personal vocabulary of images and symbols. In her examination of her own biological and psychological roots, she presents a society dominated by women, often in mysterious settings, protected from the outside world. She explores her relationship with nature and its constant recycles of birth and death, expressing these ideas in such imagery as flowers, eggs, skulls, and skeletons. Fini's work has been exhibited throughout Europe and the United States, and is included in the permanent collections of many international museums.

Tristan und Isolde, serigraph, 1977, edition of 250, 22 × 30 inches. $700

La Machine à Coudre (Sewing Machine), serigraph, 1979, edition of 250, 30 × 21 inches. $650

Rafaela, serigraph, 1980, edition of 250, 30 × 22 inches. $650

La Tenebrosa (Shadowy Figure), serigraph, 1982, edition of 250, 29 × 21 inches. $650

La Tenebrosa (Shadowy Figure), serigraph, 1982, edition of 250, 29 × 21 inches,© 1982 Circle Fine Arts Corporation Photograph courtesy Circle Fine Art Corporation, Chicago

Dan Flavin (1933–)

Dan Flavin was born in New York City. He studied in the University of Maryland Extension Program in Korea and the New School for Social Research and Columbia University in New York. He is known for his fluorescent light installations. His drawings and graphics, for the most part, come from sketchy statements he makes about the installations in a six-ring notebook. The notebook is Flavin's conceptual space and he takes it everywhere, drawing spontaneously. It follows that he believes art should be experienced at once, in one act of perception. Reluctant to try printmaking because of its impersonality, he discovered that the drypoint, etching, and crayon lithography techniques suited his style. He has personalized his etchings further by making them on a plate the size of his notebook page. His work has been exhibited in prestigious galleries and museums throughout the world. The Metropolitan Museum of Art and the Guggenheim Museum in New York are just two of many museums which have his work in their public collections.

For One Walled Circular Fluorescent Light, a portfolio of 5 black and white lithographs, 1974, edition of 35, 22 × 30 inches. Portfolio $1,500, each $350

Old Woman, etching and drypoint, 1974, 8½ × 11 inches. $350

In March, In Oakland, set of 9 etchings, 1978, edition of 25, 11 × 12½ inches. Set $1,800

For One Walled Circular Fluorescent Light, lithograph, 1974, edition of 35, 22 in. × 30 in.
Photograph courtesy Multiples, Inc., New York

Jean-Michel Folon (1934–)

Jean-Michel Folon was born in Brussels. He began to study architecture but abandoned it in favor of drawing, which allowed more expressive studies. His drawings have appeared in numerous magazines including *Time, Fortune, The New Yorker,* and *L'Express.* In 1969 he had his first one-man show in the United States, followed closely by exhibitions in Tokyo, Venice, Milan, London, São Paulo, Geneva, Brussels, and Paris. Folon has illustrated works by Kafka, Lewis Carroll, and Ray Bradbury. In 1973 he created a series of watercolors titled *La Mort d'un Arbre* (The Death of a Tree), for which Max Ernst created a lithograph as a preface. Folon has completed a 176-square-foot painting for a subway station in Brussels and a 160-square-foot painting for Waterloo Station in London. He is most comfortable using the engraving and drypoint techniques of printmaking.

Le Gardien, etching, 1979, edition of 90, 20 × 26 inches. $500

Oui?, etching, 1979, edition of 90, 20 × 26 inches. $600

Le Secret, etching, 1979, edition of 90, 26 × 20 inches. $500

Le Gardien, etching, 1979, edition of 90, 20 in. × 26 in. Photograph courtesy Transworld Art, Inc., New York

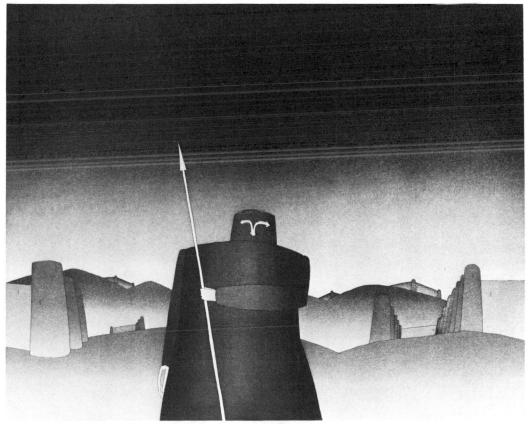

Sam Francis (1913–)

Sam Francis was born in San Mateo, California. He was graduated from the University of California at Berkeley and studied in Paris at the Atelier Fern and Léger. He remained in Paris for seven years, until 1957, exhibiting his paintings in his first one-man show during that time. He traveled extensively, and his art was acknowledged in Europe long before his talent was recognized in America. Francis's prints, like his paintings, are based on configurations of colors that seem to move to their own particular cadence. Most of his prints are lithographs, although he explored the technique of monotype in the early 1960s. Francis was the recipient of the first prize at the International Biennial Exhibition of Prints in Tokyo in 1962 and the Dunn International Award of the Tate Gallery in London in 1963. His work is included in important museum collections throughout the world.

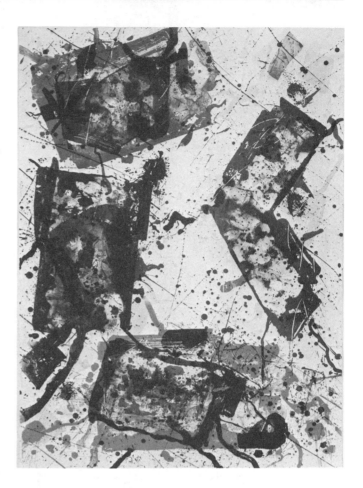

Untitled, color lithograph, 1982, edition of 250, 48 in. × 34 in.
Photograph courtesy Brooke Alexander, Inc., New York

Yunan, State III, lithograph, 1971, edition of 15, 42 × 29 inches. $3,000.

Of Vega, screen print, 1972, edition of 80, 38 × 26 inches. $1,500

Straight Line on the Sun, lithograph, 1976, edition of 32, 51 × 90 inches. $4,500

Point, lithograph, 1976 edition of 26, 36 × 36 inches. $900

Deft and Sudden Gain, lithograph, 1976, edition of 38, 51 × 51 inches. $2,500

Untitled, lithograph, 1977, edition of 25, 51 × 51 inches.$1,800

Living in Our Own Light (6-panel), lithograph, 1977, edition of 20, 88 × 108 inches. $6,000

Pointing at the Future (2-panel), lithograph, 1977, edition of 16, 44 × 72 inches. $2,000

Untitled, lithograph, 1978, edition of 25, 51 × 51 inches. $1,400

Untitled, lithograph, 1979, edition of 75, 25 × 28½ inches. $750

Johnny Friedlaender (1912–)

Johnny Friedlaender was born in Pless, Upper Silesia, Germany, and studied painting at the Breslau Academy of Fine Arts. He made his first engravings in 1928. After living in Czechoslovakia, and traveling through Austria, Switzerland, Belgium, and Holland, in 1937 Friedlaender settled in Paris, the city where he eventually opened one of the most important printmaking studios in Europe. Friendlaender is acknowledged for his mastery of aquatint. He revolutionized the process in terms of capability of textures, and made it possible to give the print added visual depth from the silkiness of a watercolor finish to a contrasting granular finish. A German romantic, he developed a new motif for landscapes, based on subtly abstract organic forms with their own vocabulary of warm earth colors. The precision, logic, and balance of his works are said to be a direct link to the symmetry of classical music. Friendlaender is the recipient of many honors, including the French title of Officer of Arts and Letters, awarded in 1978. His work is found in every prominent modern art museum in the world.

Prisme, etching/aquatint, 1974, edition of 95, 30¼ × 22¼ inches. $1,100

The Vigil, etching/aquatint, 1975, edition of 95, 29¼ × 29 inches. $1,500

Paysage, etching/aquatint, 1976, edition of 95, 22¾ × 30¼ inches. $1,250

The Counterpoint, (triptych) etching/aquatint, 1978, edition of 95, each panel 30 × 23 inches, set $3,750

The Hours (triptych), etching/aquatint, 1979, edition of 95, each panel 30 × 23 inches, set $3,150

Croissance, etching/aquatint, 1979, edition of 95, 30 × 23 inches. $1,000

Paysage Romantique, etching/aquatint, 1981, edition of 95, 30 × 23 inches. $800

Scherzo, etching/aquatint, 1982, edition of 95, 20 × 20 inches. $700

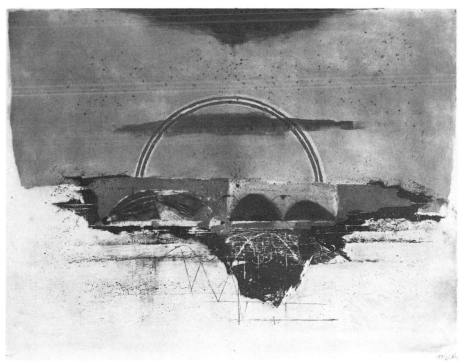

The Hours (centerpiece from triptych), etching/aquatint, 1979, edition of 95, each panel 30 in. × 23 in. Photograph courtesy Horn Gallery, New York

Dennis Frings 1945–

Dennis Frings was born in Illinois. He studied at the University of Illinois and the University of Texas. He taught art for two years while at college in Texas. Frings has received twenty-one awards for his paintings, acrylic abstractions taken a step further to illusionism, in which multiple planes appear to extend beyond or enter into the two-dimensional surface. He uses a variety of papers as a base for each painting. Powerful, complex spatial relationships are built by an interplay of shape and texture, layer and shadow, fine line, jagged edge, and intense color. They are intellectual as well as artistic studies of his world. Frings translates his vision to serigraphy by a lengthy process using many screens. He hand-finishes every impression with an airbrush, thereby sealing the uniqueness of each. His work appears in more than 125 museum and corporate collections. In 1982 he was commissioned by NASA to create a work for the National Air and Space Museum in Washington, D.C.

Counter-balanced, hand-finished serigraph, 1982, edition of 150, 40 in. × 26 in.
Photograph courtesy Frances Laterman: L'Esprit d'Art, New York

Interactional Dimension Series I
 Action Reaction, screen print, 1981, edition of 250, 26 × 40 inches. $300
 Nexus, screen print, 1981, edition of 250, 26 × 40 inches. $300
 Resumptive Patterns, screen print, 1981, edition of 250, 26 × 40 inches. $300

Interactional Dimension Series II
 Nigrosin Violet, screen print, 1982, edition of 250, 26 × 40 inches. $250.
 Refracture, screen print, 1982, edition of 250, 26 × 40 inches. $250.
 Double Stated, screen print, 1982, edition of 25, 26 × 40 inches. $250.

Interactional Dimension Series III
 South Toward Emerald Seas, screen print, 1983, edition of 195, 22 × 30 inches. $270.
 Whimsey and the Story Told, screen print, 1983, edition of 195, 22 × 30 inches. $270.
 Movement for Triangle, screen print, 1983, edition of 195, 22 × 30 inches. $270.
 Proportional Perception, screen print, 1983, edition of 195, 22 × 30 inches. $270.
 Earth and Sky: A Dichotomy, screen print, 1983, edition of 195, 22 × 30 inches. $270.

Joe Goode (1937–)

Joe Goode (José Bueno) was born in Oklahoma City, Oklahoma. He studied at the Chouinard Art Institute in Los Angeles from 1959 to 1961. He is an abstract expressionist who believes an artist's environment is the key to his work. Goode moved from Los Angeles to a secluded area about one hour's drive from Visalia, California, where the colors and textures of the landscape are inspirational, and he has the freedom to use techniques not possible in big cities. For example, in the city Goode vandalized his works by cutting or scoring them; he now blasts them with a shotgun. The pellets form clusters that give the impression of "worthless space." Goode strives to have his art appear to be natural phenomena rather than man-made creations. His work has been shown internationally in more than ninety exhibitions in the most prestigious contemporary galleries and museums. Public collections include the Los Angeles County Museum of Art, the Museum of Modern Art in New York, and the Victoria and Albert Museum in London.

Untitled (316c), diptych, lithograph with gunshots, 1982, edition of 30, each panel 13¼ in. × 10¼ in. Photograph courtesy Cirrus Editions, Ltd., Los Angeles

Lithographs

Untitled (#28c), 1971, edition of 90, 18 × 29 inches. $1,500
Untitled (#31c), 1971, edition of 110, 8½ × 9½ inches. $150
Untitled (#32c), 1971, edition of 50, 14 × 23 inches. $1,000
Untitled (#33c), 1971, edition of 50, 14 × 23 inches. $1,000
Untitled (#85c), 1972, 3 parts, edition of 75, 23¾ × 126 inches. $4,500
Untitled (#127c), 1973, edition of 75, 18 × 24 inches. $475

Lithographs with Tears

Untitled (#167c), 1974, edition 25, 30 × 41½ inches. $850

Lithographs with Razor Marks

Untitled (#238c), 1978, edition of 30, 28 × 40 inches. $650
Untitled (#245c), 1978, edition of 30, 28 × 40 inches. $650
Untitled (#246c), 1978, edition of 30, 28 × 40 inches. $650
Untitled (#247c), 1978, edition of 30, 17½ × 14 inches. $350
Untitled (#248c), 1978, edition of 30, 17½ × 14 inches. $350
Untitled (#249c), 1978, edition of 25, 17½ × 14 inches. $350
Rainy Season '78, series of 6, 1978, edition of 30, 17½ × 14 inches. $1,800 for set, each $350

Lithographs with Gunshots

Untitled (#301c, #305c, #306c, #307c, #308c, #309c, #310c), series of 7 diptychs, 1981, 14⅜ × 23 inches. Each $475
Untitled (#311c), single, 1981, edition of 30, 14¾ × 11 inches. $350
Untitled (#312c, #313c, #314c, #315c, #316c), series of 5 diptychs, 1982, edition of 30, 13½ × 21 inches. $450 each

Daniel Goldstein (1950–)

Daniel Goldstein, who was born in Mount Vernon, New York, was educated at Brandeis University, the University of California, Santa Cruz, St. Martins in London, and San Francisco State. Although he was trained as a sculptor, he is best known for his works on paper. Goldstein uses the medium of woodblock for his printmaking, drawing heavily from his sculptural background to develop his original technique. The many shapes of his composition are cut individually from plywood, then inked and assembled like a jigsaw puzzle on the bed of an etching press—enabling the whole image (all colors) to be printed at once. Goldstein sees his works as "windows onto imaginary space." He usually creates suites of prints, diptychs and triptychs, urging the collector to frame each separately and hang them at least one inch apart, to emphasize the dialogue between the component parts. Many prominent institutions, including the Achenbach Foundation for Graphic Arts, the Brooklyn Museum, and the Art Institute of Chicago, have purchased his works for their collections.

Evening Iris (diptych), woodblock print, 1976, edition of 75, 29 × 29 inches each panel. $1,000

Rocks III, Shumisen (triptych), woodblock print, 1977, edition of 90, 28⅞ × 36⅞ inches each panel. $1,200

Water Garden/Homage to Bachelard (diptych), woodblock print, 1977, edition of 125, 41⅜ × 28⅞ inches each panel. $1,000

Canyons/Passages (4-print suite), woodblock print, 1978, edition of 75, 24⅛ × 18⅞ inches. $1,200 for suite

Tulips and Window, woodblock print, 1979, edition of 100, 48⅞ × 30 inches. $500

Iris Suite (4 prints), woodblock print, 1980, edition of 100, 22³⁄₁₆ × 29⅛ inches. $1,400 for suite

Jupiter Lake (diptych), woodblock print, 1981, edition of 100, 30 × 40 inches each panel. $600

The Purple Room, wood and linoleum block print, 1983, edition of 100, 40 × 30 inches. $400

Water Garden/Homage to Bachelard, *diptych, woodblock print, 1977, edition of 125, each panel 41⅜ in. × 28⅞ in. Photograph courtesy Daniel Goldstein, San Francisco*

R. C. Gorman (1932–)

Rudolph Carl Gorman, a native American, was born in Chinle, Arizona. During his early years he lived in a hogan and had little experience with the world beyond the Navajo reservation. He was raised by his grandmother who ignited his ambition by recounting Navajo legends and by acquainting him with his artistic ancestors. In 1958 he received the first scholarship ever given by the Navajo tribe for study outside the United States. At Mexico City College, Gorman had exposure to the artists Rivera, Siqueiros, and Tamayo, who inspired him to change the direction of his art. He also met José Sanchez, a master printer, and, under his direction, made his first lithographs. Gorman has had more than twenty one-man shows and participated in thirty group shows, including the exhibit Masterworks of the American Indian held at the Metropolitan Museum of Art in New York (he was the only living artist represented). That museum is one of fourteen American art institutions to include his work in their collections.

Esta (State I), 1981, edition of 150, 38 × 26 in.
Photograph courtesy Editions Press/Walter Maibaum, San Francisco

Woman with Pears, lithograph, 1977, edition of 90, 22 × 30 inches. $2,400 (sold out)

Taos Pueblo Woman, lithograph, 1978, edition of 50, 26 × 20¼ inches. $1,800 (sold out)

Walking Woman, silkscreen, 1979, edition of 150, 39 × 30½ inches. $700

Seated Woman, silkscreen, 1979, edition of 150, 29 × 39½ inches. $700

Cochata, silkscreen, 1979, edition of 150, 28½ × 40 inches. $700

Damita, silkscreen, 1979, edition of 150, 40 × 27½ inches. $700

Pajeha, silkscreen, 1980, edition of 150, 22 × 30 inches. $600 (sold out)

Night, silkscreen, 1980, edition of 150, 22 × 20 inches. $700. (sold out).

Winona, silkscreen, 1982, edition of 150, 24 × 34 inches. $700

Daydreamer, silkscreen, 1983, edition of 150, 26 × 36 inches. $800

Red Grooms (1937–)

Red Grooms was born in Nashville, Tennessee. He studied at the Art Institute of Chicago, Peabody College, Nashville, the New School for Social Research, New York, and with Hans Hofmann at his Provincetown, Massachusetts studio. Grooms won a CAPS grant for filmmaking in 1970 and he brings an unusual ability to see beyond the surface to his artwork. Best known for his life-sized environments of stores, subways, and city scenes, he inhabits these environments with offbeat, spirited, easily identifiable characters who strike a humorous chord. Grooms' work has been exhibited in Paris and in American galleries and museums in New York, Boston, Chicago, Washington, D.C., Dallas, Fort Worth, and Stamford. He is included in the collections of the Art Institute of Chicago, the Museum of Modern Art, New York, the North Carolina Museum of Art, Raleigh, and the Chrysler Museum, Provincetown, Massachusetts.

Picasso Goes to Heaven, etching, 1976, edition of 20, 30⅜ × 29 inches. $600 (not available)

Truck, color lithograph, 1979, edition of 75, 24½ × 61¾ inches. $1,800

Truck, lithograph printed in black, 1979, edition of 36, 24½ × 61¾ inches. $1,000

The Tattoo Artist, color lithograph, 1980, edition of 38, 38 × 24¾ inches. $750

Lorna Doone, color lithograph with rubber stamp impressions (printed on 2 sheets), 1979–80, edition of 48, 24½ × 32 inches each. $1,500

Peking Delight, color screen print printed on wood, cut out and assembled, 1979, edition of 50, 16¼ × 18½ × 5 inches. $2,000

Pancake Eater, color lithograph on paper with window shade and Plexiglas, 1981, edition of 31, 42¼ × 30¼ × 3 inches. $3,000

Heads Up D. H., etching/aquatint, 1980, edition of 26, 26¾ × 29¾ inches. $400

Dali Salad, mixed media multiple, 1980–81, edition of 55, 26½ × 27½ × 12½ inches. $2,500

Dali Salad, mixed media multiple, 1980–81, edition of 55, 26½ in. × 27½ in. × 12½ in.
Photograph courtesy of Brooke Alexander, Inc., New York

Richard Hamilton (1922–)

Richard Hamilton was born in London. He studied at the Slade School of Art and later taught industrial design at the Central School of Arts in London. He is recognized as the most important figure in the British pop art movement. More than any other artist, he set the stage for its development, utilizing American pop culture phenomena as his base. He looked to movie magazines, health and diet brochures, and glitzy advertisements aimed at the mass-market middle class. Like other pop artists, Hamilton took inspiration from those things that abounded and were expendable. As his career advanced, Hamilton was one of the first artists to experiment with photomechanical processes in printmaking. He has had exhibits in important galleries worldwide and his work can be seen in many public collections, including those of the Tate Gallery and the Arts Council of Great Britain and the Museum of Modern Art and the Guggenheim Museum in New York.

Mirror Image, color colotype, 1975, edition of 100, 24 × 18 inches. $500

Palindrome, color colotype with 3-dimensional plastic, 1975, edition of 50, 24 × 18 inches. $2,500

Flower-Piece B, 10-color lithograph, 1976, edition of 75, 25⅝ × 19¾ inches. $650

Flower-Piece B-Crayon Study, 4-color lithograph, 1976 edition of 34, 25⅝ × 19¾ inches. $500

Flower-Piece B Cyan Separation, 1-color lithograph, 1976, edition of 23, 25⅝ × 19¾ inches. $350.

Palindrome, color colotype, 1975, edition of 100, 24 in. × 18 in.
Photograph courtesy Multiples, Inc., New York

Richard Haas (1936–)

Richard Haas was born in Spring Green, Wisconsin, attended the University of Wisconsin, the University of Minnesota, Michigan State University, and Bennington College. He taught art at the University of Minnesota and the Walker Art Center in Minneapolis. The recipient of numerous awards (including the annual award from the Municipal Art Society of New York in 1979) and a National Endowment for the Arts Grant in 1978), Haas is a technical virtuoso, actively involved in the entire printmaking process. His large-scale prints depict recognizable architectural images, made even more imposing because they are seen from unusual perspectives. Since 1970 millions of art lovers have seen his work in prestigious galleries throughout the United States. It is on permanent exhibit in more than fifteen museums, including the Whitney Museum of American Art and the Metropolitan Museum of Art in New York, the Art Institute of Chicago, the Boston Museum of Fine Arts, the Houston Museum of Art, and the Library of Congress in Washington, D.C.

Dakota Courtyard, etching, 1971, edition of 50, 29 × 22 inches. $600

Alwyn Court, etching, 1973, edition of 50, 29¾ × 21½ inches. $700

Erie-Lackawanna Hoboken Terminal, etching, 1973, edition of 60, 21 × 36¾ inches. $900

Ansonia Entrance, color lithograph, 1974, edition of 20, 19¼ × 16 inches. $400

Ansonia Entrance, State II, lithograph printed in black, 1974, edition of 20, 19¼ × 16 inches. $300

Olana, color lithograph, 1974, edition of 30, 23¾ × 22¼ inches. $900

Corner of William and Maiden Lane, lithograph, 1974, edition of 40, 30⅛ × 18½ inches. $400

Manhattan View, Battery Park (Night), etching/aquatint, 1980, edition of 50, 26½ × 47 inches. $1,500

Flatiron Building, *etching and drypoint, 1973, edition of 60, 41¼ in. × 17½ in.*
Photograph courtesy Brooke Alexander, Inc., New York

Al Hirschfeld (1903–)

Al Hirschfeld was born in St. Louis, Missouri. In the early 1920s he traveled in Europe, studied the European movements, and came away with a love of simple, fluid composition. After he returned to New York he decided to devote his creative life to the graphic arts and for more than fifty years successfully translated the purity of his form to the etching and lithographic processes. His caricatures of the celebrated capture perfectly the essence of the subject with added touches of humor and warmth. Deceptively simple, they are the works of an extraordinarily skilled craftsman. As a prominent observer and social chronicler of the entertainment world, in the 1930s Hirschfeld began contributing his drawings to the Sunday edition of *The New York Times*. His work appears in the collections of the Whitney Museum of American Art, the Museum of Modern Art, and the Metropolitan Museum of Art in New York.

Groucho Marx, etching, edition of 200, 20 × 15 inches. $300

Bette Davis, etching, edition of 150, 20 × 15 inches. $250

Elvis Presley, etching, edition of 150, 20 × 15 inches. $200

Lucille Ball, etching, edition of 150, 22½ × 17¾ inches. $300

Garbo, etching, edition of 200, 20 × 15 inches. $300

Jane Fonda, etching, edition of 150, 18¼ × 15 inches. $200

Bette Midler, etching, edition of 150, 20 × 15 inches. $200

Sinatra and Pavarotti, etching, edition of 200, 15 × 20 inches. $300

John Wayne, etching, edition, of 200, 20 × 15 inches. $250

Mikhail Baryshnikov, etching, edition of 150, 20 × 15 inches. $350

Keaton and Allen, etching, 1983, edition of 150, 20 in. × 15 in.
Photograph courtesy George Goodstadt, Inc., New York

David Hockney (1937–)

David Hockney, who was born in Bradford, England, studied at the Bradford College of Art and later at the Royal College of Art in London. He had his first one-man show in London in 1963. In that year his suite of sixteen etchings, *The Rake's Progress,* won the Graphics Prize at the Paris Biennial. In the late 1960s, Hockney exhibited his paintings and prints throughout the United States and had one-man shows in museums and important galleries in foreign capitals. Hockney lives and works in California where he feels an affinity for the pop-oriented life. Sun-worshiping, life-in-the-fast-lane appetites inspire his work probably the most famous of which are his swimming pool studies. Hockney has created prints for the benefit of such organizations as the National Council for Civil Liberties, Release, and Phoenix House.

Lithograph of Water Made of Thick and Thin Lines, a Green Wash, a Light Blue Wash and a Dark Blue Wash (Pool I), 7-color lithograph, 1980, edition of 80, 26 × 34½ inches. $3,000

Potted Daffodils, 1-color lithograph, 1980, edition of 98, 44 × 30 inches. $6,000

Joe with Green Window, 6-color lithograph, 1980, edition of 54, 44 × 30 inches. $5,000

The Commissioner, 1-color lithograph, 1980, edition of 50, 16 × 20 inches. $1,000

Ann Seated in a Director's Chair, 1-color lithograph, 1980, edition of 5, 30 × 44 inches. $8,000 (not available)

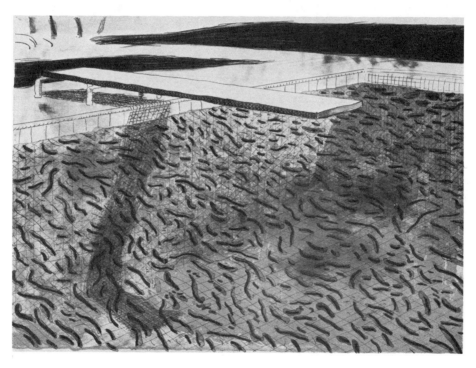

Lithograph of Water Made of Thick and Thin Lines, A Green Wash, a Light Blue Wash and a Dark Blue Wash, lithograph, 1980, edition of 80, 26 in. × 34½ in. Printed and published by Tyler Graphics Ltd. © copyright David Hockney/Tyler Graphics Ltd. 1980
Photograph by Steven Sloman, courtesy Tyler Graphics Ltd., Bedford Village, New York

Robert Indiana (1928–)

Robert Indiana is a pop artist whose fascination with advertising, billboards, and other roadway signs led him to the idealization of the word. Born in New Castle, Indiana, he studied at the Art Institute of Chicago, the Skowhegan School, and the University of Edinburgh. He is famous for his painting *LOVE,* which was subsequently issued as a screenprint in different color combinations and, later, as a United States postage stamp. It became the symbol of the sixties generation. Indiana received awards from the Art Institute of Chicago in 1953 and from the Indiana State Commission on the Arts in 1973, as well as other honors. He has exhibited his work in important galleries and museums in the United States, England, Finland, and the Netherlands and is included in the collections of America's most prominent museums.

The Golden Future of America, silkscreen, 1976, edition of 175, 26 × 19½ inches. $700

Decade: Autoportraits, portfolio of ten silkscreen prints, 1980, edition of 125, 27¾ × 27¾ inches. Individual prints $650, $6,000 for portfolio

Number 1, from Decade: Autoportraits, *1980, portfolio of ten silkscreen prints, edition of 125, 27¾ in. × 27¾ in. Photograph courtesy Multiples, Inc., New York*

Yvonne Jacquette (1934–)

Yvonne Jacquette was born in Pittsburgh, Pennsylvania. She studied at the prestigious Rhode Island School of Design and was a visiting critic at the University of Philadelphia Graduate School of Fine Arts. Jacquette's prints, like her paintings and drawings, are haunting aerial views of cities, harbors, and other landscapes, most of which eloquently capture the personality of their particular location at night. The quantity and intensity of street lights illuminating the areas convey, figuratively speaking, electricity in the air. Jacquette has recently completed a mural commissioned by the General Services Administration in Bangor, Maine. She has had frequent one-woman shows and group exhibitions, and her work has been chosen by the Corcoran Gallery in Washington, D.C., the Museum of Contemporary Art in Chicago, and the Metropolitan Museum of Art in New York, among others, for exhibit in their permanent collections.

Aerial View of 33rd Street, lithograph, 1981, edition of 60, 50 in. × 31 in.
Photograph courtesy Brooke Alexander, Inc., New York

22nd Street, lithograph hand colored with pastel, 1974, edition of 46, 23 × 21¼ inches. $1,200

East 15th Street, color lithograph, 1974, edition of 125, 17½ × 22 inches. $600

Fog River IV, color lithograph, edition of 79, 16⅜ × 18¹/₁₆ inches. $250

Green Light, Gray Day, color lithograph, 1976, edition of 38, 20 × 24 inches. $600

Aerial View of 33rd Street, lithograph, 1981, edition of 60, 50 × 31 inches. $1,500

Northwest View from the Empire State Building, lithograph, 1982, edition of 60, 51 × 35 inches. $1,000

Two Ferries Passing, color aquatint, 1982, edition of 50, 29¾ × 22 inches. $750

Jasper Johns (1930–)

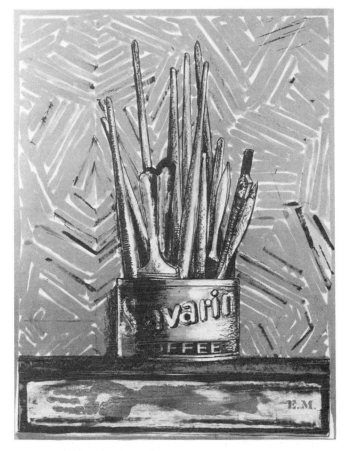

Savarin, lithograph, 1977–81, edition of 60, 50 in. × 38 in.
Published by Universal Limited Art Editions, Long Island,
New York
Photograph courtesy of Castelli Graphics, New York

Jasper Jones was brought up in South Carolina and moved to New York in 1952, where he supported himself in part by designing window displays while painting his now famous *Flag* and *Target* studies. His first lithographs were published in 1960 and were extensions of the subject matter of earlier works done in different media. These early prints are among the most sought after American prints of the 1960s. His use of ordinary objects is infused with heightened imagination, carrying them steps further from their preordained manufactured state. Like that of the dadaist Marcel Duchamp, Johns's work is an entreaty to the viewer to develop new concepts of the character of inanimate objects. His serious dedication to, and virtuosity in, the print media make him one of the most highly regarded artists of our time. He has been honored with retrospectives in many museums, including the Philadelphia Museum of Art and New York's Museum of Modern Art.

0 Through 9, from first etchings, 2nd state, 1967–69, edition of 40, 25¼ × 19¼ inches. $3,000

Target with Four Faces, silkscreen, 1968, edition of 100, 41½ × 29 inches. $5,000

Light Bulb, lead relief, 1969, edition of 60, 39 × 17 inches. $10,000

Zone, lithograph, 1972, edition of 65, 44 × 29 inches. $3,000

Zone (black state), lithograph, 1972, edition of 16, 44 × 29 inches. $3,500

Ale Cans (II), lithograph, 1975, edition of 14, 19 × 14¾ inches. $4,000

Savarin 2 (wash and line), lithograph, 1978, edition of 42, 25½ × 19½ inches. $3,000

Usuyuki, lithograph, 1979, edition of 49, 34½ × 50½ inches. $12,000

Two Flags, lithograph, 1980, edition of 56, 47½ × 36 inches. $5,200

Usuyuki, screen print, 1979–81, edition of 85, 29½ × 47¼ inches. $7,000

Alex Katz (1927–)

Alex Katz was born in New York. He attended the Cooper Union Art School in that city and the Skowhegan School of Painting and Sculpture in Maine. The recipient of a Guggenheim Fellowship (1972) and the Cooper Union Professional Achievement Citation (1972), Katz is a highly regarded artist whose prints are a natural outgrowth of the development of his paintings and drawings. He became interested in flatness and scale as his works became "symbols of gesture rather than direct emotional acts." Katz differs from other printmakers in that he relies on imperfections of technical processes, for example, colors slightly overlapping, to produce the fragile unity of the image. He works from a photograph or slide, but the image is rendered by hand onto the plate or screen in the lithography, etching, or silkscreen media. Since 1960 Katz has had frequent exhibitions in prominent galleries and museums, including a traveling exhibition of prints which originated at the Whitney Museum of American Art in New York. Katz's work is also featured at the Museum of Modern Art, New York, the Boston Museum of Fine Arts, and the Art Institute of Chicago among many others.

Alex, color lithograph, 1970, edition of 100, 29¾ × 21¼ inches. $900

Homage to Frank O'Hara: William Dunas, color lithograph, 1982, edition of 90, 33¼ × 25½ inches. $2,000

Red Sails, color screen print, 1973, edition of 60, 23 × 29 inches. $450

Sunny, drypoint aquatint, 1974, edition of 52, 15⅜ × 22⅜ inches. $600

Still Life, drypoint aquatint, 1974, edition of 62, 22⅜ × 31 inches. $750

Black and White Sunny, lithograph, 1976, edition of 40, 25⅛ x 23 inches. $450

Face of the Poet, portfolio of 14 color aquatints (to accompany each portrait, each poet has contributed a poem), 1978, edition of 25, 14½ × 19 inches each. Set for $7,500

Song, color lithograph/screen print, 1980–81, edition of 99, 32⅞ × 43⅞ inches. $2,400

Large Head of Vincent, aquatint, 1982, edition of 60, 60 × 36 inches. $2,000

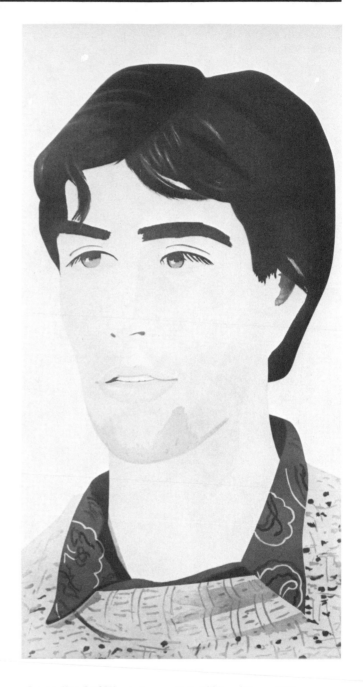

Large Head of Vincent, *aquatint, 1982, edition of 50, 60 in. × 36 in.*
Photograph courtesy Brooke Alexander, Inc, New York

Ellsworth Kelly (1923–)

Ellsworth Kelly was born in Newburgh, New York, and studied at Pratt Institute in Brooklyn, the Boston Museum of Fine Arts School, and the École des Beaux-Arts in Paris. He had his first one-man show in Paris in 1951 before returning to the United States. Kelly created his first print, a lithograph, in 1950, but abandoned the medium until 1964 when he began two major suites of lithographs. Since then he has continued to work with prints and has become famous for his minimalist style, which glorifies a single geometric shape in an undefined background. Kelly's work has been exhibited in important galleries throughout the world. He has participated in major museum shows, including the Guggenheim Museum, the Whitney Museum of American Art, the Museum of Modern Art, the Jewish Museum, and the Metropolitan Museum of Art in New York, the Los Angeles County Museum of Art and the Pasadena Museum in California, as well as the Tate Gallery in London.

Colored Paper Images XVII, colored pulp laminated to hundmade paper, 1976, edition of 22, 32¼ in. × 31¼ in.
Published by Tyler Graphics, Bedford Village, New York
Photograph courtesy Castelli Graphics, New York

Blue Black, 2-color lithograph, 1970, edition of 75, 36 × 34½ inches. $850

Yellow Black, 2-color lithograph, 1970, edition of 75, 41⅜ × 36 inches. $1,400

Black Curve I, 1-color lithograph with pencil lines, 1973, edition of 50, 34 × 34 inches. $900

Black and White Pyramid, 1-color screen print, embossed, 1973, edition of 50, 32⁹⁄₁₆ × 46 inches. $900

Colors on a Grid, screen print 1976 (after *Colors for a Large Wall, 1952),* 15-color screen print/lithograph, 1976, edition of 46, 48¼ × 48¼ inches. $10,000

Blue/Green/Yellow/Orange/Red, colored pulp laminated to handmade paper, 1977, edition of 14, 13½ × 46 inches with deckle. $4,000 (not available)

Dark Gray and White, 1-color screen print with handmade paper collage, 1979, edition of 41, 30 × 42 inches. $2,000

Wall, 1-color etching/aquatint, 1979, edition of 50, 31½ × 28 inches. $3,000 (not available)

R. B. Kitaj (1932–)

Ronald B. Kitaj was born in Cleveland, Ohio. He studied at the Cooper Union Art School in New York in 1950 and the following year at the Academy of Fine Art in Vienna. In 1957 Kitaj settled in England for ten years. He studied at the Ruskin School of Drawing, Oxford University, and taught at the Ealing School of Art. He is closely connected with the British stream of pop art. Kitaj's prints, mostly screen prints, are collages of seemingly incongruous forms, objects, and words. He inserts names, sentences, and literary references with the figurative elements of his compositions, thereby challenging the viewer to recognize the central theme. The images, while scientifically and precisely constructed, represent great depth of emotion. Kitaj was awarded first prize in the First British International Print Biennale, 1968, and has consistently been exhibited in prominent galleries and museums throughout the world. His work appears in the collections of twenty-two international museums, including the Museum of Modern Art, New York, and the Tate Gallery, London.

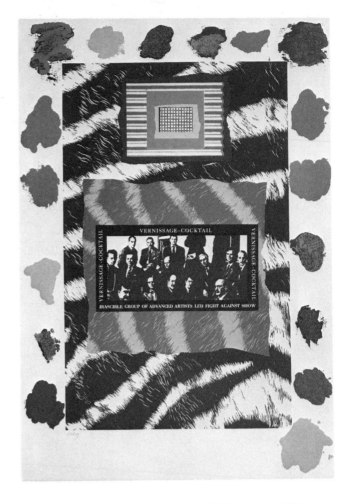

Vernissage Cocktail, screen print, 1966, edition of 70, 41 in. × 27¾ in.
Photograph courtesy Marlborough Gallery, New York

Acheson Go Home, screen print, 1963, edition of 40, 29 × 21 inches. $500

The Cultural Value of Fear, Distrust, and Hypochondria, screen print, 1965, edition of 70, 20½ × 30½ inches. $700

The Desire for Lunch Is a Bourgeois Obsessional Neurosis, screen print, 1965, edition of 70, 29¾ × 20¼ inches. $500

Vernissage Cocktail, screen print, 1966, edition of 70, 41 × 27¾ inches, $700

Civic Virtue, screen print, 1967, edition of 100, 21 × 26½ inches. $700

In Our Time, screen print, 1970, edition of 150, 31 × 22½ inches each. $4,000 for set of 50, $150 single prints

Kenneth Koch, screen print, 1971, edition of 70, 37 × 24⅝ inches. $400

Ezra Pound II, screen print, 1974, edition of 70, 35⅝ × 29⅝ inches. $800

French Subjects, screen print and collage, 1974, edition of 70, 40 × 25½ inches. $1,000

Lives of the Saints, screen print, 1975, edition of 70, 40½ × 28 inches. $750

Lebadang (1922–)

Lebadang was born in Vietnam and emigrated to France in 1939 to study at the École des Beaux-Arts in Toulouse. He had his first one-man show in Paris in 1950 and over the next thirty years gained prominence throughout France and Germany. He came to the attention of Americans in 1966 when the Cincinnati Art Museum hosted the first one-man exhibition of his paintings in the United States. In his work Lebadang fuses the cultural interests of the Orient and Europe, creating graceful imagery in infinite variations of line, shape, and color. He is recognized as an accomplished printmaker, having worked extensively in the media of etching, lithography, and serigraphy. "Lebadangraphy" is his invention whereby he achieves harmony with a minimum of colors, using the same silkscreens several times. His work is in the Rockefeller Collection and the Phoenix Art Museum, among others.

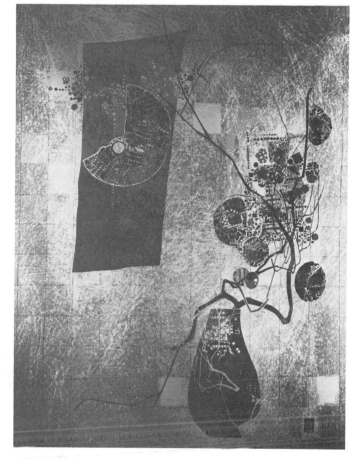

Fleurs, serigraph, 1980, edition of 300, 64 in. × 48 in.
© 1980 Circle Fine Art Corporation
Photograph courtesy Circle Fine Arts Corporation, Chicago

Le Lune Rouge, lithograph, 1973, edition of 225, 29 × 21 inches. $150

Bouquet des Fleurs, remarqued lithograph, 1976, edition of 200, 29 × 21 inches. $475

La Lune Mystérieuse, remarqued lithograph, 1976, edition of 200, 29 × 21 inches. $425

La Branche Morte, remarqued lithograph, 1976, edition of 200, 41 × 25 inches. $525

Le Chevalier Solitaire, serigraph, 1979, edition of 275, 30 × 22 inches. $375

La Montagne Ensoleillée, serigraph, 1979, edition of 275, 31 × 31 inches. $400

La Lune Blanc, embossment, 1981, edition of 300, 30 × 23 inches. $525

Mystérieux Rendezvous, serigraph, 1982, edition of 275, 30 × 46 inches. $600

Sol Lewitt (1928–)

Sol Lewitt was born in Hartford, Connecticut, and graduated from Syracuse University in 1949. He worked for a while in the offices of the architect I. M. Pei where he developed his interest in confined design. Lewitt first exhibited modular sculptures, based on three-dimensional grids, at a show at the Jewish Museum in New York in 1966. He then switched to work on paper, completing large wall drawings and smaller series of drawings which increasingly took the model of the grid to new heights of sophistication. Meticulously drawn, the tiny lines criss-cross in places, creating a sense of movement in the image. Lewitt carefully plans each design for his prints and then works with skilled draftsmen to make sure his calculations are perfectly carried out. He has had more than sixty international exhibits and his work is included in the collections of many museums, including the Museum of Modern Art and the Whitney Museum of American Art in New York, the Art Institute of Chicago, and the Detroit Institute of Art.

All One Two Three and Four Part Combinations of Lines in Four Directions, a set of two silkscreens, black and white, and color versions, 1976, edition of 20, 26 × 23 inches, set for $600

All Combinations of Red, Yellow and Blue Straight and Broken Lines on Red, Yellow and Blue, color silkscreen, 1976, edition of 50, 30 × 30 inches. $450

Serial System Using Lines and Color, set of six silkscreens, 1977, edition of 45, 14¾ × 19¼ inches. $1,000

Lines in Color on Color to Points on a Grid, set of ten color silkscreens, 1978, edition of 25, 30 × 30 inches. $3,000

Untitled, set of 8 silkscreens, 1980, edition of 50, 18 × 18 inches. Individually $300, set for $2,000

Untitled Set of Ten, set of ten silkscreens, 1981, edition of 25, 20 × 20 inches. $3,000

Forms Derived from a Cube, set of 24 aquatints, 1982, edition of 25, 21 × 21 inches. Set of 8 $3,200, individually $450, set of 24 $9,000

Untitled (set of 6), woodcut, 1982, edition of 25, 30 in. × 30 in. and 28 in. × 28 in.
Photograph courtesy Multiples, Inc., New York

Roy Lichtenstein (1923–)

Before the Mirror, lithograph and silkscreen, 1975, edition of 100, 42¾ in. × 32 in.
Photograph courtesy Multiples, Inc., New York

Lichtenstein was born in New York City and in 1939 studied at the Art Students League under Reginald Marsh. He furthered his education at Ohio State University and eventually taught there as well as at Rutgers University. Lichtenstein's earliest works reflected the influence of Marsh, but in 1961 he began to exhibit his hallmark style when he introduced the first of his now famous cartoon images. The subjects of his paintings and prints, together with his technique of using benday dots (derived from a commercial printing process) to build the images, make his works among the purest statements of pop art. Lithography and screen printing are natural corollaries to Lichtenstein's paintings, and all media have succeeded simultaneously. Lichtenstein has participated in some of the most important museum exhibitions of modern art in the United States and Europe. The Museum of Modern Art, New York, the Tate Gallery, London, and the Stedelijk Museum, Amsterdam, are a few of many prominent museums to collect his work.

Still Life with Cheese, lithograph/silkscreen, 1974, edition of 100, 33 × 44¼ inches. $3,000

Still Life with Crystal Bowl, lithograph/silkscreen, 1975, edition of 45, 37½ × 49½ inches. $6,000

Before the Mirror, lithograph/silkscreen, 1975, edition of 100, 42¾ × 32 inches. $3,000

Huh, silkscreen, 1975, edition of 100, 41½ × 29½ inches. $2,000

At the Beach, lithograph, 1978, edition of 38, 26 × 43 inches. $3,000

The Couple, woodcut/embossed, 1980, edition of 50, 39½ × 33 inches. $6,000

Head with Feathers and Braid, etching with aquatint, 1981, edition of 32, 24 × 19¾ inches. $1,250

Study of Hands, lithograph/silkscreen, 1981, edition of 100, 31½ × 32¾ inches. $1,000

Richard Lindner (1901–1978)

Richard Lindner was born in Hamburg, Germany, and lived there until 1933 when he fled to Paris. He remained there until 1939 when he joined the allied forces serving in Europe. After arriving in the United States in the early 1940s, Lindner worked as an illustrator for many publications, including *Vogue* and *Harper's Bazaar,* drawing witty characteriztions of offbeat, sometimes bizarre New Yorkers. He continued to do studies of people, depicting clues to their personal fantasies. His style is the sophisticated amalgamation of cubist and surrealist elements, mixed with the immediacy of the big city population. He taught for thirteen years at Pratt Institute, Brooklyn, and in 1963 was a visiting lecturer at Yale University. Lindner's prints have been published since the mid-1960s. Perhaps the best know series, *Fun City,* was issued in 1971. This successful artist's work has been exhibited in fine galleries, at biennials, and in major museum shows internationally.

Washington Holiday, lithograph, 1975, edition of 175, 26 in. x 19½ in.
Photograph courtesy Transworld Art, Inc., New York

Afternoon (portfolio of 8 color lithographs):
 How It All Began, lithograph, 1970, edition of 250, 28 × 21¾ inches. $715
 Man's Best Friend, lithograph, 1970, edition of 250, 28 × 21¾ inches. $715
 Miss American Indian, lithograph, 1970, edition of 250, 28 × 21¾ inches. $715

Fun City (portfolio of 14 color lithographs):
 Fun City, lithograph, 1971, edition of 175, 27¾ × 40 inches. $715
 Fifth Avenue, lithograph, 1971, edition of 175, 26½ × 20 inches. $715
 New York Men, lithograph, 1971, edition of 175, 25¼ × 20 inches. $715
 Out-of-Towners, lithograph, 1971, edition of 175, 26¼ × 20¼ inches. $715
 Uptown, lithograph, 1971, edition of 175, 26½ × 51¾ inches. $715
 Ace of Clubs, lithograph, 1982, edition of 250, 28¼ × 22 inches. $715

Robert Mangold (1937–)

Robert Mangold was born in North Tonawanda, New York, and attended the Cleveland Institute of the Arts, and Yale University. He has taught art at the School of Visual Arts and Hunter College in New York, and at the Skowhegan School in Maine. His earliest work quickly established him as an important minimalist artist. Influenced by Frank Stella, he worked on asymmetrical canvases and then on semi-circular paintings with dividing lines that created a composition. These compositions were repeated in his first screen prints. Mangold then became intrigued with the properties of circles and squares and their interaction. He switched to a combination of aquatint and soft-ground etching techniques which best suited his resolutions of the circle/square questions. These prints also introduced a new, beautiful color palette. In 1966, Mangold received a Guggenheim Memorial Grant and a National Council of the Arts Award. He has exhibited in prestigious museums throughout the world, and his work is in many permanent collections.

Seven Aquatints, color, 1974, edition of 50, 27 × 22 inches. $6,000

Five Aquatints, color, 1976, edition of 50, 9 × 9 inches. $2,500

Three Aquatints, portfolio of three aquatints, color, 1979, edition of 50, 41 × 41 inches; 40¾ × 43¾ inches; 25½ × 58¼ inches. $3,000

*From the portfolio of **Three Color Aquatints,** 1979, edition of 50, 41 in. × 41 in.*
Photograph courtesy Parasol Press, Ltd., New York

Marisol (1930–)

Marisol Escobar is a sculptor who was born in Paris to Venezuelan parents but spent most of her childhood in Los Angeles. She studied at the École des Beaux-Arts in Paris and then in 1950 settled in New York where she studied at the Hans Hofmann School and the Art Students League. Her early works, small, playful figures roughly carved from wood, matured into mixed-media assemblages incorporating painting, drawing, carving, plaster casts, and found objects. Her sculpture grew in size as well as concept and in later years were larger than life. Marisol has been successful at translating segments of these assemblages into print. A single image, taken from the whole, is treated as an important separate entity, even though the style is sometimes whimsical and is always highly personal.

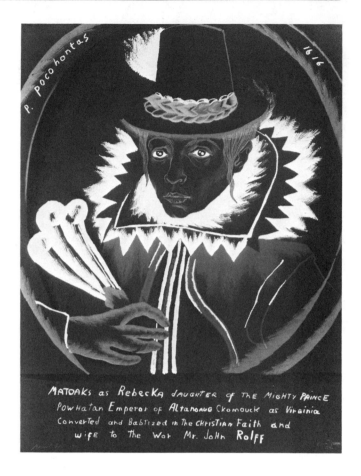

Pocohontas, lithograph, 1975, edition of 175,
26 in. × 19½ in.
Photograph courtesy Transworld Art Inc., New York

Banner, silkscreen, 1972, edition of 20, 88 × 50 inches.
$900

Pocohontas, lithograph, 1975, edition of 175,
26 × 19½ inches. $750

Sun, handcast paper, 1981, edition of 30, 19½ × 22½ × 5⅛ inches. $2,000

Peter Max (1937–)

Peter Max was born in Berlin, but spent the first nine years of his life in China and one year in Tibet. His family then traveled to Africa, Israel, Europe, and finally settled in the United States. In New York Max studied at the Art Students League, Pratt Institute, and the School of Visual Arts. After completing his studies he opened a design studio and in the next few years won more than sixty-five awards for product, fashion, food, book, and poster designs. In 1964 he closed the studio to go into "creative retreat." It was then that he begn making the colorful, mind-expanding silkscreens which are his hallmark. After Max's second retreat, from 1972 until 1976, he "reappeared" with a book of fifty paintings, in honor of each state, dedicated to the Bicentennial. Max has had approximately forty museum shows internationally, set up under the auspices of the Smithsonian Institution, and more than fifty gallery shows worldwide. His works appear in the prominent collections of many museums, including the Museum of Modern Art in New York.

Tibetan Scene, lithograph, 1978, edition of 150, 21½ in. × 29 in.
Photograph courtesy London Arts, Inc., Detroit

Night Flowers, screen print in colors, 1977, edition of 150, 18¾ × 24¼ inches. $400

Space Landscape I, screen print in colors, 1978, edition of 150. $400

Close to the Sun, screen print in colors, 1978, edition of 150, 18¾ × 23¼ inches. $400

Angel, screen print in colors, 1978, edition of 230, 27 × 19½ inches. $450

Tibetan Scene, color lithograph, 1978, edition of 150, 21½ × 29 inches. $500

Woman Face, color lithograph, 1980, edition of 200, 25 × 34 inches. $500

Bird in Hand, serigraph in colors, 1980, edition of 200, 36 × 28¾ inches. $550

American Lady, color lithograph, 1980, edition of 200, 21 × 27½ inches. $450

Freedom, color lithograph, 1980, edition of 200, 21 × 26½ inches. $450

Friedrich Meckseper (1936–)

Born in Bremen, Germany, Friedrich Meckseper studied first at the State Art Academy in Stuttgart and then at the State University for the Visual Arts in Berlin. In more than forty-five shows and museum exhibitions, he introduced his paintings and prints to a wide public in the United States, Germany, France, Italy, Switzerland, Holland, England, and Australia. His work shows a rare technical virtuosity with metal plates. His graphic oeuvre (more than two hundred etchings and engravings, drypoints and mezzotints) is noted for its variety as well as its extraordinary precision. Influenced by the German romantic Caspar David Friedrich, Meckseper has a traditional approach to his art. He is a collector, and lover, of all things mechanical and uses his own antique clocks, model trains, cars—and steamboat—as inspiration for his orderly compositions.

Stilleben 62, aquatint, 1962, edition of 15, 15½ × 15½ inches. $2,500

Uhr, aquatint, 1974, edition of 150, 16 × 20 inches. $2,500

Atelier, aquatint, 1974, edition of 100, 17¼ × 15½ inches. $1,500

Mechanischer Tisch, aquatint, 1977, edition of 100, 20 × 20 inches. $750

Stilleben 78, aquatint, 1978, edition of 100, 6¼ × 9⅛ inches. $500

Stilleben 1979, *aquatint, 1979, edition of 100, 16 in. × 20 in.*
Photograph courtesy John Szoke Graphics, New York

Robert Motherwell (1915–)

Motherwell is an American abstract expressionist painter. He studied philosophy at Harvard and was part of Columbia University's Faculty of Fine Arts and Archeology in 1940–41. Motherwell visited Europe in 1938 and the following year exhibited with the surrealists in New York. His own work was influenced by the surrealist painter Roberto Matta, with whom Motherwell worked in Mexico in 1941. He founded the Subjects of the Artists art school in New York in 1948 with painters Mark Rothko, William Baziotes, and Barnett Newman, and this school later became a forum for discussion by avant-garde artists. Motherwell started making etchings at Atelier 17 in the early 1940s. He made a few prints during the 1950s and began his work in the lithographic medium in the 1960s. These lithographs reflect his virtuosity with collage motifs and color fields.

Soot-Black Series, series of 1-color lithographs, 1975, each $500

 #2, edition of 47, 36 × 24 inches.
 #4, edition of 50, 36 × 24 inches.
 edition of 53, 36 × 24.
 ition of 50, 36 × 18 inches.

 hograph, 1975, edition of 49, 62⅜ × 40

 olor lithograph/screen print with
 f 14,
 500

 hograph, 1980, edition of 50,
 2/00

 our color lithographs, 1979–80,
 ½ inches each. Set for $3,000,

 79–80, edition of 50, 18⅞ ×

The Berggruen Series (No. 4), set of four color lithographs with embossing, 1979–80 , edition of 100, each 16 in. × 16½ in. Co-published by Brooke Alexander, Inc., New York, Berggruen & Cie, and John Berggruen Galley, San Francisco Photographs courtesy of Brooke Alexander, Inc., New York

Kaiko Moti (1921–)

Kaiko Moti was born in Bombay, India. He studied for five years at the Bombay School of Fine Arts and in 1946 won a scholarship to the Slade School of Fine Art at University College in London. In 1950 he left to study in Paris and has remained in that city. He began his etching career in 1952, studying under William Stanley Hayter, and was struck by the avenues of experimentation open to him in that medium. Influenced by the Old Masters, his technique reflects their precision and formality. Because of the refined nature of his lines, and the fact that he may add as many as thirty colors to a print, each edition takes several months to complete. His images—florals, animals, birds, and marines—are included in the collections of the Victoria and Albert Museum in London, and the Musée d'Art Moderne and Bibliothèque Nationale in Paris.

Lioness, etching, 1981, edition of 215, 19½ in. × 23 in.
Photograph courtesy Lublin Graphics Incorporated, Greenwich, Connecticut

Fleur Aquarelle, etching, 1973, edition of 220, 18¾ × 22½ inches. $600

Owl II, etching, 1976, edition of 215, 17½ × 22½ inches. $500

Nightwatch, etching, 1977, edition of 195, 22 × 29¾ inches. $650

Pomegranates, etching, 1977, edition of 215, 22½ × 30 inches. $550

Voir en Songe, lithograph, 1978, edition of 300, 21⅝ × 29½ inches. $400

Agua Blanca, etching, 1980, edition of 220, 18 × 29⅞ inches. $700

Les Roses, etching, 1980, 21⅛ × 30¾ inches. $650

Lioness, etching, 1981, edition of 215, 19½ × 23 inches. $600

La Mer, etching, 1982, edition of 220, 18¼ × 25½ inches. $650

Force de Voile, etching, 1982, edition of 270, 12 × 15 inches. $350

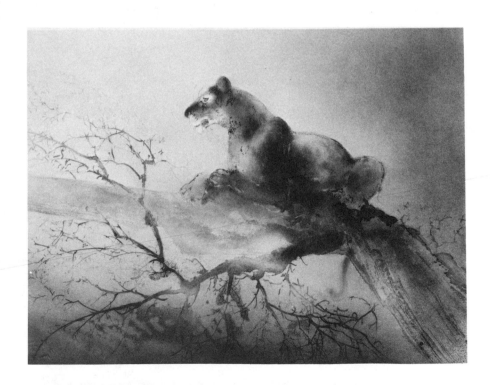

Robert Motherwell (1915–)

Motherwell is an American abstract expressionist painter. He studied philosophy at Harvard and was part of Columbia University's Faculty of Fine Arts and Archeology in 1940–41. Motherwell visited Europe in 1938 and the following year exhibited with the surrealists in New York. His own work was influenced by the surrealist painter Roberto Matta, with whom Motherwell worked in Mexico in 1941. He founded the Subjects of the Artists art school in New York in 1948 with painters Mark Rothko, William Baziotes, and Barnett Newman, and this school later became a forum for discussion by avant-garde artists. Motherwell started making etchings at Atelier 17 in the early 1940s. He made a few prints during the 1950s and began his work in the lithographic medium in the 1960s. These lithographs reflect his virtuosity with collage motifs and color fields.

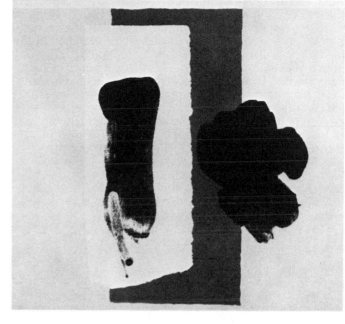

The Berggruen Series (No. 4), *set of four color lithographs with embossing, 1979 80 , edition of 100, each 16 in. × 16½ in. Co-published by Brooke Alexander, Inc., New York, Berggruen & Cie, and John Berggruen Galley, San Francisco Photographs courtesy of Brooke Alexander, Inc., New York*

Soot-Black Series, series of 1-color lithographs, 1975, each $500

> *#2,* edition of 47, 36 × 24 inches.
> *#4,* edition of 50, 36 × 24 inches.
> *#5,* edition of 53, 36 × 24.
> *#6,* edition of 50, 36 × 18 inches.

Bastos, 6-color lithograph, 1975, edition of 49, 62⅜ × 40 inches. $12,000

St. Michael I—State I, 6-color lithograph/screen print with monotype, 1979, edition of 14, 62⅞ × 25⅜ inches. $4,500

Rite of Passage I, 1-color lithograph, 1980, edition of 50, 25½ × 29¼ inches. $1,500

The Berggruen Series, set of four color lithographs, 1979–80, editions of 100 each, 16 × 16½ inches each. Set for $3,000, individually $750

St. Mark's, color lithograph, 1979–80, edition of 50, 18⅞ × 21¼ inches. $600

Kaiko Moti (1921–)

Kaiko Moti was born in Bombay, India. He studied for five years at the Bombay School of Fine Arts and in 1946 won a scholarship to the Slade School of Fine Art at University College in London. In 1950 he left to study in Paris and has remained in that city. He began his etching career in 1952, studying under William Stanley Hayter, and was struck by the avenues of experimentation open to him in that medium. Influenced by the Old Masters, his technique reflects their precision and formality. Because of the refined nature of his lines, and the fact that he may add as many as thirty colors to a print, each edition takes several months to complete. His images—florals, animals, birds, and marines—are included in the collections of the Victoria and Albert Museum in London, and the Musée d'Art Moderne and Bibliothèque Nationale in Paris.

*Lioness, etching, 1981, edition of 215,
19½ in. × 23 in.*
*Photograph courtesy Lublin Graphics
Incorporated, Greenwich, Connecticut*

Fleur Aquarelle, etching, 1973, edition of 220, 18¾ × 22½ inches. $600

Owl II, etching, 1976, edition of 215, 17½ × 22½ inches. $500

Nightwatch, etching, 1977, edition of 195, 22 × 29¾ inches. $650

Pomegranates, etching, 1977, edition of 215, 22½ × 30 inches. $550

Voir en Songe, lithograph, 1978, edition of 300, 21⅝ × 29½ inches. $400

Agua Blanca, etching, 1980, edition of 220, 18 × 29⅞ inches. $700

Les Roses, etching, 1980, 21⅛ × 30¾ inches. $650

Lioness, etching, 1981, edition of 215, 19½ × 23 inches. $600

La Mer, etching, 1982, edition of 220, 18¼ × 25½ inches. $650

Force de Voile, etching, 1982, edition of 270, 12 × 15 inches. $350

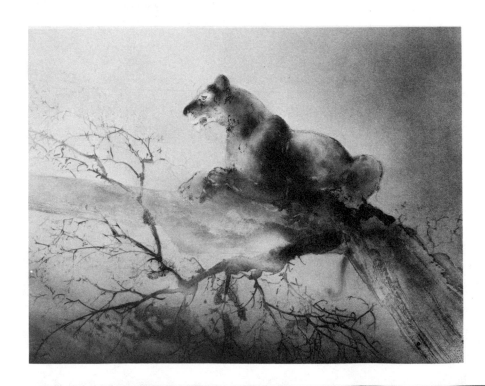

Patrick Nagel (1945–)

Nagel was born in Dayton, Ohio, and raised in Los Angeles, where he attended the Chouinard Institute of Art. After teaching at the Art Center College of Design in Los Angeles, he left for Paris where he spent several years continuing his studies. It was the significance of the Moulin Rouge—and the lifestyle of the artists of that time—that influenced him and encouraged his career. Once back in Los Angeles, he immediately became popular with collectors. The simplicity of Nagel's composition is in direct response to the complexities of our lives. It is his intention to offer the opportunity for a few calm, beautiful moments in the day. He has chosen to work in silkscreen because he feels the rich texture that is achieved best complements his subjects and because the medium allows for the purest colors on the paper. Nagel has been given numerous one-man shows, has participated in group shows at the White House and the Library of Congress in Washington, D.C., and in 1980 was honored with a retrospective at the Grunwald Center for the Graphic Arts at UCLA. The Oakland Museum and the Smithsonian Institution have collected his work.

Mirage Ship, serigraph, 1977, edition of 200, 26 × 15½ inches. $1,800

Park South, serigraph, 1979, edition of 250, 25 × 17 inches. $650

Standing Lady, serigraph, 1980, edition of 25, 60 × 37 inches. $3,000

Mask, serigraph, 1980, edition of 50, 41 × 29½ inches. $3,000

Diptych, serigraph, 1980, edition of 250, 20 × 21 inches. $1,800

Black Robe, serigraph, 1981, edition of 90, 42 × 27 inches. $3,000

Great Dame, serigraph, 1981, edition of 60, 30 × 43 inches. $2,500

Gray Lady, serigraph, 1982, edition of 90, 34 × 50 inches. $2,000

Lori, serigraph, 1982, edition of 90, 29½ × 36 inches. $2,500

Michelle, *serigraph, 1982, edition of 90, 36 in. × 41¾ in.*
Photograph courtesy Mirage Editions, Inc., Santa Monica, California

Alice Neel (1900–)

Alice Neel was born in Merion Square, Pennsylvania, and studied art at the Philadelphia School of Design (now Moore College of Art). She lived for one year in Havana, Cuba, where she had her first one-woman show, and then settled in New York. In 1933 she was one of many struggling artists chosen by President Roosevelt to participate in the WPA's Federal Art Project, to create paintings for public buildings. Known for her portraits, Neel captures the sitter's strengths and weaknesses. Her work shows her interest in seeing beyond the surface to portray the struggles, tragedies, and joys of life. Her work appears in the collection of every major American museum and has been exhibited in galleries and at biennials throughout the world. In 1981 she became the first living American artist to have a major retrospective in Moscow.

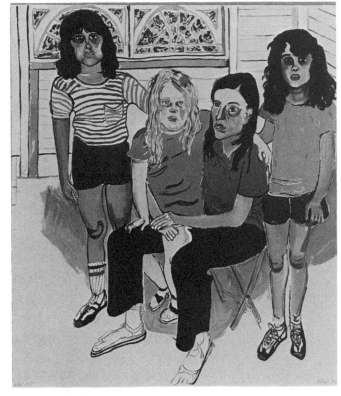

The Family, lithograph, 1982, edition of 175,
27 in. × 31¼ in.
Photograph courtesy Atelier Ettinger, Inc., New York

The Family, 17-color lithograph, edition of 175,
27 × 31¼ inches. $900

Jar from Samarkand, 16-color lithograph, 1982, edition of 175, 28 × 38 inches. $800

Mother and Child, 24-color lithograph, 1982, edition of 175, 28 × 31 inches. $800

The Bather, 24-color lithograph, 1982, edition of 175, 26¼ × 43¼ inches. $800

Light, 20-color lithograph, 1983, edition of 175,
27 × 38 inches. $800

LeRoy Neiman (1926–)

LeRoy Neiman was born in St. Paul, Minnesota, and studied at the Art Institute of Chicago, De Paul University, and the University of Illinois. He taught at the Art Institute of Chicago's school for ten years. Neiman moved to New York City in 1963 when he had his first one-man show at the Hammer Gallery. Since then he has continued to portray the people and events of the world he knows best, or which intrigue him most. His best-known works are sports scenes, a reflection, he believes, of the fact that sports are universally a dominant force. He was the official artist for ABC-TV at the Olympic Games in 1972 and 1976, and at the Winter Olympics of 1980. Neiman's work has been exhibited in galleries and museums throughout the world, including the Smithsonian Institution in Washington, D.C., and the Hermitage in Leningrad.

Toots Shor Bar, serigraph, 1975, edition of 300, 30¾ × 25¼ inches. $6,500

Elephant Stampede, serigraph, 1976, edition of 300, 30¼ × 40 inches. $12,000

Introduction of the Champion at Madison Square Garden, serigraph, 1977, edition of 300, 29¼ × 36½ inches. $5,500

P. J. Clarke's, serigraph, 1978, edition of 300, 26¼ × 39¼ inches. $9,700

Irish-American Bar, serigraph, 1979, edition of 300, 26 × 38½ inches. $5,800

F. X. McRory's Whiskey Bar, serigraph, 1980, edition of 300, 22⅝ × 45⅛ inches. $5,800

Tour de Force, serigraph, 1981, edition of 300, 23⅞ × 33¼ inches. $3,700

Silverdome Superbowl, serigraph, 1982, edition of 300, 27¾ × 38⅛ inches. $3,200

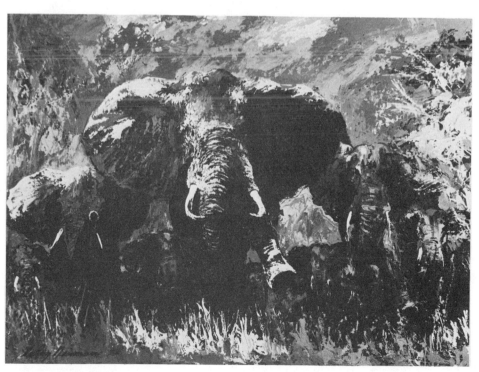

Elephant Stampede, serigraph, 1976, edition of 300, 30¼ in. × 40 in.
Photograph courtesy Knoedler Publishing, Inc., New York

Lowell Nesbitt (1933–)

Lowell Nesbitt was born in Baltimore. He received a BFA degree from Temple University's Tyler School of Fine Arts and then attended the Royal College of Art in London. An artist with a highly personal style, Nesbitt has made realistic studies of many themes throughout his career. His most well-known series, and perhaps his most beautiful and poetic, are the more than four hundred works he created using the flower as theme. Since his first show in 1957, Nesbitt has had more than eighty one-man shows in galleries and museums internationally. His paintings, drawings, and prints are included in the collections of the Museum of Modern Art in New York, Yale University in New Haven, Connecticut, the Corcoran Gallery and the National Gallery of Fine Art in Washington, D.C., the Detroit Institute of Art, the Art Institute of Chicago, the Baltimore Museum of Art, the Philadelphia Museum of Art, and the La Jolla Museum in California, among others.

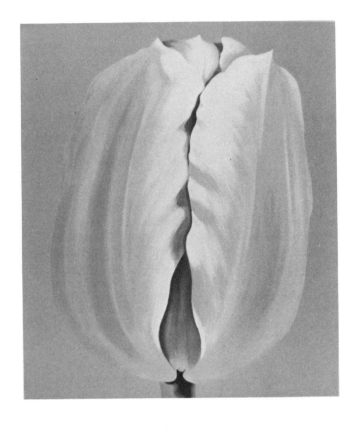

Pink Tulip, screen print, 1978, edition of 175, 26 in. × 22 in. Photograph courtesy London Arts, Inc., Detroit

Grapes, color lithograph, 1977, edition of 175, 19 × 31 inches. $400

Iris and Rose on Gold, serigraph, 1978, edition of 175, 25 × 38 inches. $500

Pink Tulip, serigraph in colors, 1978, edition of 175, 26 × 22 inches. $500

Rose—75, serigraph in colors, 1978, edition of 175, 23½ × 23½ inches. $500

Rust Iris, serigraph in colors, 1978, edition of 175, 23½ × 23½ inches. $500

Ten Lemons, serigraph in colors, 1979, edition of 175, 24 × 27 inches. $500

Louise Nevelson (1900–)

Louise Nevelson was born in Kiev, Russia, and studied art at the Art Students League in New York, at Hans Hofmann's school in Munich, and was assistant to Diego Rivera in Mexico City. Her sophisticated sculptural explorations have had tremendous impact on her graphic oeuvre. Nevelson's prints can be divided into two styles: those which reflect the three-dimensional quality of her work by intaglio or cast-relief printing and those which reflect her interest in two-dimensional collage, wherein the elements are layered (using lace and color) to create the effect of varying depths on a flat surface. Her interest in color is pursued only through the second technique. Nevelson has had exhibitions in prestigious galleries worldwide, and her work appears in the collections of more than twenty-five eminent museums including the Museum of Modern Art, New York, the Hirshhorn Museum, Washington, D.C., and the Tate Gallery, London.

Double Imagery, lithograph, 1967, edition of 20, 42 × 58 inches. $3,000

Double Imagery, lithograph, 1967, edition of 20, 22 × 42 inches. $2,500

Untitled, portfolio of six aquatints and collages, 1973, edition of 90, 37 × 26 inches. $15,000
 Print #1, $4,000
 Print #2, $4,000
 Print #3, $2,500
 Print #4, $4,000
 Print #5, $4,000
 Print #6, $2,500

Symphony Three, black polyester resin multiple, 1974, edition of 125, 18⅛ × 18⅛ inches × 2 feet. $5,000

Full Moon, cast polyester resin multiple, 1980, edition of 125, 18½ × 18½ inches. $3,500

Sun-Set, cast polyester resin multiple, 1981, edition of 125, 11½ × 17¼ inches. $4,000

Sky Gate II (gray), cast paper relief, diptych, 1982, edition of 90, 33¾ × 19⅞ inches each sheet. $3,000

Sun-Set, *cast polyester resin multiple, 1981, edition of 125, 11½ in. × 17¼ in. Photograph courtesy Pace Editions, Inc., New York*

Don Nice (1932–)

Don Nice was born in Visalia, California. He attended the University of Southern California and Yale University and taught at the School of Visual Arts in New York. Nice is a realist whose work reflects a dual interest in the landscape and everyday articles of our pop culture. His paintings reflect both themes and are usually separated into two distinct parts; one with either a landscape or an animate or inanimate object as the theme, the other having several related or unrelated images of pop culture. In the gouache and watercolor media, as well as his prints, he tends to limit the images. These works usually contain some images which he contrasts in form and surface. The Museum of Modern Art in New York, the Minneapolis Institute of Art, and the Delaware Art Museum in Wilmington have collected his work.

Hudson River Parrot (triptych), lithograph and silkscreen, 1980, edition of 50, 10⅜ × 29½ inches, 38¼ × 29½ inches, 13⅛ × 29½ inches. $750

American Still life, Portfolio of three lithographs, 1980, 30 × 22 inches. $1,250
 American Still Life I, $500
 American Still Life II, $500
 American Still Life III, $500

Two Pair, etching and aquatint, 1982, edition of 50, 30 × 40 inches. $750

Two Pair, etching and aquatint, 1982, edition of 50, 30 in. × 40 in.
Photograph courtesy Pace Editions, Inc., New York

Leonardo Nierman (1932–)

Leonardo Nierman was born in Mexico City. In 1951 he received his bachelor's degree from the University of Mexico in physics and mathematics and has drawn on this background for his studies of the harmony of form in space and the psychology of color. Nierman's lithographs come to life as they "capture the intensity and spontaneity of the dynamic forces that rule both nature and the cosmos." Swirling whirlpools of color represent that which is unchallenged and therefore not quite understood. Nierman has received several international awards and in 1965 was made a life fellow of the Royal Society of the Arts in London. His work appears in the collections of many museums, including the Museum of Fine Arts in Boston, the Fort Worth Art Museum, the Detroit Institute of Art, and the Academy of Fine Arts in Honolulu.

Forms in Space, lithograph in colors, 1974, edition of 275, 18 × 24 inches. $300

Stravinsky, lithograph in colors, 1976, edition of 270, 18 × 24 inches. $400

Prismatic City, lithograph in colors, 1977, edition of 275, 18 × 24 inches. $400

Capriccio, lithograph in colors, 1980, edition of 350, 18 × 24 inches. $400

Sonata, lithograph in colors, 1980, edition of 350, 18 × 24 inches. $400

Moonlight, lithograph in colors, 1980, edition of 350, 18 × 24 inches. $400

Musical Nocturne, lithograph in colors, 1980, edition of 350, 18 × 24 inches. $400

Jerusalem, lithograph in colors, 1980, edition of 350, 18 × 24 inches. $400

Flight Sensation, lithograph, 1983, edition of 325, 23¼ in × 17 in.
Photograph courtesy Lublin Graphics Incorporated, Greenwich, Connecticut

Claes Oldenburg (1929–)

Oldenburg, the son of a Swedish diplomat, was born in Stockholm and brought to the United States as an infant. He attended Yale University, but completed requirements for his degree by taking night courses at the Art Institute of Chicago while working as an apprentice news reporter during the day. In the early 1950s he exhibited in the Chicago area. In 1956, when he moved to New York, he began a long series of exhibits and happenings in innovative galleries. One of the artists who developed pop art, Oldenburg started in 1961 to make prints—large studies of a single object (lipstick, scissors, eraser)—at Pratt Graphics Center in New York. He has worked successfully in many print media, and he has received the Skowhegan Award (1972), the São Paulo Award (1977), and a Japan Foundation Fellowship (1979). He continues to be exhibited in the world's most important galleries and museums.

Typewriter Eraser as Tornado, color offset lithograph, 1972, edition of 200, 29 × 20 inches. $300

Lipstick on Caterpillar Tracks, color lithograph, 1972, edition of 100, 32 × 23 inches. $750

Landscape with Noses, color etching and aquatint, 1975, edition of 35, 26 × 20 inches. $750

Sailboat and Hat, color etching and aquatint, 1976, edition of 35, 24 × 17 inches. $750

Postcard of the Spoon on the Île St. Louis with Needles, color aquatint with chine collé, 1979, edition of 50, 26½ × 21½ inches. $850

Crusoe's Umbrella, color aquatint and collage, 1979, edition of 50, 20¾ × 24¼ inches. $1,200

Braque's Nail, lithograph, 1980, edition of 60, 24¾ × 18½ inches. $450

Screwarch Bridge, State I, line etching, 1980, edition of 15, 31½ × 58 inches. $2,400

Screwarch Bridge, State II, etching and aquatint, 1980, edition of 35, 31½ × 58 in.
Photograph courtesy Multiples, Inc., New York

Mimmo Paladino (1948–)

Mimmo Paladino was born in Padua, Italy, and now lives and works in Milan. He is considered one of the best of a group of young European artists known as the "trans-avant-gardists." Varying degrees of reality, states of becoming and disappearing are represented in his imagery. Metamorphoses and transformation are the energizing forces, and his symbolism reinforces a strong philosophical belief in renewal and regeneration; it also reflects his view that good and evil are but different reflections of the same whole. Remarkably, Paladino has been able to translate this intensity to the lithographic medium. Paladino's earliest shows were group exhibitions in Brescia in 1976. He had a major drawing exhibition at the Basel Kunstmuseum in 1981. His work has been acquired for the collections of such major institutions as the Museum of Modern Art in New York, the Philadelphia Museum, and the Fogg Museum in Cambridge, Massachusetts.

Con Musica, etching, 1980, edition of 35, 24½ in. × 22 in. Photograph courtesy Multiples, Inc., New York

Acqua di Stagno, etching, aquatint, and spit bite, 1980, edition of 35, 22½ × 35 inches. $475

Fantasma, chine collé, aquatint, and soft ground, edition of 35, 24 × 30 inches. $350

Acqua di Ombra, line etching, 1980, edition of 35, 23½ × 31½ inches. $350

Solo Due Pesci, etching and aquatint, edition of 35, 31⅝ × 23⅜ inches. $400

Set of Four, set of 4 etching and color linocut prints, 1982, edition of 35, 31 × 23 inches. $2,400 (set), $650 (individual)
 Tra Il Vento Fuoco
 Guardar Misteri
 Stelle sulla Schema
 Caverne Minacciose

Max Papart (1911–)

Papart, who was born in Marseilles, began his career as a landscape painter. His work evolved into abstraction, and he gained a reputation as the heir to classic cubism. Through the years he has developed spiritual affinities with other styles and schools. Elements of Etruscan, archaic European, African, and pre-Columbian art have influenced his work, leading to his present semi-figurative style. In Papart's art, composition goes hand in hand with color, each strengthening the other. He feels that "color is intuitive." His etchings are noted for contrast in surface textures, achieved with aquatint for a soft, mottled appearance and with carborundum, a technique that results in deep veining reminiscent of stone. Papart has received a number of awards for printmaking. His work is found in many collections, including those of the Victoria and Albert Museum, London, the Musée d'Art Moderne, Paris, the Israel Museum, Jerusalem, and Yale University, New Haven.

Bird Under Red Moon, etching/aquatint/carborundum, 1978, edition of 50, 37 × 54 inches. $3,400

Memory of the Future, etching/aquatint/carborundum, 1979, edition of 50, 37 × 54 inches. $3,500

Harlequin Bird, etching/aquatint/carborundum, 1980, edition of 50, 54 × 37 inches. $3,200

Splendid Summer, etching/carborundum, 1980, edition of 60, 30 × 22 inches. $950

Song Bird, etching/carborundum, 1980, edition of 60, 23 × 30 inches. $950

The Red Horse, etching/aquatint/carborundum, 1981, edition of 50, 37 × 28 inches. $2,200

Red Harlequin, etching/aquatint/carborundum, 1981, edition of 60, 29 × 42 inches. $3,400

Royal Bird, *etching/aquatint, 1983, edition of 60, 54½ in. × 38½ in.*
Photograph courtesy Nahan Galleries, New Orleans

Philip Pearlstein (1924–)

*Model in Green Kimono, color aquatint, 1979, edition of 41,
40¼ in. × 27⅛ in. Published by 724 Prints, New York
Photograph courtesy Brooke Alexander, Inc., New York*

Philip Pearlstein was born in Pittsburgh, Pennsylvania,
and studied at Carnegie Institute of Technology in
that city and then at New York University. He taught
at Pratt Institute, Brooklyn, was a visiting critic at
Yale University, and is now Professor of Art at
Brooklyn College. The recipient of many international
awards for his paintings, Pearlstein extended his artis-
tic exploration into printmaking in the 1960s. The
theme of his lithographs and aquatints, derived from
his paintings and drawings, focuses on the nude figure.
He works from a model or from photographs taken of
figures posed somewhat nonchalantly in realistic set-
tings. Pearlstein has had a long, accomplished career.
His work has been exhibited in major galleries and
museums throughout the world and can be seen in at
least twenty public collections including those of the
Museum of Modern Art and the Whitney Museum of
American Art in New York, the Art Institute of Chi-
cago, and the Corcoran Gallery in Washington, D.C.

Model in Green Kimono, color aquatint, 5 colors, 1979, edi-
tion of 41, 40¼ × 27⅛ inches. $3,500

Nude on Settee, aquatint with line etching, 1978, edition of
55, 40 × 30 inches. $1,800

Nude on Chief's Blanket, lithograph, 6 colors, 1978, edition
of 50, 27⁵/₁₆ × 39¹⁵/₁₆ inches. $1,200 (sold out)

Two Nudes with Federal Sofa, aquatint, drypoint, engraving,
line etching, with rock and roulette work, 7 colors, 1981,
edition of 41, 28¾ × 40⁵/₁₆ inches. $2,800

Two Models in Omaha, lithograph, 4 colors, 1981, edition of
60, 30 × 22¼ inches. $1,200

Nude on Summer Furniture, lithograph, one color, 1982,
edition of 50, 31 × 24 inches. $700

Nude in Hammock, etching, aquatint with roulette work, 6
colors, 1982, edition of 50, 30 × 40½ inches. $2,500

Antonio Peticov (1946–)

Antonio Peticov was born in São Paulo, Brazil. When he was twenty-one, he was invited to participate in the prestigious Bienniel of São Paulo. Soon after, he began traveling in Europe and the United States to study painting. His work is composed of many elements and is reflective of his belief that many parts are joined cosmically to create a whole. Peticov's graphic works are exclusively screen prints. He has also been recognized for his achievements in the fields of photography, sculpture, and magazine illustration. In 1978 a retrospective of his prints and paintings was held at the Museo de Arte Moderna in Rio de Janeiro. Peticov has had thirteen one-man shows, including one at the National Art Center in New York.

Scala Chromatica, silkscreen, 1977, edition of 150, 35 × 27 inches. $300

Jungfrau and Day and Night, silkscreen, 1977, edition of 150, 20 × 30 inches. $300

Amsterdam Rainbow, silkscreen, 1979, edition of 200, 27 × 35 inches. $300

Mitocondria, silkscreen, 1979, edition of 150, 27½ × 32 inches. $300

Santa Elena Canyon, silkscreen, 1979, edition of 150, 36 × 24½ inches. $300

Natura, silkscreen, 1980, edition of 195, 27 × 31 inches. $300

Passing By, silkscreen, 1981, edition of 30, 45 × 37 inches. $500

Light Explosion, silkscreen, 1981, edition of 30, 45 × 37 inches. $500

Light Texture, silkscreen, 1981, edition of 30, 45 × 37 inches. $500

Scala Chromatica, screen print, 1977, edition of 150, 23¼ in. × 30¼ in.
Photograph courtesy Fred Dorfman Gallery, New York

Robert Rauschenberg (1925–)

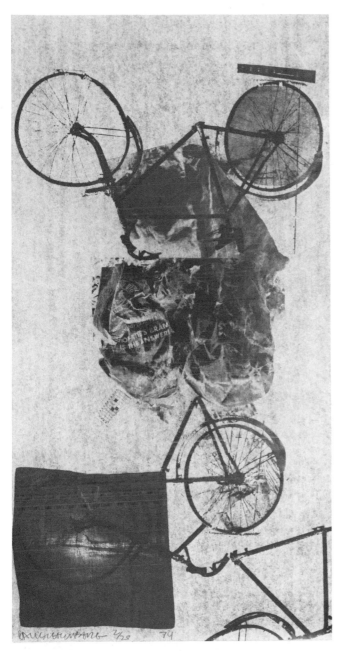

Kitty Hawk, lithograph, 1974, edition of 28, 78 in. × 40 in.
Published by Universal Limited Art Editions, Long Island,
New York
Photograph courtesy of Castelli Graphics, New York

Rauschenberg was born in Port Arthur, Texas, and studied at the Kansas City Art Institute, the Académie Julian in Paris, Black Mountain College in North Carolina (with Josef Albers), and at the Art Students League in New York. He is famous for his brilliant compositions of unorthodox combinations of materials. He established his reputation in 1952 with the painting *Bed,* which incorporated a real pillow and quilt. In 1962 he made a series of black and white paintings by printing collages of images through silkscreens on to the canvas and began lithographic experimentation based on the same collage idea. Rauschenberg frequently notes the interplay between printmaking and painting at the core of his work and has created many series and suites of collage prints in mixed media. Frequent exhibits of his work are held in prominent galleries and museums in the United States and Europe. The San Francisco Museum of Modern Art, the Art Institute of Chicago, and the Whitney Museum of American Art in New York are three of the many major museums whose permanent collections include his work.

Stoned Moon Series: Waves, lithograph, 1969, edition of 27, 89 × 42 inches. $7,000

Stoned Moon Series: Banner, lithograph, 1969, edition of 40, 54½ × 36 inches. $5,500

Horsefeathers Series: Horsefeathers Thirteen I, lithograph, screen, pochoir, collage, embossed, 1972, edition of 76, 28 × 22¼ inches. $1,500

Cactus, transfer collage, 1973, edition of 20, 60 × 38 inches. $3,500

Sand, transfer of lithographed and newspaper images and collage of fabric, 1974, edition of 30, 84 × 41 inches. $5,000

Long Island Beach, lithograph, 1978, edition of 39, 31 × 23 inches. $2,000

Rookery Mounds: Mud Dauber, lithograph, 1979, edition of 53, 41 × 31 inches. $2,000

Glacial Decoy Series: 5:29 Bayshore, lithograph with chine collé, 1981, edition of 30, 45 × 93 inches. $4,500

Arcanum I, silkscreen, silk collage, paper collage, hand coloring, water color, edition of 85, 22½ × 15¾ inches. $1,500

Larry Rivers (1923–)

Larry Rivers was born in New York City. In the 1940s
he worked as a jazz musician while studying at the
Juilliard School of Music in New York. In 1947–48 he
attended Hans Hofmann's school of painting in New
York and Provincetown, and then studied art at New
York University. In 1949 after his first one-man show,
he traveled to Europe and on his return met the poet
Frank O'Hara with whom he collaborated on a variety
of projects. Most significantly, in 1957 the two created
a portfolio of poems and lithographs titled *Stones*. Six
years later Rivers began his now famous *Dutch Mas-
ters* series of paintings. Many of his prints, like his
paintings, reflect his interest in packaging. Rather
than duplications of ordinary objects, they are varia-
tions on a theme. Rivers has exhibited frequently in
the Whitney Museum of American Art annuals and
his work has been selected for the permanent collec-
tions of the most prominent museums and
corporations in the United States.

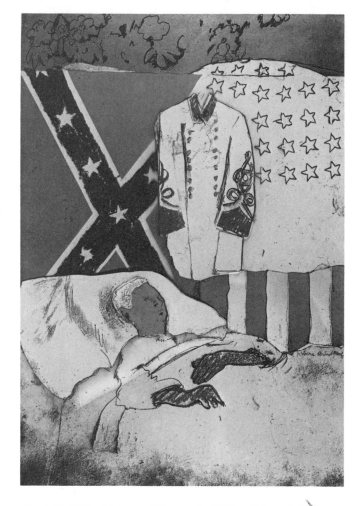

Last Civil War Veteran, lithograph, 1979, edition of 125,
42 in. × 30 in.
Photograph courtesy Marlborough Gallery, New York

Blue Line Camel, stencil drawing, 1978, edition of 120, 18 ×
25 inches. $1,750

Camel Quartet, silkscreen and lithograph, 1978, edition of
120, 28 × 20½ inches. $1,300

Last Civil War Veteran, lithograph, 1979, edition of 125,
42 × 30 inches. $1,500

Open Camel, stencil drawing, 1978, edition of 120, 22 ×
30 inches. $1,300

Stencil Pack Camel, stencil, 1978, edition of 120, 25 ×
21½ inches. $1,750

Webster (Pink), lithograph, 1979, edition of 75, 26 ×
30¼ inches. $900

*Webster (White)*lithograph, 1979, edition of 75, 26 ×
30¼ inches. $900

Juan Romero (1932–)

Romero was born in Seville, Spain. When he was nineteen years old he was admitted to the Seville School of Fine Arts, where he studied for five years before receiving two grants which allowed him to further his education in Madrid. It was there, in 1957, that Romero was given his first one-man show. He then moved to Paris where he was invited to participate in the biennials of 1961, 1963, 1965, and 1967, winning the First Critics Prize the last year. During his formative years as an artist, a chance summer vacation activity profoundly influenced his style. Romero went skin diving and through his goggles observed the minuscule, harmonious world of the seabed. This cohesiveness, highlighted by a unique color palette, has formed the basis of his work and is particularly effective in his serigraphs and lithographs. Romero has received many honors and has participated in numerous international biennials. His work appears in the permanent collection of the Baltimore Museum, the Museum of the City of Paris, and the Spanish Museum of Contemporary Art, among many others.

Luna Park, serigraph, 1979, edition of 300, 39 × 29 inches. $525 (sold out)

Spring Tree, serigraph, 1980, edition of 300, 39 × 31¼ inches. $525 (sold out)

Inhabited Tree, lithograph, 1980, edition of 275, 27½ × 19¾ inches. $325

The Enchanted Moon, serigraph, 1980, edition of 300, 30½ × 30½ inches. $450

The Joyous Boat, serigraph, 1980, edition of 300, 25¾ × 32 inches. $425

Summertree, serigraph, 1981, edition of 300, 32 × 23¾ inches. $400

Conversation Sous un Noyer, lithograph, 1981, edition of 275, 20 × 25¾ inches. $340

Alice in Wonderland, serigraph, 1982, edition of 300, 26¾ × 32⅝ inches. $400

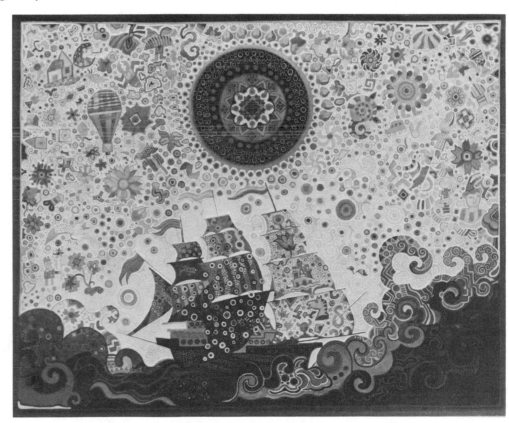

The Joyous Boat, serigraph, 1980, edition of 300, 25¾ in. × 32 in. Photograph courtesy Edmund Newman Inc., Swampscott, Massachusetts

James Rosenquist (1933–)

James Rosenquist was born in Grand Forks, North Dakota. When he was a high school student he won a scholarship to study at the Minneapolis School of Art. He was further educated at the University of Minnesota and the Art Students League in New York. He also attended drawing classes organized by Jack Youngerman and Robert Indiana; at the same time, he was designing store windows and painting billboards to earn a living. This commercial experience led decisively to his particular pop style. His most famous painting, *F-III,* is eighty-six feet long and shares many of the characteristics of a billboard. The preference for anonymity in his subjects carried through to the print media. Rosenquist has made a number of screen prints and etchings, but most of his graphics are lithographs. His prints have frequently been exhibited in galleries and museums and at biennials internationally. They can be found in many permanent collections including those of the Museum of Modern Art, New York, the Musée d'Art Moderne, Paris, and the Art Gallery of Ontario, Toronto.

Flamingo Capsule, color lithograph with silkscreen, 1974, edition of 85, 36½ × 76 inches. $3,000

Tampa-New York 1188, lithograph, edition of 40, 36½ × 74 inches. $2,600

Strawberry Sunglasses, lithograph, 1974, edition of 79, 36½ × 74½ inches. $2,400

Idea I and *Idea II,* lithographs, 1979, edition of 100, 5¾ × 4½ inches. $300 each

Sheer Line, lithograph, 1979, edition of 100, 29½ × 45 inches. $1,750

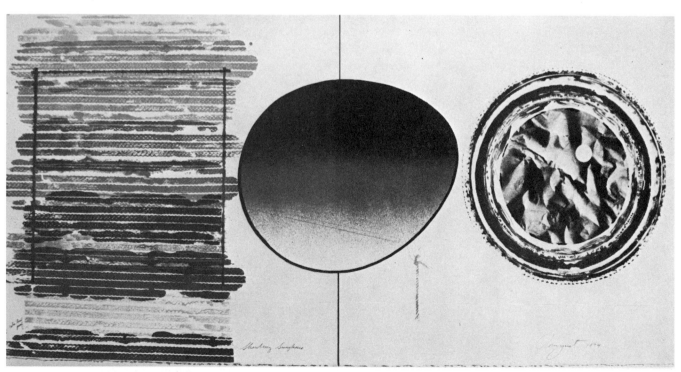

Strawberry Sunglasses, *lithograph, 1974, edition of 79, 36½ × 74½ in.*
Photograph courtesy Multiples, Inc., New York

G. H. Rothe (1935–)

G. H. Rothe was born in Beuthen, Germany, which became part of Poland after 1945. In 1947, her family, who were refugees, settled in Wiedenbrueck, Germany. Rothe studied painting and art history at the Pforzheim Academy of Design. From 1967 to 1972 she traveled extensively in Europe and Latin America, residing and working for a time in Florence, Italy, and Montevideo, Uruguay. She finally moved to the United States where she acquired a reputation for consummate skill with mezzotints. Her images, which take between two and three months to create on the plate, are superficially serene and lyrical but veil a network of emotional complexities. Weblike tracings reveal the inner workings of the subject—examinations into the mind and sensibilities at work beneath the beauty. Rothe has had at least one hundred single and group exhibitions throughout the world. Her work appears in the collections of many museums and in the collections more than thirty international corporations.

Poet, mezzotint, 1979, edition of 150, 35 × 23½ inches. $2,500 (sold out)

Chase, mezzotint, 1981, edition of 150, 35 × 23½ inches. $3,000 (sold out)

Recital, mezzotint, 1982, edition of 200, 16⅞ × 24¾ inches. $900

Youth, mezzotint, 1982, edition of 150, 27½ × 22 inches. $1,350

Trio, mezzotint, 1982, edition of 200, 16 × 11 inches. $800

Solo of Gemini, mezzotint, 1982, edition of 75, 12 × 9 inches. $600

Colts, mezzotint, 1983, edition of 150, 23¾ × 35¾ inches. $1,600

Electron, mezzotint, 1983, edition of 150, 12⅛ × 8¾ inches. $500

Colts, mezzotint, 1983, edition of 150, 23¾ in. × 35¾ in.
Photograph courtesy Hammer Publishing, New York

Ed Ruscha (1937–)

Ed Ruscha was born in Omaha, Nebraska. He went to Los Angeles in 1956, where he studied at the Chouinard Institute and where he continues to find fertile ground for his work. Ruscha's first print, a lithograph titled *Gas,* published in 1962, was the first in a long series of prints, paintings, and photographs which told of his fascination with the neon culture of Los Angeles. The Sunset Strip, the Hollywood sign, and parking lots were among his subjects. Later, from 1965 until 1972, he worked for *Artforum* magazine (under the name Eddie Russia) where he became interested in "developing the expressive content of words," isolating them against various backgrounds to let their true nature emerge. Ruscha's work is exhibited in fine galleries and museums throughout the world. The Museum of Modern Art in New York and the Los Angeles County Museum are two of the many public institutions that include his work in their collections.

Bowl (from Domestic Tranquility*), lithograph, 1974, edition of 65, 18 in. × 22 in.*
Photograph courtesy Multiples, Inc., New York

Insects, set of six color silkscreens, 1972, edition of 100, 20 × 27 inches. $2,400 (set), $450 (individually)

Domestic Tranquility, set of four color lithographs, 1974, edition of 65. $1,600 (set)
 Clock, lithograph, 1974, edition of 65, 20 × 26 inches, $450.
 Bowl, lithograph, 1974, edition of 65, 18 × 22 inches, $400.
 Plate, lithograph, 1974, edition of 65, 18 × 26 inches, $400.
 Egg, lithograph, 1974, edition of 65, 16½ × 26 inches, $400.

I've Never Seen Two People Looking Healthier, color silkscreen, 1978, 19⅛ × 50⅛ inches. $900

Kay Eye Double S, lithograph, 1978, 22½ × 30 inches. $550

Just an Average Guy, color etching, 1979, edition of 45, 15½ × 43¾ inches. $500

Two Jumping Fish, etching, 1980, edition of 55, 19¼ × 39¼ inches. $850

Two Similar Cities, silkscreen, 1980, edition of 35, 22 × 60 inches. $2,250

Lucas Samaras (1936–)

Lucas Samaras was born in Macedonia, Greece. He attended Rutgers University and Columbia University. His work represents a combination of his Greek Byzantine heritage and the contemporary pop art version of the surrealist movement. He came to prominence as part of the happening movement of the 1960s. Samaras developed an iconography which was seductive in its use of color and threatening in its use of materials; in his famous boxes he combined, for example, colorful yarns with pins and razor blades. He made pastels with a sense of color that were translated into the print medium through the silkscreen process. Since 1959, Samaras has had exhibitions in important galleries and museums throughout the world. His work is in many public collections including those of the Albright-Knox Art Gallery in Buffalo, the Art Institute of Chicago, the Fort Worth Art Center in Texas, the Los Angeles County Museum, and the Whitney Museum of American Art in New York.

Clenched Couple, serigraph, 1975, edition of 125, 40 in. × 32 in.
Photograph courtesy Pace Editions, Inc., New York

Book, book/object serigraphs, paper fold-outs, miniature books, 6 stories, 5 processes, (serigraphy, lithography, embossing, thermography, and die-cutting), 1968, edition of 100, 18 pages with each leaf, ³⁄₁₆-inch thick, 10 × 10 × 2¼ inches. $3,500

Hook, serigraph, 1972, edition of 150, 37 × 26 inches. $500

Ribbon, serigraph, 1972, edition of 150, 37 × 26 inches. $500

Clenched Couple, serigraph, 1975, edition of 125, 40 × 32 inches. $750

Fritz Scholder (1937–)

Fritz Scholder was born in Breckenridge, Minnesota, and studied at Sacramento State University and the University of Arizona, where he also taught. Scholder is one-quarter American Indian and has chosen to honor his heritage in his artistic life. Inspired by Gauguin, and concerned with color and form, he believes that his work is expressionistic in nature. Strong feelings about Indian life are translated in work that has an almost mystical quality. Many of his subjects are shown dancing, since activity, Scholder believes, is closely allied with magic, and magic and art are a natural complement. Scholder has received many honors. His work has been exhibited to critical acclaim internationally and can be found in at least fifteen American museums, including the Los Angeles County Museum of Art, the Chicago Museum of Contemporary Art, the Dallas Museum of Contemporary Art, the Boston Museum of Fine Arts, and the Museum of Modern Art in New York.

Indian with Pistol, lithograph, 1978, edition of 150, 22 × 30 inches. $5,000

Indian with Blue Window, lithograph, 1978, edition of 100, 50 red state, 50 blue state, 30 × 22 inches. $1,200

Matinee Cowboy and Horse, lithograph, 1979, edition of 150, 30 × 22 inches. $1,000

Indian with Pistol, *lithograph, 1978, edition of 150, 22 in. × 30 in.*
Photograph courtesy Transworld Art, Inc., New York

Jerome Schurr (1940–)

Jerome Schurr, who was born in Philadelphia, was educated at the University of Pennsylvania, Temple University, the Fleisher Memorial Art Center, and the Pennsylvania Academy of Fine Arts, where he received the Thouron Prize for Painting. Other honors include the Eugene Feldman Memorial Prize, awarded by the Philadelphia Print Club. Schurr's rugged landscapes of the western United States are produced by a complex "reduction" method of screen printing. The multi-leveled vistas are achieved by the gradual layering of as many as forty colors per print. After an area has been printed, that portion of the screen is blocked out, thereby reducing the open stencil area as the image builds. These prints show an unusual command of the medium and have enormous popular appeal. Schurr's work can be seen in the collections of a number of museums, including the Philadelphia Museum of Art and the Minneapolis Museum of Fine Arts.

Olympia, silkscreen, 1980, edition of 290, 26 in. × 21 in. Photograph courtesy John Szoke Graphics, New York

Padres Bay, silkscreen, 1979, edition of 290, 16½ × 28 inches. $2,000

Olympia, silkscreen, 1980, edition of 290, 24 × 21 inches. $1,500

San Andreas Lake, silkscreen, 1981, edition of 290, 23 × 28 inches. $1,300

Half Dome, silkscreen, 1982, edition of 290, 24 × 21 inches. $650

Shadow Lake, silkscreen, 1982, edition of 290, 23½ × 30 inches. $575

Arthur Secunda (1927–)

Painter and printmaker Arthur Secunda was born in New Jersey and educated at New York University, the Art Students League, New York, and art academies in Paris and Rome. He lives a good part of every year in southern France, taking inspiration from the lush countryside and Mediterranean climate. A recipient of Tamarind Lithography Workshop grants in 1970 and 1972, Secunda's exploration into printmaking has very often entailed the use of many different techniques, including photography and collage, to get the desired textural quality. The sensual tones and rhythms of his work give them an immediacy which takes a great deal of thought and technical expertise to achieve. His now famous screenprint *The Road to Arles,* published in 1976, took six months to complete because of the many layers of carefully applied colors. The Museum of Modern Art, New York, the Smithsonian Institution, Washington, D.C., the Art Institute of Chicago, and the San Francisco Museum of Modern Art, are among the many institutions which include Secunda's work in their permanent collections.

The Road to Arles, silkscreen, 1976, edition of 125, 30 in. × 22 in.
Photograph courtesy Arthur Secunda, Los Angeles

The Road to Arles, silkscreen, 1976, edition of 125, 30 × 22 inches. $500 (sold out)

Volcano, silkscreen, 1977, edition of 95, 71 × 39 inches. $2,000 (sold out)

Santana, linoleum block print, 1977, edition of 50, 31 × 25 inches. $300

Voyage, etching, 1978, edition of 99, 37½ × 30 inches. $500 (sold out)

Hot Horizon, silkscreen, 1980, edition of 150, 30 × 40 inches. $1,500

A Clear Space, etching, 1981, edition of 150, 50 × 36 inches. $750

Janvier, pochoir, 1981, edition of 150, 30¾ × 23 inches. $400

Massif Central, silkscreen, 1981, edition of 150, 40 × 32 inches. $1,250

Arlesienne Night, lithograph, 1982, edition of 150, 20¾ × 31¾ inches. $550

Beverly Hills Forest, silkscreen, 1982, edition of 50, 38 × 41 inches. $2,500

Raphael Soyer (1899–)

Russian-born Raphael Soyer emigrated to the United States with his family when he was twelve years old. He studied in New York at Cooper Union, the National Academy of Design, and the Art Students League, where he eventually taught. Soyer's thoughtful, elegant style shows influences of the impressionists and the Old Masters. His prints, more than one hundred and twenty-five etchings and lithographs, are subtle personality studies which reflect the emotions and attitudes of women in the fields of theater, dance, and the less heady working-class pursuits. He also completed many self-portraits. His sensitive work is in the collections of the Boston Museum of Fine Arts, the Detroit Institute of Art, the Museum of Modern Art, the Whitney Museum of American Art, and the Metropolitan Museum of Art in New York, the Albright-Knox Art Gallery in Buffalo, and the Addison Museum of Art in Andover, Massachusetts.

Woman Seated, lithograph, 1980, edition of 275, 16 in. × 14 in.
Photograph courtesy London Arts, Inc., Detroit

Woman's Head II, lithograph, 1979, edition of 300, 25 × 17 inches. $500 (color), $200 (black and white)

Woman, lithograph, 1979, edition of 300, 18 × 25 inches. $500 (color), $200 (black and white)

Woman with Black Hair, color lithograph, 1979, edition of 300, 18½ × 13¾ inches. $500

Woman with Black Hair, lithograph in black, 1979, edition of 300, 18½ × 13¾ inches. $200

Self-Portrait, color lithograph, 1980, edition of 250, 11 × 8 inches. $500

Woman Seated, color lithograph, 1980, edition of 275, 16½ × 13¾ inches. $500

Woman Standing, color lithograph, 1980, edition of 275, 15¾ × 9½ inches. $500

Andrew Stasik (1932–)

Andrew Stasik was born in New Brunswick, New Jersey, and studied at New York University, Columbia University, the State University of Iowa, and Ohio University. He is now Director of the Pratt Graphics Center in New York, visiting critic in printmaking at Yale University, and editor of *Print Review* magazine. Stasik, acclaimed throughout the world as a lithographer and screen printer, developed a style which combines abstraction with figurative elements. He uses symbols which work on many levels. Although they stem from a private symbolism, Stasik intends them to refer to his investigations into the technology of offset lithography as some of the most imaginative and sophisticated studies completed to date. The recipient of eleven international awards for excellence, Stasik has had more than fifty exhibits in thirteen countries, and his work is included in the permanent collections of at least twenty museums, including the Metropolitan Museum of Art in New York, the Cleveland Museum of Art, and the Palace of the Legion of Honor in San Francisco.

Night Game, lithograph and stencil print, 1972, edition of 15, 22 in. × 30 in.
Photograph courtesy Andrew Stasik, Darien, Connecticut

State of the Union, lithograph/stencil, 1966, edition of 25. $200

Summer #36, lithograph/screen print, 1968, edition of 20. $200

Summer Landscape #2, lithograph/screen print, 1968, edition of 5. $200

Summer XXXVIII, lithograph, 1968, edition of 100. $250

Gold Triangle, lithograph, 1968, edition of 10. $175

Summer Series XXXV, lithograph, 1968, edition of 30. $175

Summer View with Heart, lithograph, 1970, edition of 75. $150

Still Life/Landscape #5, lithograph, 1971, edition of 125. $250

Indian Summer, lithograph/screen print, 1972, edition of 10. $300

Night Game, lithograph/stencil, 1972, edition of 15. $250

Frank Stella (1936–)

Frank Stella was born in Malden, Massachusetts, studied at Phillips Academy, Andover, and then at Princeton University. One year after his graduation in 1968, he was included in an exhibit, Sixteen Americans, at the Museum of Modern Art in New York. The following year, his shaped canvases were the basis of his first one-man show at the Leo Castelli Gallery. Stella's work is concerned with regulation of structure and color. His first prints were often modestly scaled and monochromatic. He followed the compositions of his paintings, but was traditional in his approach to the graphic media. Then, in the early 1970s, he moved away from flat geometric shapes toward illusionism, with liberal uses of color. Later, he experimented with combinations of shapes, colors, and techniques in print series, which are an incredible number of variations on a theme. Today, his prints no longer follow his paintings—they are uniquely inventive and visually exciting in themselves. Stella is one of the most important contemporary printmakers. Highly acclaimed, both critically and popularly, his work has been exhibited in the most prominent American and British galleries and is included in prestigious public collections thoughout the world.

Black Series II, Tuxedo Park, lithograph, 1967, edition of 100, 15 × 22 inches. $600

Ifafa 1, lithograph, 1968, edition of 100, 16¼ × 22⅜ inches. $800

Grid Stack, lithograph, 1970, edition of 50, 45⅞ × 35⅛ inches. $1,500

Eccentric Polygons, Sunapee, lithograph/screen print, 1974, edition of 100, 22¼ × 17¼ inches. $900

Noguchi's Okinawa Woodpecker, lithograph/screen print/ mixed media, 1977, edition of 50, 33⅞ × 45⅞ inches. $4,000

Mysterious Bird of Ulieta, lithograph/screen print, mixed media, 1977, edition of 50, 33⅞ × 45⅞ inches. $3,500

Sinjerli Variations I, lithograph, 1981, edition of 38, 32 × 32 inches. $4,500

Taliadega Three I, etching, 1982, edition of 30, 66 × 51⅜ inches. $7,000

Imola Three I, color etching/relief print, 1982 , edition of 30, 66¼ × 51¼ inches. $9,000

Imola Three I, color etching/relief print, 1982, edition of 30, 66¼ in. × 51¼ in. Printed and published by Tyler Graphics Ltd. © copyright Frank Stella/Tyler Graphics Ltd. 1982. Photograph by Steven Sloman, courtesy of Tyler Graphics Ltd., Bedford Village, New York

Rufino Tamayo (1899–)

Rufino Tamayo was born in Oaxaca, Mexico. He studied at the Academia de Bellas Artes in Mexico City and worked there until 1936 when he moved to New York, where he taught at the Dalton School and the Brooklyn Museum. He moved to Paris in 1954 and then back to his homeland ten years later. His style, while showing expressionist and semiabstract elements, is strongly indebted to native, ancient art forms. Tamayo says, with conviction, that the spirit and soul are still valid beneath our mechanized, over-hyped societal structure. In 1972 a street in Oaxaca was named after Tamayo, and in 1974 he donated a museum to that city for the permanent exhibit of his own extensive collection of pre-Columbian art. Tamayo has been honored with many prestigious awards. His work is frequently exhibited in galleries and museums throughout the world and is included in many important private and public collections.

Hombre Rojo, mixografia, 1976, edition of 175, 30 in. × 22 in.
Photograph courtesy Transworld Art, Inc., New York

The Obscure Man, lithograph, 1975, edition of 175, 26 × 19½ inches. $850

Dos Figuras, mixografia, 1976, edition of 175, 22 × 30 inches. $1,450

Hombre con los Brazos en Alto, mixografia, 1976, edition of 175, 22 × 30 inches $1,450

Hombre Negro, mixographia, 1976, edition of 175, 30 × 22 inches. $1,450

Hombre Rojo, mixographia, 1976, edition of 175, 30 × 22 inches. $1,450

Mascara Roja, mixografia, 1976, edition of 175, 30 × 22 inches. $1,450

Mujer con los Brazos en Alto, mixographia, 1976, edition of 175, 30 × 22 inches. $1,450

Mark Tobey (1890–1976)

Mark Tobey was born in Wisconsin. In 1906 he moved with his family to Hammond, Indiana, near enough to Chicago for him to attend classes at the Art Institute there. This was only the first of dozens of moves in the United States, Japan, and Europe which played an important part in the development of his romantic rhythmic style. Tobey's trips to the Orient had the most profound influence, for there he found, in Zen monasteries, a kind of inner spirit which would guide his work. His fascination with calligraphy resulted in the creation of his own intricate pattern of lines and hazy forms. Tobey is recognized as an inventive printmaker; he experimented with materials as diverse as Styrofoam to get more texture for his monotypes. Tobey participated in many biennials and won the first prize for painting at the Venice Biennial of 1958. The most prominent museums in the world have exhibited his works, honored him with major retrospectives, and included him in permanent collections.

The Grand Parade, lithograph, 1974, edition of 150, 19½ in. × 26 in.
Photograph courtesy Transworld Art, Inc., New York

The Scroll of Liberty, lithograph, 1973, edition of 175, 19½ × 26 inches. $1,000

High Tide, lithograph, 1974, edition of 150, 19½ × 26 inches. $800

Psaltery-First Form, etching, 1974, edition of 150, 26 × 19½ inches. $750

Stained Glass, lithograph, 1974, edition of 150, 26 × 19½ inches. $800

Vibrating Surface, etching, 1974, edition of 150, 26 × 19½ inches. $800

Morning Grass, etching, 1975, edition of 150, 26 × 19½ inches. $750

Raissance of a Flower, lithograph, 1975, edition of 150, 26 × 19½ inches. $750

Homage à Mourlot, lithograph, 1975, edition of 200, 26 × 19½ inches. $500

Theo Tobiasse (1927–)

Theo Tobiasse was born in Jaffa, Israel, and moved with his family to Paris in 1933. He was hidden away in that city during the Nazi occupation, and during those years relied on his art to alleviate the anguish. After the war Tobiasse earned his living as a designer and creator of windows in the fashionable Faubourg St. Honoré section of Paris and as a commercial artist in advertising. Tobiasse puts his innermost feelings in his etchings and lithographs. He first inscribes a secret message (a prayer of sorts) on the matrix and then creates the design over that message, so that each work is an intensely personal experience. In 1961 Tobiasse won the Prix de La Juene Peinture Méditerranée. Since 1962, when he gave up commercial work to devote himself to his art, he has had exhibitions in the United States, Canada, Mexico, Israel, England, France, Italy, Switzerland, Sweden, Norway, Venezuela, Japan, and South Africa.

Cantique de Déborah, etching, 1980, edition of 75, 25 × 36 inches. $1,200

Sur Les Rives de Babylon, etching, 1980, edition of 75, 26 × 22 inches. $850

Le Train Rouge, etching, 1980, edition of 75, 19 × 27 inches. $1,200

Le Rendezvous, etching, 1980, edition of 75, 16 × 27 inches. $750

The Man Who Walks on Ramparts, etching, 1981, edition of 75, 19 × 25 inches. $500

Let My People Go (suite of 4 pieces), etching, 1981, edition of 75, 28 × 38 inches. $5,000

L'Acrobate, etching, 1981, edition of 75, 25 × 34 inches, $900

Purim, etching, 1981, edition of 75, 26 × 33 inches. $900

Dame au Grands Chapeaux, etching, 1981, edition of 75, 28 × 38 inches. $1,400

Le Fruit Qui Retient les Songes, etching/aquatint, 1982, edition of 50, 20 × 25 inches. $1,200

Lorsque Le Jour Entier Devant Fruit, etching with aquatint, 1983, edition of 60, 37¼ in. × 53¼ in.
Photograph courtesy Nahan Galleries, New Orleans

Marge Tomchuk (1933–)

Marge Tomchuk was born in Canada and has lived in the United States since 1953. She attended the University of Michigan, Pratt Graphic Center, New York, and Sophia University in Tokyo. She taught art in Japan and while there studied woodblock techniques. The flowing lines of the traditional woodblock complemented her memories of beautiful sunsets, flowing cloud formations, and the northern lights over wheatfields in Canada. Tomchuk followed her woodcuts with rich colors and earth tones. These were followed by a period of meticulously drawn etchings, many with an Americana theme. Most recently, she has developed a unique method of adapting industrial plastic to take the place of metal plates, resulting in deeply embossed intaglio prints with a freer flowing image. Tomchuk's graphic works are printed in her own studio. They are included in the permanent collections of many public institutions, including the National Air and Space Museum and the Smithsonian Institution in Washington, D.C.

Ocean, embossed etching, 1979, edition of 150, 18 in. × 24 in.
Photograph courtesy Marge Tomchuk, New Canaan, Connecticut

Icarus, etching, 1969, edition of 100, 18 × 18 inches. $800

Astronomer, etching, 1972, edition of 100, 18 × 24 inches. $600

Peanut Cart, etching, 1973, edition of 100, 16 × 20 inches. $600

View from the Ferry, etching, 1976, edition of 120, 18 × 24 inches. $350

Aces, etching, 1977, edition of 150, 18 × 24 inches. $350

Ocean, embossed etching, 1979, edition of 150, 18 × 24 inches. $275

Sierra, embossed etching, 1980, edition of 150, 22 × 31 inches. $1,000

Galaxy, embossed etching, 1982, edition of 150, 20 × 24 inches. $750

Strata, embossed etching, 1982, edition of 150, 20 × 24 inches. $500

Star Cluster, embossed etching, 1982, edition of 150, 20 × 24 inches. $275

Ernest Trova (1927–)

Ernest Trova, who was born in St. Louis, Missouri, is a self-taught painter, sculptor, and printmaker. He has worked largely on one theme, *Falling Man,* during his entire artistic career. Through this work-in-progress he studies the human condition at various times and intellectualizes his findings in his work. His prints feature silhouettes of figures arranged in formal patterns. Mostly screen prints, they rely on opaque colors to relay the intensity of the study. Trova has exhibited in the United States in New York, Philadelphia, Cincinnati, St. Louis, Palm Beach, and Memphis, as well as in Zurich, Cologne, Caracas, Jerusalem, and Brussels. His work is included in the collections of fourteen museums including the Guggenheim Museum, New York, the Walker Art Center, Minneapolis, the Los Angeles County Museum, and the Tate Gallery, London.

Mickey Mouse World, serigraph, 1968, edition of 100, 23 × 29 inches. $500

F. M. Variant, serigraph, 1970, edition of 200, 36 × 36 inches. $950

F. M. Manscapes, portfolio of 10 silkscreens, 1969, edition of 175, 28 × 28 inches, set for $4,000, individually $500

Shadows, Planes, and Targets, portfolio of 4 serigraphs, 1972, edition of 150, 24 × 24 inches. $2,000

 Print #1, $500
 Print #2, $500
 Print #3, $500
 Print #4, $750

F. M. Shadow Figure, nickel-plated bronze shadow figure multiple in a blue-tinted and colorless Plexi box, 1971, edition of 150, 7 × 11 × 7½ inches. $3,000

Four-Foot Falling Man, serigraph, 1974, edition of 150, 70 × 37½ inches. $2,000

Green Sun, etching, aquatint, and relief, 1978, edition of 90, 29½ × 33½ inches. $750

Green Sun, *etching, aquatint, and relief, 1978, edition of 90, 29½ in. × 33½ in.*
Photograph courtesy Pace Editions, Inc., New York

Victor Vasarely (1908–)

Hungarian-born Victor Vasarely is known as a founder of optical art. He studied at the Bauhaus Muhely in Budapest and in 1930 emigrated to Paris where he developed his particular vision which stems from the idea of democratizing the art object. Influenced greatly by the problems of the world's cities, he feels his work offers a solution by presenting a clear view of the "color-surface-perception" relationship. He has used the income from the sale of these "investigations," as he calls his prints, to establish a sociocultural foundation in Aix-en-Provence, France, for the study of the integration of plastic beauty at all levels of the urban environment. He is represented in major museums all over the world and has received many artistic and honorary awards. Among these distinctions are the French Legion of Honor, the Guggenheim Prize, and the Gold Medal of the Triennale in Milan.

Semiha, silkscreen, 1979, edition of 250, 28 in. × 43 in. Photograph courtesy The Vasarely Center, New York

Tigers, lithograph, 1939, edition of 135, 14 × 25 inches, $1,200

Zebras, serigraph, 1936, edition of 135, 15 × 15 inches. $900

Mamor, serigraph, 1969, edition of 250, 28 × 28 inches. $900

Teke, serigraph, 1978, edition of 250, 36 × 36 inches. $850

Neptune-Z, serigraph, 1978, edition of 250, 24½ × 19¼ inches. $550

Coelum, serigraph, 1979, edition of 350, 12 × 10 inches. $275

Semiha, serigraph, 1979, edition of 250, 28 × 43 inches. $800

Galaxy, serigraph, 1982, edition of 250, 31 × 30 inches. $800

Andy Warhol (1931–)

Andy Warhol was born in Cleveland, Ohio, studied at the Carnegie Institute of Technology in Pittsburgh, Pennsylvania, and began his career as a commercial artist. Warhol decided to devote himself to a more serious form of art when friends in the fashion industry expressed a strong interest in American art. He experimented with many techniques before he found that silkscreen was the most desirable medium for his work. Using a combination of the stencil method of screen printing and enlarged reproductions of photographs imposed photographically on the screen, he created large editions of images he had already painted. Part of the idea behind pop art was the proliferation of the image, just like the mass-marketed objects, such as the Campbell Soup cans, that provided the inspiration. Warhol evolved into a portraitist. His *Marilyn Monroe* and *Mick Jagger* series, among many others, take America's symbols to the highest personal level. The *Jagger* series is noteworthy because Warhol introduced elements of collage into those prints. Many prominent museums own his work, including the Museum of Modern Art in New York and the Los Angeles County Museum.

Soup Can Series I: Chicken Noodle, silkscreen, 1968, edition of 250, 35 × 23 inches. $800

Mao Tse-Tung, set of 10 silkscreens, 1972, edition of 250, each 36 × 36 inches. $12,500 (set), $2,000 (each)

Mick Jagger, set of 10 color silkscreens, 1975, edition of 250, 44 × 29 inches. $15,000 (set), $2,000 (individual prints nos. 1,4,5,6,8,9), $1,500 (individual prints nos. 2,3,7,10)

Muhammad Ali, suite of 4 color silkscreens, 1978, edition of 150, 40 × 30 inches each. $8,000 (set), $2,000 (individually)

Merce Cunningham, silkscreen, 1978, edition of 25, 30 × 30 inches. $1,200

Merce Cunningham, *silkscreen, 1978, edition of 25, 30 in. × 20 in.*
Photograph courtesy Multiples, Inc., New York

Tom Wesselmann (1931–)

Tom Wesselmann was born in Cincinnati, studied at Hiram College and then at the University of Cincinnati, where he earned a degree in psychology in 1956. After two years in the army, he attended the Art Academy of Cincinnati and then went to New York to study at the Cooper Union Art School. Although his earliest works leaned toward abstract expressionism, his style underwent a series of dramatic changes and eventually led to his becoming an important exponent of pop art. In 1961, Wesselmann had his first one-man show in New York and began his most famous series, *Great American Nudes.* Since then he has had frequent exhibits in prominent American and European galleries. His work has been included in the permanent collections of the Whitney Museum of American Art, New York, the Philadelphia Museum of Art, and the Walker Art Institute, Minneapolis, to name just three of a long, impressive list.

Seascape Dropout, woodcut, 1982, edition of 50, 22 in. × 25 in.
Photograph courtesy Multiples, Inc., New York

Nude Banner: Brown Version, felt appliqué, 1971, edition of 10, 60 × 70 inches. $3,600

Nude Banner: Pink Version, color vinyl construction, 1976, edition of 20, 50 × 66 inches. $4,500

Seascape Portfolio, suite of 5 hand-colored embossings, 1979, edition of 20, 9¾ × 11 inches. $5,000

Nude Aquatint, etching, 1980, edition of 100, 35 × 37¾ inches. $2,000

Seascape Dropout, color woodcut, 1982, edition of 50, 22 × 25 inches. $1,500

Cynthia Nude, silkscreen and lithograph, 1982, edition of 100, 29 × 39½ inches. $1,250

Jamie Wyeth (1946–)

Jamie Wyeth was born in Chadds Ford, Pennsylvania. He was tutored at home by his father, the painter Andrew Wyeth. In the 1960s Jamie Wyeth was named a participating artist in the "Eyewitness to Space" program sponsored by the National Gallery of Art, to record details of the United States space launchings and splashdowns. His skill as a portrait artist was recognized when he was commissioned by the Kennedy family to create a portrait of John F. Kennedy which was exhibited on the Bicentennial Freedom Train. In 1977, Wyeth was invited by the Soviet government to visit the USSR to consult and exchange views on art. Wyeth is impressed with the possibilities of the lithography medium. "Lithography has opened my eyes to shape and form and has made me aware that certain subjects lend themselves to it. Now when I think of a subject that I would like to work with, I decide if it would be better as a lithograph." Wyeth has had exhibits throughout the United States. His work is represented in many museums, including the Museum of Modern Art in New York, the Delaware Art Museum in Wilmington, and the Greenville Country Museum of Art in South Carolina.

Nureyev, lithograph, 1978, edition of 300, 34 in. × 24 in.
© 1978 by Jamie Wyeth
Photograph courtesy Circle Fine Art Corporation, Chicago

La Bohème, lithograph, 1977, edition of 250, 30 × 22 inches. $800

Nureyev, lithograph, 1978, edition of 300, 34 × 24 inches. $2,300

Moon and the Horse, lithograph, 1978, edition of 300, 24 × 23 inches. $1,000

Herring Gulls, lithograph, 1978, edition of 300, 24 × 28 inches. $1,800

The Wicker Chair, lithograph, 1979, edition of 300, 21 × 28 inches. $1,600

A Sea Pumpkin, lithograph, 1980, edition of 300, 26 × 29 inches. $1,300

Weathervane, lithograph, 1980, edition of 300, 34 × 24 inches. $1,000

Jack Youngerman (1926–)

Jack Youngerman, who was born in Louisville, Kentucky, was educated at the University of North Carolina, the University of Missouri, and the École des Beaux-Arts in Paris. An optical magician, Youngerman creates illusions with a series of prints based on a single geometric form. The central figure remains constant, as does its undefined background. Only the colors vary to create subtle changes in the way the object is perceived and its relationship to the surrounding area. Youngerman's honors include the National Council of Arts and Sciences Award in 1966, a National Endowment for the Arts Award in 1972, and a Guggenheim Fellowship Award in 1976. Between 1950 and 1982 he had thirty-five one-man shows and has participated in more than sixty-six group shows. Public collections with his works include the Art Institute of Chicago, the Corcoran Gallery of Art, Washington, D.C., the Museum of Modern Art, New York, the Carnegie Institute, Pittsburgh, and the Muscum of Fine Art, Houston.

Mandala, *silkscreen/pochoir/intaglio, blue, 1980; black, dark green, 1981, edition of 75, 36¾ in. × 35¾ in.*
Photograph courtesy Transworld Art, Inc., New York

Mandala, silkscreen/pochoir/intaglio, blue, 1980; black, dark green, 1981, edition of 75, 36¾ × 35¾ inches. $500

Changes, portfolio of 8 serigraphs, 1970, edition of 175, 43 × 33 inches. $3,500
 Print #1, $750
 Print #2, $400
 Print #3, $400
 Print #4, $400
 Print #5, $400
 Print #6, $400
 Print #7, $750
 Print #8, $600

Images, portfolio of 6 serigraphs, 1974, edition of 150, 31¾ × 31¾ inches. $2,500
 Print #1, $600
 Print #2, $600
 Print #3, $600
 Print #4, $400
 Print #5, $400
 Print #6, $400

Ukiyo-e, portfolio of 4 serigraphs, 1976, edition of 150, 33 × 39 inches. $1,500
 Print #1, $400
 Print #2, $400
 Print #3, $500
 Print #4, $500

Francisco Zuñiga (1912–)

Internationally acclaimed sculptor and printmaker Francisco Zuñiga was born in Costa Rica. He studied drawing, stone sculpture, and engraving at the School of Fine Arts in San José. Later, in 1936, he studied stone carving at La Esmeralda in Mexico City. He was appointed to the faculty of La Esmeralda where he remained until his retirement in 1970. Zuñiga's art reflects a love and respect for Central American people and traditions. In 1972, he created his first lithograph. As a complement to his emotionally powerful sculpture, Zuñiga's prints articulate the sensitivity and sensuality of the human figure. He has been the recipient of numerous international prizes and awards. His work is exhibited frequently in prominent galleries throughout the world and may be found in the permanent collections of twenty-nine museums, including the Metropolitan Museum of Art in New York, the Los Angeles County Museum, the Mexican Museum in San Francisco, and the Phoenix Art Museum.

Muchacha en la Silla, lithograph, 1978, edition of 100, 22½ × 31¼ inches. $2,500

El Niño y la Vela, lithograph, 1979, edition of 125, 19 × 23½ inches. $1,000

Woman with Fish, lithograph, 1980, edition of 135, 21⅞ × 29½ inches. $1,600

La Mecedora, lithograph, 1982, edition of 135, 23 × 31 inches. $1,400

Muchacha con Limones, lithograph, 1982, edition of 135, 34 × 23 inches. $1,250

Dos Madres con Niños, lithograph, 1982, edition of 135, 23½ × 35¼ inches. $1,250

Muchacha en una Silla, lithograph, 1982, edition of 135, 23¼ × 17¼ inches. $750

Impressions of Egypt Suite, lithograph, 1982, edition of 90, 14 × 20 inches, ten images in the suite, sold individually for $500 to $600, and sold as a suite for $5,000 or $6,000 with a hand-watercolored plate 9

Dos Madres con Niños, lithograph, 1982, edition of 135, 23½ in. × 35¼ in.
Photograph courtesy Brewster Gallery, New York

Acknowledgments

Although my name is the only one to appear on the cover of this book, I must share the credit with the many people who have generously given of their time, expertise, and talents. The publishers and I would like to thank those whose door was always open, whose interest, enthusiasm, and wise counsel far exceeded any expectations: Christopher Weston and Elizabeth Harvey-Lee, Phillips Fine Art Auctioneers, London; Mark Leach, Cintra Huber, and Michael Tworkowski, Phillips Fine Art Auctioneers, New York; Marc Rosen and Francie Johnston, Sotheby Parke Bernet, Inc., New York; Tony Curtis and Jennifer Knox, Lyle Publications, Galashiels, Scotland; Ed Sindin, Sindin Galleries, New York; Lucien Goldschmidt, Jane Carpenter, and Carl Little, Lucien Goldschmidt, Inc., New York; Alex Rosenberg and Hal Katzen, Transworld Art, Inc., New York; Marian Goodman and Susan Tallman, Multiples, Inc., New York; Richard Solomon and Georgette Ballance, Pace Editions, Inc., New York; Brooke Alexander and Ted Bonin, Brooke Alexander, Inc., New York; Kenneth Quail and Poppy Gandler Orchier, Kennedy Galleries, Inc., New York; Eleanor Ettinger, Frann Bradford, Stephen Rosenberg, and Susan Davis, Atelier Ettinger, Inc., New York; Lawrence Jeydel, Horn Gallery, New York; Lynn Epsteen, private dealer, New York; Madeleine Fortunoff, Madeleine Fortunoff Fine Prints, Long Island, New York; Arthur Secunda, Los Angeles; Jacques Carpentier, Galerie Carpentier, Paris; Amaury and Véronique Taittinger, Amaury Taittinger Gallery, New York; Lionel C. Epstein, Esq., Washington, D.C.; Deborah Stern, London; Charles Rothenberg, Palm Beach; Arden Kass, Washington, D.C.; Stanley Goldmark, New York; Piet Halberstadt, New York; Joe, Jean, and Cynthia Katz, New York; Allison Conrad, New York; Malou Walther Poloner, New York; Abbi Lindner and Ann Lindner, New York; Genevieve Moesle, New York; Tony and Lisa Zamora, New York; Rosemary Starr, Harrison, New York; and Robert Abrahams, London, England.

We are indebted to the following for their assistance in providing expert opinions, creative suggestions, and important materials: David Arky Photography, New York; Carol Barr and Angela Warren, Edmund Newman, Inc., Swampscott, Massachusetts; Max Becker, Hammer Publishing, New York; Daniel Berger, The Metropolitan Museum of Art Print Gallery, New York; Karl Bornstein and Susan Kay, Mirage Editions, Santa Monica, California; Charles Bragg, Los Angeles; Jerry Brewster and Amy Fischoff, Brewster Gallery, New York; Pat Caporaso, Castelli Graphics, New York; John Cavaliero, John Cavaliero Fine Arts, New York; Minda Cohen, Fred Dorfman, Inc., New York; Bruce Cratsley, Marlborough Gallery, New York; Alan Cristea, Waddington Galleries, London; John Downing and Kathleen Burke, Original Print Club Group, New York; Bob Feldman, Parasol Press Ltd., New York; Ann Gill, New York Law Library; Daniel Goldstein, San Francisco; Dorothy Goldstein, A.D.A.G.P., Paris; George Goodstadt, George Goodstadt, Inc., New York; Harry Greenberger, Nahan Galleries, New Orleans; Al Isselbacher, Isselbacher Gallery, New York; William Krabbenhoft, State Attorney General's Office, Sacramento; Frances Laterman, L'Esprit d'Art, New York; H. H. Leonards, Washington, D.C.; the Lesnick-Steinberger Family, The Vasarely Center, New York; Hugh Levin, Abrams Original Editions, New York; Jeffrey Linden, Cirrus Editions, Los Angeles; Nadia Lublin, Lublin Graphics, Inc., Greenwich, Connecticut; Alan Lurie, Circle Fine Art Corporation, Chicago; Walter Maibaum, Editions Press, San Francisco; Gary Medler, State Attorney General's Office, Chicago, Illinois; Marc Rosenbaum, Knoedler Publishing, New York; Andrew Stasik, Darien, Connecticut; Nicholas Stogdon and Mary Torres, Christie, Manson & Woods International Inc., New York; Jamie and John Szoke, John Szoke Graphics, New York; Marge Tomchuk, New Canaan, Connecticut; Evelyn Torres, V.A.G.A., New York; Kenneth Tyler and Barbara Delano, Tyler Graphics, Bedford Village, New York; Maureen Wong, Pasquale Iannetti Art Galleries, Inc., San Francisco; David Zelmon, London Arts, Detroit.

I am especially grateful to Donald Braunstein and Glorya Hale of The Putnam Publishing Group, whose intelligence, experience, originality, warmth, humor, and friendship made this book a reality. To Melissa Carlson, whose excellent skills and good nature in the face of rewrites proved instrumental to the final manuscript. To all my friends, whose patience and moral support were constants. And to my parents, Jack and Sylvia Laxer, and my sister Ruth Maybruck, whose love and encouragement make everything possible.

Glossary

Abstract art. Art in which the aesthetic value is placed on forms and colors independent of a subject, like a musical composition without a melody.

Abstract expressionism. The expression of an artist's ideas and emotions through nonrepresentational shapes.

Acid-free paper. Paper made of nonacidic materials. Ideal for use as mats when framing prints because it contains no harmful properties which might cause burning and staining on contact.

After. A print copied by a craftsman from another work of art.

Aquatint. An intaglio method used for creating tone on a metal plate.

Arches. The trade name of a French paper manufacturer.

Artist's proof. Abbreviated as A.P. or E.A. (from the French words *épreuve d'artiste*). Prints made as an addition to the regular edition for the use of the artist. Approximately 10 percent of the total edition is printed as artist's proofs.

Ash can School. A group of twentieth-century American artists who got their name by portraying the seamy side of urban life; usually New York City.

Atelier. A printmaker's workshop or studio.

Bauhaus. An important school of architecture, design, and craftsmanship founded in Weimar, Germany, in 1919 by the architect Walter Gropius. The school moved to Dessau in 1925, and then to Berlin where it existed until Hitler closed it in 1933.

Bid. A price offered by a buyer for an item that is being auctioned.

Bid sheet. A price offered by a buyer in writing prior to an auction.

Bite. The penetration of acid into a metal plate during the etching process.

Blaue Reiter, Der ("The Blue Rider"). An important German modern art movement. The name was given to the group in 1911 by two of its members, Kadinsky and Marc.

Blindstamp. See **Chop mark.**

Bon à tirer. From the French, meaning "good to pull" or "okay to print." A "B.A.T.," as it is abbreviated, is the final working proof, or standard, on which the edition is based.

Brayer. A hand roller used to ink a relief block.

Brücke, Die ("The Bridge"). A short-lived movement founded in Dresden in 1905, which was particularly important in reviving interest in the graphic arts.

Burin. A sharp tool used to draw lines in an engraving. Also called a graver.

Burr. A ridge of metal raised above the surface of the matrix as an engraving tool cuts into the plate. The burr produces velvety blacks on drypoint prints.

Buyer's premium. A commission charged to buyers at an auction sale; usually 10 percent of the hammer, or realized, price.

Cancellation marks. The marks an artist draws across a matrix after an edition has been printed to ensure that the matrix cannot be used again.

Cancelling. Defacing or destroying a matrix so that it cannot be used again for printing.

Catalogue raisonné. A catalog that gives complete information on the body of work of an artist.

Chiaroscuro. A woodcut technique that requires separate blocks for each tone.

Chop mark. An embossed mark (usually colorless) which identifies the artist, publisher, or printer. Also called a blindstamp.

Chromiste. A craftsman who copies an original work of art for the purpose of making it into an edition of prints.

Cliché-verre. A technique in which a design is scratched onto a piece of blackened glass. Light is then shown through the glass onto light-sensitive paper, creating a positive image.

CoBrA. A group of artists from Copenhagen, Brussels, and Amsterdam noted for bold expressionist forms and raw, intense colors.

Collagraph. A technique in which the plate is made from a collage of materials affixed to a board. The result is a raised image.

Collector's mark. An identifying stamp placed on the back of a print to show ownership. Useful when researching provenance.

Collotype. A photomechanical method for making fine-quality color prints.

Colored prints and color prints. The British Museum defines a *colored* print as "one printed in ink of one color that has extra coloring added by hand" and a *color* print as "that which is printed with inks of different colors." Most colored prints were done at least one hundred years ago. Today color is applied to paper by plates or screens—as many plates or screens as there are colors.

Constructivism. A Russian abstract art movement that grew out of experimentation with collage. It was based on the theory that movement in space, rather than volume, was important in art.

Cubism. An abstract art movement concerned with the structure and interrelation of forms. Picasso and Braque started the movement as a reaction to impressionism, to find new applications of form and color.

Dada. A deliberately shocking anti-art movement founded in Zurich in 1915. One of the most famous examples is Marcel Duchamp's reproduction of the *Mona Lisa* adorned with a mustache.

Discretionary bid. An order bid that allows an auctioneer to make one extra bid on behalf of the buyer, if the buyer's maximum price is matched by another bidder during the auction.

Drypoint. An intaglio technique in which a sharp needle is used to scratch a design in the plate, raising the burr. The best impressions are characterized by velvety black lines.

Edition. The total number of authorized impressions of an image.

Embossing. A technique which creates texture. It raises all or part of an image from the paper.

Engraving. An intaglio printmaking process in which a sharp tool incises the lines of a design into a matrix.

Estate stamp. An official stamp on the work of a deceased artist certifying the authenticity of the print. It means the family or heirs approve of the work on behalf of the artist.

Etching. An intaglio technique in which a sharp tool is used to incise a design on a metal plate through a protective ground. Acid is then applied to bite the image into the plate.

Expressionism. The strong expression of emotions by exaggeration or distortion of line and by intensity of color.

Facsimile Signature. A copy of the artist's signature, reproduced photographically, and added to an impression by means of a rubber stamp.

Fauvism. A movement characterized by works of flat composition and brilliant color. The artists, headed by Matisse, were called *les fauves* ("the beasts").

Foxing. Brownish moldy spots on the paper.

Graver. See **Burin.**

Ground. A waxy, acid-resistant coating applied to the surface of a metal plate in preparation for etching.

Halftone. A method of reproducing images photomechanically by means of a special screen. Grays and colors translate into tiny patterns of dots.

Hammer price. The winning bid on a lot offered at auction, before the addition of the buyer's premium.

Hors de commerce. Abbreviated as H.C. Proofs which are not for sale (literally, outside of commerce). They are in addition to the numbered edition, like the artist proofs, and reserved for the use of the publisher.

Impression. A single print.

Impressionism. One of the most important modern movements, founded in France in the 1870s. Artists tried to achieve naturalism in art by careful use of tone and color to portray the play of light on people, objects, and landscapes.

Intaglio. A term used to describe all printing methods which use incised plates.

Japan paper. Also called Japon paper. An acid-free high-quality paper made from mulberry fibers.

Laid down. A term used to describe a print which has been glued or taped directly on a piece of paper or a board.

Lift-ground etching. An intaglio technique used to create a textured appearance. Also called sugar-lift etching.

Limited edition. The authorized numbered edition of prints.

Linocut. A relief print in which the design is cut into a sheet of linoleum.

Lithography. A planographic printing process based on the principle that grease repels water.

Lot. An item, or items, offered for sale at an auction.

Mannerism. An Italian movement of the sixteenth century based on intellectual rather than visual perceptions.

Mat. A decorative and protective border for works of art, used in framing.

Matrix. The surface that holds the image to be printed.

Mat stain. A stain on a print caused by contact with an acidic mat. Acid-free materials should always be used for a mat.

Mezzotint. An intaglio method in which the artist creates tones by varying the degree of density of burr on a plate.

Minimalism. A form of abstract art consisting primarily of geometric forms or carefully drawn lines and/or grids. An investigation into the bare essentials in art.

Mixed media. A print made by two or more printmaking techniques, or by the incorporation of other art media in the creation of the print.

Monotype. A unique image made from a printmaking medium, often hand-colored.

Mordant. The acid solution used in the etching process.

Mulberry paper. An acid-free paper.

Museum board. An acid-free board used by framers for backing.

Oeuvre. The complete body of work of an artist.

Offset printing. A method in which the image is photographically copied and transferred, or offset, from one roller to another on a printing press before it is printed on paper. Also called photo-offset printing.

Op art or Optical art. The creation of complex, usually colored, patterns that have an illusionary effect.

Order bid. A bid submitted to an auction house by a buyer who is unable to attend the auction. These bids are submitted by telephone or in writing in advance of the auction. Also called a sealed bid.

Photomechanical process. Any method of transferring an image photographically to a plate.

Photo-offset printing. See **Offset printing.**

Pochoir. A French term for prints made by the stencil process. The artist paints directly on the paper through an open stencil.

Pop art. Art that is based on the use of mass-marketed commonplace objects and symbols as models. The starting point is the recognition of the object as an art form in itself.

Posthumous print. A print made by a technician after the death of an artist.

Poupée, à la. A technique by which an artist paints directly on the plate with a rag *(poupée)* and is therefore able to combine several colors on the plate.

Preview. A period of time prior to an auction during which buyers may view the items for sale.

Proof. An impression of a print made at an early stage of its creation.

Provenance. The history of the ownership of a work of art.

Pull. To print an impression.

Realism. Fidelity in art to real life and a rejection of that which is imaginative or visionary.

Recto. The front side of the paper on which an image is made.

Register. The alignment of colors so they will print without overlapping.

Relief. Any print made from a matrix in which the image stands out from the background.

Reproduction. A copy of an original work of art.

Reserve. A minimum price agreed upon between the auction house and the seller of a work of art.

Restrike. An impression pulled from a matrix after the authorized first edition was printed.

Rives. A trade name for a French paper.

Rocker. A tool used in the mezzotint process to raise burr.

Roulette. A tool, similar to a rocker, with a rotating head covered with small spikes.

Screen. A frame with stretched silk. Used in serigraphy.

Sealed bid. See **Order bid.**

Serigraphy. A stencil printing technique.

Soft-ground etching. An intaglio technique used to produce tone and texture in the print.

Squeegee. An applicator used by a silkscreen printmaker to force ink through the stencil.

State. Each significant change an artist makes to an image during the printing process is called a state. Normally, several state proofs are made to check the progress of the work. Old Master prints were printed and sold in many states.

Stopping Out. A method by which certain etched

areas are protected from further bite when they are immersed in an acid bath.

Sugar-lift etching. See **Lift-ground etching.**

Superrealism. An exaggerated effort to show every realistic aspect of the subject, as the camera would record it.

Surrealism. The creation of fantastic or incongrous figurative imagery by means of unnatural combinations and juxtapositions.

Transfer lithography. A technique in which the image is drawn by an artist on a piece of special transfer paper rather than on the plate or stone. The image is then transferred to the matrix for printing.

Tusche. A greasy ink or pencil used to draw the image on a lithographic plate.

Verso. The back of the paper on which an image is printed.

Watermark. An identifying mark impressed into the paper that registers the name of the paper manufacturer.

Woodcut. A relief printing method in which an image is incised into the side of a block of wood.

Wood engraving. Similar to a woodcut, except the image is cut out of the end grain of a wood block.

Wove paper. An even-textured paper without surface lines or irregularities.

Selected Bibliography

Benezit. E., *Dictionnaire Critique et Documentaire des Peintres, Sculpteurs, Dessinateurs et Graveurs,* nouvelle edition, Paris, 1976.

Carey, Frances, and Antony Griffiths, *American Prints 1879–1979* (catalogue), British Museum Publications, Ltd., London, 1980.

——*From Manet to Toulouse-Lautrec: French Lithography 1860–1900* (catalogue), British Museum Publications, Ltd., London, 1978.

Castleman, Riva, *Contemporary Prints,* Viking Press, New York, 1973.

——*Prints of the Twentieth Century: A History,* Thames and Hudson, London, 1976.

Donson, Theodore B., *Prints and the Print Market,* Thomas Y. Crowell Publishers, New York, 1977.

Goldman, Judith, *Frank Stella Prints 1967–1982,* Whitney Museum of American Art, New York, 1983.

Hayter, Stanley William, *About Prints,* Oxford University Press, London, 1962.

Ivins, William M., Jr., *Notes on Prints,* M.I.T. Press, Cambridge, Massachusetts, republication of the first edition published by the Metropolitan Museum of Art in 1930.

Johnson, Una E., *American Prints and Printmaking,* Doubleday & Co., Garden City, New York, 1980.

Massar, Phyllis, *Stefano Della Bella,* Collector's Edition Ltd., New York, 1971.

Phaidon Dictionary of Twentieth Century Art, E. P. Dutton, New York, 1973.

Selection III: Contemporary Graphics from the Museum's Collection, Museum of Art, Rhode Island School of Design, Providence, 1973.

Solomon, Elke M., and Richard S. Field, *Alex Katz Prints,* Whitney Museum of American Art, New York, 1974.

Zigrosser, Carl, and Christa M. Gaehde, *A Guide to the Collecting and Care of Original Prints,* Crown Publishers, New York, 1965.

Index of Artists